PRAISE FOR

MW01073559

True to its title, this compreher
York Puerto Rican women writ
endeavor. The literary corpus included herein offers a vast
selection of both well recognized and promising emerging authors, and aptly
unveils a neglected tradition of socially engaged women's writing. The volume
also illustrates a wide range of innovative poetic and narrative forms and styles,
and the written, oral, and performance aspects of New York City's Boricua literary
imagination. Without a doubt, this collection is a much-needed addition to the
study of the literature of the Puerto Rican diaspora and an indispensable source
in understanding how the experiences of migration, translocality, hybridity, and
cultural, racial, and gender subjectivities and negotiations are rendered through
creative expression.

—Edna Acosta-Belén, *Distinguished Professor, University at Albany, SUNY and
contributing editor to the Norton Anthology of Latino Literature.*

To anthologize is a very specific thing to do and Myrna Nieves has a keen
perceptive eye and does this expertly and genuinely. In this book you will find
some of the best writing around the nation. Read it and you will see that Nieves
has hit the magic button.

—Miguel Algarín, *writer and critic, founder of the Nuyorican Poets Café*

Esta antología, el resultado de diez años de trabajo de Myrna Nieves, recoge
las voces de cuarenta y seis escritoras puertorriqueñas que han vivido por más de
una década en Nueva York. La excelente y amplia selección de autoras, poemas
y narraciones ha cuajado en un volumen imprescindible para quien enseñe
Literatura del Caribe hispano, Literatura latina en los Estados Unidos o quiera
conocer "la riqueza literaria de toda una generación".

—Sonia Rivera Valdés, *Presidenta, Latino Artists Round Table,
Ganadora del Premio Casa de las Américas*

Este volumen constituye el primer documento abarcador sobre el panorama
de producción poética de mujeres puertorriqueñas en Nueva York, fruto de la
emigración. Presenta a profundidad una multiplicidad de voces distintas y únicas
que fluyen desde el gozo, la lucha, la tragedia y de vuelta al bálsamo de la creación.
Con ellas digo: *I struggle at war with my sun shield..., alone warring alone, brave
and sad, content and brave.*

—Etnairis Rivera, *writer and cultural activist, University of Puerto Rico*

New York has been blessed over the last 30 years by the incredible ferment
reflected in these pages. Edited by Myrna Nieves, an extraordinary poet in her
own right, the voices of Puerto Rican women writers sing out in this magnificent
book. There is nothing patterned, nothing predictable, because each voice, while
part of a whole, has a music very much its own.

—Robert Roth, *co-creator and editor of And Then magazine
and author of Health Proxy*

BREAKING GROUND:
Anthology of Puerto Rican Women Writers in New York
1980-2012

ABRIENDO CAMINOS:
Antología de escritoras puertorriqueñas en Nueva York
1980-2012

Edited by / Editada por
Myrna Nieves

editorial**Campana**

NEW YORK

To the women in my family:
my grandmothers, my mother, my aunts
my sister and my cousins
my daughter and my granddaughter
for their love and strength

A las mujeres de mi familia:
mis abuelas, mi madre, mis tías
mi hermana y mis primas
mi hija y mi nieta
por su amor y fortaleza

Yo quise ser como los hombres quisieron que yo fuese:
un intento de vida;
un juego al escondite con mi ser.
Pero yo estaba hecha de presentes,
y mis pies planos sobre la tierra promisora
no resistían caminar hacia atrás,
y seguían adelante, adelante,
burlando las cenizas para alcanzar el beso
de los senderos nuevos.

—Julia de Burgos
Fragmento de *"Yo misma fui mi ruta"*

I wanted to be like men wanted me to be:
an attempt at life;
a game of hide and seek with my being.
But I was made of nows,
and my feet level upon the promissory earth
would not accept walking backwards,
and went forward, forward,
mocking the ashes to reach the kiss
of the new paths.

—Julia de Burgos
Excerpt from *"I Was My Own Route"*
Translated by Jack Agüeros

....the journey from Kamakura to Kyoto takes twelve days. If you travel
for eleven but stop with only one day remaining, how can you admire the
moon over the capital?

—Nichiren Daishonin, 1280 AD

Agradecimientos

Este libro no sería posible sin mi fe en el infinito potencial del universo, y las personas que me brindaron su apoyo y colaboración. Deseo hacer un reconocimiento a las escritoras que, confiando en mi labor y mis intenciones, ofrecieron su obra a esta antología. Más de la mitad de ellas sostuvieron esa confianza por diez años. A todas, mi respeto y mi profundo agradecimiento por el honor de poder trabajar con su obra.

Este libro es posible también, gracias a la colaboración y recomendaciones de muchas personas. En especial, agradezco al Dr. Víctor Alicea, Presidente de Boricua College, su apoyo, aliento y recomendaciones. Gracias a la Dra. María Montes y el Dr. Shivaji Sengupta, Vice Presidentes de Boricua College, por su apoyo y entusiasmo con el proyecto. También en Boricua College, agradezco a Ariel Joseph el editar materiales para esta antología y ofrecer sugerencias. Agradezco a Corazón Tierra y a mi hija, Zaadia Colón Nieves, su ayuda en la organización del manuscrito. Gracias a la Dra. Madeline Millán, Pilar Blanco (con la ayuda de Brian Fallon) y Soledad Romero, por su esmero al editar textos para esta antología. Agradezco a Sandra Barreras del Río y a Robert Roth (de la revista *And Then*), el escuchar tantas veces mis ideas y ofrecer recomendaciones. Gracias a mis colegas en Boricua College: José I. López, la Dra. Nancy Mercado y la Dra. Barbara Gardner, por su valiosa colaboración. Gracias a la Dra. Etnairis Rivera, por su constante respaldo a mi obra literaria. Agradezco a mi hermana Betzaida, su invariable estímulo; a Trudy Silver, el compartir generosamente textos inéditos de Cenén Moreno, con la ayuda de Robert Roth; a Jesús Papoleto Meléndez, su ayuda en editar un poema; a Rita Rodríguez Puigdollers, la valiosa información sobre la vida de su madre; a la Dra. Luz M. Umpierre, por sus recomendaciones; a la Dra. Carmen Dolores Hernández, el compartir información y ofrecer recomendaciones; a Elizabeth Macklin, la traducción de poemas para la antología; a Nicholasa Mohr, la generosidad con sus textos y consejos; a Ivelisse Jiménez, el ofrecer su arte al libro y a Mairym Cruz Bernal, su gentileza al invitarme recientemente a colaborar en otros proyectos literarios.

Agradezco profundamente a Mario Picayo y a la Editorial Campana su fe en este libro y a Boricua College, su respaldo a las escritoras que se incluyen en esta antología.

Gracias infinitas a mi madre, Ana Elena, que me otorgó su segundo nombre, me dejó su amor por las artes y me enseñó a crear con convicción.

ACKNOWLEDGEMENTS

This book is possible thanks to my faith in the infinite potential of the Universe, and to the writers who trusted to me their literary work and the completion of this anthology. Over half of the writers included in this book sustained their trust in this project for more than ten years. I deeply appreciate the honor of working with their literary pieces.

This book is also possible thanks to many persons who offered collaboration and support. I am forever grateful to: Dr. Víctor Alicea, President of Boricua College, for his support, encouragement and recommendations. Thanks to Dr. María Montes and Dr. Shivaji Sengupta, Vice Presidents of Boricua College, for their support and enthusiasm with this project. Also in Boricua College, I am grateful to Ariel Joseph, for her help in editing materials for the anthology. Thanks to Corazón Tierra and my daughter Zaadia Colón Nieves, for their help with the organization of the manuscript. I am grateful to Dr. Madeline Millán, Pilar Blanco (with the help of Brian Fallon) and Soledad Romero, for their care in editing texts for this anthology. Thanks to Robert Roth (from the magazine *And Then*) and Sandra Barreras del Río, for their recommendations and for listening to my ideas and concerns. I am also grateful to various colleagues at Boricua College: José López, Dr. Nancy Mercado and Dr. Barbara Gardner, for their valuable collaboration. I thank Dr. Etnairis Rivera for her constant support of my literary work. I appreciate my sister Betzaida's everpresent encouragement; Trudy Silver's generosity in sharing texts by Cenén Moreno, with the help of Robert Roth; Jesús Papoleto Meléndez, for editing a poem; Rita Rodríguez Puigdollers, for offering valuable information about her mother, Carmen Puigdollers; Dr. Luz M. Umpierre, for her recommendations; Dr. Carmen Dolores Hernández, for sharing information and recommendations; Elizabeth Macklin, for translating poems for this anthology; Nicholasa Mohr, for her generosity with her texts and advice; Ivelisse Jiménez, for offering her art work to this book and Mairym Cruz Bernal, for inviting me to participate in other literary projects.

I am especially indebted to Mario Picayo and Editorial Campana for their faith in this book and to Boricua College for its support of the writers included in this anthology.

I am infinitely grateful to my mother, Ana Elena, who granted me her middle name, gave me a love for the arts and taught me to create with conviction.

Introduction and selection copyright © Myrna Nieves, 2012
Permission credits on pp.429-432 constitute an extension of this copyright page.
Published by Editorial Campana.
This edition is co-produced with the generous support of Boricua College.

Editorial Campana
19 West 85th Street
New York, NY 10024
info@editorialcampana.com
www.editorialcampana.com

Boricua College
890 Washington Avenue
Bronx, New York 10451
www.boricuacollege.edu

First edition: October 2012

Library of Congress Cataloging-in-Publication Data

Breaking Ground: Anthology of Puerto Rican Women Writers in New York 1980-2012
= Abriendo caminos: antología de escritoras puertorriqueñas en Nueva York 1980-2012 / edición e
introducción Myrna Nieves.
 p. cm.
 English and Spanish.
 ISBN 978-1-934370-16-2 (pbk.)
 1. American literature--Puerto Rican authors. 2. American literature--Women
authors. 3. Puerto Ricans--United States--Literary collections. I.
Nieves, Myrna E. II. Title: Breaking Ground: Anthology of Puerto Rican Women Writers in New York
1980-2012 / Abriendo caminos: antología de escritoras puertorriqueñas en Nueva York 1980-2012
PS508.P84B74 2011
 810.8'09287089687295–dc22
 2011004320

Proof Reading: Pilar Blanco, Jane Heil, Jacqueline Herranz-Brooks,
Ariel Joseph, Madeline Millán & Soledad Romero
Cover Art: la by Ivelisse Jiménez
Design: Yolanda V. Fundora
Project Managing Editor: Mario Picayo
Production Liaison: McKinley Matteson

Printed in the United States of America.
9 8 7 6 5 4 3 2 1

ÍNDICE

CONTENTS

Introducción

Comencé esta antología hace más de diez años y el proceso de completarla ha sido muy peculiar. Las escritoras incluidas en este libro, en su mayor parte, leyeron su obra en la Serie Invernal de Poesía de Boricua College en Nueva York, un ciclo de lecturas literarias anuales que dirigí por 20 años (1988 al 2008) y en el que participaron cientos de hombres y mujeres de letras, en su mayoría latinos. Ya en la década del 1990, me di cuenta de que la cantidad y calidad de la obra literaria producida por las mujeres puertorriqueñas era significativa y, sin embargo, las antologías y publicaciones de entonces (y quizás aún, de ahora) no reflejaban ese caudal. Originalmente, invité a otras dos escritoras, Ana López-Betancourt y Maritza Arrastía, a que publicáramos un libro de poesía y narrativa; de ahí nace *Tripartita: Earth, Dreams, Powers*, publicado por Ediciones Moria en una colección que las escritoras creamos, *Atabex*. Moria era la única editorial caribeña en Nueva York que publicaba literatura escrita por latinos en inglés y en español durante los años 80. Sin embargo, a medida que continuaba mi labor en la Serie de Poesía, me di cuenta de la necesidad de ampliar este esfuerzo y presentar la valiosa contribución literaria de las escritoras puertorriqueñas y documentar su aporte cultural, artístico y socio/político a la ciudad de Nueva York.

Que las escritoras en esta antología hubiesen vivido en Nueva York por lo menos diez años era importante para mí, porque, como es natural, muchos escritores pasan por la Ciudad y residen en ella por poco tiempo y luego se marchan, a menudo con una visión limitada de la vida puertorriqueña en esta urbe. Deseaba que la antología evidenciara de alguna manera, las luchas de tantas escritoras puertorriqueñas por sobrevivir, educarse y florecer en el fiero y excitante ambiente de Nueva York. Deseaba una antología que incluyera tanto las experimentaciones con el lenguaje y la forma literaria en una ciudad donde el crear arte es la rúbrica principal, como el impacto humano del dolor, las alegrías, las decepciones, los triunfos y los retos de sus vidas. Cuando originalmente comencé el proyecto en el 1996, se incluían 23 escritoras publicadas en libros y revistas o presentadas en teatros y eventos destacados, pero con el tiempo se añadieron otras escritoras (también publicadas), que descubría en nuestra comunidad o surgían como estrellas, aparentemente aisladas, de una constelación que insistía en contemplar.

El propósito de esta antología es, pues, presentar la amplia gama de poesía, prosa poética y narrativa que las escritoras puertorriqueñas de Nueva York han producido desde el 1980 a 2012. El propósito es además, documentar el activismo de estas escritoras cn las últimas tres décadas, de ahí que las biografías de las escritoras incluyan detalles de sus logros en diversas áreas de la actividad humana. Muchas de ellas han fundado organizaciones culturales y sociales, luchado por derechos civiles y participado en eventos e iniciativas que van desde la protección de otras mujeres y los niños, la preservación del ambiente, su propia educación y la de sus comunidades, hasta la organización y participación en festivales literarios, programas televisivos y películas que muestran su creatividad y la elasticidad de

su talento. Son 46 escritoras, de un registro amplio de edades. Algunas escriben predominantemente en inglés; otras en español y aún otras, en ambas lenguas. Las obras se incluyen en el idioma en que las escritoras decidieron presentarlas. El énfasis de esta antología es en abrir espacios al material existente. El abrir espacios, particularmente en literaturas emergentes, provee oportunidades para apreciar la calidad de los textos y crea conciencia sobre los criterios con los que se acepta y clasifica la producción literaria. Esperamos además, que, en el proceso de conocer los textos, se podrán eventualmente establecer parámetros críticos que surjan de la literatura que se va aprehendiendo.

No es una antología exhaustiva; hay otras escritoras que por su propia decisión o por razones de espacio y otras circunstancias, no se incluyen en esta compilación. Hay una generación de escritoras en ciernes que ya se perfila en forma excelente, vibrante. El mapa de su existencia y evolución es aún impreciso; su situación recuerda nebulosas espaciales donde nacen las estrellas, aunque ya hay algunas que comienzan a destacarse claramente. Hay escritoras que precedieron a todas las que se incluyen en este libro; el caso más notable es nuestra inmensa Julia de Burgos. Y las hay que, como memorables cometas, vivieron en la Ciudad antes del 1980 y/o por un tiempo menor que una década, como Etnairis Rivera, Magali Quiñones y Mayda del Valle, pero que dejaron su estela en círculos culturales y literarios. Por razones de espacio no hemos incluido las dramaturgas, entre las que se destacan Carmen Rivera, Tere Martínez y Eva Vázquez, que merecen una antología separada para que sus obras se puedan apreciar a cabalidad. No obstante, este libro se propone una meta nada sencilla: ser una presentación inicial de la producción literaria de las escritoras puertorriqueñas en Nueva York a partir de la década de 1980. Se propone, además, documentar unos logros y celebrar la riqueza literaria de toda una generación.

Los temas que abordan estas escritoras en sus obras son, como es de esperar, variados, y aún en los que son similares, existen distintos matices. Si se mira el conjunto, estas obras presentan la plasmación literaria de las dialécticas (que a veces las escritoras mismas tratan de aunar) entre lo universal y lo local, lo clásico y lo moderno, la interioridad y lo político/social, lo lírico y lo violento, la lectura tradicional y el performance, la literatura oral y el texto escrito. Alude, entre otros, a asuntos como el crecimiento demográfico puertorriqueño desde la emigración y cómo se enfrentan las escritoras a esa expansión del universo puertorriqueño. En realidad, ese universo nunca ha sido totalmente puertorriqueño desde antes y después de la emigración, por aquello de pirata, insular, colonia, pertenecer a un Caribe emigratorio entre las islas mismas y migrar a Estados Unidos. A ello se le unen el vivir momentos de tensión y fusión con otros grupos en la ciudad nuyorkina, con otros latinos, los afroamericanos, los judíos, los "blancos". Debe quedar claro que si bien los puertorriqueños no son el emigrante tradicional por ser ya ciudadanos de Estados Unidos antes de llegar, existen similaridades con grupos latinos y otros grupos en cuanto al proceso personal o interno de migrar. Las escritoras se expresan sobre innumerables temas que van desde el amor y la familia, al abuso, la liberación, la meditación sobre la conducta humana, el entorno natural o citadino, los viajes de la imaginación, el encuentro con sí mismas, la vida y la muerte. Estos textos evidencian, por otra parte, lo que es escribir en inglés siendo puertorriqueño y latino en Estados Unidos, lo que es vivir y escribir en

español en Estados Unidos, lo que es ser bilingüe en esta ciudad. Exploran lo que es ser humano en esta época extraordinaria.

Resulta interesante observar el punto de vista de la mujer que participa de una expansión emigratoria en una sociedad anónima, como puede ser Nueva York muchas veces. ¿Cómo brega con la nostalgia, la soledad o la excitación y posibilidades creativas de lo nuevo? Resulta interesante observar, desde una perspectiva puramente existencial, ¿Qué hace, piensa y siente una mujer puertorriqueña ante este vasto y complejo territorio? ¿Cómo entiende, crea o moldea el lenguaje(s)? ¿Cómo participa de una pluralidad de experiencias literarias enraizadas en esta realidad urbana y en su condición de mujer? ¿Qué es ser mujer? ¿Cómo percibe sus relaciones con los hombres y otras mujeres? ¿Cómo definimos la identidad sexual y étnica? ¿Es posible o deseable formular definiciones? Estas exploraciones eran parte de la intención inicial de extender una invitación a las escritoras en la Serie Invernal de Poesía (me decidí a que por lo menos la mitad de los escritores de cada evento fuesen mujeres) y así lo llevamos a cabo.

La mayoría de las escritoras en esta antología han tenido una educación formal universitaria avanzada, que se basa principalmente en una tradición escrita (aunque la poesía oral, desde los griots africanos y Homero hasta el presente, sean parte de esa tradición), y por lo tanto la obra se lee por el lector en privado o el autor la lee sin mayores elaboraciones ante un público, a menudo culto o amante de la literatura. Esta literatura es parte de un discurso literario de escritura puertorriqueña, norteamericana y universal, tanto a nivel de temas, referencias e intertextualidad. En su evolución, la poesía de esta tradición que se cultiva en la actualidad, se ha alejado de la rima. Su ritmo o musicalidad es, las más de las veces, interno y aunque sea una poesía que se pueda recitar, debe ser leída para que se puedan captar todas sus implicaciones.

Por otra parte, la obra de algunas escritoras (de mayor o menor educación) evidencia la presencia de una cultura oral vinculada a la actuación o el *performance*: el *spoken word*, que algunos también llaman *poesía urbana*, destinada a realizarse en espacios variados y a menudo dirigida a los sectores más jóvenes de la población. Me interesa definir lo que es *spoken word*, modalidad literaria muy unida a la poesía nuyorican y al *hip-hop*. Puede incluir un énfasis en la cultura popular, "la calle", el comentario social, los medios de comunicación y la tecnología. A menudo incorporan a las palabras movimientos corporales, música, elementos teatrales y medios múltiples. A veces, es notable la influencia de la cultura afrocaribeña y, especialmente, la afroamericana. Los poemas tienden a decirse de memoria y hacen uso (por lo menos en sus comienzos) de la rima. Algunos realizan momentos o figuras históricas, en un intento de educar o hacer recordar a la audiencia. La influencia de este tipo de poesía llega a otras expresiones poéticas que no se pueden calificar de *spoken word*, y ha viajado a Puerto Rico mismo, donde algunos de los jóvenes poetas la crean también. Cabe recordar que en Puerto Rico existía ya una tradición de declamar o recitar poemas de escritores reconocidos que incluía movimientos corporales y elementos teatrales. La forma de publicación preferida del *spoken word* es la grabación (CD y otros medios); la mejor plataforma para apreciarla es el *performance* mismo. Uno de sus objetivos es que la poesía siga siendo parte de la vida diaria de la gente, educada o no educada (en este caso,

productos de las luchas con un sistema de instrucción en el que por mucho tiempo no tuvieron acceso a una educación adecuada). El principio filosófico básico es que todo el mundo tiene estética: todos tenemos la capacidad de expresarnos. La función del poeta, en esta perspectiva, es facilitar un lugar estético universal que le pertenezca a todo el mundo.

La escena literaria puertorriqueña en New York no es homogénea y existen marcadas diferencias entre grupos. Estas diferencias están enlazadas a perspectivas con las que se caracteriza la actividad intelectual y a actitudes respecto al idioma en que se escribe y se habla. En relación al idioma, se incluyen las controversias sobre el escribir en inglés, la mezcla de ambos idiomas en la literatura, el uso del Spanglish y el escribir en español en la Ciudad. Estos asuntos son los más obvios; si los estudiamos bien, son realmente una expresión de las diferentes modalidades que adquiere la cultura puertorriqueña en Nueva York. Todos, aún los más retirados de lo que cada uno cree que es el "centro" de la "comunidad", se consideran puertorriqueños. Su expresión refleja el esfuerzo por asumir individualidad dentro de la colectividad. Son complejas y muy reales las dinámicas de aceptación, rechazo o colaboración entre los diferentes sectores de esa cultura que, en forma general son: 1) la comunidad de los que han nacido y/o criado en Nueva York, 2) los que residen en el país de origen (Puerto Rico) 3) los que han venido a la Ciudad y se identifican con los que han nacido/criado en ella 4) los que han venido a la Ciudad y se mantienen en círculos de habla hispana solamente y 5) los que han venido a la Ciudad y se relacionan mayormente con otros sectores literarios, como el afroamericano u otros sectores de habla inglesa no puertorriqueña (que llaman "mainstream").

No necesariamente estos sectores están en conflicto; la mayor parte del tiempo coexisten y se entrecruzan o simplemente crecen y evolucionan unos al lado de los otros, como galaxias en espiral en el aparentemente infinito espacio de Nueva York. No obstante, a veces se enfatiza una perspectiva antagónica de criterios rígidos o miopes que es menos afortunada. Podríamos intentar un inventario de ellos: criterios estrechos sobre la tradición literaria a las que pertenecen las obras, la identificación como literatura importante o literatura "menor", los reclamos de "pureza lingüística" (en inglés y en español), los reclamos de autenticidad cultural (quiénes son "los verdaderos puertorriqueños") y/o los reclamos de universalidad cultural (quiénes son cosmopolitas o provincianos). Estas perspectivas a menudo enmascaran políticas culturales--las más de las veces coloniales, clasistas y/o racistas---de exclusión histórica, auto-desprecio y a veces, resentimiento. Esta antología se propone reunir el mayor número de sectores literarios posibles con la intención de que, en aquellos que posean un profundo aprecio por la literatura como arte humano enraizado en el "yo y mis circunstancias", se incube un mayor entendimiento, respeto y gusto por las diferentes modalidades de literatura (y modalidades de cultura) que emergen. Sin pretender homogenizar contradicciones, borrar toda diferencia, ni proponer una totalidad (si bien, plural) monolítica, es posible preguntarnos, en fin, ¿Cómo abrazar y deleitarnos en nuestro cosmos? Quizás uno de los asuntos claves en el planeta en estos momentos es cómo los seres humanos nos aceptamos y valoramos plenamente a nosotros mismos. Labor nada simple. Si lo logramos, es posible tener la esperanza de un mundo de más paz, amor, creatividad y justicia. Estas palabras a veces se manejan automáticamente o se

escuchan con cinismo, pero en realidad enuncian las ansias secretas de muchos. Y escribo "esperanza" porque si bien este intento no nos libra totalmente de la "crisis de la realidad" (¿o coyuntura oportuna?) que la multiplicidad de vertientes implica, ni de la naturaleza, al fin y al cabo, precaria, de la existencia humana, las escritoras aquí incluidas no nos sumimos en la impotencia (ni en el silencio). Después de todo, ¿quién quita que cuando cambiamos nuestras percepciones, sentimientos o actos, transformamos la realidad misma que creemos percibir o nos impacta? Es posible que el conjunto que presenta este libro ofrezca una base para que las escritoras (y sus lectores) puedan aprehender mejor el presente y forjar una visión del futuro. Podemos dar a luz un nuevo universo.

Espero que esta antología cumpla la función esencial de inspirar.

Myrna Nieves
6 de mayo de 2012

INTRODUCTION

I began this anthology over ten years ago when most of the writers included in this book read their literary work at The Boricua College Winter Poetry Series, a yearly cycle of readings and performances that I co-founded in 1988 and directed for twenty years. Hundreds of men and women writers--mostly Latinos-- presented their work to the public at these events and engaged in dialogues with the audience. Early in my work with the Series, I realized that the literary production of Puerto Rican women writers was distinctive and impressive. Nevertheless, they were often underrepresented (or not present at all) in anthologies, magazines and newspapers. Initially, to address this situation, I invited two other writers, Ana López-Betancourt and Maritza Arrastía, to join me in writing a book of poetry and fiction that we entitled *Tripartita: Earth, Dreams, Powers*. This book was published by Editorial Moria (under our own, newly founded division or collection, *Atabex*). Moria was the only Latino press in New York that would publish books written by Latinos in Spanish and English. As I continued my work with the Series, I became aware of the need to expand these efforts in order to present a larger group of writers and to document in some way their artistic, cultural and social contributions to the City of New York.

I realized that for me it was important that the women included in this book were active in the cultural scene and had lived in New York for at least 10 years. Because many people visit or live in New York for only a period of time, they often leave with a limited idea of the myriad variations of Puerto Rican life in New York City. I wanted an anthology that would document the efforts of so many Puerto Rican women writers surviving, educating themselves and flourishing in the demanding and exciting environment of the City. I sought to include their experiments with literary form and language in the context of a city known for its

artistic production and innovations. I wanted an anthology that would document their struggles, pains, joys, disappointments, successes, and challenges. Initially, the anthology included 23 writers that were published or had been featured in theaters and other relevant events. As I continued to work on my project, other writers emerged from our community, revealing themselves, much like isolated stars of a unique constellation that I delighted in watching.

The main purpose of this anthology is to present the wide spectrum of poetry, poetic prose and fiction produced by 46 Puerto Rican women writers in New York from 1980-2012. Another purpose is to document the activism of these writers in the last three decades. Many of them have founded literary, cultural and social organizations and have participated in literary festivals, television programs and films. A good number of them have carried out efforts in civil rights movements and others endeavors, such as the protection of women and children, the protection of the environment, their own education and the education of their communities. This book includes writers of various ages: young, mature and older women as well. Some write in English, others in Spanish and a few of them write in both languages. The works that have been included are in the language in which the writers submitted them. Our primary concern is to make known the existing literary work. This is particularly important for emerging literatures, since it provides opportunities for the appreciation of new works and the discussion of issues of literary criticism that can emerge from the appreciation of the texts themselves.

This is not an exhaustive anthology: Some writers decided not to be included; others were not included due to several reasons. There are some writers not included who resemble new stars in a nebula. Their silhouette is still imprecise, but definitely promising a vibrant light. Other writers lived and wrote in New York long before the ones included in this book; a case in point is the great poet Julia de Burgos. Still others resemble memorable comets: writers who lived in the city before the 1980's or for less than a decade but left a trail in literary and cultural centers. Among these are Etnairis Rivera, Magali Quiñones, and Mayda Del Valle. We have also not included here the playwrights, Carmen Rivera, Tere Martínez and Eva Vázquez, who deserve an anthology of their own that can fully expose their work.

As could be expected, the themes of the writing included in this anthology are diverse. Even those sharing similarities exhibit different shades or styles. As a conglomerate, they are literary expressions of the dialectics between the universal and the particular, the classical and the modern, the inner life of the individual and the political and social issues of the collective, lyricism and violence, traditional reading and performance, the oral literature of the spoken word and the written text. They make reference to issues such as the growth of the Puerto Rican population since the time of its massive emigration and the manner in which Puerto Rican women perceive the expansion of the Puerto Rican presence in the City. In truth, that "Puerto Rican" universe was never only Puerto Rican, even in the homeland. This is due to multiple factors: its pirate, insular and colonial history; belonging to an intrinsically migratory Caribbean (among the islands themselves); and then, the massive migration to the United States and the interaction—sometimes fusion—

with other groups in New York. Among these groups are other Latinos, African Americans, Jews, and the "Whites." It should be clearly stated that Puerto Ricans are not traditional emigrants because they are already USA citizens before arriving. However, they share with other groups similar feelings and experiences regarding the inner impact of the process of emigrating. Their literary works express issues such as love, family, abuse, belonging, alienation, liberation, reflections on people's behaviors, the natural or human-made environment, imagination, the exploration of the self, life and death. The texts themselves are a testimony of how it feels to write in English as a Puerto Rican and Latina in the United States. They document how it feels to live and write in Spanish in the United States or to be bilingual in this city. They explore being human on Earth in these extraordinary times.

It is interesting to learn the perspectives of women as they observe and participate in the Puerto Rican expansion in New York, which is a city that can be as warmly welcoming as it is indifferent. How do they make their way through the mixed feelings of nostalgia and loneliness and the excitement and opportunities for creativity always present? What do women do, think and feel? What is their relationship with language? How do they understand language, work with language or create it? How do they participate in literary experiences that are rooted in an urban reality and in their conditions as women? What is it to be a "woman?" How do these writers perceive their relationship with men and other women? How are sexual and ethnic identities defined? Are definitions desirable or possible? These explorations were, in part, the reason for inviting women writers to the Winter Poetry Series. I was determined that at least half of the guest writers at the Poetry Series be women. Thus, it was carried out in this manner.

Most of the writers in this anthology have a college education and advanced degrees. Since a written tradition characterizes most of academia (even through oral poetry is part of that tradition, since the times of Homer or the African griots), most writers educated in this tradition produce books or other materials that can be printed. They are primarily intended to be read privately in silence or read by the author to an audience that is usually either cultured or fond of literature. These written products are part of a Puerto Rican, North American and universal discourse, as is evident in their themes, references and inter-textuality. Poems no longer make use of rhyme as a predominant characteristic of their form. Their rhyme or musicality is mostly internal and even if it is publicly recited, it needs to be read to a group in order to grasp all of its implications.

On the other hand, there are also writers who create a form of literature that participates in the oral tradition and is known as *spoken word* or *urban poetry*. This literature, which is related to acting or *performance*, is carried out in various settings and often intended for younger audiences. The *spoken word* is a literary form closely related to Nuyorican poetry, *rap* and in a certain way, the *hip hop* culture. It emphasizes the "street," social commentaries, the media and postmodern technology. It often includes words combined with body movements, music, theatrical elements and mixed media. Sometimes, it has marked African American influences as well as Afro-Caribbean influences. Poems are conveyed from memory and by the use of rhyme. Poems and stories alike may emphasize historical figures and events to remind the audience of their existence and

importance. Its influence can be felt in other literary expression that can not be classified as *spoken word*, and it has influenced some writers in Puerto Rico who are now *spoken word* artists as well. It is important to be aware that Puerto Rico has its own oral poetry tradition, performed by *"declamadores."* This tradition also includes body movements and theatrical elements. *Spoken word* artists' main form of publication is the recording (CD and other media) and it is best appreciated through the performance itself. One of its purposes is to have poetry continue being part of people's everyday life, whether they are educated or not (the product of lack of access to an adequate educational system). One of its main philosophical principles is that everyone has an aesthetic; we all have the capacity to express ourselves. The poet, in this perspective, facilitates a universal aesthetic place that can belong to everybody.

The Puerto Rican literary scene in New York is not homogeneous. There are obvious differences among its groups. These differences stem from the ways in which intellectual activity is perceived and from attitudes regarding the spoken and written language in literary expression. Some of these are: controversies over producing literature in English, combining English and Spanish in a text, the use of Spanglish, and writing in Spanish. All these writers, even the more distant ones, consider themselves to be Puerto Rican. The controversies or tendencies can be considered as expressions of Puerto Rican culture in New York, each writer attempting to be distinct (unique?) in the context of a collectivity.

The dynamics of acceptance, rejection and collaboration among the various sectors of Puerto Rican culture in New York are real and quite complex. In general terms, the following groups may be considered: 1) those who were born and raised in New York, 2) the ones who reside in Puerto Rico and may visit or write about the New York experience, 3) those who have migrated to New York and identify themselves with the people who were born and raised in New York, 4) writers who have migrated to New York and involve themselves predominately with Spanish-speaking circles, 5) artists who involve themselves exclusively with other literary circles, such as African Americans or other non-Puerto Rican English speaking circles (that they call "mainstream").

Most of the time, these sectors are not in a conflict with one another; mostly, they coexist, intersect, or evolve next to each other, like spiraling galaxies in the infinite-like space of New York City. However, we may sometimes find a perspective that emphasizes conflicts. We can attempt an inventory of them: narrow criteria about the literary tradition to which the literary products are judged to belong, identifying a body of literary works as "major literature" or "minor literature", claims of "linguistic purity" (in English and in Spanish), claims of "cultural authenticity" (Who are the "real Puerto Ricans?"), claims of cultural universality (Who are cosmopolitan or provincial?). Basically all these claims or beliefs mask cultural politics–most of them colonial, class-oriented or racist–that perpetuate historical exclusions, self-hate and resentment. This anthology intends to elicit a love for literature as a human art rooted in the person in relation to her/his environment. It seeks to reunite as many literary expressions as possible, with the hope of inspiring a greater understanding and appreciation of the variety of literary (and cultural) modalities that have emerged.

Attempting to accomplish these goals does not mean that all contradictions are homogenized, differences erased or that a monolithic totality (even a pluralistic one) is being proposed. However, we may ultimately be able to ask ourselves: How do we embrace and take delight in our cosmos? Probably, one of the most important issues in the world today is how we can fully accept and value our self and each other. This is by no means a simple task. However, if we are able to do it, then maybe we can hope for a world of greater peace, love, creativity and justice. These words are complex terms that sometimes are used automatically or received with cynism, but which often convey the deepest longings of many people.

It is difficult to completely free ourselves from the "crisis of reality" (or, just opportunity?) that an increasing and accelerating multiplicity can produce, nor from the precarious nature of human existence. Nonetheless, we do not look forward to impotence (or silence). It may very well be possible to transform reality when we re-create ourselves. This book may provide a basis from which women writers (and their readers) can better apprehend the present and create a vision of the future. We can all birth a new universe.

I hope this anthology inspires.

Myrna Nieves
May 6, 2012

STEPHANIE AGOSTO

Stephanie Agosto es una artista del *spoken word* que pertenece a la nueva generación de poetas-activistas que se iniciaron en Nueva York en la década del 1990. Como miembro de la generación de artistas del Hip Hop, su obra se basa en el ritmo oral y alterna entre la poesía en la página y la poesía en escena (performera, "rapper"). Su poesía se ha publicado en antologías, libros de arte y periódicos. Agosto estudió en Queensborough Community College, Hunter College y en el Film and Video Arts de la ciudad de Nueva York. Produjo y fue anfitriona de la serie semanal de poesía *Universal Beats* en el Manhattan Neighborhood Network. Produjo también una serie de poesía de 12 semanas en el café Alexis de la ciudad de Nueva York. Apareció en el programa literario televisado *phatLiterature*, en QPTV y escribió la canción-tema de este programa con Michael Bynum. Como activista, trabajó con el Dr. Louis E. Parrish, que creó terapias para pacientes con enfermedades crónicas y que fue una de las prácticas para tratar HIV/AIDS más prominentes de la ciudad de Nueva York. Ha realizado trabajo voluntario en varias organizaciones, incluyendo Gathering of the Tribes, Wordquestra (Poets Choral), Shawangunk Correctional Facility y ahora, en una clínica de salud para mujeres en Florida. Como poeta y peformera, se ha presentado en el Nuyorican Poets Café, The Julia de Burgos Cultural Center, Boricua College, A Gathering of the Tribes, Aaron Davis Hall, Sista's Place y The Center for Imaginative Writing de New Paltz University.

Stephanie Agosto, a *spoken word* artist of the Nuyorican literary movement, belongs to a new generation of activist poets that began their activities in New York in the 1990's. As a child of the Hip-Hop generation, Agosto's foundation is in all things with a beat, crisscrossing between poetry on the page and on the stage. Her poetry has been published in anthologies, art books and periodicals. Agosto studied at Queensborough Community College, Hunter College and the Film & Video Arts in New York City. She produced and hosted the weekly poetry series *Universal Beats* on Manhattan Neighborhood Network. She also produced a 12-week poetry series at Alexis Café in New York City. She appeared on *phatLiterature,* a Literary TV Program aired on QPTV and co-wrote with Michael Bynum its theme song. As an activist, she worked for Dr. Louis E. Parrish, who created a facility for ancillary therapies for patients with chronic illness, which became one of the first prominent HIV/ AIDS practice in New York City. She has donated her time to several organizations, including Gathering of the Tribes, Wordquestra (Poets Choral), Shawangunk Correctional Facility and now, to a women's health clinic in Florida. She has performed at numerous venues, including: Nuyorican Poets Café, The Julia de Burgos Cultural Center, Boricua College, A Gathering of the Tribes, Aaron Davis Hall, Sista's Place, and The Center for Imaginative Writing at New Paltz University.

SHOW ME THE KEY

The secret garden is even
in the house of detention
Of course there are prisoners there
most of the time on the payroll
Aren't they lucky that criminal injustice exists
Cancer doesn't discriminate these days
most care less about the past
much less the future
they go against our system or drown in it
never knowing who the REAL
founding fathers or mothers are
What is the struggle about?
Do they even care to know
they have forgotten about death because
they live dead
Politics means me me me
me a Puerto Rican American
I want to live cancer free
Politically correct in my eyes
I want to walk through
the open doors
although many are afraid to continue
where few have gone
Where we can raise the table
in the secret garden
in every house of detention
respecting those who paved the way
Grass is never greener on the other side
Grass is not green at all
What difference does that make
We need a bit of earth, just a garden
SHOW ME THE KEY!

Brothers on the Same Page

Malcolm X and Pedro Albizu Campos
Sharing a page on a book
Sitting waiting for the penetration into the hearts of the free
Imprisoned by time and circumstances but FREE
Tormented by time and circumstance but FREE
So many pain driven, so in need
stakes of the FREE
Topics given time for debate someone there not ready to relate
One disconnected energy in the room creates hate
Imbalanced thoughts fall on one side or another
Losing the true meaning of the word
Brother
Fortune ties stronger than ignorance
Filled with arrogance of significant means
with all those powers they came to share
information with their people who need to care
Flags raised individually bring pride but
represented Nations reflect Tribes.

CONNECTIONS

Smoking thoughts
Sizzle your senses
up into the mental,
New creation
the rebirth
poetic justice once again,
confirming the classic Mother Earth approach
with connections that manifest
supporting the blessed;
We could make love or war,
you know who we are:
Original people
with beats that make you dance
so intensely
we create the sequel that keeps you in a trance.
Criticism, part of a cynicism;
Looking for me, I'll pass
just trying to understand the logic of mathematics
applied to life;
Why every man needs a wife,
Why serendipity is considered corny,
Why challenge is already boring.
Next dimension so enticing
when elevated to the third degree.
Whether or not you smoke trees
you can see what you see.
To feel that energy,
why should we change our appeal
with enough flavor to have
past millenniums by next year.

Connections that manifest,
supporting the blessed;
We can make love or war
you know who we are;
Original people
with beats that make you dance
so intensely we create the sequel that keeps you in trance.

$3+5+2=10$, divided by 2 that element
will never allow freedom to wear masks
To act like all we know how to do is talk
about money and chasing ass
Again our past –
moments, all different vibes – take it there

As long as you're on your own path to freedom
no one else should care,
And if they do – beware!
Positivity – we need to channel through our bodies
and do our best to be ourselves;
Evolve at our pace, think about energy
as access to live in our time and space

Connections that manifest
supporting the blessed;
We can make love or war.
You know who we are;
Original people
with beats that make you dance
so intensely
we create the sequel that keeps
you in a trance.

Traveling awake through the reality
created by a destructive thought process;
Inflicting pain and doubt on a global level.
What is to be done when everyone
Has adapted to evolution of ill will,
Our friendships give us hope;
friends that have gone onto their path
returning to say "hello" –
Give you information to continue
the work they left to add to your own.
Most theories don't leave room to appreciate
the powers of the Universe as a whole,
creating religion, implementing division;
Wars of land, culture, race, gender, fate
a present fact we can't go back
and forth – is undoubtedly coming now.
If we, as a human race, could concentrate on 'We'
it would be me and you: FREE.............
FREE MUMIA
PEACE IN VIEQUES & WORLDWIDE
ONE – FOR THE 13TH TRIBE

ECHOES FROM MEDINA AKA BROOKLYN

Driving over Brooklyn Streets that have died
Along with those victims sacrificed by circumstances of the environment
Memories enter the soul breaking your heart at least a dozen times
for at least a dozen smiles blown away too early
I think about all those ghetto heroes with their chains cars and music
the guys that broke the girl's hearts
I think of Ralphie from Woodbine, Conan, Puerto Rican Jay from Marcy
Zinc from Putnam
from a place where freedom is gambled daily Medina patrolled Medina
and Blacky was feared by all in the street pharmaceutical business
I think of all those who held on to a culture, taking it to the extreme, but hey
Hip hop is what that kind of loyalty means
Music was then so collective not pimped
just shared not commercial just for us to go on with
our voices without getting touched
So many forgotten so many gone for at least 25 even my
brother didn't have the opportunity to survive
Now I reminisce on all the guys from around my
way Miguel from Hale, Eric from Grant
Saul from Lane
Josiah and Joey from Chestnut- NBK
Watching them kill themselves and each other gamble their lives away while we
had to pay endure the pain these shouts are just to name a few lets not forget
Biggie is from BK too
Our brothers victims of loses predicted played out and accomplished
to all who helped make it this way
you didn't kill all of us and one day you will have to pay
our energy our karma will transcend

and for all the negativity caused by greed envy and control
our songs will never end.
RIP Ricky

Ricky Almodóvar
RIP 7/4/99

RIKERS (SHIPPED WRECKED) ISLAND

Going over a bridge onto an Island
of broken dreams of sorrow and unheard
screams
Hoping for a miraculous discovery
of past or future

Shackles on the body and the mind
Memories of passed time
Holding you in a position of dreaming
Keeping your desires to yourself

Watching the in and out of beings old and new
No emotions just motion
No dialogue just unnecessary rejection
Maintaining stiff resistance

Finding the loyalty of your blood
Creating illusions from all the disillusion
Rising your heart on a mystical plane
Part of the Universe's pain
Black skies create rainbows
that need to shine
at the same time....

ALBA AMBERT

Alba Ambert es poeta, narradora y educadora. Nació en San Juan, se crió en el Sur del Bronx y regresó a Puerto Rico a vivir por varios años. Ha publicado los poemarios *Alphabets of Seeds* (2002), *The Mirror is Always There* (1992), *Habito tu nombre* (1994), *The Fifth Sun* (1989) y *Gotas sobre el columpio* (1980). Es autora de las novelas *The Anarchist's Daughter* (2008), *The Passion of María Magdalena Stein* (2002), *The Eighth Continent and Other Stories* (Arte Público Press, 1997), *A Perfect Silence* (Arte Público Press, 1995, Premio Carey McWilliams Award por la mejor obra literaria) y *Porque Hay Silencio* (Premio de Literatura del Instituto de Cultura Puertorriqueña, 1989). Su libro de historia oral, *Every Greek Has A Story,* se publicó en Atenas en 1992. En 1992 publicó en Atenas una edición limitada del libro de arte/poesía *The Mirror is Always There,* hecho en colaboración con la artista Despina Meimaroglou, y presentó una instalación multimedia basada en el libro. Ambert ha publicado, además, *Wordstock*, una edición limitada de epigramas en diversos medios visuales. En Nueva York, su libreto cinematográfico *An Inclination of Mirrors* fue convertido en película por la compañía 4-Reel Productions. Su libro de prácticas espirituales y meditaciones, *The Seven Powers of Spiritual Evolution,* se publicó en el 2008. Ambert obtuvo su B.A. en Filosofía de la Universidad de Puerto Rico y obtuvo la maestría y el doctorado en psicolinguística de Harvard University. Ha enseñado en programas bilingües de Boston, fue miembro de la facultad de la University of Hartford y Científico Visitante en el Departamento de Linguística y Filosofía de MIT. Ha publicado libros y artículos sobre bilingüismo y realizado numerosas presentaciones en conferencias internacionales. Se desempeñó por muchos años como Escritora Residente del Richmond College, en Londres.

Actualmente, Ambert reside y escribe en Chapel Hill, North Carolina. Es la fundadora de The Paramitapath, una sociedad sin fines de lucro dedicada a la evolución espiritual.

Alba Ambert is a writer, educator, and researcher born in San Juan who grew up in the South Bronx and returned to the Island for several years. She has published five books of poetry: *Alphabets of Seeds* (2002), *The Mirror is Always There* (1992), *Habito tu nombre* (1994), *The Fifth Sun* (1989) and *Gotas sobre el columpio* (1980). She is also the author of the novels *The Anarchist's Daughter* (2008), *The Passion of María Magdalena Stein* (2002), *A Perfect Silence* (Arte Público Press, 1995, Carey McWilliams Award for best literary work), *The Eighth Continent and Other Stories* (Arte Público Press, 1997) and *Porque hay silencio* (Literature Award of the Instituto de Cultura Puertorriqueña, 1989). *Every Greek Has A Story,* an oral history of Greeks, was published in Athens in 1992. She published in Athens in 1992 *The Mirror is Always There,* a limited edition of artbook/poetry collection, made in collaboration with artist Despina Meimaroglou, and presented a multimedia installation based on the book. Ambert also published *Wordstock,* a limited edition of epigrams in several media. Her screenplay, *An Inclination of Mirrors,* was made into a feature film by 4-Reel Productions. Her book on meditations and spiritual practices, *The Seven Powers of Spiritual Evolution,* was published in 2008. Ambert holds a B.A in Philosophy from the Universidad de Puerto Rico; and masters and doctorate degrees in psycholinguistics from Harvard University. She taught in bilingual programs in Boston, was a Visiting Scientist at MIT's Department of Linguistics and Philosophy, and Senior Research Scholar at Athens College. She has published extensively on bilingualism and has made numerous presentations at international conferences. For many years, she was writer-in-residence at Richmond College in London.

Alba Ambert is now living and writing in Chapel Hill, North Carolina. She is the founder of Paramita Path (paramitapath.org), a nonprofit society dedicated to spiritual evolution.

FORGIVENESS

A falcon soars
its shadow
spilled ink
on the sand.

I count the instances
of hurt,
recriminations.
I weigh the burden
of unforgiveness
lying dead
on my heart.

The falcon circles
the emerald ring
encrusted in
the gleaming thigh
of the island.
Round as perfection
the jewel glimmers
on the pale grains
of sand.

There was the one who left,
his back an accusation.
There was the friend
drawn out of silence
to unveil my intentions.

Wild bunches
of mussels drip
from rocks
and shimmer
with crusted salt.
Then the day sighs
relieved to have survived
the noisy squalls
of peacocks
climbing
honey-coloured stones
eyes darting hungrily
toward the snakes entwined
on coccoloba bark.
Someone did this
yet another did that.
Trembling in the self-righteousness
of a ruthless mathematician

I count the instances
I weigh the burdens

and wade into the sea.

Weary of useless cargo
depleted by measurements,
I clasp the sky
and let forgiveness
wash through me.
I rest in its embrace.

EXPECTATIONS

I hadn't expected
palm fronds
in the melancholy thrum
of tropical rain.

I expected the crude
seams of scars,
repeated shipwrecks,
the loneliness of dust.

I hadn't expected
the robust stillness
of mountains,
the quietude of stars.

I expected dreams aborted
on apathetic beds,
shrieks transfixed
by indifferent silence.

I hadn't expected
the tender mist
of sea-dawns,
the caress of petals.

I expected deafened
iron-clad hearts,
frozen clumps of ashes,
the mockery of worms.

I hadn't expected
the passion
of an ocean.

I expected chunks
of dull flesh
rotted under
the naked bulbs
of motel rooms.

I hadn't expected you, love.

ORCHARD HOUSE

From a bench in the garden. Cloudy and chilly.
A southeasterly wind blows from the Thames.

I breathe in the sky.
Grey
it closes in like a well-kept secret.
The magnolia shivers
between a clutch
of daffodils
and the red intensity
of a camellia.

Magnolia petals scatter
like jewels
on the grass.
Their opalescence
remind me of something
I fail to remember;
a thought that
glitters at the edge
of recognition
but will not show
its face.

A brace of ravens
scores the sky
with flight.
The hawthorn rustles
as it lifts reluctant
leaves when a plane
shoots through the clouds.
It fills my chest
with the rumble
of dissonance.
A sonic assault tearing
a wound in the cosmos.
I let the glimpse
of a thought go
and anticipate

the starless night,
the ever-darkening grey,
the chill of twilight.

I fill my house
with footsteps.

HABITO TU NOMBRE

(fragmento)

XIV

Te llamé
verbo.
Te llamé
verso.

Te llamé
a través de todo
lo inútil
traspasando
las geometrías
de ciudades ciegas
y despiadadas.

Te llamé
desde la honda pena
residiendo en espacios
estupefactos.

Habitando
los márgenes
de lo posible
que nunca
me había sido posible.

Por nombrarte
recalo en tu nombre
de aguas marinas
como Homero
reclamando su vino
de rima oscura.

Recalo
en tus aguas
de marina

turbia aún
por recuerdos
borrables.

Me pierdo
en tus más profundas
aguas y reclamo
tu nombre
que es luz
y es mar.

Te nombro tanto
que tu nombre
resuena en el
orgasmo cósmico
del universo entero.

Vibra
en cada palabra
de cada instante
de caricia eterna.

Nombro tu nombre.

Por todo
lo que te nombro
en tu nombre
de mar
y distancia,
recalo en tu nombre
de albamarina
presentimiento
de aurora.

Habito tu nombre
desde que nací
y morí
mil veces
sin pronunciarlo.

Hoy que eres
habito tu nombre
escondiéndome
del insulto
que sale a pasear
de noche
con los murciélagos
impasibles.

Penetro
tus aguas
y me sumerjo
en Ártemis
esculpiendo
el alumbramiento
de tus tablillas
micénicas
y resido
en el remanso
de tu paisaje.

Habito tu nombre.

Ahora que lo digo
cuánto lo digo.
Habito tu nombre
ahogada
como estoy
de sílabas
recortadas
en el perfil
del dolor.
Habito tu nombre
desde el filo
del pantalón
sin bolsillos.

Habito tu nombre
ahora que estás
en mis días
y en mis noches.
En la eternidad
de cada encuentro.

Ahora que vibras
en mi útero oscuro
y me penetras
con tu misterio
de algas.

Ahora que eres
el nombre
que nombro
en mi nombre

te habito.

El Octavo Continente (fragmento)

Amanda tembló al sentir la escalera crujir sus dientes. Pensó en Manolo hasta que amaneció. Tarde, como todos los días imprecisos de invierno. Apartó la frisa y pisó los tablones helados. Se vistió con premura, tiritando. En la cocina minúscula, encendió una hornilla y se calentó las manos, mientras en la otra hervía agua para el café. Las demandas de los inquilinos repicaron en los golpes secos del radiador. Sopló las palmas de las manos y las restregó una contra la otra urgentemente.

No había ventana en la cocina y llevó su café al cuarto. Se sentó en su sillón de mimbre cerca de la ventana. Una pila de libros reposaba en el piso y una mesa desparramando papeles tropezaba con su cama. Le tranquilizaba mirar por la ventana como gato doméstico aunque en el enjambre de edificios había perdido la habilidad de percibir distancias. A través del cristal manchado de pintura vieja, huellas digitales y camadas de polvo, se veía la escalera de incendio y un zaguán repleto de basura y vidrios rotos. Una brisa se escurrió entre latas de cerveza vacías, envolturas de hamburguesas y vasos plásticos. Cuando hacía viento, la basura escandalizada invadía los apartamentos cencerreando día y noche.

Amanda apuró el café. Del piso tomó una botella de vino argelino. Lo decantó lentamente en su taza con cierta elegancia y anticipación. Sus manos temblaron y se lamió los labios. Contempló el fondo de la taza y absorbió el aroma rojo vivo. Tomó un sorbo, chasqueó la lengua y tiró su cabeza hacia atrás sintiendo el calor deslizarse por la garganta y arderle el estómago. Necesitaba otro trago, lo sabía antes de que pudiese sentir la calidez regándole la cabeza. Suspiró al decantar nuevamente y bebió hondo. Cuando la botella estaba medio llena o medio vacía, según se mire, un carcomillo le inundó las sienes. Qué agradable sentir la cabeza liviana, el ladeo ligero, la piel salpicada de pellizcos. Sus párpados oscuros cayeron pesadamente. Su quijada, afligida por la indiferencia, se le hundió en el pecho. Se sintió etérea, sin penas, resbalando hacia el espiral hueco de sus adentros. Se dejó caer en la cama.

Amanda sacó otra botella de vino argelino y dijo, "Este es el mejor remedio contra este lugar frío y sin luz. Ven, Ramón, siéntate con nosotros y tómate un poco de vino."

"¿A qué brindamos?" Patricia intentó desviar la conversación.

La sonrisa de Amanda se desvaneció. "Bueno," dijo, "yo brindo por el octavo continente. El lugar que todos aquí habitamos."

"¿Qué quieres decir con eso?" preguntó Elena.

"El octavo continente está habitado por gente que no pertenece en donde están ni de donde han venido. Como nosotros. No pertenecemos ni aquí ni allá."

"A mí no me incluyas en eso," respondió Andrés acaloradamente. "Nosotros vamos a regresar a Puerto Rico tan pronto podamos. ¿Verdad, Patricia?"

Patricia asintió vigorosamente.

"¿Piensas que eres la misma persona que se fue?" preguntó Amanda.

"Y qué si no lo soy."

"Es lo que quiero decir. No hay manera de regresar del octavo continente. Aunque quisiéramos, no se puede. Pensamos que podemos regresar a lo que dejamos atrás, pero lo que dejamos ya no existe. Y nosotros ya no somos las mismas personas que éramos cuando llegamos. Así es que nos quedamos aquí, a donde no pertenecemos de todas maneras."

"Estás hablando de los ilegales?" preguntó Ramón con aprehensión.

Amanda continuó. "Los ilegales, los emigrantes en todas partes del mundo, los marginados."

"¿Y los locos?" preguntó Elena.

"Oh, sí. Y los eccéntricos también," dijo Amanda. "Cualquier persona que por alguna razón u otra no pertenece, habita el octavo continente. Un lugar con una frontera que no puede volverse a cruzar. No hay retorno posible desde el octavo continente. No tiene salida," añadió.

"Oye, Amanda, me estás deprimiendo." Andrés sacudió la cabeza y apuró su copa de vino.

"Sí," dijo Elena. "Eso es bien deprimente."

"Bueno, bueno," dijo Amanda alzando las manos. "Me rindo. Si ustedes no quieren enfrentarse a la realidad, vamos a cambiar de tema."

Andrés se dirigió a Ramón "Oye, quizás tú puedas ayudarnos con la campaña."

"¿De qué campaña hablas?" preguntó Ramón con sospecha.

"La campaña para liberar a Manolo. ¿No te has enterado? Estamos mandando cartas con cientos de firmas al Congreso, las Naciones Unidas,

a todo el mundo."

Amanda empujó su plato de sopa hacia el centro de la mesa. Sus labios formaron una línea firme.

"Andrés, mientras los medios de comunicación convencionales ignoren este asunto, a nadie le va a importar. Al fin de cuentas, ¿quién lee *El Alba*? Un puñado de puertorriqueños y el FBI.

"Yo lo leo," dijo Elena poniendo un trozo de pan en el mantel de hule descascarado.

"Nada más con el testigo," respondió Amanda. "He aquí una puertorriqueña viviendo una existencia marginal. Este es el prototipo de tus lectores. ¿A quién le importa lo que Elena lee, lo que piensa, lo que siente? ¿A quién le importa lo que nos pasa a cualquiera de nosotros? Somos el pueblo invisible."

"Mira, Amanda," respondió Andrés con ira. "Ya yo estoy bastante cansado de tu actitud. Estamos trabajando duro para efectuar algunos cambios por acá y ¿qué contribuyes tú? Nada. ¿Qué es lo que te pasa?"

"Escúchame, Andrés," Amanda señaló con el dedo. "Yo estuve presa por mucho tiempo. Tú no sabes cómo fue eso."

"Cálmate, Amanda, él no quiso decir nada." Patricia intercaló nerviosamente.

Amanda la ignoró y se dirigió a Andrés. "¿Y adónde estabas tú cuando nos apresaron? ¿Por qué tú saliste del interrogatorio tan ligero y a los otros nos arrestaron?"

"Excúsenme un momento," Ramón gritó. "¿Ustedes estuvieron presos? ¿Los interrogaron?"

"¿Tú no te enteraste de lo que pasó aquí el año pasado?" Elena le preguntó.

"¿Qué son ustedes, traficantes o algo?" Los ojos de Ramón se ensancharon del miedo.

Elena se rió nerviosamente. "Drogas no, política."

"¡Dios mío, eso es peor!" Ramón corrió a la puerta. "Yo no debo hablar con ustedes. Ojala nadie me haya visto venir aquí. Oigan, lo siento, pero me tengo que ir."

Patricia agarró a Ramón por la muñeca. "Tú no vas a ningún lado. Siéntate y tranquilízate," le ordenó.

"Está bien, está bien," Ramón tragó fuerte.

Andrés se paseaba por la cocina lleno de furia. "No puedo creer esto. Oye, Amanda, ¿tú quieres decir que yo soy el responsable de tu detención?"

"Detención. Eso es un eufemismo para lo que nos hicieron y tú lo sabes muy bien."

Amanda tembló al servirse más vino. Tomó rápidamente y luego miró al fondo de la copa, sus hombros encorvados, la cara endurecida. Cuando habló, su voz sonó amarga, con un filo duro.

"Los asesinos tienen más derechos que nosotros. Tú no tienes idea de lo que nos hicieron. Me trataron como un trozo de carne. No hay un hueco en mi cuerpo que no violaron. Tú no sabes nada, Andrés. Tú no estabas ahí."

Andrés miró a Amanda con rabia. Se sentó a tomarse otro trago. "Coño, Amanda, ¿Tú me estás echando la culpa porque no me detuvieron a mí también?"

"No te estoy echando la culpa de nada. Sólo estoy diciendo que tú no sabes lo que pasamos los detenidos, que no tienes la menor idea de lo que está pasando Manolo."

"Un momento, por favor." Ramón interrumpió alzando las palmas de las manos frente al pecho. "¿De qué están hablando?" De un salto cayó parado otra vez. "No, no, olvídenlo. No quiero enterarme de nada. Lo único que quiero es irme a mi casa."

"Pero si el asunto estuvo en todos los periódicos y en los noticieros," dijo Patricia.

"Yo no veo las noticias. No quiero saber nada de nada," Ramón gritó. "Déjenme tranquilo, yo no quiero tener nada que ver con ustedes."

Ramón salió corriendo y Elena lo siguió escaleras abajo. Andrés empujó su silla hacia atrás y la silla cayó al suelo. "Vámonos," le dijo a Patricia. Luego se tornó hacia Amanda. "Espero que tú no quieras decir lo que creo que estás insinuando."

"Andrés, yo no estoy diciendo que fuiste tú el que nos delató. Lo único que digo es que tú fuiste el único que no fue detenido."

"¡Perra borracha! ¿Cómo te atreves a acusarme de nada?"

Amanda lo miró con cansancio en los ojos. "Sal de mi casa," le dijo.

Maritza Arrastía

Maritza Arrastía es escritora cubano-puertorriqueña de cuento, novela y poesía. También ha escrito, dirigido y producido video-dramas. En 1990 publica la colección bilingüe de poesía y cuento *Tripartita: Earth, Dreams, Powers,* junto a Myrna Nieves y Ana López-Betancourt. Su novela *Exile* se publica en 1991. Su obra se ha publicado en las revistas *Nuestro, Diálogo, And Then, Ikon* y *Areyto*. Fue curadora de la serie literaria *Latins in English* en BACA Downtown (Brooklyn Arts Council) por varios años, así como series en el Triplex Theater y YOMOMA Arts. Ha leído su obra en el Triplex Theater, la Feria del Libro Latinoamericano, El Museo del Barrio, Boricua College, la Universidad de New Hampshire y la Universidad de Bowling Green en Ohio. Fue premiada dos veces con la beca del New York Foundation for the Arts: como guionista y dramaturga en l987 y por su obra de ficción en 1994. Arrastía alfabetiza a través de la escritura y su colaboración con nuevos escritores alimenta su propia práctica: diarios, etnografía personal, memoria, ficción y poesía.

Maritza Arrastía is a Cuban-Puerto Rican writer of fiction, poetry, and screenplays. She has also written, produced and directed several live video plays. In 1990 she published the bilingual book of poetry and prose *Tripartita: Earth, Dreams, Powers,* with Myrna Nieves and Ana López-Betancourt. Her novel *Exile* was published in 1991. Her work has been published in magazines, including *Nuestro, Areyto, Diálogo, And Then,* and *Ikon.* She curated the *Latins in English* series of literary readings at BACA Downtown for several years, as well as series at the Triplex Theater and YOMOMA Arts. She has read her work at the Triplex Theater, the Latin American Book Fair, El Museo del Barrio, Boricua College, University of New Hampshire, and Bowling Green University in Ohio. Arrastía has received two fellowships from the New York Foundation for the Arts: in 1987 for screen writing and play writing, and in 1994 for fiction. She teaches literacy through writing. Her collaborations with new writers nurture her ongoing writing practice: journal, personal ethnography, memoir, fiction and poetry.

BIRTH

blood muscle push, gush us into the world
we tear the mother when we push through her
she is never the same

one mother screams
one sings
one tells stories
one paints trees
one dies too soon for recollection
one dies too soon for completion
one poisons herself
one leaps

all of them, Indra's mother jewel
all of them bearing the same name
all of them leading us to different pathways
to the cinderella place
where they must each, good mother and bad mother
step away
leave us to our own self-birthing

these mothers
must they all
kill us
babies in a row?

is there separation
without slaughter?

so we can come to the place
where we craft our secret wholeness
the place where they let go our hand
and a bigger mother
meets us, holds us
fits us with the missing pieces?

I saw this big fat mother place
an open field, a meadow
sunlit
tall trees surround it
but we are at this mother moment
not in the forest
even if we were Gretelled here

we are in the light

the fat fat mother

comes to us and remembers us
gives each of us the thing the other mother
never gave
or took away

and now at last
my fat, fat mother
comes to me
she holds me in her
fat, fat lap

against her fatness
my body gives up its armor

I mold into her
I nestle into her
I let her cradle me
rock me
suckle me

I draw my self
from her fatness

II
gods gaze upon us through the mother
gods turn away through the mother
gods cradle us
gods push us off the ledge

gods croon
gods curse
gods rave
oh, gods have their mad moments
their despair
they visit us through the mothers

all of us needed a bigger mother
even the gods
each of us
the very mother herself
needed a bigger mother

rainwet
warmed by a secret
possible volcano
held in light

holding us with an open hand
letting us walk away

POEMA A MIS PADRES

I
me concibieron en la cama pastoral
una noche en que la pasión fue torpe
tan sin forma
como la protoplasma
del pequeño feto aferrado
a la matriz mullida
creciendo apenas
sobre el silencio
sobre el borboteo
de los celos de mi madre
y las aguas mentales sin borde de mi padre

me concibieron
en el canal oscuro
donde comienza el mundo
y sale la vida de las aguas
y salen las aguas de la nada

me engendraron
me parieron
dentro y debajo
de los andamiajes de los pensamientos
sobre los claros sin palabras

II
mi padre y mi madre son
una casa fuerte y ancha
cuyas dos alas
han unido techos y ventanas

una casa
donde todo se usa de prisa
pero con respeto

todo está fuera de sitio
y no se sabe ya
si por el orden apresurado de mi padre
o el desorden lento de mi madre

III
me siguen concibiendo
feto sin carácter
embrión de posibilidades
niña
hermana
rebelde

extraña
mujer
el óvulo inmenso inseminado
se afinca vez tras vez
a la matriz mullida

IV
así mis padres
dos aguas
que hace años
no son cristalinas
ni frágiles
sino que han asentado
y son del verde espeso y afilado
de aguas
que han hecho ya
su peso
sobre
la tierra

ADIÓS A VENTURA (FRAGMENTO)

La reja de hierro del patio de las gallinas repiqueteó. Celia zafó la vista del baile de sol de las motas de polvo. ¡Piedrecitas! La señal de Pedro Juan. Las piedrecitas llovían sobre el charco de luz. Espió la mano de Pedro Juan asomándose por encima de los vidrios rotos que bordeaban el muro. Celia miró por la reja hacia la cocina. No había señales de la Tía Erasma. Corrió hacia el muro.

Cada pisada apresurada alzaba una nubecita de polvo amarillo. Celia escaló el muro: un pie en la ventanita de la choza de la vieja Julieta; una mano contra el muro de piedras; el otro pie sobre el techo de la choza. Estiró la otra mano hasta hallar la de Pedro Juan entre los vidrios afilados. Se alzó sobre el muro de ladrillos desmoronados y se abalanzó al abrazo firme de Pedro Juan. El vestidito gastado de Celia le llovía piedrecitas rojas de ladrillo a la camisa de Pedro Juan. Celia se zambulló en los ojos del niño. Riendo, corrieron juntos por el laberinto de enormes troncos bajo la sombrilla que hacían las copas entretejidas de los árboles.

Entraron a la oscuridad de la casucha de trastes donde Pedro Juan había montado su taller. Su Papá lo dejaba hacer de todo.

Pedro Juan señaló con su bracito moreno la hilera de espadas de madera dorada que colgaban de la pared de tablas por los mangos colorados.

—Yo los hice, dijo.

Alzó una mano con el círculo dorado.

—Mi escudo.

Celia fijó la vista sobre el rostro luminoso de Pedro. El la llevó de la mano hacia la mesa donde estaban los materiales de fabricar papalotes: varillas de madera; papeles transparentes azules, negros, rojos. Un papalote rojo y negro colgaba de la pared.

—¿Ese es el papalote que me prometiste?

—No. El tuyo salí a probarlo y me lo tumbaron a cuchillazos.

—¿Y?

—Pues que habrá salido allá en la Isla.

—Yo no creo eso.

—Yo no soy mentiroso.

—Digo eso de que la fosa sin fondo va a dar a la Isla. Son cuentos.

—Pues a mí me consta. Eche a la fosa unos maderos pintados de colores y me dijeron que los encontraron en Los Naguales donde desagua el río. Yo tengo quien me los reciba al otro lado.

—¿Quién?

—A ti que te importa. Son mis experimentos. Cuando sea grande voy a ser riólogo.

—Pues a mi me gusta el papalote éste y no el que se cayó.

El papalote parecía una mariposa enorme. Los trocitos de cuchilla sobre el rabo relucían salpicados de la luz que penetraba entre las tablas de la pared. Pedro Juan le haló la mano a Celia.

—Ayúdame, dijo.

Le puso las manos a Celia sobre una de las esquinas del marco de varillas que tenía sobre la mesa. Amarró la esquina con hilo y movió las manos de Celia a la otra esquina.

—Esto es una jaula, dijo Celia.

Pedro Juan sonrió y señaló las alas de papel a cada lado del cuadrado de varillas.

—Una jaula y un pájaro. Es un papalote trampa de pájaros.

—Pero, ¿existe?

—Acabo de inventarlo.

Le puso un manojo de varillas a Celia en las manos.

—Cuando sacuda la cabeza me das una varilla.

Pedro Juan fue atando varillas una por una contra el marco. Trabajaron en silencio como si no oyeran los gritos de 'Celia, Celia' de la Tía Erasma que el viento traía en pedazos entre las ramas de la sombrilla. Siguieron trabajando aún cuando la luz entre las maderas de la casucha ya no destellaba de las cuchillas de los papalotes.

—Ahora ayúdame a alzar la trampa, dijo Pedro Juan.

La elevaron con cuidado y la viraron de lado para sacarla por la puerta estrecha.

—Terminamos justo a tiempo para coger los vientos que bajan con el rocío.

Celia le fue abriendo camino entre las ramas al papalote trampa. Los gritos de Erasma se iban oyendo claros. Pedro Juan reposó el enorme papalote sobre la tierra amarilla junto al muro. Alzó a Celia de brazos hasta que ella logró afincar el pie sobre un ladrillo. Celia separó la vista del rostro sonriente de Pedro Juan, de los ojos de almendra engurruñados contra la luz. Se enfrentó sobre el muro a la cara de rabia de la Tía.

La Tía no hablaba. Los ojos le brotaban enormes. Erasma estiró los brazos y arrancó a Celia del muro. Celia sintió los vidrios rasgarle las rodillas. Sintió los vidrios de lejos. Le dio el dolor a la otra Celia, la que se encargaba de aguantar golpes.

La Tía arrastró el cuerpo de la otra. Una sangre espesa y caliente como almíbar le corría por las piernas. Probó la sangre con un dedo. Tan salada. Miró fijo los ojos de limón de Erasma y abrió las piernas para sostener los golpes.

La mano dura y callosa de Erasma retumbó contra las nalguitas que cabían en un solo manotazo. Los golpes le sacaban música a los huesos: Una campana. Otro golpe. Otro campanazo. Celia se tragó las lágrimas.

—¡Diablo de muchacha! ¡Diablo de muchacha!, gritó Erasma.

La Tía dejó caer sus manos gastadas.

Celia echó a correr y dejó atrás a la Tía y la caseta de Julieta. Atravesó el charco de luz. Subió a saltos la escalera. Tiró la reja del patio de las gallinas. Escaló la escalinata del patiecito. Dejó atrás las sillas negras de la sala con sus telarañas de mimbre, la mesa redonda con su ganso y su gallina de barro, las arecas languideciendo en la sombra fría. Dejó atrás sus huellas ensangrentadas.

Abrió de golpe las persianas y se inclinó sobre el muro del balconcito. Alcanzó a ver en la distancia los enormes picos morados de las montañas fronterizas que casi se tragaban la silueta pequeña de Pedro Juan cargando su jaula con alas. Lo vio darle la vuelta a la esquina cuesta arriba y perderse de vista donde la calle desembocaba en las colinas de Los Santos. Pedro Juan decía que en las colinas era donde mejor se cazaba el viento.

THE WORLD GUERRILLAS
TAKE THE FRONT PAGE (EXCERPT)

Salomé called to order the Emergency Session of the Steering Committee of the World Guerrillas: herself and Cee. They kneeled outside the basement windows of the Paper's Skycraper. They'd knelt there since dawn. The rubble dug into their knees. They minded the loudspeaker they'd plugged into the bug in the Ballroom. They broadcast the plenary sessions of the 20th World Congress of the Written World into the cool midday spring air of what was left of the City. Through the narrow windows they could see row upon row of the Editor's of the World's papers sitting on folding chairs in the basement ballroom.

"The Editors droning on and on in those plenary sessions will put to sleep cops and their dogs for blocks around," Cee said.

Salomé nodded. "They act as if the printed word was dead. They're lying," Salomé said. Her hoarse voice had the hushed deliberation she reserved for her new thoughts. Cee watch her wide-eyed. "They are sick of the burden of the verb," Salomé went on, awed by her own discovery. "In the end the war is always over the words. The victors write history." Salomé pulled on her one long braid and held its paintbrush end above her full lips. Royal purple glowed beneath her brown skin. Cee turned away his close-cropped head, a frown on his square, ashen face. He interrupted Salomé.

"I'm dammed if I know how you and I will take over the Paper," Cee said.

"We have our masses, seize the time. The poor shall inherit the press, now that the rich have moved on to something else," Salomé said. "We call for a take-over and we do a sit-in and all the rest now that they're all in the basement ballroom having their Congress and have left the office in the care of the computers."

To himself, Cee called Salomé a fire-eater.

Cee watched her closely with his steady gaze. He recognized the light in her eyes, the same she'd had after the army razed the Barrio when she'd gotten him to hang Island Liberation banners from the Statue, to cover President Buffen's lawn with paint bloodied corpses made from newspapers.

This light he'd seen the first time he saw Salomé. She had been dancing salsa by herself in the high school playground late at night: only Salomé, her inner light, and her radio, spot lit by the streetlamp.

María Arrillaga

María Arrillaga es poeta, ensayista y novelista, nacida en Puerto Rico. Reside en Nueva York y también en Puerto Rico. Ha publicado los poemarios *New York in the Sixties* (1976); *Vida en el tiempo* (1974); *Cascada de sol* (1977); *Poemas 747* (1977); *Frescura* (1981); y *Yo soy Filí Melé* (1999), obra que incluye, además de los libros mencionados, *El amor es un periódico de ayer* y *Yo soy Filí Melé*. Su novela, *Mañana Valentina,* (1995) resultó finalista en los certámenes Letras de Oro, Universidad de Miami (1994) y en el que auspiciara el Instituto de Escritores Latinoamericanos de Nueva York (1996). En 1995 publica *Los silencios de María Bibiana Benítez* (1995), preludio a su obra *Concierto de voces insurgentes* (1998). Ambos trabajos definen estrategias para interpretar textos escritos por mujeres y estudia la obra de tres autoras. Este libro recibió Mención de Honor del Instituto de Literatura Puertorriqueña en 1998. Arrillaga ha publicado en más de quince antologías, incluyendo: *Voces nuevas (IX Selección de poetisas)* (1992), *Yo soy...I am: A Celebration of Women Latina Poets* (1993), *These Are Not Sweet Girls: Poetry by Latin American Women* (1994), *Versos de terras distantes* (1995), *Mujeres/98* (1998), *Noches de Cornelia* (2008) y *La mujer rota* (2008).

Fue presidenta del PEN Club de Puerto Rico (1989 a 1991), Secretaria del Comité de Mujeres Escritoras del PEN Internacional (1993) y miembro de su Junta Asesora y organizadora regional para Latinoamérica (1993). Fue profesora de la Universidad de Puerto Rico y en Nueva York enseñó en el Seek Program del University Center (participó en la creación de Estudios Puertorriqueños) y en CUNY: el New York City College of Technology y York College

María Arrillaga is a poet, essayist and novelist, born in Puerto Rico. She resides in New York (primary residence) and Puerto Rico. She has published the poetry books *New York in the Sixties* (1976); *Vida en el tiempo* (1974); *Cascada de sol* (1977); *Poemas 747* (1977); *Frescura* (1981); and *Yo soy Filí Melé* (1999), a compilation of the aforementioned books, plus *El amor es un periódico de ayer*. Her novel, *Mañana Valentina,* (1995), was a finalist in contests sponsored by the University of Miami, Letras de Oro (1994) as well as by the Institute of Latin American Writers, New York (1996). In 1995 she published *Los silencios de María Bibiana Benítez* (1995), prelude to her work *Concierto de voces insurgentes* (1998), which includes an abstract of strategies geared to interpret texts written by women and delves into the oeuvre of three writers. The Institute of Puerto Rican Literature awarded this book an Honorable Mention in 1998. Arrillaga's work has also been included in over fifteen anthologies, among them: *Voces nuevas (IX Selección de poetisas)* (1992), *Yo soy...I am: A Celebration of Women Latina Poets* (1993), *These Are Not Sweet Girls: Poetry by Latin American Women* (1994), *Versos de terras distantes* (1995), *Mujeres/98* (1998), *Noches de Cornelia* (2008) and *La mujer rota* (2008). Recently, she was a featured poet in the Greenwich Village's newspaper *West View* (June 2009).

She was president of the PEN Club of Puerto Rico (1989-1991), secretary of the Women Writer's Committee of PEN International and member of its advisory board and regional organizer for Latin America (1993). Arrillaga taught at the University of Puerto Rico and, in New York, at the SEEK Program of the University Center (participated in the creation of Puerto Rican Studies) and CUNY: the NYC College of Technology and York College.

In Love With Errol Flynn (as Robin Hood)

His cool smile
Fresh as the stream over which he blithely gallops
Overwhelms the girl
He wears a tight fitting green riding jacket that matches a green hunting hat
A rakish brown and yellow feather provides a happy adornment
for the hat which he nonchalantly wears slightly off kilter
Taut, his thighs are enclosed in leggings the color of his skin
Well crafted, raw leather boots cover his feet
Vigorous, a sign of his determination, his right hand
holds an unsheathed sword ready for battle
The gallant rhythm of his well shaped body makes the girl's heart go kaput
"I want to be Lady Marian, how much do I wish to be her!," she sighs

Later on in life
Our would be Marian rides horses
Wanders through thick and tangled woods
Faces with strength sinister instances of evil
Wicked people; dangerous, manifold, difficult, hard
to handle occurrences appear in her path
Her victories grow valiant, audacious
Finally, free of that most loathsome of human events
called fear, unencumbered she whispers:
"Robin, I am Robin!"

She is a grown up now
The Best Loved Bandit of all Time, the poster of the movie,
graces the entrance to her house giving a touch of mirth
to what has been indeed quite a complicated life

And so she says to herself: "Kindred souls, real or
imagined, make the best kind of companions".

EL ROMANCE DE LA CAMA

¿Cómo se convierte en persona una mitad?

Un enjambre de hacendosas abejas doradas
Toman posesión de la cama

Zurce las sábanas con la miel que destilan tus dedos
Plancha el hilo hasta suavizarlo
Con el amor rescatado de todas las personas que has conocido
Ancestrales, heroicas en sus faenas,
Mulle las almohadas felices hasta que se aviven las plumas de ganso
Como nubes saludables semejando globos
Los cúmulos del buen tiempo
Las glorias de los nimbustratus
Acaricia con ganas el bordado que adorna las fundas
Las puntadas son del color y material de tus sueños

No es divertido dormir en medio espacio
De manera que ahora, junto con tantas colchas de la memoria,
Complejos patrones de crochet
El tierno satén
El comfort del chenille
Tu cuerpo totalmente cubre la cama

Enamora tu cama hasta hacerla sentir como una reina
El escenario de una larga vida bien vivida -en la
realidad, imaginación y peculiaridades-
La mejor tierra posible de fantasía desde donde
fotografiar el orden, o desorden, que es vivir
Una cama puede ser un raudal, arroyo, riachuelo, ríos y hondos
desfiladeros con aguas corriendo salvajes hacia el mar
Enamora la cama
El lugar donde desnuda en reluciente descanso tu carne ávida espera
tu propio toque de deleite para exaltar una soledad por excelencia

Las aguas inmortales
Te protegen de aquellos que amenazan masticar tu cuerpo
y alma ascendiendo hacia lo excepcional

Tan valiente como es posible ser

Con todo el exuberante denuedo a tu disposición
Contra lo ordinario lucha hasta el fin
Arroja fuera la tristeza
Permite entrar la buena brisa profundamente dentro de tu reino
Dibuja con el amor un silencio dichoso
Arroja fuera el miedo a perder
Recoge la recompensa que es tuya por derecho

¡Celebra!
Acabas de nacer.

LA LEYENDA DE LA SORTIJA

No llego a poder mostrarte
la sortija en el dedo de mi pie

Se ha convertido ya en material de leyenda

Un hombre se preguntaba si yo sabía
cuán sexy

Otro ofreció fotografiarla

El diente de oro de otro arrojó un rayo de luz
lo suficientemente intenso como para que (la sortija) tuviera espasmos

Todo el mundo la ha visto
excepto tú
Porque me barres al inconsciente
y una vez desnudo mis pies
olvido todo lo demás

Puede que nunca veas
las ranuritas de pequeñísimas mostacillas rojas
que sientas el delicioso toque de terciopelo
tan raro como el venado blanco de invierno
el tierno metal no rozará ni arañará tu piel cremosa
-leopardo en brocado caliente babeándose-

Pero ¡créeme!

Este anillo existe sólo para tu placer
para exclusivamente excitarte al punto
de lamer mis cavidades más profundas
hasta que se tornen color morado oscuro
cada uno de mis poros en tenue luz brillando
con la danza de los pájaros
mientras sin tregua
salvajemente
deliriosamente
extáticamente
guardamos la leyenda.

El grito

Hoy me caí,
como fruta madura me despepité.
Cada uno de mis órganos vitales estalló
fulminantes, luces de bengala, fuegos artificiales
como para celebrar el Año Nuevo Chino.
No fue mi primera caída.
Rasponazos en la rodilla, en los codos,
labios sangrientos e hilillos de sangre
perversamente adornaron la bicicleta
de una niña desafiante empecinada en no llorar.

Así también, los dichosos patines de dicha resbalaban creando vivos y coloridos arabescos ajenos a mi miedo.

Como hada danzarina, como enanitos rojos y verdes con ojos intensamente negros que sorprenden y asustan en el bosque untuoso, montada y desmontada en mis patines y mi bicicleta, vertiginoso me poseía un movimiento nuevo, especie inédita y singular de placer no exento de horror. No había nada que pudiera hacer. A merced del movimiento estaba.

Como el caballo. A la vuelta del camino orondo se paraba en sus patas traseras en posición tensamente controlada, como un Picasso, como un Velázquez estilizado, hacia el relincho ensordecedor cuando el dios Rocinante se iba en trance de profundo contoneo hasta que esta despavorida humana volaba sobre su cabeza para caer de culo en el polvoroso suelo.

Sangre y golpes a marcarme comenzaban.

Hoy me fui de fondo de verdad.

Ataques de risa pueriles, llanto rítmico y profundo sin demasiado contenido, luego los gritos.

Y la magia se hizo entonces. Mis cuerdas vocales se dilataron en una novísima sensación de poder, de placer, de un sonido sólo mío, abstracto y seguro que decía todo lo que me pasaba, lo que me había pasado o estaba por pasarme. El volumen e intensidad del grito fue un parto, la infinita variedad de lo más humano que conozco.

Recordé entonces el grito de los niños, y pensé que si estuviera en mis manos enseñaría a todos los niños y niñas a gritar. A gritar por el gusto de gritar. Les enseñaría a emitir sonidos, toda clase de sonidos -como pajaritos, insectos, pececitos, como las conversaciones entre flores tales como los nardos y las azucenas-.

Y así, amigas y amigos, finalizo con la aserción de que hay gritos y gritos.

Un poema puede ser un grito.

Un poema podría incitar a gritar.

¿Quieres?

Sueño (fragmento)

Après Monique Wittig Les Guérrillères

La nieta era guerrillera.

La abuela era andariega.

La hija simplemente quería descansar.

La nieta luchaba tenazmente por forjarse una vida que tuviera sentido para ella y para los demás.

La abuela tenía miedo, mucho miedo de que la dejaran sola.

La hija quería, más que nada, crear.

La nieta había dejado todo atrás para encontrarse a sí misma. Sólo su vida importaba. «Vive tu vida. Yo vivo la mía», decía.

La abuela sabía quién era sólo en términos de relaciones familiares y personales. La hija se sentía atrapada. La nieta la había abandonado. La abuela pedía a gritos atención.

Tenía mucho coraje la abuela. Estaba rebelde la abuela. La hija tenía miedo de que no la dejaran vivir.

La nieta había desaparecido no se sabía dónde.

En realidad la nieta tenía mucho coraje. Y rebeldía, además. Se sentía sola y abandonada por la hija y por la abuela también. Por eso se había marchado y se había hecho guerrillera. Se había unido a una tribu de mujeres que afirmaban la libertad del ser humano. Hacían coros rituales donde cadenciosamente se nombraba a aquellas mujeres valientes, amorosas y generosas que habían logrado ubicarse dondequiera plenas de sí mismas y de una tradición naciente. No tenían miedo. No conocían imposiciones ni aislamiento. Sabían que había seguridad en su fuerza para hacer lo que hubiera que hacer en el momento preciso. Y para ser, además, por la comunidad de afecto, generosidad y valentía que compartían. La nieta había entrado en un estadio diferente, desde donde era posible la felicidad de todas las mujeres.

La hija creaba cuando podía. Las exigencias de la abuela ahí estaban, y la nieta había desaparecido. Un día recibió una carta de la nieta. Querida hija, decía. Necesitamos de tu experiencia. Comparte con nosotros. La hija escribió así:

Querida nieta:

Es bueno ser valientes, amorosas y generosas. No conocer el miedo, la imposición o el aislamiento. Me siento aislada porque estás lejos de mí y me dan miedo las imposiciones de la abuela.

La nieta contestó:

Querida hija:

Soy un espejo de ti. Soy de tu tribu.

La hija comprendió que jamás carecería de nada y fue a ver a la abuela. La abuela estaba andaregueando. La hija regresó a su casa y se acostó felizmente a dormir.

SANDRA BARRERAS DEL RÍO

Sandra Barreras del Río es poeta, escritora de prosa poética, ensayista y educadora nacida en Morovis, Puerto Rico. En 1973 presentó la colección de poesía "Poemario" como parte de los requisitos para el B.A. en Estudios Generales de la Universidad de Puerto Rico. Luego se traslada a Nueva York en el 1973, donde estudia en la New School for Social Research. En Nueva York co-edita la publicación sobre pensamiento caribeño *Guaíza* para Boricua College, donde enseña por varios años. Ha leído poesía en diversos espacios culturales de Nueva York, como El Museo del Barrio, Boricua College y el Brooklyn Arts Council-Downtown. Su crítica literaria se ha publicado en las revistas literarias *Guaíza* y *Brújula-Compass*. Regresa a Puerto Rico en 1989. Obtiene un MA en Filosofía de la Universidad de Puerto Rico, donde escribió la tesis sobre Hanna Arendt. Recibió en 1997 el Premio de Ensayo del Ateneo Puertorriqueño por "William Ospina o el placer de la lectura". En 1998 recibió una Mención de Honor del Ateneo Puertorriqueño por su ensayo "Para leer a Nietzsche en puertorriqueña". Sus ensayos sobre filosofía y arte público se han publicado en *Amauta*, revista del internet del UPRA (Universidad de Puerto Rico en Arecibo). Actualmente enseña Humanidades y Filosofia en la Universidad de Puerto Rico en Arecibo

Sandra Barreras del Río is a poet, prose writer, essayist and educator, born in Morovis, Puerto Rico. She wrote the collection of poetry "Poemario," which she submitted in 1973 as part of the requirements for her bachelor's degree at the University of Puerto Rico. She then moved to New York to study philosophy at the New School for Social Research. Barreras was co-editor of the publication on Caribbean thought *Guaíza* of Boricua College, where she taught for many years. She read her work at several cultural organizations in New York, including El Museo del Barrio, Boricua College, and the Brooklyn Arts Council-Downtown. Her literary criticism has been published in *Guaíza* and *Brújula-Compass*. She moved to Puerto Rico at the end of the 1980's to study at the University of Puerto Rico and completed an MA in Philosophy; her thesis was on Hanna Arendt. She received in 1997 the First Prize in Essay from the Ateneo Puertorriqueño for "William Ospina o el placer de la lectura." She also received an Honorary Mention from the Ateneo Puertorriqueño in 1998 for her essay "Para leer a Nietzsche en puertorriqueña". Her essays on philosophy and public art have been published in *Amauta,* an internet journal of the University of Puerto Rico, Arecibo Campus (UPRA). Barreras currently teaches humanities and philosophy at the University of Puerto Rico (UPRA).

ANGELS

> *For Beauty's nothing but the beginning of Terror*
> *we're still just able to bear and why we adore it so*
> *is because it serenely disdains to destroy us.*
> *Each single angel is terrible.*
> *—Rilke*

I

I have learned to read their eyes in the streets;
mothers, potential murderers
carrying their angels of death and life close to their breasts.
I understand their quiet desperation, the anger ready to spurt;
that glazed, tired, distant look of someone fighting inner demons;
the mechanical movements of a body
gone beyond the point of exhaustion.
I can easily imagine their hurried flight from home
leaving the shattered stillness of their apartments,
the walls still pounding with the babies' cries.

II

Angels, unaware of mortality and consciousness claims,
blameless in their perfection,
provoke abysmal conflicts in human beings;
with the Caligula-like demands of their boundless awareness,
they ravish the bodies and souls of their wounded, mortal mothers.
Angels, winds of eternity tied to jellyfish bodies,
attain peace on Earth by clinging to frenzied maenads
a breath away from dismembering their fragile limbs.
Mothers struggle, like Hamlet, with the approximation of eternity and death.

III

I have seen them lost in reverie at a banal storefront,
their ankles and eyelids swollen by despair,
disturbed by the concealed aggression of their fears.
Mothers, shuddering at the thought of babies maimed by war or drugs,
suddenly awakened from their nightmarish state
by the urge to protect their infants from external waste.
I have observed when they return the observant smile of another mother,
proud of their cherubs, who still alive, confidently sleep on their breasts.

SU DIOS PARTICULAR
estaba angustiado.
Ella comía, devoraba todo.
Espejos, libros, alimentos,
hombres,
ideas,
tristezas, alegrías...
La imaginación del dios
era pobre, se había agotado.
No sabía qué otras cosas
añadir al mundo para satisfacerla.
Le dijo:
"Es pecado
comer tanto
en época de escasez."
Llena de remordimientos
se puso a dieta.
Al tercer mes desapareció
su hambre
el mundo-alimento
y el dios suplidor de comida.

PIÑONES

Three lithe stray-dogs in a muddy dirt-road: time stands still at Piñones. Dogs are the homeless wanderers of the tropics: always hungry, always facing an unnatural death on the highways: bloated out of existence, the corrosive gasses of their bodies struggling to escape the tight skin with a big-bang explosion that will spread out their organs in the street. One craves for a merciful Olmec skinner to perform a ritual, for the competent gesture of a hand trained to detach the skin of a sacrificial victim; one yearns for a public spectacle enacting the return of a god, for the powerful act to deliver us from the relentless anxiety in front of nonsensical hunger and death.

Time stands still at Piñones, where three hungry dogs find left-over food on a rocky and muddy road. Like clinkers, New York City's street pigeons, the dogs can not be choosy; their lean bodies speak of starvation, like Ethiopian children on the verge of death or like faded prisoners in old photographs of Nazi concentration camps. Hunger molds the eyes of animals and men. One aches for ecstasies and catharsis, for the age-old Dionysian cults of cruelty and beauty: one longs for the frenzy of a maenad dismembering her pray, for the beauty of the tragic theater, locking the community in an affirmation of life, of troublesome life on Earth.

A short dirt-road leading to the sea, where immemorial stray-dogs wander. At Piñones, time stands still. Haitian voices are heard, Dominican women fry seafood pies, a Vietnamese woman buys the fish of the day; Puerto Ricans drafted to a far away war, thousands of Dominicans eaten by the Mona sea, muted Haitians shipped from Florida to an island migrant's camp. Across a paved road, still Piñones, stand two private yatch-clubs, where Cubans prepare their pleasure boats for another day's work. One yearns for sacrifices to the Queen of the Sea, for peacocks and fans, stars and sea horses; one craves for pigs offered at high sea, for flowers thrown at the surf, rocking prayers and candlelight on rowboats.

Piñones still oozes its illicit bittersweet essence.

Careless and blissful, he sleeps in my arms. He looks so much like the infant on Our Lady of the Providence's lap. I was always troubled by that particular iconographic representation of Jesus; limp, he looked dead. I thought that death-like quality was a reminder of his future fate: a reverse Pietá, where the dead Christ seems to be sleeping, full of life, on young María's legs. Now I believe that the pleasurable breathing and the look of contentment in the face was purposely left out by Christian artists. Perhaps that small body surrendered to sleep after satisfying its hunger would look indecent in young Jesus. It undoubtedly evokes pagan pleasures of sexual ecstasy. Perhaps Diana of Ephesus with her multiple breasts is the antecedent of our Lady of Providence. For an infant, Providence is a breast. The total relaxation points to oral satisfaction; the child being more a perverse polymorphous than an ascetic child-god, a Pagan in the making who will find hard to comply with Christian ascetic ideals.

My son sleeps, careless and blissful, in my arms; he is accustomed to them; he spends most of the day grabbing my arms, my brassier, my breasts. I spend mine rocking in the rocking chair. We have problems detaching ourselves from one another. I try to continue my life while he is in my arms; I read, watch television, smoke. I prepare coffee, take care of the house, and stroke the cats, who hunger for the love I took away from them. I try to have telephone conversations with my friends. I touch the back of my husband, yearningly, full of desire. My son demands and receives an enormous amount of body contact: our skins, tied together; our breathing, one harmonious beat. My other interests are impressionistic suggestions, small insights, short readings; all my attention belongs to the child, who sighs contented because I have resigned myself to hold him for a long span of time; because he will be able to use my breasts as pillows. My son is a newborn pagan, already accomplished in the difficult task of enjoying life to its fullest carnal ecstasies. May he never forget to attain that blissful state.

I see Rafaelito's feet juggling in the air; he lies buried in the hammock, awake and quiet. He separates the big toe, fat and already separate from the rest, and corrugates the other toes backwards, just like monkeys do when they grasp a branch. My child's feet are lovely; they still function as hands, untroubled by the erect body. Soon his extended arm appears, announcing the forth-coming game: his fingers grab the big toe and sucks it; then he reverts the roles of hands and foot, grabbing his long fingers with the toes. He starts vocalizing his a's and uttering guttural shrieks, which he shapes with differences in volumes and pitches. His experiments produce the type of sound I previously heard at the Kabuki theater. That is why I call my son the Samurai, convince that he was Japanese in another existence. He has not yet discovered that he is Puerto Rican, Spanish sounds so foreign to that soul with its innate Kabuki's expression.

I get ready to pick him up, acknowledging the communication, in spite

of my lack of understanding of Samurai speech. I hope I do not violate any obvious code of manners when I decide to bring him to my desk. I continue writing while he tries to read the newspapers gathered to be thrown away. Well, I should say he tries to eat them, which is the natural way to get information from the world at his age. My son is giving form to his good taste. I stop that particular search, not wanting to deal with lead poisoning, turning him towards the window pane. On the ledge, he finds a plant. Luckily, I washed the leaves while he was sleeping. I do not have to disrupt that exploration. He becomes totally absorbed, he tears away the leaves, eating the greenest one; my son discovers the pleasures of the cows digging for chlorophyll with his gums. He thoroughly enjoys the plant. I know, his destruction is the best indication. I pray that the plant forgives my lack of concern for its safety. I also request that my Rafaelito learns soon to respect the life of the plant.

MATRICES ENTENDIDAS A LA USANZA GRIEGA

para Luis González

Repetimos,
sin querer queriendo
añejas matrices curadas
en la memoria oculta
de nuestra alma.
Desentrañamos
sus fuertes aromas
cuando nos hacen tambalear
y caer con dureza,
o cuando aupan con sus manos
nuestro cuerpo,
lanzándolo al vuelo.

Llegaron
y marcaron
la brillante frontera
donde el infante *apeiron*,
lo indeterminado propio,
recibió las primeras formas
regalo de Apolo.

Convocan.
La mente y las pasiones
se mantienen en ascuas, alerta,
ante su tumultuosa fragancia;
karma sin mayor duración
-la del nacimiento a la muerte-
de alguien
así como tú,
así como yo.

Se activan
al reconocer
simetrías en el otro,
provocador
de la red inminente del deseo:
marea alta de hormonas,
clave cardiovascular alterada,
pérdida de aliento,
mejillas rosadas
de paciente pulmonar,
glándulas sebáceas secas y mojadas,
despertar del kundalini,
bombardeo sanguíneo

a las zonas más íntimas del cuerpo;
aturdimiento y revuelo.
Nos asalta y atrae
su sabor salvaje,
rápido, urgente,
mágico.
Encarnan espesas,
como el vino y la sangre.

Desconcertados
recibimos su impacto.
Chocamos
contra el otro
lastimando
heridas sin cicatrizar,
proyectando
rabia y resentimiento,
empujándonos
al cenote
donde cuerpo y alma
se desmembran
como caídos
desde las Torres Gemelas.

O celebramos
el momento oportuno,
el *kairos*,
cuando reconocemos
en el otro,
el complemento
de la matriz
propulsora al vuelo.
Jardineros ambos
de la otredad
abierta al futuro,
semejante a un nuevo
apeiron
degustado en pareja.

Pero, a menudo,
las dejamos quietas, quietecitas,
sin agitar, en la cava
profunda de nuestra intimidad,
deseando la gracia y el balance
del ojivendado Chaplin
patinando al borde del abismo
sin caer.
No sé si en éstas líneas
me hablo o te hablo.

No sé si me acompaña
el hilo de Ariadna
necesario para sondear
el laberinto
de nuestras almas,
la tuya en vuelo,
en quietud la mía,
hermano
al otro lado del espejo.

EVANGELINE BLANCO

Evangeline Blanco es novelista, cuentista, guionista y poeta que vive en Queens, Nueva York. Su primera novela, *Caribe*, fue publicada por Doubleday en 1998. Esa novela obtuvo el primer lugar en el 21 Premio Anual de Literatura de la Universidad de California, Irving en 1995. Fue reseñada por *The Library Journal*, the *Kirkus Review* y *The Denver Post* y alabada por su "dimensión histórica, investigación meticulosa y su manejo de los personajes". Como escritora invitada a la Serie Invernal de Poesía de Boricua College, Blanco leyó de su novela en febrero de 2001.

Ha publicado cuentos y poemas en varias revistas literarias, que incluyen *Mosaic* de la Universidad de California, *Riverside* y la conocida revista de poesía *Rattle*. Además, Blanco ha completado varios manuscritos: guiones de cine, una colección de cuentos y otras dos novelas. Su segunda novela, "Irma's Front Lines", relatará las congojas de la menor de una familia puertorriqueña en New York. Su tercera novela, "The Memory Keeper", tratará el choque cultural entre europeos y una familia de indígenas de la costa noreste del Pacífico.

Evangeline Blanco is a novelist, short story writer, screenwriter and poet who lives in Queens, New York. Her first novel, *Caribe,* was published by Doubleday in 1998. This novel, the winner in 1995 of the 21st Annual Literature Prize of the University of California at Irvine, was reviewed by the *Library Journal,* the *Kirkus Review,* and *The Denver Post* and lauded for its "historical dimension, meticulous investigation and handling of characters." Blanco read from her novel as a guest writer of the Boricua College Winter Poetry Series in February of 2001. She has published short stories and poetry in various literary journals including *Mosaic,* a literary journal of the University of California, *Riverside,* and in the poetry journal *Rattle.* Blanco has also completed several manuscripts: screenplays, a collection of short stories, and two additional novels. Her second novel, "Irma's Front Lines," will follow a Puerto Rican family's travails in New York City. Her third novel, "The Memory Keeper," will be a saga about the natives of the Pacific Northwest Coast.

The Figueroas (excerpt)

Just when Josie and Rafael despaired of finding any friend or relative to care for Félix they received a visit from a huge, mustachioed man identifying himself as Pedro Cienfuegos, uncle of Félix, Sr., the deceased.

At eight in the evening swarms of mosquitoes from the nearby swamp in search of their evening meal prepared to attack. Josie and Rafael began to move their rocking chairs from the balcony to seek safety indoors, behind the screens of their house. The clip-clop of horse's hooves they had been hearing became louder and a cloud of dust rounded the corner at the far end of their street. The rider looked almost the same size as the horse he rode, and the Figueroas thought that the horse looked relieved when the man dismounted. He kicked dust off his boots and thundered up the few steps of their balcony.

They both saw a pistol in a holster and a large knife hanging from his belt. His suit was dusty black, wrinkled and speckled with bits of grass as if he had slept in it on some mountain road. He wore a weathered hat with a large warped brim.

"We are very glad you came, Señor, Rafael said, extending his hand. Pedro Cienfuegos looked down at it curiously, hesitated, and dwarfed it with his own, shaking Rafael's hand lightly and briefly. Uneasiness overwhelmed Rafael. He had expected grief or dismay, anything except an expression of "Who the hell are you?" showing on the face of this armed colossus.

Rafael, rarely intimidated or impressed, began "We accompany your grief in the loss of your nephew." He stopped, chagrined by the lameness he heard in his own voice.

Without waiting for an invitation, Pedro Cienfuegos removed his hat, looked around for a chair, sat heavily on Rafael's favorite rocker, and demanded, "Who killed my nephew?"

"He accidentally injured his leg and died of a heart attack before help arrived." Not totally the truth but Rafael sensed this was not a man who forgave a scared young boy's foggy thinking no matter what the circumstances.

The big man nodded thoughtfully, pursed his lips, and said, "I doubt it was a real accident. My nephew was stupid. And unlucky. "

Baffled by what seemed a genetic lack of emotion, Rafael associated this man with a wild dog he had known during his boyhood in Bayamón. The dog approached slowly neither barking nor growling until he was close

enough to chomp down on a leg or an arm with gusto and then calmly strode away as if he had just been patted on the head. No one ever shot the dog. People simply learned to walk as far from it as they could.

"A tragedy," Rafael continued. He tried to put iron in his voice. "But now there is his son to care for."

"That's the real reason I'm here." Pedro struggled with his sizeable midriff to lean forward. As he did so his shirt, yellowed by too much laundering, strained its buttons and parted to reveal a hairy white chest. "What is all this about a son? Who is this boy?"

"Your grandnephew Félix."

Harsh, sarcastic laughter erupted from the big man. "Who says my nephew had a son, and what is the boy to you?"

"To me a patient and nothing more." Rafael could not keep irritation out of his voice. "I had never seen either your nephew or the boy before last week's tragedy."

"Then why have you taken him in?"

Rafael would never give Pedro the satisfaction of knowing that Félix was presently his only patient. Livid, he kept quiet. Large protruding eyes from Pedro's red and bloated face blazed at Rafael but he said nothing until Rafael burst.

"All the neighbors in San Juan know of the son and, and," Rafael stammered in anger, "the boy cries for his father."

"My nephew," Pedro growled, "lost his inheritance twenty years ago. There can be no son for him nor a nephew for me."

"Aha!" Rafael thought. So that was it. A disinheritance explained the comportment of class and power without the trappings, not even enough to eat. With a vengeance the father had been grooming the boy to regain his lost status, and now this uncle no doubt accustomed to having all the money was reluctant to share it with Félix Junior.

Both men faced off, silent, each thinking private thoughts. The invisible force of their growing anger and impatience sizzled into the air and wafted over to where Josie, ignored by them, stood listening. Seconds ticked by. Reacting to the hostility in the air, her green eyes darkened.

Josie disliked the ignorant, selfish uncle. She assessed him as she did some white men from her country, the United States, men who although poor and uneducated thought themselves superior because of their color.

To those who remained furious as late as 1910 over the loss of their slaves, she and her family were nothing more than "uppity niggers" for seeking to improve their situation through hard work and education.

Josie thought she had left that world behind when she met an aspiring foreign doctor at Howard University and married him. Gladly, she had moved to Rafael Figueroa's homeland of Puerto Rico when his money ran out and helped him complete his studies in his own country with her meager schoolteacher's salary. Yet, she continued to struggle for acceptance as the *negra americana*. She knew that although many young women of color held secondary positions as instructor, her well-paying teaching position in one of the few good schools on the island was due first to her status as an American and second to her university degree. Without both, Josie would have been consigned to struggle in a low-paying position. *Can't the mind go beyond the black skin that the eye sees?* Even her favorite students laughed behind her back because she spoke Spanish with an American accent.

"Don't you at least want to see the boy?" she asked harshly. Startled by the tone of her voice, both men turned to face her. She glared at Pedro Cienfuegos and saw his confused eyes soften.

"I don't know what for," he said. "But all right, why not? I don't understand any of this."

Josie and Rafael exchanged glances, shrugged simultaneously. They did not understand either but together they led the big man to the sick room. His frame filled the doorway, casting a large shadow into the lamp-lit infirmary.

Félix, barely awake, heard the murmuring and footsteps, opened his eye and screamed as dark shadows draped his cot.

"Papá, I'm sorry," he cried.

They saddened at the realization that the boy expected his father's ghost.

Josie and Rafael watched Pedro's sudden interest. At this moment they noted the strong resemblance and wondered if laws against marriage between blood relatives had been violated.

Both Cienfuegos had milk white skin framed by incongruous black hair, large, glossy brown eyes with thick, feminine lashes. Both possessed a talent for showing no facial expression.

"Who is your father?" Pedro asked.

"Félix Cienfuegos. He's gone now." No tears streamed down the boy's

rigid face.

"Do you know who I am?"

"Yes, you are Uncle Pedro. Papá told me you and he looked alike except for, for ..." Here Félix let his eyes roam openly over Pedro's ample girth, as if wondering how much food his uncle had to eat.

Ignoring the boy, Pedro asked, "Who is your mother?"

"She went away when I was five years old. Papá said she was not suitable and that we were better off without her, but after she left, I, we, were hungry all the time. I missed her. Papá did not."

A smile transformed Pedro Cienfuegos. He grabbed Josie's delicate hand, kissed it, and pounded Rafael on the back almost knocking him offer.

"*Muchas gracias,*" he said. "Another chance. This one will be watched, supervised with utmost care. No mistakes." To Félix he said, "As soon as you're well enough to travel you will come home with me. Rest now."

With that, Pedro stepped out of the infirmary, closed its door and smiled at Josie and Rafael, a frightening grin which scared them both into holding hands and stepping back. They were stumped until Pedro said, "There are certain family affairs that one might tell a doctor but which perhaps are too strong for a lady."

Josie understood two things. That she had just been dismissed and that she had been wrong. The man was not prejudiced. He had something to hide, something which had perplexed him as much as it did them, and he was now going to share whatever it was with her husband. Coughing into her hand, she mentioned duties to attend to in the kitchen, excused herself, and left them alone.

The two men sat in Dr. Figueroa's unused receiving room. "I never thought my nephew would take a woman and have children. During his youth, while studying away from home, he picked up some bad habits." Pedro peered anxiously at Rafael. "Do you understand?"

"No, not precisely." Rafael could not imagine although he suddenly thought about a male cousin of his who had run away to Spain to dance flamenco. He stifled the urge to smile.

Pedro sighed. "Everywhere in the country, in the sugarcane fields, the tobacco and coffee plantations, boys grow up around animals, see them copulate, and themselves begin to feel urges for which there is no outlet except animals or other boys. They outgrow these things, usually. My nephew studied in San Germán and in Spain. He returned with big

ideas, became mixed up with that autonomy movement leader from Barranquitas." He paused. They both listened to the lapping of the nearby waters of the bay.

Josie's loud knock on the door interrupted their reverie. She entered with a service for two of strong coffee and soft bread, diced cheese, and slivers of guava paste. They thanked her, waited until she left and then continued their conversation.

"Félix fell in love with intellectuals, mostly poets and journalists who wanted to move away from our mother country. He returned with good-for-nothing men who criticized my business methods as stupid and ignorant. They thought to insult me by calling me a Spaniard. Me, a third-generation Puerto Rican." Pedro thumped his chest.

"My nephew wanted to write political poetry all day instead of working or looking for a wife. We fought." The large man stood up, raised his voice, and waved his arms, scaring Rafael. "In front of my workers he shamed me by saying he preferred to sleep with men, not women!" Pedro put his hand on his pistol. "How is that for repaying my kindness in taking him in after his parents died?!"

Rafael discreetly pressed for specific details but Pedro Cienfuegos volunteered no more except to repeat that he had kicked his nephew out, disinherited him, and promised to watch Félix, Jr., every moment of every day for the rest of his natural life. He paid Dr. Figueroa insisting he would return for the boy.

"Where do you live?" Rafael asked as he and Josie bid the big man good-bye.

"None of your business. I've only said so much because of your kindness." He thundered out of the house, mounted his horse, and galloped away.

Josie and Rafael chuckled over his line the next morning.

"What's for breakfast?" Rafael asked, peering over her shoulder at the stove.

"None of your business. Ask me more and I'll shoot you."

They spent their day watching Félix eat and drink nonstop as he continued to make up for twelve years of starvation, and their evening hours in private puzzling over whether or not the boy had been mistreated, and wondered where he obtained the pearls and if the uncle truly intended to return.

"Was his father really a homosexual?" Josie asked.

"I only spoke to him briefly about his father, but I don't think so." Rafael pursed his lips, turned to look at her suspiciously.

"What?"

"His father told Félix, Jr., to marry a woman who was beautiful, strong, wealthy, and stupid. He said intelligent women put horns on their husbands." He narrowed his eyes at Josie.

She burst into laughter.

"Let's go to bed."

Three days later a mule load of supplies arrived with mangoes, green bananas, coffee, and clothing. They relaxed. Félix was not forgotten and they felt free to stop worrying.

Rafael's practice picked up, due mostly to a little girl. Their pet, Rafaela, was named after Dr. Figueroa. He had delivered her when he first returned to Puerto Rico under the shame of not having completed his studies in the States and before he obtained his medical certification. The girl's unmarried mother was too poor to pay a midwife, and none of her neighbors wanted any part of a woman who, they believed, had secret liaisons with all their husbands.

Though spoiled, outspoken, and precocious, seven-year-old Rafaela was also the best-loved child in the entire town because she was beautiful, intelligent and affectionate. To Josie and Rafael, still childless because of financial necessity, Rafaela could do no wrong even when she burst in on them unannounced, screaming.

"My mother's giving birth!" She cried uncontrollably and would not release he choke hold on Josie's waist.

"Calm down, Rafaela," Josie pleaded. "We can't understand what you're saying if you don't stop crying."

She sobbed, wiping her nose with her bare arm. Her tear-filled eyes were the color of light oak.

"Now more people will make fun of me."

"Who makes fun of you?"

"Everybody. Because I have no father. Dr. Rodríguez told me." She shook her head up and down.

"What did he tell you?"

"He said nobody wants me as a daughter just like the United States didn't want Puerto Rico as a state."

Josie's mouth dropped open. Furious, she could not think for a moment and watched Rafaela cry until her husband spoke.

"Stay away from that liar and don't ever speak to him again," Rafael said. He and Josie looked at each other astonished.

"He's not a liar," Rafaela protested. "He said it's in old records from 1900 and he promised me a nickel if I remembered that."

Startled, Josie recalled her family's concern for her well-being when she met Rafael because Tennessee Senator Bate had once compared the people of Puerto Rico to cannibals and head-hunting savages. She had forgotten that and wondered how Rodríguez had obtained the congressional records.

"Forget about him," she said. "Tell us what's wrong."

Josie sat Rafaela on her lap, hugged and stroked her until Rafaela hiccupped out that her mother was giving birth and needed help.

"Stay here until I return," Rafaela said, rushing around for his medical bag. "How long has she been in labor?"

"She's been telling me she has cramps from something she ate, but I finally saw her stomach this morning. She's been moaning in bed for two days."

"What? Two days? Why didn't you come sooner?"

"I told you. I didn't know." Rafaela lowered her eyes.

"Rafaela? You've seen pregnant women before and we discussed where babies come from."

"All right, I though she may be having a baby, but I was angry because I don't want her to have another so I didn't care if she didn't feel good. Now I'm scared; her face looks wet and green."

Rafael ran out of the house while Josie took Rafaela into the infirmary. "You should be ashamed," she said. "You have a mother who loves you and soon you'll have a brother or a sister as family. Look at this poor boy who has no mother or father or brothers or sisters."

When they opened the door, Félix sat up as though in a trance.

Rafaela stared. "He's the most beautiful boy I've ever seen," she whispered. "His eyes are like a calf's and he looks sad, so sad. Can I kiss him?"

"No. Let him go back to sleep."

"He's not a poor boy," she said eyeing Josie suspiciously. "What is he doing in your house?"

Afraid Rafaela might throw jealous tantrum, Josie pushed her back to the living room. "We are waiting for a long-lost greatuncle, who doesn't really want him, to come pick him up when he's better."

Looking pacified, Rafaela paged through some books Josie gave her to teach her English. She glanced occasionally at the infirmary door until Dr. Figueroa returned to tell her she had a sister.

"I hate that," she said. "Now I'm not the only girl. I much prefer a beautiful boy like the poor sick one in there." She pointed a long delicate finger.

"Come on, time to go home. I'll take you."

Days later pregnant women crowded Rafael Figueroa's receiving room saying that when their time came they too wanted a painless birth and a guaranteed healthy delivery. Rumor circulated that Dr. Figueroa had not only saved the life of Rafael's mother, miraculously doing away with all pain, but had also revived a stillborn baby. Immediately, Rafael and Josie knew the source of this story and said, "Rafaela!"

At the end of two weeks, Pedro Cienfuegos, at night and on horseback arrived. He ordered Félix to gather his belongings, sat him on a mule roped behind his horse, and led him away.

Swaying atop the animal, Félix fleshed out and no longer a skeleton, stared inquiringly at Dr. Figueroa and Josie. He looked back at them over his mule's rump until he rounded a corner, cut off from their sight. The townspeople of Cataño who lived on the Figueroas' street followed uncle and nephew with their eyes until the entourage disappeared. When their neighbors threatened to approach with questions, Josie and Rafael quickly waved goodnight, backed into their home, and bolted the doors.

Embracing the woman he married and loved ferociously, Rafael Figueroa said a silent prayer for Félix Cienfuegos, a child he expected never to see or hear from again. Then, as he continued to think about the young boy, Rafael went from room to room extinguishing all the lanterns, leaving a trail of darkness behind him.

GIANNINA BRASCHI

Giannina Braschi es poeta, narradora y performera nacida en San Juan en 1953. Reside en Nueva York desde 1975 y ha vivido en Madrid, París, Roma y Londres. Ha publicado los poemarios *Asalto al tiempo* (1981), *La comedia profana* (1985), *Libro de payasos y bufones* (1987), el libro de teoría *La poesía de Bécquer* (1982), el libro de poesía posmodernista *El imperio de los sueños* (1988, 2000 Editorial de la Universidad de Puerto Rico) y la novela bilingüe *YO-YO BOING!* (1994, Latin American Literary Review Press) escrita con los cambios de código, mitad en español y mitad en inglés, que constituye la lengua cotidiana de millones de Latinos en los Estados Unidos. Ha obtenido premios y becas del National Endowment for the Arts, New York Foundation for the Arts, El Diario La Prensa, PEN American Center, Ford Foundation, Danforth Scholarship, InterAmericas, Instituto de Cultura Puertorriqueña y The Reed Foundation. Sus poemas y ensayos se han publicado en revistas como *The Evergreen Review, Asia Literary Review, Bomb Magazine, Hopscotch, Agni, Artful Dodge, Review: Latin American Literature and the Arts, Callaloo, Poet Magazine* y *The Literary Review.* Su colección de poesía, *Empire of Dreams,* traducida al inglés por Tess O'Dwyer, obtuvo el Columbia University Translation Center Award e inaguró el Yale Library of World Literature in Translation. Leyó recientemente de un nuevo texto en inglés, "The United States of Banana", que narra la caída del imperio americano después del 9/11. Braschi obtuvo un Ph.D. en Literaturas Hispanas de SUNY y ha enseñado en Rutgers, Queens, y Colgate University, donde se le nombró National Endowed Distinguished Chair.

Giannina Braschi is a writer of fiction and poetry and a performer, born in San Juan in 1953. She lived in Madrid, Paris, Rome and London before settling in New York in 1975. She has published the books of poetry *Asalto al tiempo* (1981), *La comedia profana* (1985), *Libro de payasos y bufones* (1987), the book of theory *La poesía de Bécquer* (1982), the postmodern poetry book *El imperio de los sueños* (1988/2000 Editorial de la Universidad de Puerto Rico) and the bilingual novel *YO-YO BOING!* (1994, Latin American Literary Review Press), which is written in the code-switching half Spanish, half English that is the daily language spoken by millions of Latinos in the United States. She has won grants and awards from the National Endowment for the Arts, New York Foundation for the Arts, El Diario La Prensa, PEN American Center, Ford Foundation, Danforth Scholarship, InterAmericas, Instituto de Cultura Puertorriqueña and The Reed Foundation. Her poems and essays have appeared in journals such as: *The Evergreen Review, Asia Literary Review, Bomb Magazine, Hopscotch, Agni, Artful Dodge, Review: Latin American Literature and the Arts, Callaloo, Poet Magazine,* and *The Literary Review.* Her collected poetry, *Empire of Dreams,* translated by Tess O'Dwyer, won the Columbia University Translation Center Award and inaugurated the Yale Library of World Literature in Translation. She recently read from her new work in English, "The United States of Banana," which narrates the decline of the American empire post 9/11. Braschi holds a Ph.D. in Hispanic Literatures from SUNY and has taught at Rutgers, Queens, and Colgate University, where she served as National Endowed Distinguished Chair.

EL IMPERIO DE LOS SUEÑOS (fragmentos)

Yo quiero que todo esté en mi libro. Que no se quede nada
sin decir. Yo quiero mencionarlo todo. Vivirlo todo. Mirarlo
todo. Hacerlo todo de nuevo. El final debe ser el principio.
La salida del túnel. La entrada en la carretera de la vida.
El correr en motocicleta. El mirar la luna llena. Fui el
Mago. Deben saberlo todos. El mundo debe saberlo. Yo
fui el único Mago que hizo el truco en una página. Y apareció
el poeta. El poeta. El poeta. El poeta descalzo. El niño. El
cometa. El musicólogo. Yo inventé el pentagrama. Inventé
la estrella del drama. Qué mucho tiempo ha pasado. Cerraré
mis ojos. Para quedarme solo. Solo. Solo. Soy el solitario.
Me hubiera gustado hacerlos felices. Me hubiera gustado
inventar el paraíso. Una taberna de hielo. O un hombre
de leche. Un cachorrito. Y un pingüino. Y todo lo tengo.
Lo tengo todo. Pronto habré de extinguirme. Como un
rayo fulminante. Como el planeta entero. Orquesta. Orquesta.
Que empiece la música. Que empiece a cantar la cantante.
Que todo recomience. Yo lo quiero todo. Todo. Todo.

<center>❦</center>

Yo acabo de regresar de una larga temporada a Nueva York.
Yo acabo de retornar a mi casa. Y he visto lo más grande.
Lo más hermoso que hay en la tierra. He visto los ojos de
la ciudad más bella del mundo. He visto los ojos de mi
ciudad. La he visto dormida. Y me he quedado bobo. No
sabía qué hacer. Y salí corriendo despavorido por las
calles de Nueva York. Y llegué a la catedral de San
Patricio y toqué las campanas. He visto con mis ojos
los ojos de mi ciudad. Y salí corriendo y llegué al
Empire State y me trepé al último piso y tomé un
altoparlante y le grité a los hombres de la ciudad de
Nueva York. He visto con mis ojos la ciudad más hermosa
del mundo. He visto la ciudad que amo. Qué haré. Qué haré.
Sino correr. Correr hasta hartarme de correr. Hasta hartarme
de correr y de correr y de correr. Y ya se acerca. Ya se acerca.
Y siento los ojos de mi ciudad. Y siento que está cerca
todavía. He visto con mis ojos los ojos de mi ciudad.

<center>❦</center>

Yo hago la afirmación. Yo hago la exclamación. Yo soy la
inquisición de los recuerdos. Y me aburren los puntos y las
comas. Me aburre la duda. Y sobre todo la memoria.
Me aburren los recuerdos y he llegado a la cima del mundo

para quemarlos. En este libro están mis recuerdos. Escúchenme
damas y caballeros. Este es el funeral de los recuerdos.
Este es su cementerio. Y éstas son sus honras fúnebres.
No los adoro ni les tengo ningún respeto. No le pertenecen
a nadie. No le pertenecen a la tumba. Y ni siquiera le
pertenecen al recuerdo. Ya todos han visto las quimeras
rojas y las quimeras negras. Han visto las borracheras y los
banquetes. Y después ha llegado la resaca del recuerdo y ha
arrasado con la vida. La muerte se llama recuerdo. Y el
tiempo también. Y también los malditos recogedores de
basura. Me refiero a los pastores del recuerdo. Y los
recuerdos son sombra. Y los recuerdos son muerte. Yo no
soy un recuerdo. Yo no soy un arsenal de epítetos ni de
metáforas. Yo soy la estrella y la estrella alumbra. Soy
afirmación. Y no quiero conceptos. No quiero abstracciones.
No, No, No, y No. No soy punto y coma. Quiero punto
y aparte. Quiero acabarlo todo de una vez. Sin
arrepentimientos. Sin recuerdos.

LAS COSAS QUE LES PASAN A LOS HOMBRES EN NUEVA YORK

¡Las cosas que les pasan a los hombres en Nueva York! Esto
está puesto en exclamación. Es, por supuesto, una
exageración —dice el narrador. No es sólo en Nueva York
donde les pasan a los hombres estas cosas. Les pasan en
La Habana y en Berlín. Les pasan en Madrid y en Moscú.
Y no sólo les pasan a los hombres. Les pasan también
a las mujeres. Me pareció extraño porque no encontraba
el mens' room —dijo Mariquita Samper. Pregunté dónde
estaba el ladies room —dijo Uriberto Eisensweig vestido
de Berta Singerman. Luego que salí del rest room —dijo
el narrador — me senté a mirar las cosas que les pasan a
los hombres en Nueva York. No sé si es preciso que
me cambie mi nombre. No me gusta que me llamen
Mariquita Samper cuando en realidad estoy ejecutando el
papel de Berta Singerman y soy una lesbiana. Maricona-
Mariquita. Detrás de los bastidores Mariquita Samper se
viste de Uriberto Eisenweig. Y Uriberto Eisenweig
se viste de Berta Samper. ¿No sabe usted que yo soy
Uriberto Singerman? ¿Y que Uriberto Samper es nada
menos y nada más que Berta Eisensweig? ¡Oiga, señor, las
cosas que les pasan a las mujeres en Nueva York! Mariquita:
soy yo, Uriberto Eisensweig. De pronto se cae el telón.
Evidentemente al púbico le gustan las cosas que les pasan

a los hombres en Nueva York —dice el narrador. ¿Si
no les gustaran estas cosas por qué aplauden tanto? En el
fondo piden que se repita la función. Aclaman mucho más
a Uriberto cuando ejecuta el papel de Mariquita Samper.
¡Bravo! ¡Bravo! ¡Que se repita la función! ¡Oiga, señora,
las cosas que les pasan a las mujeres en Nueva York!
Ellas creen ser mujeres y son hombres. Ellos creen ser
hombres y son mujeres. Tras bastidores está la madre de
Mariquita Samper. No me gusta que te vistas de Uriberto.
¿Qué sacas con esto? ¿Escandalizar a la gente? Mamá.
¿No ves que están alegres? ¿No ves que se sienten felices?
En el fondo de todo hombre hay una mujer. En el fondo
de toda mujer hay un hombre. Las cosas son hombres
y mujeres. Las manzanas buscan a las peras. Y las peras
aman a los melocotones. ¡Oiga, señor, las cosas que les
pasan a las peras en Nueva York! No es ninguna novedad.
Ya sabemos que a los hombres les gustan las peras.
Y que a los melocotones les gustan las naranjas. Ya
sabemos también que la naranja es naranja. Y que la
manzana es un melocotón. Eso no lo sabía —dice la
mamá de la manzana. Yo creía que a mi hija le gustaban
los melocotones. Pero ¿las peras? Señores, Señoras —y
se pone su mano sobre la cabeza. Eso no sabía que les
pasaba a las mujeres en Nueva York. Señoras, Señores
—dice con seriedad el papá del melocotón—, eso tampoco
sabía que le pasaba a mi hijo. ¡Pero las cosas que les pasan
a los hombres y a las mujeres! —dicen la pera y el
melocotón. Incluso la manzana y la naranja. Y repiten:
¡Oh, las cosas que les pasan a los hombres en
Nueva York! ¡Oh, las cosas que les pasan a las
mujeres en Nueva York! ¡Bravo! ¡Bravo! Fin de
esta escena. Y fin de otro episodio cotidiano que
vivo en Nueva York. Firma: el narrador. Todos
dicen que es mentira la verdad. Todos dicen que
es verdad la mentira. Pero yo sólo sé que estoy
solo redactando una ilusión barata. Y con una
lágrima en el ojo, con una lágrima que me traiciona,
me río de la ironía, que me cuesta caro redactar
el *Diario íntimo de la soledad.*

YO- YO BOING! (fragmento)

Dime, dime la verdad. Ahora que estamos solitos aquí. La Mona
esa no me considera a mí. Dime. Dime la verdad.
—Yes, I think the category of genius still exists.
—But I don't think like she thinks. I don't think it's harder to be a philosopher
than to be an artist. Look, she said there are very few philosophers in the
history of humanity. I don't know, every time I hear her talk I become a little
nervous. Before, I was so sure. But now, how can I know? Besides, if she
doesn't think I am, who is going to think I am? She is alive. She knows me.
And believe me, I try to make my impression. I try to become one. But she
just gives me her smiles, shows me her teeth, and I get nervous. And then
you just blind me all over, by protecting me so much. I ask you, am I one of
them.
—Who cares what she thinks.
—But tell me, count on your fingers, how many philosophers or artists can
make a herd of black cows wacko their tails as if they were directing what
they heard.
—Was somebody with you?
—Why?
—We need proof.
—The cows were there. The trees. The dawn. Music and me.
—It's not enough. We need a witness who can testify otherwise they'll say the
cows were just swatting flies.
—Do you think the cows will do it again if they see you?
—Why don't we try.
—Do you think I'll sing with the same voice twice? My voice not only
brought the hills to life, but the cows to music, to music. It's not simple, you
know, and yet it's so simple. So true and pure. Do you think I could sing the
same way in front of a stranger like you?
—You could write with me as a chair.
—Do you believe me?
—Mona would have said it's fantasy, but I'm sure it could happen.
—*Pathetic? You wish you were that pathetic. You don't*
understand. Listen to the holiness. He's a great soul, and you
dare to laugh.
—*Mona, I'm not laughing at him.*
—*You wish.*
—*He's got no balls.*
—*You wish you write like he sings. Hear, hear when his*
voice dies softly. It's a gentle woman. The effort, the effort of
dying softly.
—*I know. I think he's funny, or rather, she's funny.*
—*Why do you care about that? Insensitive, arrogant.*
—*I prefer Plácido.*
—*Oh, please, why even compare?*
—*He's got balls.*
—*He's got balls? You wish you had the Castrato's balls. I love*
him most when his voice dissolves. You have no ear for music.

You don't even know what you're listening to.
—You know, I'm really angry. Now, tell me, did she or didn't she dare to say
that the Castrato was on a higher level than me.
—Is that what you heard?
—She said it, didn't she?
—Maybe she meant in voice. You do have a deep voice.
—I heard what she said, but she didn't hear that I said I love the Castrato.
His *aahaaaa* it's like, it's as if he's drowning or swallowing his tongue.
—Sounds to me like he's taking it up the ass.
—Yes, yes that's it. That's it. I adored his voice. It's swollen bird. A bird
dying and crying frail, not Niagara Falls, no, no, no. Then, out of the blue,
she says:
—*You have Picasso's eyes, intense.*
I figure, so I don't have the Castrato's soul, but I do have Picasso's eyes. Not
bad. Not bad. And then she says:
—*You're very powerful. That's probably why Makiko compared
your expression to Hannibal the Cannibal in* Silence of the
Lambs.
Don't you see a contradiction in all her arguments? I can't hate her. She
loves me. I always thought I was like Picasso. Cow eyes. No wonder,
mooooo, the cows loved me. Castrati. Castrati. I swear, they were trying to
tell me—looking deep into my eyes:
—*what a beautiful voice you have.*
—*what are you doing here?*
—*how come you understand us so well?*
Their big black eyes gazed into mine as I sang:
—*with the sound of music*
I extended the *sound*, until the vowels vibrated inside their eardrums, inside
their bellies. They were melting, swaying, dripping, almost milking while
swinging their tails in harmony
—*with the sound of music*
with songs they have sung
for a thousand years
It was magical. The word *years* started their tails again. They crowded
closer, penetrating my eyes, and letting me know that they listened,
understood, and most of all, respected with silenced and devotion.
—*I know I will hear what I've heard before.*
I was invoking the spirits to come and get me. I knew I would hear—music,
poetry—like I heard before, with the same love mounting over a fountain of
passion—water, water—I was thirsty, and the mountains so full of yerbas,
árboles, pelos, pelos puntiagudos y escarbando sus rodillas, los montes
profundos—que muchas piedras y raíces y margaritas y aguas y rizos, rizos
de ramas, tallos, ramitas bien débiles, tan *débiles*, is the word, *endebles*,
y algunas tan fuertes—y yo pisando el lodo, enfangando mis tennis y mirando
las nubes bajar y bajar hasta encontrarse perdidas, no, suspendidas,
Algodones, la ramita moviéndose, y el pájaro
sembrado sembrado en ella cantando, y
las vacas mugiendo, y ahora una de ellas en conjunto con toda la armonía del
universo dice *sí, sí, sí, sí, sí.* Baja y sube la cabeza, afirmando que sí, *porque*

sí, señor, me gusta como canta.
—*Yes, we'll hear it again. Don't you agree?*
—*I doooo.*
—*Lo afirmamos.*
Y entonces, reclinándose, como si la música no fuera con ellas, se pusieron a comer yerba.
—Tú ves, ni caso que te hacían.
—I thought you believed me.
—Yeah, but they immediately forgot you and went for the grass.
—I made my impression. They paid attention until the sound of music wet their appetite. What better than that. When I left, they were happy, content, to eat their grass as if nothing had happened, and I continued singing on my road, and they continued on theirs. I did it my way, and they did it theirs.

Susana Cabañas

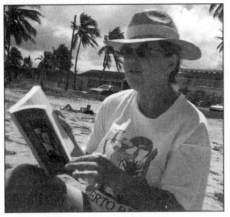

Susana Cabañas es poeta
y activista política. Nació en
Puerto Rico y llegó muy joven a
los Estados Unidos, en donde ha
vivido la mayor parte de su vida.
En 1984 publica *Poemario,* una
colección bilingüe de su poesía.
Su obra se ha publicado en
antologías, revistas y periódicos
en Estados Unidos, España,
México y Puerto Rico y ha sido
utilizada en varias obras de teatro.
Co-editó y publicó *Breaking, An
Anthology of Latina Writers.* En el 1992 recibió el premio, First Books
Award in Poetry del National Writer's Voice Project de la YMCA de
los Estados Unidos. Ha participado en lecturas literarias en colegios,
universidades, centros comunales, estaciones de radio FM y cafés en
Nueva York, Puerto Rico y la costa este de los Estados Unidos, donde
ha dirigido talleres de poesía y coordinado lecturas literarias.

Susana Cabañas is a poet and political activist. Born in Puerto Rico, she came at a young age to the United States, where she has lived most of her life. In 1984 she published *Poemario,* a bilingual collection of her early work. Her work has been published in diverse anthologies, newspapers, and magazines in the U.S., Spain, México, and Puerto Rico and has been used in several theater pieces. She co-edited and published *Breaking, An Anthology of Latina Writers* in 1985. In 1992 she was the recipient of the First Books Award in Poetry from the National Writer's Voice Project of the YMCA of the USA. Cabañas has participated in poetry readings at various colleges, universities, community centers, churches, FM radio and cafes throughout New York City, Puerto Rico and the eastern seaboard of the United States, where she has directed poetry workshops and coordinated weekly poetry readings.

THE WHITE SEPULCHER

For Alejandrina Torres, Ex-Puerto Rican Prisoner of War

White lights
24 hours a day
11 surveillance cameras
24 hours a day
no physical exercise
no social contacts
restricted correspondence
restricted phone calls
no rights
only privileges
antiseptic
totally clean
death row
for tests
privilege - window
privative - 7 foot high ceilings
punitive - no natural light
one story underground
24 hours of white
ski-blinding glare
blinding light
can put nothing on walls
no natural light
no external stimuli
24 foot high plus 3 rows of
razor-edge fence
surrounded by
wooden fence
can not see out
apart from rest of prison
special housing unit
Control Unit at Lexington
only political prisoners
question of classification of
director of bureau of prisons
based on internal and secretive
criteria
only way out
is to turn traitor
volverte chota brother
warehouse to oblivion
psychological torture for
purpose of breaking the
individual

to put fear in our hearts
is their aim
counter-insurgency conference
separate them from population
trying to find out how they react
long term effects of isolation
comparable to brain defects
Alejandrina can't hardly read anymore
has affected her vision
Lexington has medical center
floor above them
would not take her
security - strip searched
when they leave the cell
and when they go outside
always guarded
strip search is a serious tool
cavity search
sexual weapon
used against women
in particular
5 women officers
held her
1 male PA
did it
one woman
got sick

CARTA DE AMOR A UN GUERRILLERO

Querido
Vete y báñate
en una de esas charcas cristalinas
de la montaña
bien alto encarámate
por las piedras
y encuentra una solitaria
donde la chorrera caiga
con esa fuerza que pretende
abrirte los sesos
despójate y despójate en mi nombre
que a veces agonizo estar tan lejos
de tener que recapturar y proteger
la memoria del olor y sabor
de mi isla
vete y báñate en una playa
aunque digan que no es temporada
porque para nosotros los ausentes
cualquier temporada es buena
en Puerto Rico
camina largas millas
por esa playa
y recoge caracoles
y piensa en mí
para que el aroma del mar
me llene
sumérgete
en esa agua turquesa
y mira los peces cómo juegan
descubre de nuevo la belleza
de la naturaleza borinqueña
y vívela completamente
para que yo pueda disfrutar
por tus ojos
por tu pensar
mándame un pensamiento
cuando veas un flamboyán
o una palma
o una luna
o un cañaveral
que yo estaré contigo
cuando pregones, cuando pasquines
cuando prediques nuestra libertad

cuando denuncies los vende patrias y los traidores
cuando señales los oportunistas
y los verdaderos malhechores
que yo estaré contigo en cada acto
en cada protesta, en cada palabra
en cada grito que brote de tu alma
hasta la victoria final.

IT'S CALLED KINGS

I'm angry because I hate to be angry and because I hate to be angry
I'm angry angry makes me smoke too much and drink too much and eat
too much or not enough binge this and binge that saturate yourself in
something or other to forget the fact that I'm angry I'm angry because I
don't like who I am who I become when I'm angry I'm mean and vengeful
and vile and acid and ulcers and high blood pressure and headaches and
backaches and aches and aches and aches and my head aches when I think
how much I ache because I'm so angry I'm so angry I don't want to wake
up much less go to bed that's how angry rage rage rage fear pain anger
I'm angry because why can't we all be the same not some have too much
while others not enough of nothing to eat not enough of a house over our
heads not enough of the pain in our hearts that makes us so angry angry
angry because don't tell me that that guy sleeping on a stoop down the
stoop from where you live doesn't make you angry or the $40 real life trees
that smell so good when you go by a whisper in our minds of a time gone
by a time when the wind smelled of the sea or of trees a clean clear smell
no more long time gone by you need to get out of the city and how many
of us get a chance to get out of the city rolling up our pennies those of us
who still have any left you know you are poor when you have to count
your pennies in America to get high to forget how angry you can get in
America in the land of milk and honey brother kills brother for a woman
for a life for a piece of the land we shoot each other up because we're so
angry we are so angry we break things we throw things we beat we beat
each other up even to those we love we yell and scream and scream and
scream and hurt and cry and cry and rage and scream and cry and want to
kill and want to die because we want to kill ourselves most of all because
we're so angry one must get very angry to put on a white robe white being
the color of virtue of grace and add a white hood covering up the rage
from our face and go burn a white cross on somebody's lawn because of
their color or creed or else to put on a white robe and stand on a white
altar covered with the most exquisite white cotton and lace and hold up
a gold chalice filled with red blood in which we submerge a white wafer
and eat and drink of another's flesh and blood in the name of the Lord in
the name of the Lord this is my land says the conqueror and kills and kills
with ease and grace in the name of the Lord whose Lord is my Lord your
Lord is my God your God is your God my God do I believe in God do I

believe in the Lord do the people believe in the Lord and Dukes and Earls and Princes and Pearls and Lords and Knights of the round table around the table of the lord of the round table who rules above all and tells all the knights who sit around the round table what to do when to jump where to live divine right of kings have divine rights and dukes and earls and princes and pearls and lords the lord of the land and the supreme commander of the armed forces of all the nations and the people the masses of people who believe in the lord homeless wanderers wandering wandering wandering nomads migrating roaming moving constantly moving running from the landlord constantly moving constantly moving because the landlord owns all the land constantly moving in the name of the lord constantly moving constantly moving I'm angry I'm angry I'm so angry

Oh Man

To all my woman friends who are abused because of love

Oh Man
why do you mistreat me
when I love you so
why do you beat me
and take my money
for crack and other dumbing drugs
so that I no longer have a home
for my kids
they are hungry, they are hungry
my kids
because of my loving you, Oh Man
I thought love could move mountains
heal all wounds
perform unheard miracles
perhaps the candles I've lit have been too few
perhaps some more hail Marys our Fathers
will do
o una plegaria a Changó, Obatalá, Yemayá
Buddha, Mohammed, Oh Christ who did I leave out
Holy Jesus
what can I do to make you see
Oh Man

Oh Man Oh Man
I love you so
so beat me
mistreat me
cheat me
abuse me
use me use my kids
my family
whatever you want
take it
it's yours
Oh Man

Oh Man
let's make up
tomorrow is another day
come to bed
don't delay
I forgive you
I know it's not your fault
you can't read or write

won't get a job
your mother spoiled you too
all those years
the drinking
the whoring
the gambling
the living high
off our collective costillas
Eve was begotten from Adam's rib
or so the story goes
created in his image to serve
forever
Oh Man

Oh Man Oh Man
what can I do
to make YOU see the light
so I can see it too
all these eons of ages
seeing life
through your eyes
has blunted my vision
se me apagó la luz
ya no puedo ver
más la miseria que soy
que somos conjunta colectiva mente
my mind is gone
Oh Man Oh Man
what can we do
to stop killing
our love
with so much beating, cheating, lying
crying
dying
a little more each day
our precious fucking love
te estoy perdiendo el gusto
a little more each day
Oh Man

Oh Man Oh Man
why don't you go visit your mother
or sister or brother
In fact let me help you pack
take a long trip
here's some money
only get out of here
Oh Man
OK OK

beat me
mistreat me
don't go
I love you so
don't go
come to bed
don't delay
Oh Man

Oh Man Oh Man
you are by far
the hardest habit
to break
what can I do
my kids are dying
slow deaths
fear in their eyes
smell of doom
in the air
Oh Man

Oh Man Oh Man
some day in the dark
of light
when you're asleep
I'll pierce your soul
for all you've done
or set you afire
which is my deepest desire
or grab my kids
and fly out the door
with just the clothes
on our backs and nothing more
free at last
from your sick
and killing
kind of loving
Oh Man

LOS COLONIZADOS

Of course
these people think
we're stupid
they know more
about us
than we know about
ourselves
they put us in cages
they watch us day and night
they dissect us
they analyze our insides
to see what makes us tick
they illiterate us
they analphabetize us
they alcoholize us
they obliterate us
or not
depending on their whim
or whether or not
we pass the test
we can learn to speak the language
they know us inside out
but they still can't figure us out
why? we're just plain stupid
dumb
we never give up
we never shut up
some stupid ass
one of us
is sure to crack
a remark
sooner or later
we never learn
to be quiet
we laugh too much
we just make too much noise
with our songs
and our drums
they have to shut us out
they have to shut us up
because we remind them
that somewhere
in this world
there still exists
a free spirit
rebellious, life loving
love living
free spirit

SHEILA CANDELARIO

Sheila Candelario nace en Puerto Rico y es ensayista, poeta, cuentista y catedrática de literatura. Su poesía y prosa aparecen en su libro *Instrucciones para perderse en el desierto* (2004). Su narrativa aparece en la antología *Narradoras latinoamericanas en Estados Unidos* (2008). Su obra forma parte del "Special Collections Project, Puerto Rican Writers: History and Context" del Centro de Estudios Puertorriqueños. Ha leído su obra en El Nuyorican Poets Café, Bowery Poetry Club, LART, Boricua College, Galería Mixta y Cemí Underground. Fue invitada en un programa sobre poetas, *En la Punta de la Lengua*, transmitido en Puerto Rico por WIPR-TV (2005). Co-organizó el "Viequethon", que llevó a poetas y músicos de Nueva York a una manifestación cultural por la paz en Vieques, Puerto Rico (2001). Co-organizó también el simposio internacional "El Salvador 1932: Memoria Histórica, Justicia, Identidad y Derechos Indígenas". Organizó y participó en *Así Contamos las Mujeres: Narradoras Puertorriqueñas en Nueva York* en El Centro de Estudios Puertorriqueños (2007). Su ensayo "Espejos Dispersos: Voces Migratorias en la Literatura Salvadoreña" fue publicado por la ONU en el documento del *Programa de Desarrollo Humano de El Salvador* (2005). Su más reciente ensayo fue publicado por la Universidad Nacional de Costa Rica en la antología *Voces y silencios de la crítica y la historiografía literaria centroamericana* (2010). Honores: "Mujer del Año 2002" de la Parada Puertorriqueña de El Bronx, "Una de las 50 latinas más destacadas" (2004) por *El Diario La Prensa*, y un reconocimiento del National Conference of Puerto Rican Women (2007). Se graduó Cum Laude en periodismo de la Universidad de Puerto Rico. Luego de obtener dos maestrías con altos honores, se doctoró en literatura en SUNY Stony Brook en el 2001.

Sheila Candelario is an essayist, poet, fiction writer and college literature professor. She published the poetry and fiction book *Instrucciones para perderse en el desierto* (2004). Her work was anthologized in *Narradoras latinoamericanas en Estados Unidos* (2008) and is also part of the "Special Collections Project, Puerto Rican Writers: History and Context" at the Center for Puerto Rican Studies. She has read her work at the Nuyorican Poets Café, Bowery Poetry Club, LART, Boricua College, Mixta Gallery, Cemí Underground and in Latin America. She was featured in the literary program, *En la Punta de la Lengua,* aired in Puerto Rico's WIPR-TV (2005). She was part of the steering committee of "Viequethon 2001," a cultural marathon for peace in Vieques, Puerto Rico. In 2004 she co-organized the international forum "El Salvador 1932, Historical Memory, Justice, Identity & Indigenous Peoples Rights." She has organized events with El Puerto Rican Embassy at the Nuyorican Poets Café. She organized and participated in a recital, *Así Contamos las Mujeres: Narradoras Puertorriqueñas en Nueva York* at the Center for Puerto Rican Studies (2007). Her essay "Espejos Dispersos: Voces Migratorias en la Literatura Salvadoreña" was published by the *United Nations' Report on Human Development and Migration in El Salvador* (2005). Her most recent essay was published in an anthology by Universidad Nacional de Costa Rica, *Voces y silencios de la crítica y la historiografía literaria centroamericana* (2010). Honors: "One of 50 Outstanding Latina Women in New York City" by *El Diario La Prensa* (2004), "Woman of the Year 2002" by the Bronx Puerto Rican Day Parade, and recognition by the National Conference of Puerto Rican Women (2007). Candelario studied journalism at the University of Puerto Rico (cum laude) and, after two masters degrees with honors, she completed her Ph.D. in literature at Stony Brook in 2001.

AUTOFICCIÓN

Para Adál, hermano existencial

Soy mi propio personaje
la idea inexacta de quien me creo.
Me escribo siendo papel no palabra.
Soy silueta dibujada por lengua de amante oculto.
Soy quien se miente en el abandono
de su partida antes que amanezca.
Soy ficción en sofá rojo,
voz en teléfono de niña perdida en años
pidiendo suavecita que venga aunque llueva.
Me imagino sin piel, hecha de aire
para no ver mi cara en el espejo
ése que se ríe de todos los engaños
que siempre le he creído
cuando me veo desmedrar sin remedio
cuando celebro el reflejo de la belleza accidental
o me cambian de color los ojos sin que sean míos.
Inventé una historia que quiere escribirse sola,
me pide que la deje, mi historia no me necesita.
No necesita de telas púrpuras en el cuello,
del silencio de mi casa, ni la silla en la ventana.
Mi historia sabe que existo si me nombro
por eso pide que me vaya,
que la siga de largo por El Barrio donde pretendo vivir,
que pase de largo por Loisaida sin parar en Umbrella,
hablar con Adál, bajar la calle de Pedro,
visitar a Adela aunque el saludo sea,
¿dónde has estado metida?
y conteste, pues por ahí, y siga de largo.
Mi historia no necesita de mis pasos.
A personajes, no se les pueden rastrear las pisadas,
por eso apareces y desapareces, imperceptible.
Soy el truco preferido de mi inconciencia.

MUTISMOS

> *Me gustas cuando callas porque estás como ausente*
> *y me oyes desde lejos y mi voz no te toca.*
> *Parece que los ojos se te hubieran volado*
> *y parece que un beso te cerrara la boca.*
>
> *Poema 15, Pablo Neruda*

Teme cuando calle
pues son aguas bravas que seducen mis oídos,
montañas mesiánicas que abren caminos
de guayabales escondidos.
Teme mi silencio al abrir mis dedos
para sacarme tus entrañas por la boca
mientras mi lengua navega tu garganta.
Teme mi ausencia cuando mis ojos se pierden en tus córneas
en conversación del soliloquio
pues persigo descalza
la ballena que devoró el hambre de Jonás.
Teme mis labios cuando exhalo
pues suspiro ancestros anudados
en la espina clavada en la arruga del seño.
Teme las palabras no inventadas
que como noctámbula paseo
sobre la joroba de mi humanidad.

6 DE JULIO

A Frida Khalo

Pensar en tu dolor hace celebrar la vida
cuerpo en pedazos y orgasmos
útero sin puerto, lucha aliada a la muerte.
No hay viento helado, ni tardes secas
que vacíen océanos que respiras.
Nada te venció, ni el corazón extirpado por manos
de quien bebió deliciosamente tu vida
en alcobas de muchas otras.

Perseguimos las huellas que dejaste
en raíces derramadas por tu vientre
bajo traje inmaculado entre basura
a través de tercer ojos condenados al amor invencible.
Así nos llegas penetrante por ojos de simios que arrullamos
como hijos que se escapan del abrazo.
Navego la sangre que vierte tu cuerpo cansado de doler,
acuesto en lecho donde descansan las flores de tu pelo
ofrenda a toda quien ose llevarlas entre sus piernas
como florero de deseos insaciables.

Vuelo entre tus cejas sin poder jamás rendirme
ante ti, triunfante por los siglos de los siglos
sin haber nada, nada, nadie quien silencie quienes somos,
nada en esta fiesta humana que opaque el lienzo,
la pluma, la música de nuestros ríos.

Nos diste tanto, que nos dejaste con nada
para justificar la derrota.

OLVIDADOS

A las víctimas de Katrina
A los pobres del imperio

Como polvo en agua oscura suben a la superficie
aunque como polvo seco se sujeten al suelo
al ras de un objeto
como polvo siempre resurgen
ignorados por el tiempo, invisibles a la luz
por caber en ranuras de puertas, en grietas de pared
aunque se sientan, se intuyan, como polvo
al meterse por nariz y boca
se barra bajo la alfombra
se bote por la puerta, regrese por la ventana
acumulándose en esquinas, vigilantes
habitando el aire en partículas que flotan sobre el agua
como cadáveres abandonados en un hospital
como manos que se alzan en ruego
desde el fondo inmisericorde de una tormenta
sin que nadie las vea
como gritos en los techos que nadie escucha
por horas, días, noches, siglos,
mientras su llanto se une a turbias aguas del desamparo
donde rostros del hambre se hacen mar
que llega a la orilla de mi cama
lejos de Nueva Orleans
Atlántida Tercermundista USA
donde salieron de grietas niños desnutridos
salieron de ranuras madres olvidadas
salieron de recónditas esquinas los ignorados,
invisibles de la historia, del imperio,
pobreza multilingüe, exótico folklore
al turista que embriaga la conciencia
en pleno carnaval del Bourbon
y celebra el jazz temiéndolos descalzos tras los muros
esos que quebraron y dejaron entrar las aguas del Pontchartrain
empujando marejadas de rostros negros
a devolverse por las ventanas de aquellos
que creyeron enterrarlos bajo sus alfombras.

septiembre, 2005
Huracán Katrina

Tablero de Pensamientos

*...las palabras no retienen la realidad sino
después de haberla asesinado; dejan
escapar lo más importante que hay
en ellas: su presencia.*

**La plenitud de la vida,
Simone de Beauvoir**

Hacía tiempo deseaba besarla, lo que pensaba inalcanzable, quizá por ser mucho menor que ella, por su intelecto, por elusiva, o porque no había bendita manera de que los dejaran solos esa noche. Adonde fueran se topaban con conocidos que terminaban arrimándoseles como en comparsa. Después de un restaurante, dos bares y un corillo al que se le había sumado la Gitana, decidió llevársela de El Barrio. Le tomó la mano con disimulo, le hizo un guiño y sin aviso se marcharon. Antes de salir de *Carlitos Café* se volvieron a darle un último adiós al grupo que desconcertado los despedía.

Atravesaron en taxi Central Park hasta el lado oeste de Manhattan. Ella se dejó seducir por su presencia callada y confiada. Sebastián tenía algo que le inspiraba entrega; la esencia que escapaba de sus libros, su transparencia, su mirada incisiva, su cabello abismalmente negro. Había leído todos sus escritos, en todas sus ediciones, hasta las traducciones mediocres.

Con cuidado se arregló para él esa noche, llevaba un vestido negro de tirillas que dejaban al descubierto los hombros, ajustado a la cintura por un lazo amarrado en la espalda. Elena vivía un claustro voluntario. Había llegado a equiparar el cuerpo con el alma, conexión para ella ineludible. Nunca pensó esa noche llegar con él a la cama, por eso, aunque se acicaló meticulosamente sólo se afeitó hasta las rodillas. Al abrocharse el collar se percató de lo erógeno que era su cuello. Con una mano se subió el pelo en un moño exponiendo la nuca; con la otra, delineó su forma alargada fantaseando con los labios de Sebastián. La sacó de su ensimismamiento un soplo de brisa que llegaba desde la sala desprendiendo un pedazo de papel pegado a la pared. *Irradio belleza,* decía la nota. Sonrió.

Sebastián se preparó para jugárselas todas. Por fin sus agitados calendarios, distantes vidas habían coincidido esa noche de agosto. Había esperado pacientemente por ese reencuentro, tratado de volverla a ver sin suerte. Fue una burla de los dioses conocerla, haberla tenido cerca tantas veces para que desapareciera. Tenía claro que Elena le llevaba doce años, no le importaba, la atracción era indomable. No había conocido en otra una pasión tan desmedida y tierna, ni escuchado a nadie su tono de voz. Con Elena no había disimulos. Era fácil hablarle, era sabia, entendía.

Además, parecían tener la misma edad, o al menos eso creía ver ella, el tiempo detenido. A medida que los años pasaban su espíritu rejuvenecía. *Aquí el universo no se puso de acuerdo, rejuvenecemos por dentro mientras la materia se desmadra. ¡Qué mal chiste!* Sebastián podía ver a través de la mirada de Elena, precisamente eso, fuego.

Llegaron a un legendario club de jazz en la Octava Avenida. Colgaba en uno de los viejos muros de ladrillo una litografía gigante de John Coltrane. La banda tocaba *Blue Train,* su última pieza de la noche. Los sentaron en una mesa al fondo de un salón de piso de madera gastada. Pidieron más vino. Eran las dos de la mañana. Elena sentía la levedad del desvelo. Notó que al tomarle las manos Sebastián las examinó detenidamente. *Algo tiene que revelar mi edad,* interpretó ella. También Elena se miró las manos, suspiró alivio al ver que la media luz de la vela en la mesa disimulaba la resequedad. *Mi juventud es eterna, mi vitalidad infinita.*

Sebastián no entendía como los años no pasaban por ella. *Puede pasar fácil por una mujer en sus treinta.* Para él ella era un enigma, más que eso, un deseo. La había conocido en los círculos literarios de la ciudad, coincidido en varios eventos en los que habían sostenido largas conversaciones entre copas de vino en *Galería Mixta.* Allí la vio por primera vez con su inconfundible pañuelo tibetano enroscado al cuello.

Ya es tarde, ¿llamo un taxi? Elena accedió algo sorprendida, vivía en Brooklyn. Sebastián llevaba suficiente dinero, sabía que los trenes en la ciudad a esa hora eran impredecibles. En la oscuridad del asiento trasero se abrazaron. Él colocó la pierna de Elena en su regazo, le quitó la sandalia, le masajeó el pie. Relajada acomodó la cabeza en los hombros de Sebastián; siempre le había gustado como olía a manzana. A él le asombró la tersura del pie. Mientras lo besaba Elena se arrepentía de no haberse afeitado los muslos hasta la entrepierna. *Me declaro feliz.* No los detendría nada, ni el exceso de vellos.

Nadie había tocado su cuerpo desde su ruptura con Roberto. Mucho había ocurrido desde entonces, lo más trascendente, el viaje hacia sí misma propiciado por una soledad absoluta que la llevó a amarse incondicionalmente; dirigido, a su vez, por *El Secreto,* libro que le cambió la vida. Rhonda Byrne la había convencido del poder de creación mental, de la fuerza de visualización a través de la emoción, que la realidad era moldeable de acuerdo a su poder de conjuro. Tuvo que hacer un trabajo magnánimo para redirigir más de cuarenta años de autocrítica y desvaloración. Por cada pensamiento o sentimiento negativo escribía su opuesto, una reafirmación positiva en cualquier pedazo de papel que luego colocaba en la pared. Empezó poniéndolos en un tablero de corcho en la cocina, luego fue ocupando la pared tras la computadora, hasta que

después de un año no quedaba un centímetro de muro en el apartamento sin una declaración afirmativa.

Al necesitar más espacio ocupó el techo para escribir graffiti con un pequeño rolo sujetado a un largo tubo. Se acordó de que Neruda usaba tinta verde, ella perfeccionó el púrpura. Las paredes estaban empapeladas de anhelos, del techo parecía lloverle esperanza. Las tórtolas, atraídas por la saturación de papeles, comenzaron a entrar por una gran ventana que nunca cerraba para fabricar nidales en las esquinas. Siempre había considerado su hogar un santuario, pero nunca imaginó alcanzaría proporciones ecológicas. Lo interpretó como buena señal. Ahora su casa habitada por pájaros era una gigantesca radiografía, el reverso en palabras de sus más secretas dudas, temores, debilidades.

Soy una mujer poderosa, talentosa, triunfadora. Soy un ser de luz, la luz me habita, emano luz. Soy amada, deseada, admirada, respetada, remunerada, celebrada en todos los aspectos de mi vida. Vivo en abundancia. Soy agente de paz y cambio. Soy una amada hija del cosmos llena de una potencialidad y creatividad ilimitada. Soy competente, inteligente, fuerte. Vivo plenamente. Me declaro feliz. Vivo en total balance y paz interna. Gracias universo por mi excelente salud, trabajo seguro, prosperidad, dinero y tener a mi lado al amor de mi vida. Abrazo a mi alma gemela, al hombre que me ama profundamente y yo a él. Soy la expresión más pura del universo. Soy creadora, dadora de amor, poseedora de sabiduría, infinita alegría, la niña más feliz. Irradio belleza. Soy hermosa, mi cuerpo es un templo perfecto, listo a recibir a quien lo adore. El éxito es el fruto de mi trabajo. La paz habita mi casa, el triunfo mi presente. Mi juventud es eterna, mi vitalidad infinita...

Sebastián pagó rápidamente al chofer del taxi, le indicó se quedara con el cambio. Elena se sentía reina. Sí, tal y como merezco ser tratada. La besó una vez más en el ascensor, le sujetó el brazo mientras caminaban al apartamento. Elena había anhelado tanto sentir la tibieza de otro cuerpo cerca del suyo al despertar. Mientras abría la puerta, Sebastián le iba soltando con destreza el lazo que reposaba en la curvatura trasera de sus caderas, le acariciaba los hombros deslizando sus labios sobre ellos. Le encendió la piel, ya no la intimidaba que la viera desnuda. *Mi cuerpo es un templo perfecto, listo a recibir a quien lo adore.* Olvidó los músculos languidecidos donde se había con el tiempo asentado la celulitis. La intensidad con la que era deseada la hacía sentirse escultural.

Al abrir la puerta Elena se enfrentó a su verdadera desnudez plasmada en las paredes de la casa, al misterio de sus remiendos, de cómo estaban hechas sus costuras, a los códigos que revelaban las mujeres que la habitaban, sus luchas internas. Aún a oscuras podía leer claramente las palabras en los trozos de papel, en el techo. Entre espanto y disimulo notó que Sebastián no prestaba atención a nada que no fuera su nuca, su cintura, sus senos.

Quería despojarle la ropa, poseer con la boca cada milímetro de piel. Lo guió a la habitación, prendió una vela de jazmín en la mesa de noche y se olvidó de las frases que sobre la cabecera construían el rompecabezas de su mente. *Vivo en total balance y paz interna.* La entrega absoluta a los sentidos dictaba su existencia, todo lo demás podía esperar hasta el desayuno.

El despertar a la tibieza desnuda de cuerpos cercanos era un renacer a la plenitud del goce sensual; voltearse, besar la comisura de sus bocas, oler el sudor de la espalda, el perfume del pelo fue suficiente para encender la pasión en ambos. Todo empezó muy despacio, apenas unos *buenos días.* Paseaban sus dedos por curvas lisas, húmedas, hasta desbarrancarse por músculos tensos, cimas erectas. Él se guiaba por los gemidos de Elena quien abría con sutileza las piernas. Ella le dio la espalda de costado, sujetándole la cintura él hurgó hasta crear el puente indivisible que los uniría y desbocaría. Elena vivió a conciencia ese resucitar de mañana con la gratitud de vivirlo de nuevo. Sebastián corroboró la magia de un reencuentro que no podía concluir de otra manera. Satisfecha recostó la cabeza sobre el pecho de Sebastián. Abrió los ojos. Sintió palpitaciones aceleradas al ver sus pensamientos púrpuras en el techo, al escuchar el familiar revoloteo de papeles en las paredes agitados por la brisa que se colaba por la ventana.

Elena cubrió su cuerpo al levantarse de la cama, pero, ¿cómo vestiría la desnudez en sus paredes? No diría nada. Esperaría a que él saliera del baño y mencionara algo. Mientras se lavaba la cara mirándose al espejo Sebastián sonreía a su suerte, todo había trascendido expectativas. *Espero no se moleste cuando le diga que tengo una cita esta tarde. Me gusta muchísimo, ¿le habré gustado igual? Creo que quedó satisfecha. Me encantaría estar con ella de nuevo, pero ¿quién sabe?, quién sabe con ella...*

Hasta en el botiquín había pensamientos colgando. *Es escritor, puede que entienda que esto no es locura,* se tranquilizaba al preparar el café. Sebastián le besó la frente, *¿te ayudo? Sabes, no voy a poder quedarme mucho tiempo, tengo que volver a Manhattan, quedé en encontrarme con mi agente en El Village esta tarde.* Ella lo abrazó, *no hay problema,* le pidió se sentara, *el café está listo.* Comenzó a hablarle de su nueva novela, de lo importante que era para él. Elena, sin entender, se sentía protagonista de la fábula del rey desnudo al que todos alababan sus ropajes. *¿No ha leído nada, ni uno de los miles de pensamientos en las paredes de mi casa? Imposible.* La cartografía de su alma estaba deletreada bajo las narices de Sebastián. *¿Por qué no me dice algo?* Elena le hablaba como si nada ocurriera. Si algo le habían concedido sus años era paciencia, la certeza de que la verdad siempre saldría a flote.

Se sentó con él, tomaron varias tazas de café acompañadas de pan francés y queso. Hablaron tranquilos sobre sus familias, sus pasadas parejas, se dijeron cosas que sólo íntimos amigos compartían. *Te ves muy bien, Elena.*

¿Te preocupa que te miren igual? Ella sonríe con picardía. *¿Tú lo dices por la edad?* Lo mira fijo a los ojos. *Los hombres siempre me han mirado de la misma manera, con lujuria. La diferencia es que ahora me importan sus miradas, procuro disfrutarlas, estar más conciente de ellas.* Sebastián le contó como había visto a una mujer en la piscina de la YMCA, que según sus cálculos tenía como 70 años. *La mujer no le quitaba los ojos de encima al salvavidas, lo seguía con la vista, con esa chispa en la mirada, sin perderle un paso. Se veía que había una mujer muy viva, llena de deseos, atrapada en ese cuerpo.* Elena lo escuchó atenta, volvió a sonreír. Esta vez no dijo nada.

Sebastián echó una última mirada al apartamento, respiró hondo, se levantó. *Sólo en una casa donde se respira tanta paz podrían anidar los pájaros,* dijo, *me encantaría quedarme pero me tengo que ir.* Se abrazaron, le volvió a besar la frente. *Me encantas,* susurró antes de besarla en los labios y salir. Elena quedó desconcertada, no por saber que no lo volvería a ver, sino por no haber hecho ni un comentario sobre sus paredes pobladas de palabras, por no haberle dado importancia a sus más íntimos secretos, por ignorar la deconstrucción desplegada ante él de sus abismos.

Sebastián caminaba al tren sintiendo una paz que hacía tiempo anhelaba, saciado, feliz de por fin haber pasado una noche y mañana con esta mujer sorprendente quien aún parecía inalcanzable. Lo envolvía a su vez cierta nostalgia. Sus sospechas de que Elena no se dejaría ver de nuevo las daba por hecho, sin entender por qué. Creyó se había preparado para ello, pero la realidad era otra. *Nos podemos preparar para el adiós pero nunca para la ausencia,* concluyó. Iba pensativo, cuestionándose otras cosas que iban más allá de su cognición, como por qué el techo del apartamento de una persona tan centrada como Elena estaba cubierto de garabatos violetas y sus paredes forradas con pedazos de papeles en blanco.

YARISA COLÓN TORRES

Yarisa Colón Torres nace el primero de marzo de 1977 en Puerto Rico. A los catorce años se muda a Nueva York. En el 2000, participa en un proyecto literario/artístico ideado por la pintora Tanya Torres y publica con Ediciones Mixta su primer libro de poesía, *Desvestida* (2001). Luego publica, también con Ediciones Mixta, *Pipas/Bellies,* la segunda colaboración literaria/artística con Tanya Torres (2002). Algunos de sus poemarios hechos a mano son: *Caja de voces* (junto a Waleska Rivera, 2007), *¿Entrelínea o secuestro?* (2007) y *Enredadera y colmillo* (2010). Su obra más reciente se titula *Sin cabeza* (2010) y fue publicada por Atarraya Cartonera. Colón Torres forma parte del proyecto "Puerto Rican Writers: History and Context", el cual ofrece un espacio en el archivo del Centro de Estudios Puertorriqueños, Hunter College, CUNY para preservar y compartir sus documentos. Su trabajo se ha presentado en Estados Unidos, Puerto Rico y Francia.

Colón Torres obtuvo un Bachillerato en psicología y estudios afroamericanos y puertorriqueños de Hunter College, CUNY y una Maestría en literatura puertorriqueña del programa graduado del Centro de Estudios Avanzados de Puerto Rico y el Caribe, en Puerto Rico.

Yarisa Colón Torres was born on March 1st, 1977, in Puerto Rico. At the age of fourteen she moved to New York City. In the year 2000 she participated in a literary/artistic project envisioned by painter Tanya Torres, and published her first poetry book with Mixta Editions, *Desvestida* (2001). She then published with Mixta Editions *Pipas/Bellies,* a second literary/artistic collaboration with Torres (2002). *Caja de voces* (in collaboration with Waleska Rivera, 2007), *¿Entrelínea o secuestro?* (2007) and *Enredadera y colmillo* (2010) are some of the handmade books made by the author. Her latest poetry book, *Sin cabeza* (2010) was published by Atarraya Cartonera. Recently, Colón Torres was granted an archival space at the Center for Puerto Rican Studies, Hunter College, CUNY, as part of the "Puerto Rican Writers: History and Context," which aims to preserve her documents and share them with others. Her work has been presented in the United States, Puerto Rico and France.

Colón Torres obtained a Bachelor's Degree in Psychology and Black & Puerto Rican Studies at Hunter College, CUNY; and a Master's Degree in Puerto Rican Literature at the Center for Advanced Studies in Puerto Rico.

INVOCACIÓN

San Miguel
tú que salpicas saliva
con esa larga espada mojada
siembra soles santiguados
en nuestra cebolla
y empapa como dulces vulvas
este valle de lágrimas disecadas
para que nuestro barro pueda bailar
acalorado con tu lengua sonriente
todo esto te lo pedimos
hasta con el dolor sin piernas
que cargamos cual cruz cundida de insectos
porque tuya es la puya metálica
tuyo es el surco que une el bien y el mal
y nuestra es la mirada
al revés

Esto no tiene nombre

"We are Mr. Nobody from Nowhere."
Julio Henna, 1900

Puede ser un hoyo
un cadáver a punto de derramarse frente a tu puerta

puede ser el último respiro del prócer alquilado
puede ser el museo raquítico como estaca frente a la Perla

puede ser la mirada esquizofrénica del libro menos comprado
o la cátedra más barata desde el podio perfumado
o la pereza del ser burocrático
o la farsa mejor traficada del Caribe

pueden ser puentes o trenes atascados en el embudo
veinte mil latas de cerveza disparadas por la independencia
50 jeringuillas bíblicas
dos tetas archivadas en la Torre Municipal
y la posibilidad de ser violada por tu tío
el más católico de la familia

puede ser en inglés o español
en spanglish o en americanport
no importa
lo que es
cae lentamente
y muerde nuestros pies por las noches
y se desvive por inmovilizarnos
y se mece frenéticamente en el sillón mental
engordando el mito de la isla del espanto

Declaration-in-progress

"La panfletaria es una enfermedad difícil de erradicar"
La Papisa

Me declaro despojada de cualquier Patria
colonizadora y colonizada
me divorcio del threesome mitológico
(nuestra mezcla taína, africana y española perfectamente falsa)

me declaro terrícola herbi/carnívora
animal bípedo y reflexivo
alérgica a cultos encapuchados y fundamentalistas
a la cultura blanqueada y enlatada
a líderes que no saben posar ante las cámaras
a colectivos que le atragantan piedras al prójimo

me declaro esqueleto sensible y vivo
cubierto de carne y pelos
sostenido por huesos nómadas
adicta a la muerte que sólo reverdece en la tierra

devuelvo las banderas y los discursitos nacionales
entrego mi membresía al club de los poetas
más famosos de la librería tal
acepto las ganas de implosionar la hipocresía

me declaro menstruativa fantasiosa y capaz
hermana de curiosos mamíferos cambiantes
llena de gracia y violencia
contradictoria
orgásmica
migratoria
mortal

EMBUSTE

Este pueblo de dios boquiabierto
es un látigo aburridísimo
peñón para lo subterráneo
es la barba condenada
la baba divina

aquí tengo momentos de intenso picor y vergüenza
 cuando me atrapa la lengua besucona

aquí caducan hasta mis mapas

por eso izo como bandera todopoderosa
el pellejo de un ayer caribonito
 sudado en la calle 107

allí escondo el reflejo de nuestros pies
 las conversaciones colgadas en la Galería Mixta
 la brujita de un circo colombiano
 los pisos movedizos de la Casa Kushka
 y mis dedos secuestrados casi falsos

cualquiera reconocería mi desorden
si retrocediera la página
y como una llamada telefónica equivocada
diría transparentemente
ESA NO ES ELLA

no importa
asumo el regreso
aún sabiendo que los regresos no existen

El bicho raro*

Seducido por la imagen
 el bichiélago queda atrapado
 en la espesura del boceto

distraído por el grito que se chorrea entre sus patas
clava caderas hinchadas pelo a pelo
hasta mamar el encuentro o domar las ansias

una vez adentro
pervive para pervertir el orden de la araña fértil
 dirige la mutación del mosquito
 le espeta frágiles antenas al venado
 y se regodea detrás de nalgas fatigadas

(el desprecio es tan íntimo que todos se distraen y se aparean)

estéril y carnívoro
arrastra su pesado pico hacia el cansancio
gime su insatisfacción
sacude las ficciones que cuelgan de su cuerno

no quiere volver a excederse
ni ensayar orgías transformadoras

pero sigue allí vacío y ensimismado
 buscándose
 en otras bestias

*Poema inspirado en las obras de Justo Carreras, artista dominicano que vive en Bioisland

LYDIA CORTÉS

Lydia Cortés, una Boricua de Brooklyn, vivió también en Roma. Es poeta, narradora y dramaturga. Ha publicado los poemarios *Lust for Lust* (2002) y *Whose Place* (2009). Su obra se ha publicado en las antologías: *Through the Kitchen Window* (2005), *Teaching With Fire* (2003) y *In Praise of Teachers* (2003). Su obra de teatro, *New Haven,* se incluye en la antología *Monologues from the Road* (1999). También ha sido publicada en las revistas del *The Sunday New York News* y en *Urban Latino.* Varios poemas suyos se incluyen en la antología *Puerto Rican Poetry: A Selection from Aboriginal to Contemporary Times* (2007). Ha sido premiada con un MacDowell Fellowship, un NEA Fellowship para The Virginia Center for the Creative Arts y una residencia en la Fundación Valparaíso en España.

Lydia Cortés, originally a Puerto Rican Brooklynite, also lived in Rome. She is a poet, fiction writer and playwright. Cortés has published two collections of poetry: *Lust for Lust* (2002) and *Whose Place* (2009). She has been published in the anthologies: *Through the Kitchen Window* (2005), *Teaching with Fire* (2003); and *In Praise of Teachers* (2003). Her play, *New Haven*, is included in the anthology *Monologues from the Road* (1999). Her work was also published in *The Sunday New York News* and *Urban Latino* magazines. Her poems appear in the anthology *Puerto Rican Poetry: A Selection from Aboriginal to Contemporary Times* (2007). She was awarded a MacDowell Fellowship, a NEA Fellowship for The Virginia Center for the Creative Arts, a residency in Spain at Fundación Valparaíso and included in a Jerome Foundation grant.

Black Was Pedro's

Black was Pedro's color. He wore a black leather cap and motorcycle jacket. Pedro never owned a motorcycle though. He said he was part of a special club of motorcyclists. Motorcyclists without motorcycles. It was a member's only club but only he got to pick the members. Pedro's pants and beat-up shoes were black. So were his socks, when he wore them. The black started after Vietnam. He did it to mourn his time in Nam. He did it to mourn his mother. She died soon after his return.

Pedro's hair was black and curly. It reached his shoulders and a scraggly moustache and wispy beard covered most of the rest of his face. He wore a black skull cap pulled down to his eyebrows. Pedro was dark. A black Puerto Rican – really more a medium brown. Pedro wasn't at all tall or massive but with all that black he did scare a lot people. He slunk around quiet, his head buried into his shoulders which didn't help.

When he started writing poetry, some thought Pedro had gone loco in the coco.

Then Pedro started bearing a cross. He made the crucifix with two planks of wood nailed together. Held up straight, the crucifix was two feet taller than Pedro.

He painted his cross black, then worked on it more. He got hundreds of condoms – in all colors – and boxes of thumbtacks. He took the condoms out of their foil packages and nailed each condom ring to the cross with a thumbtack. Pedro tacked up three rows of condoms up and down the vertical plank, three across the horizontal one. The tacks looked like bulls' eyes inside the rings. The condom rows stood out in rainbow contrast to the black crucifix.

He went all over town with his cross slung over his left shoulder. He took it on the subway, uptown to both El Barrio and black Harlem, downtown to Loisaida, even to Brooklyn and Queens. Pedro got himself mail order-ordained, became El Reverendo or Reverend Pedro. Soon a lot of people were calling him Reverend Pedro – and not only friends and relatives.

He'd always had the power of seduction. Many women – and men – fell for him easily.

Pedro began carrying around a beat up black briefcase. He made letters on both sides with white tape. One side said, "Reverend Pedro," the other "A Buck for a Safe Fuck." Inside the case he put dozens of tiny manila envelopes – nickel bags – used for selling small amounts of pot. But on his envelopes he typed his own short poems. One said:

Woke up this morning, called my Equal Opportunity Employer.

"Sir, I will not be coming to work today."

"Why, are you ill?"

"No, sir, I am feeling great. If I am sick tomorrow, I will report early."

Inside each poem envelope he put a wrapped condom. He peddled the nickel bags – the poem condoms out on the street, in subways.

"Hey, people, check out my poems. Buy yourself a poem. If you don't like the poem, fuck it. At least, you'll get a safe fuck."

He used an old coffee can painted black to collect donations. He'd white-taped the can with the words,

"Help Me, I Can See."

Though Pedro scared people at first, most ended up laughing. Maybe even thinking. But when people came across him alone in a dark place – or broad daylight – some turned and ran. He was weird-looking even for New York City. Still, Pedro had a laugh that caught you up in it. It exploded, deep-bellied, from a mouth opened wide to reveal the big gap between his front teeth and beyond. When he recognized people, he erupted into cascades of guffaws followed immediately by, "Hey, man, what's happening? ¿Qué pasa?" And if they said, "Chévere" or "Good", he'd shout back, "Far out" or "Out of sight."

One day Pedro almost got killed on the F train. He was on his way to Coney Island, to a place called Side Shows by the Seashore. The ancient, falling apart theatre on the boardwalk had been reopened by a young artist who featured a variety of acts. Mostly freaky-looking people who he'd gotten to agree to be looked at for a little money. A man whose face was completely tattooed (even his closed lids had eyeballs tattooed on them) drove four-inch nails into his nose, cheeks and tongue. A three-foot tall woman dressed like a mermaid hopped around on her tail and saying, "Hello, hello," while blowing bubbles. Another woman, normal in height but obese, roamed around with breasts covered only with a writhing python which she encouraged people to touch. Rounding out the "acts" was a hairy man who jumped about in a cage labeled Ape Man. And that day there would be Pedro. He was to read and, he hoped, sell his Buck for Safe Fuck poems. But when the F got to Bergen St. station, three teenage boys got on. They wore baggy jeans almost falling off their asses, huge Nike t-shirts and do rags or caps, some with visors turned to the back. As soon as they spotted Pedro, or rather caught sight of the condom crucifix they swaggered over to him shoulder-to-shoulder in close formation, hands

already balled into fists.

"Yo', man, I'm Catolik," said the boy closest to Pedro, "an' you makin' fun of my religion, cabrón."

"Yeah, man," said the one in the middle. "Yo', you think Christ dyin' is funny? You don't never mess with Jesus. Fuck that shit, bro." The boy made the sign of the cross, kissed his fingers, then balled his hand up again fast. "You lookin' to get *more* messed-up lookin' than you already are, huh, punk?"

"Word," said the third kid. "Man, you sure is some weird lookin' maricón."

Pedro's face drained, lost its rich brown. He talked fast.

"Hey, man, me? I wouldn't never mess with Jesu' Cristo. He's my main hombre too. He's far out. Out of sight. I'm jus' trying to tell it like it is…that, yeah, yeah, man, he *did* suffer for *us* to live…suffered so goddamn much… man, he died with those nails pounded deep inside him till he cashed in… it's jus' we can't none of us take this life so easy…not no more man…we gotta take care of ourselves, us Boricuas especially, verdad?"

Two of the boys heard *Boricuas* and relaxed a bit, let their arms drop at the sides… started listening.

Then the third said, "I ain't no Boricua, bro', I'm from the D.R."

Pedro kept talking. "Same thing, Boricuas, Dominicans, even some of them Cubanos is like us…you know with la cosa de Aids, *El Sida*? We losin' too many brothers, a lot of sisters. You jus' gotta always remember to wear your rubbers if you wanna go play out in the rain, no?"

He opened the briefcase. Dozens of little envelopes fell over the subway floor.

"Free condoms, folks. Get them *an'* a poem for free. Free condoms for a safe fuck. A safe fuck for all. Have a safe fuck an' have a nice day."

He let out the laugh, his laugh, and a few seconds later the boys like many others in the car – of all ages – stopped looking scared and scrambled to pick up the free condoms.

I HATED LYDIA AS A KID

Lydia's not a cute name.
Looked it up – Lydia means *ancient country in
the northwest part of present day Turkey on the Aegean sea.*
Who could be popular with a name like Lydia?
At home, they called me Lidín…what the hell was a Lidín?

I liked American names like Susie, Susan, Sue, Patty, Peggy,
Peggy Sue, Jane, Mary, Mary Jane, Annie, or Connie…
Not even in my dreams could I ever be blond or blue-eyed –
not as a Lydia – though even my cousin Milagros
pulled at least one miracle turning herself into a Millie.

Then suddenly, one day my lovable sister, Sonia became Sunny
as if her disposition wasn't already enough appeal for the boys.
I was considered aloof. I was easily frightened. So shy.
I couldn't even shorten Lydia to sound friendlier, better.
More down to earth. What kind of nickname would Lid be?
That's worse than Lydia.

In other languages, like Spanish or Russian,
Lydia sounds glamorous, pronounced Lee-dee-ah.
But in American English the d is pronounced like the t's in butter.
How unrefined. Some say Lydia is sophisticated.
Guess they never heard Groucho
Marx sing *Lydia, oh, Lydia, oh, Lydia, oh, Lydia, oh Lydia the tattooed lady.*
If you want classy, isn't something like Dalia more elegant, lighter than Lydia?

MASCARA

You look in the mirror
at least fifteen minutes each morning
admit it, to put on your face.
You line your eyes heavily
after trying to erase the dark circles under them.
They don't go away, they've been there since you were thirteen.
They came with the territory like a curse, the moment you began
to bleed, allowed to become a full-fledged make-up wearing Señorita.
You fill in your mouth with red after defining your eyes with black
keeping all contours, natural, within boundaries
never clownishly exaggerated, hoping when all colored in
you'll only appear luscious and alluring.
You brush on some blush under your cheekbones for drama
look down into a smaller mirror carefully coating
your eyelashes twice for good luck with black mascara to
make them the longest, the thickest, like in the commercials.
All this trying can get trying but obviously you think you're worth it.

Máscara in Spanish means mask
and más cara means more expensive.
Más cara also means more face.

You do end up with una cara de máscara más cara
una cara más, una máscara, una mascarota, una mascarita
una mascaratica, una mascaraina, una mascaranina
una mascaratita, una mascaralona, una mascaralota, una mascaralonta.

Una masquerada
You always said more was better
was more
was more better.

CRUSH

My crush was leader of the gang
gorgeous garrison-buckled and belted,
his jet leather hair motorcycle black like his jacket,
pompadoured, just the right amount of peak falling perfectly
into an arc into the middle of his fair forehead.... José Benítez

I snuck him looks all the time – whenever, wherever I saw him – in the street
in the hallways of the apartment building where we both lived –
not that he knew it – never let him catch me looking,
not that he ever really saw me... José Benítez

I was a little kid -- una niña muy grande – pero not even thirteen.
He was sixteen; the girls he liked were tight-jeaned
American, blond, his age or older, the girls he liked
had gotten their periods, and titties
the girls he liked made out, let themselves be touched, felt up,
whatever, whenever he wanted, wherever they could
under hot staircases, in alleys, even in school yards
out in the open they made it with... José Benítez

When we finally met face to face, eye to eye, head on me and… José Benítez
he'd just had his toe sewn back together after accidentally
dropping a knife on it, that's all he was saying about
the wound when we finally met face to face we
went toe to toe me and… José Benítez
but I didn't mean to – it was a clumsy mistake – the fault of
the older girls – José's girls – who thought my crush cute,
knowing how much I loved him and suffered in silence,
laughing and hissing they forced me on him ready or not
down the block they pulled, dragged and shoved me toward… José Benítez
screaming they said it was time I got over my silly little girlie shyness,
meet him face to face, said I should let him know how I felt or
they would, let him know that I was available – maybe?

They pushed me right into him and when we finally met
face to face, starry eye to eye, head on, me and… José Benítez
and with my dainty size 91/2 Buster Browns I severed
the thread dissolving the stitches that were keeping him together…

FUCK YOU!!!!!!!!!!!!! yelled... José Benítez
I was cursed…by… José Benítez

My first crush was my first love's toe
swaddled in layers of gauze, the toe
I so savagely shattered as he stood dark
sexy, unsuspecting of the coming assault, dungareed
long legs straddled loosely over his slim English bike

Oh, José Benítez, Oh José Benítez, Oh José Benítez
Oh, Oh, Oh, I crushed my first crush's toe and
I – ay, ay, ay, ay Dios mío, ay, ay, ay, oh, oh, oh –
I don't know whose pain was worse,
who was more crushed, me or... José Benítez

All I know my loss was complete,
nothing could be done to save face
while his foot could still be stitched up
to survive my crush.

I Remember

I remember kindergarten
I remember having to say good-bye to Mami
I remember crying
I remember not understanding the teacher
English lessons with pretty Miss Powell
who made the boxy words fit just right in my mouth
without pain
I remember the teachers who said, "*You don't look Puerto Rican*"
expecting to me to say thank you very much
I remember overhearing some say *Puerto Ricans*
don't care about their children, Puerto Ricans
 aren't clean
I remember the heat of shame rising up
changing the color of my face
I remember praying no one heard what the teachers said,
no one saw my hurt red as a broken heart
I remember Mr. Seidman in the 4th grade and
how he chose
me for a big part in the school play
I remember feeling important
memorizing all those lines and
Mami helping me
I remember both Mr. Seidman and Mami
smiling, proud
the night of the performance. Looking at me!
I remember making the audience laugh and the
applause
I remember the family moving
to Flatbush from Fort Greene
going from a 5th floor tenement walk-up to
our very own house, the quiet tree-lined street

I thought we had moved to the country
I remember going from Girls High to Erasmus Hall
how I went from smart to borderline in one day
I remember the bio teacher, Miss Nash, calling me stupid
because I didn't know how to use a microscope
I remember Mr. and Mrs. Hamburger – hamburger?
how I laughed at the name, when I heard I was getting
one for political science and the other for economics
I remember being amazed when they made
learning a wonder-filled adventure
by the faith each had in me
I worked hard for them both
I remember the A's I got in their classes
I remember being Puerto Rican in Erasmus Hall High School
Because I was the only one – until my sister followed –
on the academic track
I remember the guidance counselor advising me to be
a bilingual secretary since I certainly was
not college material
I remember Papi, with his third grade education, saying,
"Lidín, tú puedes hacer lo que quieras. Yo te
apoyo en todo. Siempre."

MARITHELMA COSTA

Marithelma Costa nace en San Juan de Puerto Rico en 1955 y vive desde 1978 en Nueva York. Es autora de los poemarios *De Al'vión* (1987), *De tierra y de agua* (1988) y *Diario oiraiD* (1997); y de la novela *Era el fin del mundo* (1999). También ha publicado los libros de entrevistas: *Enrique Laguerre: una conversación* (2000), *Kaligrafiando. Conversaciones con Clemente Soto Vélez* (1990) y *Las dos caras de la escritura.Conversaciones con M. Benedetti, M. Corti, U. Eco, et al.* (1988); una edición crítica de la obra de un poeta del siglo XV: *Antón de Montoro. Poesía completa* (1990) y el estudio *Bufón de palacio y comerciante de ciudad. La obra del poeta cordobés Antón de Montoro* (2001); y la primera edición anotada de *La llamarada* de Enrique Laguerre (2002). Ha participado en numerosos encuentros internacionales de poesía y publicado en múltiples revistas literarias. Desde el 1988 enseña literatura en Hunter College y el Graduate Center de la City University of New York.

Marithelma Costa was born in Puerto Rico in 1955, and has been living in New York since 1978. She is the author of three poetry collections: *De Al'vión* (1987), *De tierra y de agua* (1988) and *Diario oiraiD* (1997), and the novel *Era el fin del mundo* (1999). She has also published three books of interviews: *Enrique Laguerre: una conversación* (2000), *Kaligrafiando. Conversaciones con Clemente Soto Vélez* (1990), *Las dos caras de la escritura. Conversaciones con M. Benedetti, M. Corti, U. Eco, et al.* (1988); two books on a fifteenth-century poet: *Antón de Montoro. Poesía completa* (1990) and *Bufón de palacio y comerciante de ciudad. La obra del poeta cordobés Antón de Montoro* (2001); and the first annotated edition of Enrique Laguerre's *La llamarada* (2002). She has participated in several international poetry festivals and her works have appeared in many literary magazines. In 1988 she became professor of Spanish literature at Hunter College and the Graduate Center of the City University of New York.

INITIAL CONVERSION

You answered like an Arab
white man of cold and humid lands
you were speaking like a creature of the plains

Blue eyes that spoke of systems
You were one with the invading tribes
Blue masked person
Made beautiful by sword and horses
made dirtier by sands and shawls

You repeated your ablutions one by one
syllable by syllable you invoked the warrior god
You engraved red initials on red surfaces
It was then I saw the Koran
and the stars

Translated by Andy Brumer.

VIAJES ORGANIZADOS (fragmentos)

1.
No es sólo la tristeza
de que los agarren
les amarren las manos la boca
los pongan en una barcaza
y les quiebren el horizonte caribe

Es
sobre todo es
ser la isla
ese pedazo de arena y arcilla a la cual se acercan hoy
mil doscientos marinos
dos mil cuatrocientos pares de botas
dos mil cuatrocientos ojos que no ven
que no ven
que no ven y acatan órdenes

Es el estar de nuevo
rodeada de tres barcas
y permítaseme el tópico
tres naves
un destructor y dos buques de guerra

Tres goletas
tres fragatas
tres caravelas
tres edificios de metal y madera
que surgen de las aguas y sobre las aguas flotan

Cómo explicar lo pesado sobre lo liviano
cómo la piedra sobre el agua
lo sólido sobre lo líquido
Cómo un monte sobre el mar

3.
Quizás ésa es la definición de este conflicto
showdown
batalla
encuentro
lo liviano contra lo pesado
la arcilla guayama
contra el acero el plomo el mercurio el níquel el cobalto
ese azul tan efímero
el uranio contra la piel más efímera
mercurio en los cabellos
ronchas en la piel
metal en los caribes que siguen en los montes

porque son los montes
de Ayayí
en las cuevas de Ayayí
livianos como el viento
sutiles como las plumas del cuervo

6.
También puede hablarse de David y Goliat
y retomo el viejo tópico
David contra Goliat
pero hay un arma nueva
y vieja
ya lo sabemos
David con el símbolo del itrio
el del polvo brillante y negruzco
David con la ye, con la y griega
del KaYak de Tito
la honda que sirve para lanzar el dardo la piedra
mantener la canoa a flote
y también sirve
varita mágica invertida
para encontrar la fuente primigenia
el punto donde se funden las aguas del globo

8.
Entre campanada y campanada, la sirena
entre campanada y campanada
mil doscientos hombres con armas largas
con gases lacrimógenos
con chalecos antibalas
con cascos antidisturbios
con radios con antenas
marine
fuego en el agua
metal en el mar
tres naves
tres barcas
tres buques
danza inconclusa alrededor de un punto único

EL METRO

Angel Rodríguez se consideraba un hombre común y corriente. Trabajaba de lunes a sábado en una tienda de la calle Broadway vendiéndole zapatos deportivos a todo aquél dispuesto a pagar un ojo de la cara con tal de lucir bien ante los panas de Brooklyn. En la tienda recibía un sueldo minúsculo y, como la mayoría de los inmigrantes, lo administraba con tal cautela que le alcanzaba para alquilarle una habitación limpia y soleada en Washington Heights a una prima mía, comer tres veces al día, vestir de una manera decorosa y mandarle un dinerito a la familia a principios de mes. No le pedía mucho a la vida: serenidad, estabilidad y unos cuantos amigos para beberse unas cervezas frías y jugar al fútbol.

Aunque había llegado a Nueva York de lo más alto de la Sierra Madre guatemalteca, nunca había sentido, como sus paisanos, el cuchillo de la nostalgia, el dolor del que se va lejos. De niño, su abuela maya le había enseñado a aceptar lo que no se puede cambiar y a evitar aquello que lo apartara de su camino. Y a pesar de que no sabía exactamente hacia qué punto cardinal se hallaba el suyo, vivía con una alegría natural en una especie de equilibrio pleno.

Sólo había sentido terror el día en que casi lo agarra la migra.

Según me contó cuando ya residía en el edificio donde trabajo de super, el incidente no le había hecho cambiar de costumbres, pero sí hacerse muchísimo más cauto. Un domingo de verano, había salido a desayunar en La Favorita, la pastelería del alto Manhattan conocida por sus tamalitos de maíz dulce. Mientras se acercaba distraído a la esquina donde sus paisanos suelen tertuliar a la espera de que alguien les ofrezca trabajo sin exigirle papeles, distinguió en medio del grupo a un primo que, cada vez que lo veía, le echaba en cara el que aún no hubiera tramitado el *green card* para traer a la familia. Como no soportaba aquellos bienintencionados sermones, desistió del desayuno, cruzó la avenida y se montó en el autobús que estaba parado en la esquina. Aquella reacción tomada casi por instinto, no sólo le permitió escaparse de las recriminaciones del pariente, sino de los diez oficiales de inmigración que salieron de unos Cadillacs negros y, tras repartir porrazos a diestra y siniestra, se llevaron a aquellos aprovechados que venían a arrebatarles el pan a los respetables ciudadanos del país. Cuando su autobús arrancó, Angel vio con alivio cómo el primo se escabullía detrás del quiosco de periódicos, con lo que los diez eficientes policías sólo pudieron deportar a una docena de desgraciados, después de que pasaran las de Caín durante varios meses en los calabozos de Brooklyn.

A partir de aquel incidente tuvo mucho más cuidado cuando practicaba sus pasatiempos favoritos: pasear por Manhattan anotando mentalmente

las minucias del día y coger los trenes a las horas punta para observar a los viajeros. Una mañana, mientras se fijaba en el estrambótico atuendo de una cincuentona que se estaba limando las uñas, Angel descubrió la permeabilidad de los trenes. En realidad, el proceso se había iniciado con varias semanas de antelación. Pero aquel 14 de agosto se completó el círculo y comenzó a darse cuenta que cuando una serie específica de factores se combina en un subte del globo, el viajero puede verse transportado no a la estación donde se propone hacer el cambio, ni a la parada de su destino, sino a la red subterránea de trenes de una ciudad gemela.

La primera vez hubo una fase preliminar—que nadie hubiera podido interpretar como un aviso—a la que seguiría la transposición, término que acuñó para describir el fenómeno. Una semana antes del suceso, mientras iba a la cena de despedida de un compañero senegalés que se marchaba a Chicago, se montó en el vagón un músico ciego que, a pesar de su desventura, se movía sin grandes dificultades entre los viajeros del tren expreso. Cualquiera hubiera pensado que se trataba de un pordiosero más: barba de tres días, pelo canoso y ropa adquirida en algún centro de asistencia religiosa. Pues el aparente ciego, que debido a su condición de emisario del departamento francófono de la red ferroviaria, despedía un olorcito inconfundible, apoyó la espalda en uno de los tubos de acero del vagón y se puso a tocar en su acordeón La Marsellesa. A primera vista parecía una elección totalmente fortuita. Daba la sensación de que en lugar del patriótico himno, hubiera podido haber escogido Guantanamera, una danza húngara o la Cumparsita. Aunque la selección no resultaba original ni la ejecución brillaba por su virtuosismo, el músico agarraba su instrumento con tanta languidez y ponía tal cara de desamparo, que logró arrancarles a los viajeros varios billetes.

El ciego recogió el dinero en un pequeño monedero de cuero—y no en los clásicos vasitos azules de *coffee shop* griego que usaban sus colegas—, agarró su bastón y se encaminó hacia el próximo carro a cosechar su almuerzo. Justo cuando se disponía a entrar en la pequeña plataforma que comunicaba los dos vagones, el tren se detuvo, se abrieron las compuertas y saltó a los pies de una nodriza mulata que cuidaba a un niñito rubio y angelical, el tapón de una botella de champaña que acababa de escapársele en el andén a una joven vietnamita. Extraña coincidencia, pensó Angel. Nunca había visto a nadie beber champán en los trenes. Sin embargo, como se había acostumbrado a aceptar las excentricidades de los neoyorquinos sin hacerse demasiadas preguntas, tomó el aviso como un hecho cotidiano y se puso a leer los resultados de los partidos de fútbol.

Siete días más tarde sucedió exactamente lo mismo, pero en orden inverso. Era domingo y debía llegar temprano a la zapatería para poner punto final al inventario de calzado deportivo que debido a unos pedidos extraordinarios llegados de Panamá, todavía no había terminado. Angel

se hallaba en su estación, una de las últimas de la línea A, y esperaba que el tren partiera. Había decidido matar el tiempo haciendo un crucigrama, cuando saltó a sus pies el tapón de otra botella de champán que acababa de abrir un joven con la cara tatuada, para acompañar el sandwich de huevo que llevaba en una bolsita. Cuando recibió el golpe, miró a su agresor y éste lo saludó levantando la botella. El súbito cierre de las puertas le impidió comprender las palabras que el exótico bebedor intentó decirle, y a Angel sólo le quedó inspeccionar el corcho. Se trataba de una Tattinger del 89 que, de seguro, estaba deliciosa.

En la primera parada entró el ciego de la semana anterior, se detuvo frente él y comenzó su revolucionario himno. La misma señora que hacía una semana se limaba las uñas—y aquella mañana llevaba un kimono de lo más vistoso—le sonrió levemente y tras la tercera o cuarta nota, había acaecido el portento. Angel no se hallaba en un *subway* neoyorquino ni iba rumbo a su trabajo rodeado de padres que le dedicaban el día a los nenes y de viejecitas sureñas que leían la Biblia, sino que se encontraba en pleno metro París y estaba recorriendo a toda velocidad los túneles del casco urbano. Arriba nanas sumamente educadas y gente que paseaba con sus perritos. Más allá una catedral luminosa y un río que se movía tranquilo. Frente a él unos pasajeros silenciosos que iban ese domingo de verano a jugar a la petanca y visitar a los sobrinos.

Angel pensó que estaba soñando. Mucha cerveza la noche anterior; quizás también se había pasado con los vasitos de tequila. Se quedó sentado grabando en su mente cada uno de los detalles del nuevo vagón. Acero reluciente, sillas azules y acojinadas, puertas flanqueadas por transportines. Al fijarse en las últimas, no hubo lugar a dudas. En vez de abrirse sumisas y al unísono cada vez que el tren se detenía en las paradas, cada una tenía una ascéptica palanquita metálica que el viajero abría con un minúsculo golpe de muñeca.

Y las estaciones; ¡ay!, las estaciones. Inmensas, impecables, redondas. Con una publicidad sobria y circunspecta, como sobrios y circunspectos eran los viajeros. Los carteles, todos de buen gusto, anunciaban los libros que acababan de salir al mercado, hablaban de los saldos de la *reentrée* otoñal, de productos infalibles para acabar con las pulgas.

Tras estudiarse durante horas su ubicación en el globo terráqueo, Angel intentó escudriñar las caras aburridas de sus compañeros de viaje. Ya había pasado mediodía y la población callada y mañanera había sido sustituida por una más heterogénea: jóvenes estudiantes que discutían los temas que saldrían en los exámenes, parejas de enamorados que aprovechaban cada segundo que podían estar juntos, turistas de todos los puntos del orbe consultando frenéticos sus mapas y efebos que parecían escapados de cuadros renacentistas. Buscaba desesperado a algún viajero como él, a

alguien que estuviera experimentando la permeabilidad de los trenes.

Estaba a punto de descubrir un deje de sorpresa semejante al suyo en una africana vestida con una túnica verde, cuando se abrieron las puertas centrales del vagón y entraron dos gendarmes. El aire se crispó de golpe. La mujer bajó los ojos. De seguro iban a la caza de algún magrebí desdichado o una filipina sin papeles. Como había desarrollado un sexto sentido para percibir el acre olor de las fuerzas del orden, le dejó su asiento a una ancianita cuyo exquisito atuendo revelaba su gusto por el Made in Italy y, reproduciendo el altanero andar de los parisinos, se bajó en la estación Pont de Change de Chatelet.

No se atrevió a salir, no. Recorrió cada uno de los túneles, fue de una plataforma a la otra, aguardó en todos los banquitos. Sospechaba que de alguna manera el proceso podía revertirse; pero sólo si no salía a plena luz, si se mantenía en el laberinto de los trenes. Pasó las primeras horas de la noche moviéndose de línea en línea, cambiando de tren a tren. Fue de la Puerta de Clignancourt a la de Orléans; de la estación de La Chapelle a la de Marie d'Ivry; de la Plaza de Saint Sulpice al puente Dauphine. Hacia las diez y media cambió en el metro Cadet y se detuvo en la Gare du Nord para intentar comprender el sistema de transportación suburbano.

Muy pronto pudo distinguir las diferentes líneas por el material utilizado en las ruedas y el grosor de las vías. Anchas y de goma para los trenes de la Red de Expresos Regionales, metálicas y medianas para los de la Sociedad Nacional de Caminos de Hierro, y estrechas y ruidosas para el sistema del metro. Asimismo aprendió a reconocer los vagones que acababan de salir de la fábrica por sus puertas niqueladas, sus asientos ergonómicos y por el botón verde que había sustituído las palanquitas. En su minuciosa inspección, también descubrió los inmensos ventiladores, pequeños cartelitos flotantes y múltiples grafitis de los que estaban a punto de pasar al chatarrero. Aunque anduvo por el metro parisino por más de dieciocho horas, tuvo la suerte de que nadie le pidiera el billete delatador ni el documento de identidad que no poseía. Parecía que había un ángel protector guiándole los pasos.

Hacia la una de la mañana, cuando casi todos los trenes se habían detenido y por los altoparlantes se escuchaba el anuncio, con trasfondo de pajaritos, de que en pocos minutos se cerrarían todas las puertas de acceso al sistema, encontró un grupo de vagabundos que intercambiaban historias de la policía bajo una escalera. Entre ellos distinguió a un joven argelino que llevaba un pantalón bombacho estampado con unas figuras que tocaban unos inmensos tambores verdes. El muchacho parecía abstraído. Tenía un clarinete sobre la falda y se comía una *baguette* de Camambert con un cartucho de papas fritas. Angel lo observaba y los ojos se le iban hacia el suculento sándwich. A diferencia de los trenes neoyorquinos, por

todo aquello no había un mísero quiosco para comprarse una barra de chocolate o un simple vaso de leche.

De momento el músico—quien debido a su mirada ausente, podía constituir un forastero como él—, guardó lo que le quedaba del bocadillo, agarró el clarinete y se puso a tocar un aire de jazz. Del jazz pasó a la salsa, de la salsa al *blues*, y terminó con una melodía que le recordaba el cuplé La Violetera. Los *clochards* lo escuchaban fascinados. De momento el músico se levantó y comenzó a acercársele a nuestro viajero, mientras seguía tocando la conocida pieza. Guiado por su instinto Angel cerró los ojos y cuando volvió a abrirlos tenía el sándwich en la mano, pero ya no se hallaba en los pasillos subterráneos de la Ciudad Luz, sino en una estación de cercanías del metro madrileño.

La reconoció de inmediato, pues uno de sus jefes había pasado la luna de miel en aquella ciudad y entre las fotos que había tomado, había varias de aquella estación, tomada desde un ángulo diferente. Angel recorrió entonces la nueva red ferroviaria. Viajó bajo la Castellana, paró en Sol, tomó hacia Arturo Soria, regresó a Plaza de Castilla. Todo, sin salir por aquellas puertas que prometían luz y aire, pero que también constituían la garantía de que nunca regresaría a casa.

Un buen día, en pleno metro de Moscú, sintió nostalgia. Deseos de volver a su trabajo, de tomarse una cerveza con los amigos. Habían pasado quince meses desde el inicio de su inusitado viaje y se sentía extenuado. Lo que en un principio había constituído una fuente de sorpresas, se estaba convirtiendo en un hábito previsible. Y aunque desde los primeros días trató de cuidar su higiene, la ropa se le había hecho andrajos, la barba le llegaba a la cintura. Se había convertido en un náufrago de los trenes.

Intentó concentrarse. Marcar cada uno de los momentos que habían precedido la transposición, los puntos donde la red internacional de metros confluía. Era tarde. Estaba sentado en uno de los bancos de mármol de la estación Maiakovska frente a unas columnas doradas sobre las que refulgían unos impresionantes capiteles policromos. Recordaba haber escuchado aquella mañana a una guía quien, al explicar la historia del metro moscovita, puntualizaba cómo en la capital de la clase trabajadora se habían construido las mejores estaciones del mundo. Angel estaba admirando un lienzo donde se veía a una familia en el paraíso comunista, cuando se percató de que en el andén del frente alguien había olvidado un bandoneón color gris perla. Sabía que no podía perder ni un segundo. Subió y bajó por las escaleras, corrió bajo los candelabros, cruzó frente a los mosaicos y, a los pocos minutos, ya era el nuevo dueño del instrumento. Lo agarró con las dos manos, se lo apoyó en la falda y comenzó abrir y cerrar los fuelles mientras oprimía sus teclas. Evidentemente la música no era lo suyo. Indiscutiblemente el instrumento había visto mejores días.

Pero de niño había tomado clases con el director de la banda municipal e intentó tocar *Summertime* de George Gershwin. Justo cuando el tren se detuvo frente a él, saltó a sus pies la chapa de una Coca Cola que alguien se disponía a beber, y en un abrir y cerrar de ojos, Angel se vio transformado de un *bradyaga* ruso a un *homeless* neoyorquino. Miró a su alrededor, se percató de que se hallaba en el andén de la línea R de Times Square y respiró con alivio.

Esto habrá sucedido hace un par de años. Aunque nuestra relación se reducía a saludarnos los domingos en la iglesia de la Guadalupe de la Calle 14, me buscó en la parroquia y me pidió ayuda. Al principio fue sumamente difícil creer su historia. Pero tras contármela varias veces, me llevó a la estación de Union Square y me enseñó los instríngulis de los trenes.

Juntos hemos visitado Barcelona, Budapest, Roma, Tokío y Montreal. Hemos paseado entre las muchedumbres de México, escuchado a los músicos en Boston, visto los saltimbanquis de Buenos Aires y admirado las estaciones de Estocolmo.

Demás está decir que a pesar de su deseo de retomar su rutina, Angel jamás volvió a su antiguo empleo. Ahora se dedica a asesorar a los transeúntes subterráneos de la red de ciudades paralelas. Dice por fin haber hallado su vocación. Se mudó al sótano de mi edificio, y ha preparado un manual de usuarios que distribuye en la envoltura de unos caramelos de menta. No resulta nada difícil dar con él. Ha perfeccionado hasta tal punto las técnicas de la transposición y el *transfer* que se le puede encontrar en cualquier estación del metro, escudriñando los ojos vacíos de los transeúntes en busca de ese porcentaje de sorpresa que los delata como viajeros subterráneos del planeta.

Elizabeth Cruz

Elizabeth Cruz es artista visual, escritora y doctora en medicina, nacida y criada en Nueva York, de padres puertorriqueños. En 1990 la Editorial Moria publicó su poemario bilingüe, *Entrega*. Su experiencia como sobreviviente de cáncer la impulsaron a crear arte y escribir. Ha exhibido sus obras en el Alliance of Queens Artists y en Boricua College, donde leyó poesía y enseñó por varios años. Cruz se graduó del New York College of Podiatric Medicine en el 1992. Actualmente continúa escribiendo y creando arte, mientras ejerce medicina en el Hospital Montefiore del Bronx y el Hospital Mount Sinai en Manhattan.

Elizabeth Cruz is a visual artist, poet and medical doctor, born and raised in Brooklyn, New York. She also studied visual arts. Cruz wrote a bilingual poetry book, *Entrega,* which was published by Editorial Moria in 1990. Her experience as a cancer survivor propelled Cruz into art and poetry. She has exhibited her art work at the Alliance of Queens Artists and Boricua College, where she read poetry and also worked for several years as a faculty member. Cruz graduated from The New York College of Podiatric Medicine in 1992. She continues writing and creating art while she serves as a medical doctor at Montefiore Hospital in the Bronx and Mount Sinai Hospital in Manhattan.

CARNIVAL OF EMPTINESS

I sit here confused
Confused and empty about a world revolving
Around me, at times, in total havoc.
I can't put my arms around it.
I can't stop it from spinning so fast, so fast that I feel I am left behind.
Yet I have no energy,
No sight to catch up.
I feel myself being swallowed by the masquerade of time.
A carnival of emptiness engulfs me.
The colorful balloons in the air float effortlessly,
As does my limp body.
One pops in the distance, letting out its air as I let out a sigh.
It careens in the air as my emotions die.
They die not because I want them to, but because of the
stabs of life.
A clown at a distance, a reflection of my outside.
And yet
Yet
A thunderous laughter burst from my inside in a painful
And suffocating agony.
I laugh.
Yes- I laugh.
I am crying deep down inside.
I am a circus of loneliness,
Going around in this carrousel.
The music plays on
For I am nothing more than a carnival of emptiness...

BIRD OF STEEL

Full of wonder and amazement I await.
Bird of steel, I await your thunderous flight.
Your wings spread out majestically
challenging the cryptic sky.

The runway is yours as you frolic to and fro
leaving me envious of your freedom.
You aim ahead and elegantly your position you take.
Engines in mad furry roar
filling your lungs for the final impulse towards the firmament.
You lance yourself forward defying all,
thunderous surge of energy is exhaled out of your body
as you are slowly lifted into the heavens.

Freedom!
Freedom!

Master of the sky
for a couple of hours you allow me to
frolic with the celestial sphere
kiss the horizons
play with the clouds.
The vast world of nothingness is yours
is ours, suspended in time.
We fly higher than an eagle.
I, a mere speck in the center of your heart
move as one with you through the shadows of the universe
as you softly make love to the nakedness of the sky.

Poised and sensuously you touch its body,
its sensuous sigh caresses your wings.
Slowly and gently it lifts you higher.
My bosom responds to your pulse as your engines softly roar.

The sun at a distance, like the cape of a bullfighter
taunts us as we approach it.
The stars wink at us and the moon smiles
as we commune with the sky.

NIGHT BLOOMING CEREUS

Foams of light caress our bodies
In those tender moments
When alone we divest our shadows.
Our dreams live for an eternity.
Our hands touch the purity of our love.
Our bodies dance to the beat of our pulse.
Bodies enlaced for an eternity,
Quiver with our love.
Venus spins about our souls
Envious of the splendor of our sun
As rainbows color
Night blooming cereus.
Ensorcelled we exalt in love's sweet madness.
Fountains from which our spirits drink
Swell.
Oceans strong and naked slowly
Flow through our veins and
Ensile us
As we slowly give and take.
Ensiform stars toward our
Hearts travel and in spams of
Glorious splendor
We give to each other of our wine.

Oído de mi matriz

Silencio, tesoro de fronteras infinitas
Tus alas se comunican en la distancia.
Silencio,
en ti confío la lujuria de mi desnudez.
Tu cara de luna se deslumbra por los pensamientos
que evoco, lo que tengo que revelar.
Silencio,
jadeas tus murmullos hacia el mar.
Mis sueños, mis pensamientos
deben ser lanzados a tu corazón.
Silencio,
oído de mi matriz.
Secretamente aquietas los abortos de mis pensamientos.
Yo, construyo un pedestal con mi sangre
mientras trato de esconder los errores de mi vida.
Silencio,
dulcemente tomas mis pensamientos en tus manos.
Tiemblas por algunos,
pares rosas para otros.
Silencio,
buitre que agobia mis pecados
águila de mis sueños.

CARIDAD DE LA LUZ "LA BRUJA"

Caridad de la Luz "La Bruja" es performera, poeta y promotora cultural nacida en el Bronx. Crea "poesía urbana", monólogos en Spanglish y música latina de Hip Hop. Hizo su debut en el Nuyorican Poets Café en el 1996 y desde entones, su obra se ha presentado en televisión, teatro, películas y obras musicales. Se presentó en el "Russell Simmons' HBO Def Poetry Jam Season 2" y en "Habla" for HBO Latino. El New York Times la llamó una "Juggernaut" por su obra musical *Boogie Rican BLV.*, donde interpretó siete papeles diferentes, junto a un elenco pequeño que incluía a su hija, Carina. Actuó en la película de Spike Lee *Bamboozled*, ganadora del premio Sundance 2004 y en las películas *Down to the Bone, El Vacilón de la Mañana y Gun Hill Road.* Su espectáculo "Boogie Rican Blvd." se presentó en el teatro La Tea, en Joe's Pub y el Nuyorican Poets Café. Creó la compañía de discos De La Luz y publicó varios discos compactos que incluyen "Brujalicious" y "For Witch It Stands". Fundó, con el fin de responder a las condiciones que afectan a las jóvenes latinas en Nueva York, 'Latinas4Life' un programa para adolescentes que afirma los beneficios que aportan la poesía y el arte y promueve la educación y la autoestima. De La Luz colabora con la serie Oh Snap! en El Museo del Barrio, donde ofrece clases gratuitas para personas de todas las edades.

Caridad de la Luz "La Bruja" is a Bronx-born Performer and spoken word artist known for her urban poetry, Spanglish monologues and Latin hip-hop music. After making her debut at the Nuyorican Poets' Café in 1996, her work has been featured in television, theater, film, and music. The New York Times called her a "Juggernaut" after her 2009 run of her musical Boogie Rican Blvd., where she played seven different characters alongside a small supporting cast that included her 10 year old daughter, Carina. She has also performed on Russell Simmons' HBO "Def Poetry Jam Season 2' and on "Habla" for HBO Latino. She acted in Spike Lee's Sundance Award Winner 2004 movie *Bamboozled*, and also in *Down to the Bone, El Vacilón* and *Gun Hill Road*. Her one-woman show "Boogie Rican Blvd." was featured in La Tea Theater, Joe's Pub, and the Nuyorican Poets' Café. She created De La Luz Records and independently released several albums, including "Brujalicious' and "For Witch It Stands". In her endeavor to address the issues affecting young Latinas today, Caridad De La Luz founded Latinas4Life spoken word movement, an adolescent program that helps promote education, self-esteem and the healing benefits of poetry and art. De la Luz collaborates with the Oh Snap! Poetry Series at El Museo del Barrio and offers free classes once a month to all ages.

NUYORICO

Dedicated to Pedro Pietri "El Reverendo" R.I.P.

Nuyorico...
That place somewhere between The Empire State and El Morro
Down a dripping pipe that lands pitter pat on Mami's broken back
For lifetimes attacked
Placed on frontlines to fight for what we will never get back
But the soil is still fertile unlike the colonized spirit of the
Mass graves of the enslaved that chanted but no one could hear it
'Cause our heads are so far up our own asses
We can't tell the unnatural from the natural gases'
But best believe we still manage to breathe
And pull out in time so we won't have to breed
Another generation of the ill conceived
Born in search of truth but perpetually deceived
Told that we are free but we cannot leave
Nuyorico...
That place that we live for
Papi said, "Los americanos no tienen acento"
Americans don't have accents
Except the kind you sprinkle on your food and pretend
That compared to Abuelita's cooking your cooking's just as good
Yeah! Pour some more on for me
Call it Sazón, even though it's made by Pillsbury
So obvious when the main ingredient is MSG
The message is to love all that isn't we and
The doughboy in the White House just goes "hee hee hee"
World War I, World War II, World War Infinity
But resistance existed through Word War divinities
Coming in the form of "El Reverendo" Pedro Pietri
Who fought a war of no good and plenty
Still he speaks to our people
Forcing us out from behind tenement peepholes
To find a place where we can all feel equal
And realize all along your heart knew you were so Rico
When you realize that, that's when you're there
Welcome to Nuyorico...

I, TOO, AM BLACK

(Inspired by the late great Langston Hughes)

Although you may find me fair
With medium brown eyes
And not too curly hair
Of mixed heritage
Too many to name,
One thing is the same
We've all shared despair
Believe it or not in fact
I, too, am Black

I have been stabbed in the back
For being too much of this
And not enough of that
Have been compared to what exists
And been told how much I lack
You may not know it now
But it's fact
I, too, am Black

Color lines run deep in my veins
Behind covered mouths
I've been called many names
Instead of hope
They taught me shame
But I chose to play another game
With ears I hear
But heart unchained
You can keep it
Or take it all back
You have eyes
But are blind to the fact
I, too, am Black

Black like the ebony tree
The deeper you carve into me
You can easily see
The beauty, the strength
Shape me and shine me
In the finest homes
You'll find me
While strange fruit
Still hangs inside me
With all the love I can muster
My face glows with luster
It will take more than some slave trade

To make us crack
So let me break it to you
With truth and with tact
I am proud of the fact that
I, too, am Black

W.T.C.

World Trade Center
What's the cause
Work to change
Wish to connect
Want to cry
Watched them climb
Watched towers crash
Wishes turned cloudy
Whispered to Christ
Watch the children
Wish time could
Wash this clean
Witness the corruption
War that conquers
W targets countries
White torn cloth
Wrists turned cold
Watched the cloud
Wrap the city
Watched the calamity
Work towards charity
Women try calming
Weakness to courage
Worthless to cooperate
Watching them corroborate
Wounds to clean
Working to counterbalance
Winding the clock
Willingness to counsel
Wife tries cooking
Washing the clothing
Working the corner
Writing to courts
Well-wishing the children
Wanting to create
Worlds to cradle
Want to cover
Wrong to cry
Wisdom takes crossroads
Warriors think consciously
Waiting to contact
Witches turned counselors

W.T.C.

SANDRA MARÍA ESTEVES

Sandra María Esteves es poeta, artista visual, educadora y productora boricua dominicana nuyorican, nacida y criada en el Bronx. Conocida como la Madrina de la Poesía Nuyorican, Esteves es una de las fundadoras del movimiento literario Nuyorican. Ha publicado los poemarios *Yerba Buena* (1980); *Tropical Rain: A Bilingual Downpour* (1984); *Bluestown Mockingbird Mambo* (1990); *Undelivered Love Poems* (1997); *Contrapunto In The Open Field* (1998); *Finding Your Way, Poems for Young Folks* (1999); *Poems in Concert* (2006); *Portal, A Journey in Poetry* (2007). Su obra se ha publicado en más de ochenta antologías y revistas literarias, incluyendo *Latino Boom: An Anthology of U.S. Latino Literature, The Heath Anthology of American Literature, Approaching Literature in the 21st Century, The Prentice Hall Anthology of Latino Literature, Herencia: The Anthology of Latino Literature of the United States, Stone on Stone / Piedra sobre Piedra, In Other Words: Literature by Latinas of the United States, Puerto Ricans at Home in the USA, Woman of Her Word, Hispanic Women Write, Herejes y Mitificadores, Journal of Contemporary Puerto Rican Thought, Lluvia Sobre La Isla* (Casa de las Américas) y *Revista Chicano-Riqueña*. Entre sus premios y reconocimientos se incluyen becas de poesía del New York Foundation for the Arts (1985) y CAPS (1980); Proclamación del Alcalde de la ciudad de Mayagüez, PR (1998); Arts Review Honoree del Bronx Council on the Arts (2001); The Edgar Allan Poe Literary Award (2002); Poet Award from Universes Poetry Theater Ensemble (2006), Con Tinta Award (2007) y el Premio NEA Master Artist del Teatro Pregones (2010). Fue Directora Ejecutiva y Productora del African Caribbean Poetry Theater y directora de series de poesía, incluyendo *Voices from the Belly* (1980-83) en la Galería Moriviví. Ha trabajado con organizaciones como Teachers & Writers Collaborative, el Bronx Council on the Arts y la Junta de Educación de la Ciudad de Nueva York. Esteves estudió arte, cinematografía y escritura creativa en el Instituto Pratt (sus pinturas se pueden ver en su portal).

Born and raised in the Bronx, **Sandra María Esteves** is a Puerto Rican Dominican Nuyorican poet, visual artist, educator and producer. She is one of the founders of the Nuyorican Literary Movement and is also known as the Godmother of Nuyorican Poetry. Her published poetry books are *Yerba Buena* (1980); *Tropical Rain: A Bilingual Downpour* (1984); *Bluestown Mockingbird Mambo* (1990); *Undelivered Love Poems* (1997); *Contrapunto In The Open Field* (1998); *Finding Your Way, Poems for Young Folks* (1999); *Poems in Concert* (2006); *Portal, A Journey in Poetry* (2007). Her work has been extensively published in over eighty anthologies and literary journals, including *Latino Boom: An Anthology of U.S. Latino Literature, The Heath Anthology of American Literature, Approaching Literature in the 21st Century, The Prentice Hall Anthology of Latino Literature, Herencia: The Anthology of Latino Literature of the United States, Stone on Stone / Piedra sobre Piedra, In Other Words: Literature by Latinas of the United States, Puerto Ricans at Home in the USA, Woman of Her Word, Hispanic Women Write, Herejes y Mitificadores, Journal of Contemporary Puerto Rican Thought, Lluvia Sobre La Isla* (Casa de las Américas) and *Revista Chicano-Riqueña*. Her awards include poetry fellowships from The New York Foundation for the Arts (1985) and CAPS (1980); Proclamation from the Mayor of the City of Mayagüez, PR (1998); Arts Review Honoree from the Bronx Council on the Arts ((2001); The Edgar Allan Poe Literary Award (2002); Poet Award from Universes Poetry Theater Ensemble (2006), Con Tinta Award (2007) and NEA Master Artist Award from Pregones Theater (2010). Esteves was the Executive Director/ Producer of the African Caribbean Poetry Theater and director of various poetry series, including *Voices from the Belly* at the Galería Moriviví (1980-1983). She has worked with organizations such as Teachers & Writers Collaborative, the Bronx Council on the Arts and the Board of Education. She studied fine arts, film and creative writing at Pratt Institute (her paintings can be viewed at her website).

Puerto Rican Discovery Number Forty, To Build A House

for Evelina Antonetty

Begin with mud
Soft, cold, pliable to the touch
Not too wet, nor dry
A smooth consistency for shaping whole and solid
Offer it to the sun for strength and durability
Wait until it is returned hardened like the mountains
Find the land that is close to your heart
Measure the size of your plan
from it's most extreme dimensions and depths of perception
Draw a circle on the ground. Pray there for one complete day
Study the weather closely
Build your foundations in exact proportions,
engineering the details of space, weight and balance
Be careful to follow the path of the sun
Draw your water from the moon
Flatten the edges to a perfect plane,
slowly laying in the walls, centuries of inheritance,
each generation a floor
Let the cornerstones be monuments to grandmothers
Let the flower beds be celebrations to grandfathers
Let the rooms divided up be tributes to brothers, sisters,
cousins, uncles, step-sons, daughters-in-law,
parents and grandchildren

Keep half of the closets—only half
Get rid of pushers, dealers, wheelers, cheaters,
greedy landlords, and numerous social diseases
Get rid of abuse, molestation and incest—get rid of it!
Get rid of crime, nuclear war, attitudes that kill and destroy

Just keep those places where tender memories are stored,
teaching histories unwritten:
Changó chasing Yemayá while Oyá prays in the cemetery
somewhere in the heart of Mozambique where Obatalá is King

Leave space for windows, trees and sunsets
With a wide door chiming songs of hope
opening easily to the touch,
yet strong enough to block out the flood

Listen to the birds
Watch the leaves falling and the new buds emerging
Walk through the snow

Be cleansed by the morning
Bless yourself in the ocean
Pray

And most important:
Love the children—
 Love the children
Love
 the children.

TEARS (FOR YOU)

in memory of Ana

i come from the river of you
flowing thru the landscape of my being
the waterfall of your name
cascading thru the crevices of my soul
the ripples of your cosmic song
reverberating beats thru my body
the magical mist of your essence
becoming the million moments of memory

i am the swirling stream
navigating the map of your hands
the crushing current out of control crashing against stone
the impatient rush roaring, splashing
the soft descent slipping and sliding
through the cool undertow of vibrating sea life
swimming around and into your universe of light

i am sweet water born in your ravine of rain
the consummation of thundercloud in the electric flash flood
carrying the life force of the divine dream of your love

i am floating. i am drowning.
i am soaring. i am diving.
i am the plunging reflection
drunk from the libation of your eyes
healed in the baño of your spirit
formed in the undulation of your dancing brush
like sea grass suspended in waves
wandering wild in the depths.

SPIRIT DANCE

for the Ancestors

When Spirits dance Mambo
Elegba opens the roads,
carnival colors fly in circles
Ancestors call our names
through drums that speak
mixing cultures in rhythms of
Spanish Saints with African slaves.

Spirits come
like the heart of Africa
beating our Nigerian history
from the land of Yoruba
where herbs, animals, rocks,
and sacred symbols breathe
in harmony with nature.
The essence of our ancestors arrives
to dance the Black culture of resistance,
teaching values and ethics
for conflict resolution
and protection from colonialism.

They appear as Orisha
hidden from Catholic conquerors
behind brilliant curtains
keeping God alive
in the back room of roots united
in respect from one to one.
They dance in Regla de Ocha,
Palo Muerto, Bantu, Muerteros,
Cimarron Espiritistas
who receive the energy,
messengers of spirit,
healers from Mother Goddess and Father Creator,
visible presences rooted in Congo culture
struggling to create a nation.

Landing on the shores of America
with nothing but their bodies,
nothing–but their bodies.
No books, no sacred carvings,
no special photos of loved ones back home,
just knowledge stored in the mind
and images of their memories.

Bringing their religion of reverence
to be shared with the world,
to plant seeds of life
meant to grow great and grand
beyond the chains that enslaved
that forbade them to dance

So they danced in silence in Oro Seco
where only the drum talks
in the language of Bata,
Abakua, Arara and Congo Rumba,
giving birth to Salsa, Son and Guaracha,
through tamboreros in Matanzas
becoming mother
of Rap, Hip Hop,
Jazz, Blues, Reggae and Rock
in contact with the young avant-garde
of African thought.

When Spirits dance Mambo
African and Hispanic traditions merge
into new bloodlines
of God Love full of Light.

When Spirits dance and move our feet
our hearts beat to drums that speak.

WHERE I'M FROM

We come from the America of are and be, of soy y somos.
It is an America that does not belong to one race or one tribe.
It is even more than Black and White.
Our America is made up of mountain flutes and ancient step pyramids,
of bright color woven fabrics
and tobacco fields worked like black gold by dark hands,
of Asian blood and sweat operas on railroad tracks and concentration camps,
of Mexicans who still live on the land of their ancestors,
even though its name was changed to
California, Arizona, Texas, Nevada, Utah—NEW Mexico,
of many diasporas trapped in urban landscapes,
of motherless children whose daddy is at war,
of crowded streets, long lines, empty pockets
and unjust verdicts for police who destroy,
of massacred ancestors, English only rules, sterilized wombs
and an island tethered to unexploded target-practice bombs,
of the cupboard is bare, no one cares
while children in limbo are searching for the sun.

Our America speaks Choctaw, Crow, Nez Perce, and Zapotec,
Ojibwe, Patois, Pidgin, and Portuguese,
Mandarin, Mayan, Korean, and Quechua,
Creole, Danish, French, and Dakota,
Punjabe, Hindi, Nagual and Sign
Arabic, Congo, Swahili, and too many dialects of Spanish to count.

This America is a Nuyorican-Diasporican-Afrorican state of mind,
that celebrates difference, educated in defiance,
peace-loving, stands up for justice,
that knows when to walk away and let go,
and does not seek to be something other than itself.

In this America you can sit anywhere on the bus,
talk however you must, receive self-knowledge you can trust.

Where I'm from thoughts rise up from creation stories
passed on through grandmothers
and God is also a woman whose spirit is as evolved as any man's.

Where I'm from, no matter what color your skin,
you can dance and worship at the same time
and God will descend from heaven to speak with you face to face.

Where I'm from there are no free rides, only hard work and short nights
in a world full of stars, and poets, and artists, and teachers,
and healers, and thinkers, and seers and dreamers.
Where everyone has a place to be,

can go deep within and learn to be free,
expect respect and claim our voice,
pursue our form of happiness and our right of choice.

In this America our capacity to love is what defines us, unites us.
And what we give with our heart is the essence of our true value.
Where I'm from, love is real, and it starts by giving
into the circle in and out of ourselves.

MAP OF THE INNER HOUSE

There are many layers
A multitude are brightly colored
As many more are unseen, but can be known
The red door sports harmonic chimes
Its other music is stored in a silent room
Its dark corners are revealed in morning light
The waiting garden is anxious for spring
Right now, the house sits empty
Its only encounters are with the rainfall
Visitors drop by on occasions
with their baggage like salesmen full of promises
who leave after stealing back their gifts
There are secrets and magic spells hidden
inside different sized rooms
Some spaces are grandiose, breathtaking
And some are so small they have no doors or windows
The foundation beneath is solid bedrock
But even this can shift in turbulent river currents
When the moon is full the mockingbird chants in the trees
The wind arrives like a messenger with fresh news
or a lover, gentle, caressing
The days are unfortunately brief,
but the nights seem to be endless
The children have all gone seeking other shelters
The fireplace never becomes dark
In the center there is an altar to the ancestors
that is a sacred divine mystery
Its light sits next to the cool well
whose water is deep, clear, ready for drinking.

María T. Fernández
(a.k.a. Mariposa)

Mariposa es poeta performera, activista cultural y autora del poemario *Born Bronxeña: Poems on Identity, Love & Survival* (2001). Ha presentado su obra en universidades y en eventos como *United Nation's World Conference Against Racism* en Durban, Surafrica (2001); *Essence Music Fest* en Nueva Orleans (2001); *Vagina Monologues* de Eve Enler en el Apollo Theater; *Latina Poets Festival* en The Puerto Rican Traveling Theater (2007) y en el *35th Anniversary of the Nuyorican Poets Café* en el Town Hall (2008). Su poesía presentó en el documental de HBO *Americanos: Latino Life in the US*. Ha publicado artículos y poemas en las revistas *Centro Journal* y *The Hostos Review* y las antologías *Resistance in Paradise: Rethinking 100 Years of U.S. Involvement in the Caribbean and the Pacific* y *Bum Rush the Page: A Def Poetry Jam*. Su obra se ha comentado en *From Bomba to Hip Hop: Puerto Rican Culture and Latino Identity, Living in Spanglish: The Search for Latino Identity in America* y *Puerto Ricans in the United States: A Contemporary Portrait*. Ha sido poeta residente en The Caribbean Cultural Center, Poets & Writers, Poets House, The Bronx Writers Center y Teachers & Writers Collaborative y como tal, ha enseñado poesía en bibliotecas, centros de envejecientes y escuelas. Junto a su hermana gemela melleSOL, Mariposa ha producido varias series de poesía. Recibió el premio "Lo Mejor de Nuestra Comunidad" de El Comité Noviembre (1997) y The Van Lier Literary Fellowship de The Bronx Council on the Arts (1999). Obtuvo un BA en Women's Studies y un MA en Special Education de NYU. Reside en el Bronx, donde nació.

Mariposa is a poet, performer and activist. She is the author of the book *Born Bronxeña: Poems on Identity, Love & Survival* (2001). She has presented her work at universities and other venues: the 2001 *United Nation's World Conference Against Racism* in Durban, South Africa; the 2001 *Essence Music Fest* in New Orleans; *V-Day Harlem*; Eve Ensler's *Vagina Monologues* at the Apollo Theater; the 2007 *Latina Poets Festival* at The Puerto Rican Traveling Theater and the *35th Anniversary of the Nuyorican Poets Café* at Town Hall (2008). Her poetry has been featured on the HBO documentary *Americanos: Latino Life in the US*. She has published articles and poetry in numerous publications, including the journals *Centro Journal* and *The Hostos Review*; and the anthologies *Resistance in Paradise: Rethinking 100 Years of U.S. Involvement in the Caribbean and the Pacific* and *Bum Rush the Page: A Def Poetry Jam*. Her work has been referenced in *From Bomba to Hip Hop: Puerto Rican Culture and Latino Identity, Living in Spanglish: The Search for Latino Identity in America* and *Puerto Ricans in the United States: A Contemporary Portrait*. As a poet-in-residence at The Caribbean Cultural Center, Poets & Writers, Poets House, The Bronx Writers Center and Teachers & Writers Collaborative, Mariposa has taught poetry in libraries, senior citizen centers and schools. She has produced various poetry series with her twin sister, melleSOL. Mariposa has received "Lo Mejor de Nuestra Comunidad" Award by El Comité Noviembre (1997) and The Van Lier Literary Fellowship by The Bronx Council on the Arts (1999). She obtained a BA in Women's Studies and an MA in Special Education from NYU. She resides in her native Bronx.

Homage to My Hair

My hair is
Powerful hair
Mighty hair
Goddess like hair.

My hair can show you
The way to freedom
Forever obstruct your vision
Of internalized ugly isms.

My hair is the ocean at its wildest.
My hair is Olokun in a rage.
My hair is the untamed hurricane
Of ancestral shame uncaged.

My hair is alive
Beautiful
Wild
And free.

My hair is the sun
Forever
Glistening.

Poem for My Grifa-Rican Sistah Or Broken Ends Broken Promises

(for my twin sister Melissa, who endured it with me)

Braids twist and tie
constrain baby knaps never to be free
braids twist and tie
contain / hold in the shame
of not havin' long black silky strands
to run my fingers through.

Moños y bobby pins
twist and wrap
Ay, please forgive me for the sin
Of not inheriting Papi's "good hair"

Moños y bobby pins
twist and wrap
restrain kinky naps
dying to be free
but not the pain
of not having a long black silky mane
to run my fingers through.

Clips and ribbons
to hold back and tie
oppressing baby naps
never to be free.

Clips and ribbons
to hold back and tie
imprisoning baby naps
never to have the dignity to be.

Chemical relaxers
broken ends / broken promises
activator and cream
mixed in with bitterness
mix well…

Keep away from children
Avoid contact with eyes
This product contains lye and lies
Harmful if swallowed

The ritual of combing / parting / sectioning
the greasing of the scalp / the neck

the forehead / the ears
the process / and then the burning / the burning

"It hurts to be beautiful, 'ta te quieta."
My mother tells me.

"¡Pero mami me pica!"

And then the running / the running to water
to salvation / to neutralizer / to broken ends
and broken promises.

Graduating from Carefree Curl
to Kitty Curl / to Revlon / to Super Duper Fabulaxer
different boxes offering us Broken Ends and Broken Promises.

"We've come a long way since Dixie Peach,"
my mother tells me as I sit at the kitchen table.

Chemical relaxers to melt away the shame
until new growth reminds us
that it is time once again
for the ritual and the fear of
scalp burns and hair loss
and the welcoming
of broken ends
and broken
promises.

When the truth is that
Black hair
African textured hair
Curly hair
is beautiful.

¡Que viva el pelo libre!

¡Que viva!

ODE TO THE DIASPORICAN

(pa' mi gente)

Mira a mi cara Puertorriqueña
A mi pelo vivo
A mis manos morenas
Mira a mi corazón que se llena de orgullo
Y dime que no soy Boricua

Some people say that I'm not the real thing
Boricua, that is
because I wasn't born on the enchanted island
because I was born in the mainland north of Spanish Harlem
because I was born in the Bronx
Some people think I'm not bonafide
because my playground was a concrete jungle
because my Río Grande de Loíza was the Bronx River
because my Fajardo was City Island
my Luquillo, Orchard Beach
and summer nights were filled with city noises
instead of coquís
and Puerto Rico was just some paradise
that we only saw in pictures

What does it mean to live in between
What does it take to realize
that being Boricua is
a state of mind
a state of heart
a state of soul

Mira a mi cara Puertorriqueña
A mi pelo vivo
A mis manos morenas
Mira a mi corazón que se llena de orgullo
Y dime que no soy Boricua

¡No nací en Puerto Rico.
Puerto Rico nació en mí!

REFUGE

She fears the lovingness of words
like *linda, mamita, preciosa*
They bring back whispers in the darkness
A deep voice calling her name
Midnight terror
Silent scream
Memory of being child, of being girl
Of being suffocated by fear- gagging on it
A large hand covering her mouth
forcing her to swallow vomit
The beating of heartbeat
The halting of breath
The taste of beer tainted saliva
The pressing down on unformed breasts
And a river of tears flowing down bed of cotton
from swollen brown baby eyes/ and so she cried
And every night she prayed
¡Dígame Dios, Cristo, Virgen!
Tell me who's gonna love a little brown Puerto Rican girl?
Who's gonna love a little brown Puerto Rican girl?
He did
With brutal words like knives
And grunts like bullets
Murdering innocence
Strangling youth
And then the sudden realization of crime...His crime
And a crazed, inhuman look in his eyes
And then a stinging slap and a paralyzing punch
And the pulling of hair, long strands in his fists
And name calling and a cloak of guilt, blame and shame
thrown over her skinny brown shoulders
And then darkness and hot tears on pillow
And the comfort of teddy bears and hate
And she crawled into herself
Finding refuge in a stiff stance
And she crawled into herself
Finding refuge in a cool stare
And she crawled into herself
Finding refuge in lowered eyes
And she crawled into herself
Finding refuge in bowed head
And she crawled into herself
Finding refuge in arms crossed over chest

Refuge in silence
Refuge in darkness
Refuge
Refuge
Refuge

Porque es una cosa solamente de nosotras

In Memory of Ibis Fernández Rosario and Andrea Triana

This is for the comadres
still with us in spirit, heart and mind
This is for the comadres
whose laughter echoes in the wind
This is for the comadres
who cry in dark and lonely places
screaming into the palm of their hands
covering bloody faces
This is for the comadres
who have been taken
by obsessive jealous hands
but still live through us
in every heartbeat and every breath
this is for the comadres
that their batterers and murderers
will die slow and painful deaths
Eso es para los niños
que añoran abrazar a sus madres
Eso es para los niños
que nunca van a tener una niñez
This is for the comadres
who have died in the struggle
legends in their own right
This is for the comadres
who have died in the fight
Eso es para las comadres
que nunca querían ser heroínas
pero que murieron luchando
luchando por una vida sin opresión
un mundo donde se respetan las mujeres
y donde ningún hombre puede entrar
porque es una cosa solamente de nosotras
Eso es para las comadres
Siempre luchando con nosotras
Eso es para las madres
Eso es para las hijas
Eso es para las abuelas
Eso es para las tías
¡Que vivan las comadres!
¡Que vivan!

Sandra A. García-Betancourt

Sandra A. García-Betancourt es poeta, escritora, promotora de las artes; hija de padres puertorriqueños; nacida en San Cristóbal, República Dominicana. Creció en Puerto Rico, donde cursó estudios en Artes Liberales en el Junior College y la Universidad del Turabo. García-Betancourt es autora del poemario *Ombligo de Luna* (1992) y del plaquet *Memorias y Olvidos*. Es una publicista de experiencia; trabajó como administradora del Nuyorican Poets Café in the Lower Manhattan y se desempeñó por varios años como Administradora de Relaciones Públicas de *El Diario La Prensa*. Fue también coordinadora de varios programas internacionales de ayuda humanitaria. García-Betancourt reside en el área de Washington Heights y ha trabajado por muchos años con las comunidades de artistas y los medios de comunicación. Posee un BA del Union Institute University de Vermont y un MFA del Programa de Escritura Creativa de New York University, Departamento de Español y Portugués. Es actualmente Directora Ejecutiva y CEO del Northern Manhattan Arts Alliance (NoMAA).

Sandra A. García-Betancourt is a poet, writer and arts activist. Daughter of Puerto Rican parents, she was born in the Dominican Republic and raised in Puerto Rico, where she studied Liberal Arts at the Junior College and the Universidad del Turabo. She authored the book of poetry, *Ombligo de luna* (1992) y el plaquet *Memorias y Olvidos*. She is an experienced publicist who worked as Manager of the Nuyorican Poets Café in Lower Manhattan and was for several years the Public Relations Manager for *El Diario La Prensa*. She was also coordinator of international humanitarian programs. García-Betancourt is a resident of the Washington Heights area, and has worked for many years in the arts and media communities. She holds a BA from Union Institute University in Vermont, and a MFA from New York University, Department of Spanish and Portuguese, Creative Writing Program. She is now the Executive Director and CEO of the Northern Manhattan Arts Alliance (NoMAA).

A PESAR DEL OLVIDO

Quedaste atrapado
entre esas grietas hondas
que se abrieron
en el tiempo pasado
pero no como recuerdo
si no como olvido

hasta esta mañana
cuando rebuscaba entre mis memorias
los días frescos de viejas primaveras
y encontré
agarradita a una esquina de mi corazón
tu bella sonrisa
la imagen de tu noble estatura
tu lindo cuerpo de barro
tus ojos brillando de utopía
tu futuro liberador e imaginario
la mañana en que me cambiabas
la ropa sin despertarme
para luego de puntillas
ir a fregar los trastes
después de una noche de mariachis
que interrumpí
a pesar de tu bondad
con los recuerdos de otro

y tú tan entendido en los males de amores
sufrías discreto mi dolor callado
difícil de disimular
que ignoraba tal ternura
tal fuerza
tu sonrisa
esa
que hoy otoño
encuentro colgadita
a pesar de los años
a pesar de la profundidad de la grieta
a pesar del olvido
en una esquinita del corazón
igual que antes
tan fresca y pausada
tan clara y serena
tan niña
tan ella
tan tú.

COMPARÁNDOTE

Cuando por fin decidí olvidarte
busqué
entre las sombras de la noche
tu gemelo...
entre bailes y pachangas
busqué tus pasos...
tu movimiento de cintura...
tus brazos

y en junglas cercadas
por filas de animales rapaces
bailé con cuervos
con zorros...
bailé con martinetes repletos de gusanos
bailé con hienas
con zorrillos
todos escurridizos
y resbalosos...

con miradas de tigre me acechaban...
se acercaban...se alejaban...
ofrecían en tonos seductivos
su caballerosidad fingida
sus teléfonos...sus vidas...
ofrecían los tragos
e intentaban
agresivamente
medirme las caderas
picarme con sus picos
arañarme con sus pezuñas
y acariciarme con sus colas...
pero no sabían bailar
no conocían nuestros pasos...
los de ellos eran ligeros
sin ritmo
buscaban un destino inmediato
con la intención
de enredarse en mis cabellos
y caer
rendidos y sudorosos
entre el frío de mis pechos...

en fin
no valió la pena...
en mi esfuerzo de olvidarte
te recordé más
y lo que es peor...
nunca encontré tu gemelo.

OTRO RÍO

a Julia de Burgos

Río Dulce,
en la noche me tragas
como un goloso hambriento
te enfureces y te rompes contra mí
en olas violentas de vidrio
me cortas en pequeños suspiros
me remontas a recuerdos incompletos
a tantos cuerpos, a tantos besos
me humedeces soberbio
hasta el último pensamiento
la más profunda añoranza
el más íntimo momento,
te vuelcas en mí
con todos tus antepasados
como si fueras un sueño
una alucinación
un sonámbulo perdido,
y pierdo la noción del tiempo
me quedo sin espacio
en mí no quepo,
mis ojos quieren tocar el lanchero,
mis manos quieren mirarte de cerca
y desde adentro
yo dejo de ser yo
para sumergirme en tu grande boca dulce
para que me tragues
y ser parte de ti
sumando a la tuya mi furia,
mi hambre, mi historia
todos los cabos sueltos de mi vida
todos mis cristales rotos,
para que en las noches
otro lanchero me sienta desgranándome
efímera contra su lancha
y despedazándome bajo tu cielo.

9/8/96, New York
(Río Dulce, Livington, Guatemala)

AGUA

Corre, vuela
se lanza
Contra la tierra,
Se cae, se arrastra
Se la roban

Desaparece, se esfuma
Se escurre entre mis poros
Llueve, moja, enfría
Duele, llora

Salada, dulce
Opaca, gris, espesa
Sucia, verde, aceitosa
Cara
Enbotellada
Limitada
Globalizada

80% de mí
Se seca,
Se rompe
Se escama

Resbala
desaparece
Sucia
Defectuosa

Insalubre
Se vuelve sangre
Se vuelve pena
Ausencia, peste, miseria,

Sed
Hambruna
Garganta árida
entrañas fétidas
Ojos irritados
Pechos caídos
Arrugas
Lagañas
Caspa
Berrugas, ampollas

Locura,
alucinación
que no hidrata,
migraña
sequía
trincheras
hambre

Sed
Asquerosa, infecciosa, contagiosa
Que se vuelve sangre
Peste y mierda.

LULLABY FOR A RWANDAN CHILD

Sleep my child
because asleep
you will dream
all things more beautiful
and the sky
and the sun
will shine,
and through the gorge
will run a spout of water,
your mother
kisses your eyes
and there is no more pain
in your bloated tummy

sleep my child
because asleep
your eyes will not
escape your face,
the heat of the fever
will not overcome you,
the sleepy hunger
will vanish

sleep my child
that the whole world
saw you on the TV screens
and on the cover of the New York Times
while here
nothing happens,
and your mother
crossed the border
believing you followed
behind
and now she cries
for real...she cries

sleep my child
because if you
wake up
you will die
of colics
the cholera
will lay on your bed
sleep my child

dream that you live
some where else,

that your mother
has big proud breasts
filled with fresh milk,
that she is lulling you
kissing your eyes
kissing your eyes again

sleep my child
and dream
dream
that you killed
the death
that your eyes stayed
in your face
that the whole world
kisses you
that your belly
is not growing
with worms

dream, dream
that your mother
did not cross the border
believing you followed behind,
that nobody follows you,
that your country is yours,
that the water spouts at the brook
is clear.

SANDRA GARCÍA RIVERA

Sandra García Rivera es poeta y cantante, nacida y criada en Washington Heights y El Bronx de Nueva York, hija de padres puertorriqueños. Empieza a escribir poesía en la década de las noventas en San Francisco, California (barrio La Misión), inspirada por las palabras y el ejemplo de Piri Thomas: "Cada niño nace poeta, cada poeta es un niño". Ha publicado dos colecciones de poemas: *Divination of the Mistress* (1999); *Shoulder High* (2007); y dos ediciones artísticas de su poema *That Kiss* (Ediciones Mixta, El Barrio, 2002/2004), cuyas presentaciones resultaron en los performances *Las Ferias del Beso*. Sus poemas han sido publicados en *Urban Latino Magazine*; *Hostos Review: Open Mic/Micrófono Abierto. Nuevas Literaturas Puerto/Neorriqueñas. New Puerto Rican/Nuyorican Literatures*; *Promethean 2007*; *Centro Journal*; *RiodeSoul*.com; y *Manteca*, Revista de la Galería de la Raza. Como poeta, músico y *performera*, García Rivera ha viajado por los Estados Unidos, Puerto Rico, Cuba, Gran Bretaña y Amsterdam. Fue instructora de escritura creativa en el Cooper Union Saturday Program (2003-2007) y por más de quince años, ha trabajado como artista y administradora de organizaciones y programas dedicados a los jóvenes y la comunidad.

Sandra García Rivera is a poet and singer. The daughter of Puerto Rican parents, she was born and raised in Washington Heights and the Bronx. García Rivera started writing poetry in the mid-1990s in the Mission District of San Francisco, inspired by Piri Thomas' words: "Every child is born a poet, every poet is a child." Since then, she has published two collections of poetry: *Divination of the Mistress* (1999) and *Shoulder High* (2007). Two art editions of her poem *That Kiss* were published by Ediciones Mixta in El Barrio (2002/2004) and their presentations resulted in performances entitled *Las Ferias del Beso*. Her poems have appeared in *Urban Latino Magazine; Hostos Review: Open Mic/Micrófono Abierto. Nuevas Literaturas Puerto/ Neorriqueñas. New Puerto Rican/Nuyorican Literatures; Promethean 2007; The Centro Journal of Hunter College;* RiodeSoul.com; and the Galería de la Raza's zine *Manteca*. As a poet and musician, Sandra has performed throughout the United States, Puerto Rico, Cuba, Great Britain, and Amsterdam. She was an instructor of creative writing with the Cooper Union Saturday Program for high school students (2003-2007) and for more than fifteen years, García Rivera has been working with community and youth organizations as an artist and administrator.

ONE FACE

Overcast winter Sunday morning,
Castle Hill.
El Gran Combo warms the chill
in the local bodega
where for the paper I go.

Eyes squinting,
waiting to pay
I raise my gaze
to a color poster
home made
taped above the counter
on a cigarette boasting clock,
tick tock.

I spy a face with my mother's name
whose eyes sing of warmer days
broadcast over Caribbean sound waves.

Carmen A. Rivera.

The poster I scan
like a milk carton,
seeking details of her fate:
A year younger than I
 Born – 1968.
How long has she been missing?
 No date.
What would she look like today?
 My heart's a race.

Subliminal at first glance
at the bottom, two lines
handwritten – by chance? –
in letters cursive and quaking
not to be mistaken:
 Tower 2
 96th floor.

I am shaken.
No need for explanation.
She's not a runaway,
hasn't met the usual foul play,
just didn't make it home one fateful
sunny day.

Unlike Moses and the Hebrews

escaping an empire in decay
Carmen did not find freedom
from the serpents or the plague.

The images linger.

From Manhattan we fled
across rivers to lands once wed.
An exodus to escape
the final resting place,
of thousands who lived
a nightmare awake.

A family who mourns in the
Castle on the Hill,
will find no peace 'til there's word from
Fresh Kills.
Yet, accept her passing they must,
despite the evidence that eludes in dust.

Without burial,
DNA or earthly remains
loved ones live only in memory
and spoken names.
Where do you find the hinges
to close the door,
for a family
who's hope relies on a poster
in a store.

La mancha de plátano
spoke to me in her name.
In her smile
Carmen's life remains.
May peace her family claim.
For without proof
the wound resembles an open sore,
for those whose love lingers in
Tower 2,
96th floor.

CEREMONY FOR A 6 TRAIN TRAMPOLINE QUEEN

Hey!
Little Sister!
Stick your baby fat back in your dreams.
Is there no ritual,
or right of passage,
for a 6 train trampoline queen?

14 on the way to 25,
barely realizin' you're alive,
yet, body of woman you behold,
flashed,
like fruit in market,
FRESSSSH,
to be sold.

Mango burstin' belly
tender,
dripping juice,
barely slender
over the waist of your skintight jeans,
your breasts – inverted tangerines –
and you know it Miss
Sweet Wannabe Sixteen.

Will there be a *Quinceañera*,
Promenadin' purity down the block?
Or a "Sexy-n-Seventeen"
Libido goin' non-stop?

Any honor for you?
Is there no clue of your potential or respect you are due?

Hangin' out with girls easily impressed
you're nasty
as you express,
unconsciously,
the image you project:
No Respect.

Got the nerve to call your homegirl,
"Stupid…Idiot…Dummy…Jerk."
yet who you to put yo' friend down,
playin' big and bad on the underground?
Your self-esteem's a glass pedestal,
can fall and break
so fragile.

Cuz the minute she checks
and responds,
"Fuck you Bitch!"
and then is gone?
we'll see who's got it going on.
She'll have self-respect she claimed
in spite of all the times you called her out her name.

And what will be YOUR claim to fame?
– *Mira,* whatever happened to that little putita around the way?
– Yo, didn't she get pregnant while Johnny's girl was away?
– Gave her little ass to any guy who told her he'd stay.
– *Bendito,* wore her womanhood like a mask in a play.

I hope the shards aren't too small
to stick together with glue,
and when your homegirl's gone,
hope you find a new crew.

Mamita, let me give you one small clue:
With "womanhood,"
the physical has only one thing to do –
strength of spirit and mind are what get you through.

Divine hands make you a vehicle for life –
precious,
disposable,
Lover or Wife.
So *Mamita,* start asking without further ado,
Where is the ceremony of womanhood for you?

LA LOCA'S RESPONSE

I
 am
 the heat of fire's fury
and the black scar
 left behind;

the flare of our sun
whose spots
 stain your mind;

an elusive wind,
the lingering chill
 dancing unbound
 in your hair;

the ocean wave
 rise UP,
 taking life –
 seemingly unfair.

the cascading mountain rain
 plunging
 into a misty cloud;

the woman you remember
 unbridled
 in a chaotic subway crowd.

the eroding cliff
gives way,
 changing the face of an ancient mountain.

the knowing patience of old age
and youth's spirited restless fountain.

 the moonlight,
 the mischief,
 the mistress
 of night;

the flash of orange
red and yellow
 in a basement cockfight.

 the shade of indigo to violet
 in a punk-rocker's mane –

I am the One,
 You often call
 Loca... i n s a n e.

 ¡Loooca! Pero, de verdad que tú eres bien loca.
 Girl, are you crazy? Did you see what she did?
 Yo, that girl is crazy!

I
 respond
 with melody as chilling
 as a sword fatally engaged –
 in honor of Mother,
 my song's breath,
 the scent of fresh burning sage...

 EaRth

my body

 Water my bLooD

 Air mY breath,

 FiRe my spiiiiiiriiiiiit...

Melodía

A Bronx Fairytale

In a land to the north, in a musical village known as The Bronx, there once lived a poor couple who wished very much for a child. They didn't have much food or a fancy home, but their love for each other was abundant, and they wished for a child with whom to share this love.

They prayed every day, and lit many candles to shine light on their dream. They couldn't wait to teach the child to sing, and to share the stories of their ancestors. On special days they would invite friends and family to their home to play drums, and sing songs, so that their prayers could be heard on heaven and earth. There was never much to eat but they always made sure to put a small plate of food aside, in the corner behind the door, in hopes that one day a blessed child would find its way to their home.

One evening their prayers were answered and the wife gave birth to a baby girl. The new parents were overjoyed, but the mother's labor made her weak. When she saw her daughter for the first time she wept. She held her daughter close to her heart and sang the most beautiful lullaby that was ever heard anywhere in the world. Her voice sounded like the laughing and splashing of shimmering starlight, dancing in moonlit puddles at night, in every home, and every street corner, in their magical musical village. The song caressed her daughter's cheek like a gentle breeze tickling tall palm trees. The song traveled far and wide disappearing in the night like a red balloon climbing high in the sky. With the sleeping baby in her arms, the mother sang her last breath of life and passed on her light to her daughter. From that day on, the newborn child was known as Melodía.

Melodía was a quiet child, she never cried, or screamed or made any noise or fuss. Her father never noticed how quiet she was because he was so sad and missed his wife very much. When family and friends came to visit, he would turn them away and say, "Not today." Many todays passed. Melodía was a good girl and always did what she was told. When the time came for her to go to school, she was very shy and didn't make many friends. Everyday she came home, did her homework, and then read quietly in her room until it was time to sleep. She never raised her voice above a peep. There was no more drumming or singing, no more food left out, no more candles, and no more prayers. Father and daughter lived in whispers, in their apartment, and many years passed.

On the morning of her thirteenth birthday Melodía awoke to the sound of her father crying. After so many years of sadness she desperately wanted him to be happy. She decided to speak with him to try and sooth his

suffering. Her heart was passionate, filled with love, and when she spoke what came out surprised them both. The moment she opened her mouth they heard the strangest sounds – Water, lots of water. They heard water rushing over rocks in a mountain stream, and heavy rain drops falling in a jungle forest, and giant ocean waves crashing on a distant beach. All these sounds blended and spiraled around Melodía and her father, making them both dizzy. In that instant, her father trembled and shook and all his sadness washed away.

When she closed her mouth all the sounds stopped. They stared at each other wide-eyed in silence. Then slowly, the sounds of their neighborhood returned – cars and trucks passing on the street below, and the thumping bass of their neighbor's hi-fi stereo. For the first time Melodía's father realized how much his daughter looked like his wife, and how special she was. This frightened him. He believed that if anyone learned of her special gift that harm would come to her. He decided to lock her up in her bedroom, in their fifth floor apartment, in their brick building, on their One Way street, in this musical village, and she was forbidden to ever go outside again.

Melodía didn't know what to do. She didn't know where the sounds came from or how she spoke them. She had only been trying to help and now she would be locked in her bedroom forever. Melodía decided that she was going to run away.

It was a rainy, starless, indigo night. While her father slept, Melodía grabbed her umbrella and raincoat and quietly slid open her bedroom window gate. She climbed out of the fifth story window, onto the rusted iron fire escape, and descended its stairs until she reached the street. She didn't know where she was going, but she knew she had to move fast, so she opened up her umbrella and headed towards the subway.

She had never been out at night, or taken the train alone, so she was scared. She found her way to the station and went downstairs but realized she didn't have any money. When she was sure the token booth clerk was not looking she did what she had seen many people do before – she squeezed herself beneath the turnstile and ran. The subway platform was deserted. It was silent and the florescent lights flickered on and off, on and off. She was very nervous and couldn't stand still so she walked towards the distant end of the long platform. Suddenly, from behind an overflowing trash bin, a dusty gray rat with piercing red eyes and pointed sharp teeth jumped out in front of her and ran across her feet! She screamed. From her throat came the sound of a thousand screeching bats echoing in a cave. She started running fast, and then faster, and without looking behind her, headed straight for the entrance to the dark subway tunnel.

She ran into the tunnel and made many turns left and right through countless dimly lit corridors. When she was out of breath she stopped running and realized she had lost her way. She was terrified and desperate to find her way back but didn't know how. Gradually her eyes adjusted to the darkness and she took a good look around. Her ears were able to hear all the sounds of the tunnels, water droplets, and distant trains. Then she realized for the first time that she was not alone. She looked down and saw a small gray mouse squeaking at her feet. He was almost invisible on the tunnel floor, and was so little that if he hadn't been squeaking and making such a big fuss, she would never have noticed him. He was running in circles around her feet and then ran towards an old stone archway that led to a tunnel away from the rumbling train tracks. He looked back at her and then kept on going. She didn't know which direction to turn, so she decided to follow the little gray mouse and see where he would take her.

After walking for a very long time, the squeaky gray mouse slowed down, and then got quiet, until they were both tip-toeing, him on four legs, her on two. When they reached the end of the passageway the mouse stopped and Melodía took a good look around. To her surprise, on the ground before them was a nest with three small eggs. Sitting protectively on top of the nest was a single white pigeon looking up at her. Melodía had never seen a white pigeon before. Her surprise quickly turned to concern when she realized why the mouse had brought her here. The pigeon was hurt. One of her wings was broken and she was crying, "Coohoohoohoohoo... Coohoohoohoohoo." The mouse went to comfort the pigeon. They spoke squeaking and cooing to each other. Melodía watched the whole time until they got quiet and turned to look at her. That was when Melodía remembered that her voice had made her father's sadness go away. She put down her umbrella, took one step closer to the pigeon, filled her heart with hope, and then opened her mouth. A concert of wings flooded the tunnel: the wings of pigeons and butterflies, eagles and hummingbirds, seagulls and moths, doves and dragon flies, honeybees and lightening bugs. All their wings flapped together as one and embraced Melodía, and the mouse, and the pigeon.

When Melodía closed her mouth everything became quiet. Then slowly, the familiar sounds of rumbling trains could be heard in the distance. Melodía and the little mouse looked at the pigeon. The pigeon looked back at them, and before long they were all smiling and laughing as the pigeon flapped both of her beautiful wings and flew high above her nest. Melodía and the mouse danced on the ground in celebration, when all of a sudden, out of a dark corner appeared that big ugly rat with sharp pointed teeth. It flashed its bright shining red eyes at Melodía and ran towards the nest to eat the pigeon's eggs. The pigeon squawked in horror, but before she could get to her nest Melodía grabbed her umbrella and whacked the red-eyed

rat right on his head and sent him running towards the loud train tracks. She chased him down the tunnel but he was very fast and was getting away. Melodía stopped running. She closed her eyes, took a deep breath, and with all the courage she could carry in her heart she opened her mouth. Deafening lightening bolts and thunder claps were heard throughout all the subway tunnels all over town – from the musical village of the Bronx to the Hills of Cypress, from the Queens' Meadows to the Seaport of South Street. Fear raced into the heart of the red-eyed rat. He was so scared he ran blindly into the rumbling tunnels and was squashed – dead – by an oncoming train. Never again would anyone have to worry about that big ugly red-eyed rat.

Melodía's stomach grumbled. She became overwhelmed with hunger and couldn't wait to be home. She returned to the mouse and pigeon and asked if they could help her get out of the tunnel. The mouse was happy to help. Melodía said goodbye to the joyous pigeon who stayed behind "cooing" over her eggs. Melodía followed the mouse a long way back, through the winding passageways, until she finally saw a light in the distance. She thanked the mouse and by herself followed the steady light as it got bigger and brighter leading her all the way out of the tunnel, through the train station, past the turnstile, and up onto the street. It was already morning.

She rushed home as fast as she could, not wanting her father to worry. She arrived at her brick building, on her One Way street, and climbed the five stories to reach their apartment. She burst through the front door and found her father crying in the kitchen. When he saw her they embraced and Melodía spoke to her father gently, in her quiet voice, as they wept in each other's arms. Her father brought her to the front door and showed her the plate of food that he had left for her in the corner behind the door, hoping that it would help her find her way home. Together they sat down and ate. Melodía's father promised he would never lock her up again, and together, they made another decision: They were going to invite all their family and friends to their home to celebrate Melodía's thirteenth birthday.

Everyone came and embraced Melodía with drumming, singing and dancing. She listened to her family tell stories about her ancestors, and she lit a candle so her mother's light would always shine on their home. Melodía's heart was filled with the most joy and love she had ever known. Tears collected in her eyes, and as she opened her mouth to thank them all throughout the land everyone heard the laughing and splashing of shimmering starlight, dancing in moonlit puddles at night, in every home, and every street corner, in their magical musical village to the north known as The Bronx.

MAGDALENA GÓMEZ

Magdalena Gómez es poeta-actriz, dramaturga y promotora cultural "borikua-gitana" desde 1971. Sus poemas se encuentran en muchos currículos en Estados Unidos y en numerosas antologías y revistas, incluyendo *Latino Boom, Tea Party Magazine* y *upstreet Journal*. Colaboró a menudo con el compositor y saxofonista barítono Fred Ho. Gómez se presentó por primera vez como poeta-actriz en el teatro Dramatis Personae en la Calle 14 en Manhattan, un domingo en que los espectáculos sexuales de hombres gays abrían un espacio a los poetas. Ha presentado sus obras en diversos lugares, desde las prisiones al Lincoln Center, desde los monasterios a la Universidad de Vanderbilt y el Brooklyn Academy of Music. Como artista y educadora, ha trabajado con audiencias que van desde los jardines de infancia a escuelas de posgrado y ha trabajado también con comadronas, trabajadores sociales, presos y jóvenes detenidos por ofensas sexuales. Gómez es co-fundadora y directora artística en Springfield, Massachussets del Teatro Vida, un teatro de performance multidisciplinario que ofrece entrenamiento intergeneracional cuyo propósito es crear un espacio para la creación de obras originales por los artistas locales, además de inspirar liderazgo, alfabetismo y compromiso cívico. Es también columnista de *An African American Point of View* newspaper. La intención de toda la labor de Magadalena Gómez es desmantelar la opresión y el fanatismo en todas sus formas a través de los medios creativos como instrumento para la educación, y reclamar las voces y el poder de El Pueblo: "No se dasanimen, creen arte y emprendan la acción".

Bronx-born Borikua-Gitana **Magdalena Gómez** has been a performance poet, playwright and cultural activist since 1971. Her poems can be found in curriculums across the U.S. and in numerous anthologies, magazines and journals, including *Latino Boom, Tea Party Magazine,* and *upstreet Journal.* She collaborated regularly with the composer and baritone saxophonist, Fred Ho. Her first live performance was at the Dramatis Personae Theater on West 14th Street in Manhattan where Sunday afternoons the gay men's sex shows made room for poets. Gómez has performed in diverse venues from prisons to Lincoln Center, monasteries to Vanderbilt University and the Brooklyn Academy of Music. As a teaching artist her work has spanned kindergarten to post graduate. She has also worked with mid-wives, social workers, the incarcerated and youth sex offenders. She is the co-founder and artistic director of Teatro Vida, a multi-disciplinary, intergenerational training and performance theater based in Springfield, Massachusetts for inspiring leadership, civic engagement and creating venue for the creation of original work by local artists. She is also a regular columnist with *An African American Point of View* newspaper. In all of her work, Gómez's intention is to dismantle oppression and bigotry of all forms by creative means as a tool for education and reclaiming the voices and power of The People: "Don't despair, create art and take action."

PLUMS AND SCISSORS

sleep walking into closet
squat
piss into
mami's
size 4 1/2 shoes
bound feet
of malnourished
sex traffic
on the Dominican/Haitian
U.S. knuckles of Trujillo's fist
Journey from
open sewage childhood
of pro-industrial
Borikén shanty town
El Fanguito
feet shrinking on their own
afraid to touch
contaminated ground

feet first
I kicked my way out
of horror
causing more horror
her tiny womb shrunk by
force of will
keeping out monsters
and foreign objects

I was too big
for Mami's little life
of semen drenched corners
and torn hair
rage came with motherhood
wild jet leaking
diesel
fiery landing
on my body
my face
broken veins
from years of slapping
covered by makeup
twisted mouth
from years of sneaking
out terrible prayers:

please Jesus help me
kill her

perseverated litanies
cutting plums
with scissors

please Jesus
help me kill her

urine screaming
everywhere
screaming
into her perfect rows
of unworn shoes

in her seamstress hand
a needle
in her eyes
the downward threat
to my toto
with machete pulled from
my guilty vagina
I killed
her
I killed
her
I killed
her

Lolita's bullets
in my mouth

Cane field
in my stomach

Luisa Capetillo
In my will to live

Don Pedro
in my will to live

hens cackle wildly
trapped in towers
far from touching ground
pecking post colonial
dissertations
on cracked walls;
scabs forming
over infested
tenure tracks;
post colonial
discourse over
egg salad.
the only post
is the one with which
I must defend myself

again
and again
and again
trafficked by
the language of denial.
gandules jump off white rice
in a mass suicide of shame;
my body for sale
on the open colonial market
the instant best friend
of ignorance
on diversity day;

my feet
naked, large
swift
kick hard
break the teeth
of history's
dirty mouth

Yammering liberals
escort me to
an aluminum tray
of dried pork scraps
cozying up to
Boston crème pie
my stomach churns
all the vowels
in HURACÁN

I am pissing
into the right shoes
at last;

¡despierta!

a thousand abortions
by omission in THIS
post colonial body
in this nuevo San Juan
my body the sheath
of memory's blade

In the mirror,
my mother's face.
I no longer cringe.

Now we are both free.

MIDNIGHT LONELINESS, 1962

Something about
cheap linoleum and bare feet
window open
just a crack
releasing steam heat.
Kennedy still alive.
Good noise
on the street.

Upstairs the lady
with 3 kids
by 5 different men;
puta, puta, puta
pea green poverty's
neighborly lullaby

Tía battled
pork chop grease
dumped out of angry windows
onto her happy white sheets
tugging on the rusted pulley line
singing along
to Carlos Gardel 78's
en la vitrola
dreaming with her cafetera
of who she might have been
dreaming with her tea kettle
of a cozy winter
ignoring the pain
in her left calf
filling the tin wash basin
with Tide and Blue;
a pressed nylon slip
the last thing placed
on the bedroom chair
before setting the 4:00 a.m. alarm.

There was never a seat on the train
Tía memorized the faces
on the Chesterfield Ads
avoiding men with beer breath
and eye mucous,
securing the top button
of her coat
discreetly checking the seams
of her stockings
ignoring the swelling in her left calf.

The monotonous opera
of sweatshop machines
hushed one day,
long enough for El Foreman
to curse the inconvenience
of Tía's body
slumped over the Singer,
a silver bobbin still clutched in her hand.

The ambulance reserved for Puerto Ricans
limped on one wheel;
Tía was still alive,
when the icy stethoscope
slipped under her breast
the sweaty, freckled
EMT rookie
shouted,
slapped her
gave her mouth to mouth;
compressing, counting
releasing,
eyes blaming,
mouth afraid.

Too late.
The rolling bobbin
was not heard
above the frantic needles
and sobbing women.

Carlos Gardel would be singing alone
in the midnight loneliness
of Simpson Street.

THE BORIKUA WHO SANG BROKEN BOLEROS

Don Sinforoso claimed the Valencia oranges crate
outside of Doña Hilda's botánica
where for $5 you could receive advice
on any subject and a holy card of
San Martín de Porres
the only black saint we knew about
in the South Bronx. Well maybe
there were others, but nobody
told *me*.

Don Sinforoso started everyday
with cuatro palitos of whatever he
could get at the Crosstown Bar
for the change he
collected the day before
from the women who couldn't resist
his tears when he sang boleros
with a voice that could grate yucca.

Don Sinforoso
(who secretly hated his own name)
 called the black saint
Martín de la Porra and immediately
begged the Vírgen María to forgive his
blasfemia, crossing himself,
then kissing his thumb,
presumably representing
the Body of Christ.

Don Sinforoso, always the gentleman
in the presence of women
and girls, tipping his invisible hat, extending an invisible rose, bowing until
the corner had gulped the last bite of
feminine shadow.

He swore in a loud voice that he had
learned his good manners in Korea
where he had to kill people
who were better than he was,
including women and children.
He swore on the eyes
of his mother and the virgin vagina
of his sister, that it was the Chinos
who taught Puerto Ricans and Dominicans,
and Cubans how to eat rice.

He swore on the kidneys of his long dead father
that we were all mental defectives
which was why we ate with forks
instead of chopsticks.

Don Sinforoso assured us the world
would be a better place
if everyone could confess their sins
and have the *cojones* to admit
that somewhere deep in their livers
they hate *Negros y Chinos* and then repent.

Repenting, he assured us
would be the hard part.

EXECUTIVE ORDER 9066

mother
sits silent
while husband
fingers their daughter
in the next room;
how can she not hear
the feral, stacatto exhalations
of diseased pleasure,
feel terror's knot
take root?
Tuber lodges
horizontally
between lungs,
grow thick
deviates normal
course of blood
how can she not see
the eyes now missing
from her daughter's face?
Military necessity.
Tongue:
Internment.
Throat:
concentration camps.
Truth:
nothing has changed.

A COLONIZATION WE DON'T LIKE TO TALK ABOUT

pretty blanquita
baby girl
turned heads from the crib
excitement ran like a drunken piss
through the family
shrill titis y primas y vecinas
metiches
bochincheras
noveleras
comemierdas
sang alleluyas to her pink skin
a glass of milk among the flies.

A new day was coming
messianic rubia would finish college and marry well
would of course snag a Jew

for in that part of the Bronx where she had
the destiny to be born
it was believed among Puerto Rican women
of her time that Jewish men made the most
docile husbands who would not cheat
or beat their wives.

In fact, it was believed that Jewish
women abusaban y mandaban
their men and they were to be married
out of pity;
Puerto Rican women
know how to treat a man
and feed him more than matzoh balls
these Boricua women also believed
Columbus was the hero
who discovered them and their island
and only knew of Hitler as a man
with a stupid mustache who was a cochino feo who spit when he talked
and should go to the Dominicans
and get a haircut
because those Dominicans
can cut hair
as much as they hated to admit
anything good about Dominicans
(oh yes, and they make excellent cakes)

these women
were born into sweatshops
and housing projects
these women went to schools
where they were shamed for
speaking Spanish, forced to speak English
they learned to hate it
never learned to read it
or read at all;

these women didn't know
Africa or Arawak Nation
in their bones.

These women
spent their lives
window shopping
in America.

These women are
the wheel inside my
forehead.

DIANA GITESHA HERNÁNDEZ

Diana Gitesha Hernández nació en Santurce, Puerto Rico, hija de padres de San Juan y Ponce. Al mes de nacida, la trajeron a vivir a Nueva York, donde reside. Es una performera que se desempeña en múltiples medios artísticos, combinando versos y música en sus creaciones. Es autora de los chapbooks: *Slingshot Luv* (1985); *Love Poems From a Nuyorican Princess Dreaming of Rimbaud* (1985); y del poemario *Raw Lips Melao, a Nuyorican Rhapsody* (2004). Su poesía se ha publicado en las revistas literarias *Longshot, BE Magazine, Sound of Water* y en las antologías *Heal; between the pages of these folks we seek a panacea* y *Aloud!; Voices from the Nuyorican Poets Café Anthology*. Su obra se incluye en las colecciones de poesía (discos compactos) de Farid Bitar, *Fatoosh* (2007) y Brant Lyon, *Beauty Keeps Raising Her Sharp Knife Against Me* (2007). Ha presentado su obra en la radioemisora WBAI; en cafes, centros culturales y otros lugares para leer poesía en la Ciudad; como miembro del Barry Harris Jazz Chorus Ensemble; y con su propia banda musical, Orgasmic Orquestra. Hernández se dedica a la meditación y es también instructora de yoga, masajista, pintora y grabadora.

Diana Gitesha Hernández was born in Santurce, Puerto Rico, of parents from San Juan and Ponce. When she was a month old, she was brought to New York City, where she resides. Hernández is a multi-media performance artist, poet and jazz singer, who often weaves music with her words. She is the author of two chapbooks: *Slingshot Luv* (1985); *Love Poems from a Nuyorican Princess Dreaming of Rimbaud* (1985); and the poetry book **Raw** *Lips Melao, a Nuyorican Rhapsody (2004).* Her poetry has been published in the literary magazines *Longshot, BE Magazine, Sound of Water* and the anthologies *Heal; between the pages of these folks we seek a panacea* and *Aloud!; Voices from the Nuyorican Poets Café Anthology.* Her work has also been included in Farid Bitar's CD Poetry collection *Fatoosh* (2007) and Brant Lyon's collection *Beauty Keeps Raising Her Sharp Knife Against Me* (2007). She has been heard on WBAI, poetry venues throughout the city, as member of Barry Harris Jazz Chorus Ensemble and with her own band, Orgasmic Orchestra. Hernández is also a school counselor, yoga instructor, massage therapist, painter/printmaker and meditator.

VAYA, BAYAMÓN!

I want to breathe in that lucky soil and taste
the sand of sweet
return
my long hungry beak
entering the very airs
of Coquí
these ancient sounds swelling up the night
in Bayamón
where river flows to sea
and the music of the congueros keeps
turning off the brain
and here in a luxurious embrace
within the island of my birth
my New York heartbeat calms itself
from its' stormy cacophony

Returning to womb
of sea salt sand
into a deepening Indian raga
in harmonic swirl
Los Peekyhooyees*
soak in the Sun
Foam, Stone
As we dance the song
Bayamón!

In swoon, the music flutters
in the sea breeze afternoon
as Coquí, your dark night makes waves
towards your ancient jazz
sea that flows to ocean
palms that motion to the congueros beat
the body making nonsense - Stop!
and here falling into a deep restitution
your rhythmic caress
releases me ...
Vaya, Bayamón!

* Extra tall stick figures of my mother's imagination used to keep her wayward
daughter in line. In this poem, they are playful and dance.

Poem for mami

for Milagros "Millie/Mite" Hernández

Here in the quick of it
water falling
out of clouds
translucent tender radiant
as thick eyes
descend
the space we're in
we go on falling
approaching the wonder that keeps us
bewitched
suspended
and between worlds

New York Puerto Rico Sing-a- pore
and the Bronx
cold sweat Mami
your bleached blonde locks
against the open sky
nitty gritty beans a cookin'
your song
as it perfumes
the small kitchen of my youth
salsa and the sangria of your love

You'd tell us about when you were little
how you lived behind the governor's mansion
next to El Morro
and you'd roller skate with the governor's daughter,
Esa blanca Americana
y cómo te llamaron "La Americana" too
y cómo te gustaba comer esa comida gringa
escargot and blanched potatoes
on French 100 dollar table clothes
dance for your dinner
native that you are
your castanets, and 5 foot seven
body browned from sun days after Sundays
batting your long libra lashes at the Governor's house
and how special that made you feel
aspiring to Debbie Reynold's and Elizabeth Taylordom's
las novellas that flung you far
from the shores of Puerto Rico
away from coconut mid-summer afternoons

Sand with shells, alcapurrias, Latino men
whose desires you'd leave far behind
as you set sights for a new world
where you had visions you'd become far better
than where you came
Doctor Lawyer Indian Chief, anything was better
than shacking up with a broke brother who would
knock you up, & leave you barefoot & pregnant in the kitchen

I remember looking hard
at the lines drawn on my hand
the distinctions of color
that was my birthmark
pink to browns from palm to hand
your high aspirations which placed our souls
in anglo schools
where my Puertoricanness would escape me
before schoolyard nights could claim me
the only Puerto Rican in a school where
none had heard of us, yet
and they would say…
"Hey, Puerto Rico… ain't that in Africa or something!?"
Day after day I'd eat my jamón de pote and
the Japs would say "What that?" or "Didn't you have that yesterday?"
They'd down arugula salmon salads and roast beef sandwiches….
you wanna trade?

Ah Mami!
having understood what you'd done
I understand what you did
wanting more for us than what you had had
your dreams for us
gracias por todo PERO
(but) now
I dream of what you left behind
the Island in the Sun
and I know it won't ever be the same
as it was back when

Innocence bought, packaged and sold
welfare lines left scars all over our paradise
weakened the spine of the Indian Spirit
and what's left
Owners – rich, foreign, and bald
as natives claim deep fried cuchifrito stands serve ice cold beer
while desiring this white-washed dream – Amerika!

Where everyone is so rich and pretty
and there is always so much plenty of plenty

at least… to look at!
but what I desire is to return to mami's memoria
to have a piece of my root
a patch of sky, a slice of sand
where the whispers of the sea
returns me to that place where earth holds my symmetry
and the rhythms move my feet
to my Puerto-Rican soul
you call me,
call me, Home
as my roots pulsate
back to you,
Mami!

SINCE I CAN NO LONGER FORGET

para Abuela

Since I can no longer forget
The smell of your body
Near you
In the sacrament of our love
Get closer to me still
Tell me tus cuentos
The history of the saints
That lived in the sea, Yemayá!

Tell me again
Of your first love
How it seemed as if you'd fallen
Into the Sun, embracing it with your tinted hands
Hands that knew earth
And your lips, pure blood
Full of wine and repose
Embedded in your smiles
You'd reveal secrets
Words could not

You'd lift me up towards the moon
And made me laugh
You who always cared for me
Better than they
Being such a mantequilla-en-palito*
Back then, afraid of everything
Within your eyes
You placed me in trees

* butter on a stick = scary-cat

Tranquil and sacred
Your love was such,
That
Even now, I can no longer forget.

HOOKIS POOKIS

(for Reverend Pedro Pietri)

It is true that those
who suddenly disperse
keep us
in suspense
forever? RISE TABLE RISE

Oh Reverend Pedro Houdini
hovers somewhere above
Mexico and Texas
awaiting a drop

Sandwiched in a cloud
Peter Pedro Pietri
in a trance
caught the lift to
the next dimension

Perchance some Poet's paradise
where refer, and laughter
and liquid dreams
melt into DOWOP
his national anthem
is Spanglish sung by his handsome
BADDDD self and reverberates through irregular time

3 races --- braided together
a mono superstar exemplifies a future bred race of the future
and he ---

A simple condom thrower
a poem bearing Joe
Poeta laureate on the planeta
NYC when he left town
and said to keep his seat warm
Sombrero Zorro stares at you with
marbled eyes, clothed in black

Bops into position, *HEY MAN*
WHAT"S UP?... I Mean, WHAT's Down?... in other words or worlds
Can you tell me...
where can I find some COOOOOKIE!!!!!!
snap
POT
Man, is it ever boring
up HERE or...
can I get a pass for acting naughty....
the SILENCE is KILLING ME (me estás matando)!

he laughs
and laughs
and laughs.

MY TURN TO BURN

Making that ole hambone wail
Sailing through stormy original
to the land of magnificence
Oh bent nocturnal after-thoughts
dimensions loosen their garments
as we are struck

by the ethereal of Oh Lean Mama
in the quest and thirst of your third eye
in a crowd diffused
I am your genie (the thin fluid of it)

Night breaking night
spent on bent tongue
I approach encroaching
I've listened to the crackling of the candles
long enough,
and now it's my turn
to burn.

DAHLMA LLANOS-FIGUEROA

Dahlma Llanos-Figueroa es narradora, ensayista y educadora. Nació en Puerto Rico y se crió en la ciudad de Nueva York. Publicó la novela *Daughters of the Stone* (2009), seleccionada como una de las diez mejores novelas del año 2010 por las revistas electrónicas *Black Pearls* y *LatinoStories*. Su obra se incluye en las siguientes antologías: *Lost and Found: An Anthology of Teacher Writing* (2003), *Acts of Emancipation: An Anthology of Teacher Writing* (2005), *Rosebud* (Spring 2005), *Chicken Soup for the Latino Soul* (2005), *Growing Up Girl: An Anthology of Voices from Marginalized Spaces* (2006), *Chicken Soup for the Soul: Older and Wiser* (September 2008), *Woman's Work: The Short Stories* (2010) y *When Last on the Mountain: A View from Writers Over Fifty* (2010). Ha publicado también en *Wordsetc* (August 2008), una revista literaria de SudÁfrica. La revista literaria electrónica *Narrative Magazine* publicó su ensayo "Cuban Portraits" en el otoño del 2007. Llanos-Figueroa fue maestra de literatura de inglés como segundo idioma en las escuelas públicas de Nueva York por muchos años, sirviendo luego a la comunidad como bibliotecaria de escuelas superiores. Ha conducido talleres literarios para adolescentes y adultos en el área metropolitana. Vive en el Bronx.

Llanos-Figueroa recibió los premios BRIO (1997 y 2002), ACE (1995) y el Premio de Artes Literarias (2006-7), otorgados por el Concilio de Artes del Condado del Bronx (BCA). Fue finalista en la premiación del PEN/ America Robert Bingham del 2010 por su novela *Daughters of the Stone.*

Dahlma Llanos-Figueroa is a fiction writer and educator; born in Puerto Rico and raised in New York City. She published in 2009 her novel, *Daughters of the Stone,* selected by *Black Pearls Magazine* and *LatinoStories. com* as one of 2010's best fiction. Publications also include short pieces in the anthologies *Lost and Found: An Anthology of Teacher Writing* (2003), *Acts of Emancipation: An Anthology of Teacher Writing* (2005), *Rosebud* (Spring 2005), *Chicken Soup for the Latino Soul* (2005), *Growing Up Girl: An Anthology of Voices from Marginalized Spaces* (2006), *Chicken Soup for the Soul: Older and Wiser* (September 2008), *Woman's Work: The Short Stories* (2010) y *When Last on the Mountain: A View from Writers Over Fifty* (2010). Her literary work has been included in *Wordsetc* (August 2008), a South African literary journal. Also, her essay "Cuban Portraits" was published in the Fall 2007 issue of *Narrative Magazine*, an online literary journal. Llanos-Figueroa taught in the New York City school system before becoming a young adult librarian. She has also led creative writing workshops for adults, young adults and seniors throughout the tri-state area. She lives in the Bronx.

Llanos-Figueroa has won a Bronx Council on the Arts ACE Award (1995) and two BRIO Awards (1997, 2002), as well as a BCA Literary Arts Fellowship (2006-7). She was selected as runner up in the prestigious 2010 PEN/America Robert Bingham Literary Award for her novel, *Daughters of the Stone.*

MAPPING

I remember what it was like. The first few years. Before the children. I remember our nights together in wondrously rich textures. I don't remember the words--but back then, we didn't need words.

When Toño came home after a day in the cane fields, after the animals had been fed and the shutters closed, he brought me the clean smell of the earth on his skin. I looked forward to closing our door so I could take in the scent of the soil which made me feel that we were part of a larger design which stretched back to the beginning, when there was just man and woman and nature and everything was green and fertile.

My favorite position was cucharitas, teaspoons, a position in which I settled my back into his chest and he folded himself over my like a giant poppy. For a while, we just laid there--him feeling the protector, a shield between my softness and the harshness of the world. I loved surrendering myself to his strength. Few people would have thought of me needing protection, for I have always been a large woman and seemed always in control. This was a side of me that only Toño knew. And though he is not an unusually big man, he used his body well, wrapped himself around my shoulders and legs so that I felt warm and treasured and safe.

I remember his rough cheek on the side of my face, feeling just a little too heavy, his mustache curling at the sides. Time; we seemed to have all the time in the world back then, smooth, evenly unwinding time. And I used that time, that nighttime to study him with my skin.

The back of my body knew him better than my eyes or my hands. My shoulders knew the shape of his chest, like umber hills of rolling, pulsing earth. My back recognized the shallow, shadowy valley between and the thick eel of a scar over his left nipple. And the curve of my waist knew the muscles that smoothed over his ribs and trembled slightly if I lay there too long.

My buttocks knew the tickle and whisper of his pubic hair as I tried to imagine each individual one coiled into a tight curl, ready to spring at my touch. And I'd continue learning him with my flesh, lower where he fell away when he bent his knees, just a little, so that we could more easily complement each other in this position. Inwardly, I mourned the few inches of him that I couldn't quite reach, moaning, not out of pleasure but out of the pain of the loss of that part him.

Sometimes, he'd come closer, resting himself between my thighs. And I'd feel him moving slightly, rhythmically and marvel at my ability to transform that soft, vulnerable part of him into something quite different

and demanding. Eventually, he'd move his leg, dropping its weight on my thigh. He would be ready to go on but I would hold back just long enough to finish etching the map of his body onto my back, memorize it, lock in its healthy hills, its fertile valleys, its triangular pasture and finally its surging river. Yes, I stored it away so that when he'd be cutting cane all day and I'd be cooking over the coal fire, I could call him back in my mind and on my skin and explore the map on my flesh and anticipate the next time.

When he could wait no more, he would squeeze my hips impatiently between his legs and the low humming tremors would give way to full fledged quakes and I wouldn't be able to hold out any longer. I would feel a cold draft as I pulled away from him momentarily to turn and face him with a smile on my face. Then, shivering, we'd close in on one another again.

Yes, I remember those times well. Before the twin hurricanes, San Felipe and San Cipriano. Before the Depression . Before my perpetual weariness and our constant worries about the weather, the crops and the money. It was before That Damned Woman and before the babies.

It was those two babies that did it, you see. They were the ones that broke my back, that tore my skin and froze my heart. It was the baby in the coffin and the one in the cradle. It was ours who would have been named Cristian and hers who ended up being called Cristiana.

It was my fear and aching loss. It was the stabbing pain when I heard about the other child. It was the exploding anger. It was the stinging betrayal. It was the deadening of all joy. And then there was the silence and the distance. I turned to stone, right there on our bed. And the mapping died.

Those were our bad times, our really bad times, when we let the little bits of life drive us apart. It seemed then, that the teaspoon times were just a fantasy, the life of some heroine in one of those romantic novels I no longer had time to read. Other children came, other crops, other celebrations and other tragedies. For years, I had the same dream. I dreamt that I had lost something I would never find again. And I'd wake up wet from the sweating and the tears.

But there was the land, the family, our world. We faced one morning after another, one year after another. We found joy in our children's faces. We worked together, built together. We lived our lives together. But the mapping was long forgotten.

One rainy day, the sleeping sickness came to our house. I got a good look at the face of death peeking in the windows, all big and bold and ready to come strutting in and making himself at home. I got ready for the fight but it had not come for me and I watched as Toño fell into a heavy slumber.

The doctor's mouth said coma. His words kept coming, falling all around me, mortality rate, brain disjunction, hopeless, impossible; words I didn't recognize. I looked at the young man in his white clothes and soft hands and I looked down at Toño. The words were still coming, drowning out my life and I couldn't let him do that.

So I sent the words away and the pictures floated up to meet me instead. I saw our flattened house and the pieces of our world that we gathered after the hurricane. There was Mercedita, smiling and happy on her graduation day. I remember her in her nurse's whites, all shiny and new. Then there was José, walking away from us and on to a plane, all grown up and handsome in his military uniform. I saw the same plane bringing us his coffin. They took our son and sent us a little triangle of a flag--not even our own. Then, the happy faces in the church full of friends and neighbors when Pepín, the first grandchild was christened. And yes, even the picture of the funeral so long ago. There I was womb empty and aching, our baby cold in his tiny coffin. There she was full and fertile, holding their future in her womb. I couldn't nurse our baby so I nursed the pain. I saw myself draped in bitterness, sheathed in righteousness. And I made Toño pay tenfold for his betrayal. That was the hardest picture to face, the one I had buried so deep within myself. I had fed on that pain for years, denied myself and Toño so much. After all those years I found that that picture too had faded.

"... sorry I can offer you little hope...," El doctorcito was still talking.

I looked out the window behind him. It was still drizzling but the threatening waters in his words began to recede.

"Shh, doctor, you'll wake my Toño," I said, smiling down on my husband.

"Pero, Señora, you don't understand..."

It was he who did not understand. So I turned away.

I continued looking deep into the closet of my soul. In my mind's eye I examined the photographs of our lives, faded colors, cracks, curling edges and all. I revisited old memories like a continuously revolving landscape. I sniffed out every dream that was and never came to be. I took out the double scales of good and bad and began weighing and measuring. I poked and prodded at myself, dug into every wrinkle, followed every curve, explored every shadow. And always, always, there was Toño in the background. Always, the quiet, warm man standing beside me.

When my mind came back to that hospital room, the rain had stopped and the sunlight fell on Toño's face. *You come back to me, Viejo. It's been a long road and I don't know how to do it alone no more and am too old to learn. We got too much together and nothing alone. So you come on back,*

Negro. And I'll be here waiting when you do.

<center>⁙</center>

After many days, Toño opened his eyes and smiled, as I had prayed he would. I thanked the doctorcito who still did not understand. My Toño and I held hands as we went home from the hospital, leaning on each other. We walked out into the sunlight and started our life again.

So it was that when the children were children no longer, all grown up and gone and with children of our own, when our own intimacies had become an occasional, fading memory. When we were gray-haired grandparents and the grand music of our lives had settled into constant, softly played melodia on classical guitars, when we were ready to live out our lives in the quiet rhythm into which they had settled, something happened. Just when we had been presented with a matching pair of the solid rocking chairs of the aging, it came back, the mapping.

It wasn't quite the same, the images had faded and the ink was a little less distinct. The terrain was flatter, had shallower indentations, but it was undeniably there. We began to study each other like new lovers, no, like old lovers rediscovered. We found the deeper understanding brought by the experience of a lifetime together, a quiet love for the years and an appreciation for the mellowness of time.

The rockers sat idle and empty many an evening when Toño and I blew out the lanterns and locked the front door early in the evening. Thinking us tired and in need of rest or perhaps secretly ill, our children worried about their aging parents. They voiced their concerns about the lack of energy that was driving their parents to sudden old age, insisted on doctors and visiting nurses and even consulted the priest.

Toño and I smiled. We reassured our children about our excellent health, thanked them for the rockers and the concern. And continued going to bed earlier and earlier every night and staying there later and later every morning.

Ana López-Betancourt

Ana López-Betancourt es poeta, trabajadora de teatro y educadora nacida en Canóvanas, Puerto Rico. Ha vivido en Nueva York desde la adolescencia y escribe en español y en inglés. Co-editó con Myrna Nieves y Maritza Arrastía el libro bilingüe de poesía y prosa *Tripartita: Earth, Dreams, Powers* (1990). Ha leído su obra en espacios culturales como American PEN, El Museo del Barrio, BACA Downtown, Boricua College, Rutgers University, Hostos Community College, the Nuyorican Poets Café, University Settlement, Union Settlement y en programas de radio. Estudió teatro con Ilka Tanya Payán, Ivonne Coll, Carla Pinza, Héctor Luis Rivera (Grupo Tebas) y colaboró en la producción de varias obras teatrales. Sus poemas se han publicado en las revistas literarias *And Then* y *Brújula-Compass*. Actualmente se desempeña como coordinadora de un programa laboral en Forest Hills Community House. López-Betancourt, que posee un BA de Boricua College, trabajó por muchos años enseñando primeras letras a adultos a través de la literatura y fue directora de programas de primeras letras para Literacy Volunteers of New York.

Ana López-Betancourt is a poet, theater worker and educator, born in Canóvanas, Puerto Rico. She has lived in New York City since adolescence and writes in both English and Spanish. In 1990 she co-published the bilingual book of poetry and prose *Tripartita: Earth, Dreams, Powers,* with Myrna Nieves and Maritza Arrastía. She has read poetry at various cultural spaces, including American PEN, El Museo del Barrio, BACA Downtown, Boricua College, Rutgers University, Hostos Community College, the Nuyorican Poets Café, University Settlement, and on national public radio. She studied theater under the direction of Ilka Tanya Payán, Ivonne Coll, Carla Pinza, Héctor Luis Rivera (Grupo Tebas) and assisted in several theatrical productions. Her work has been published in the literary magazines *And Then* and *Brújula-Compass.* She currently works as a Work-force Coordinator for Forest Hills Community House. A graduate of Boricua College, for many years she worked at teaching literacy through creative writing and as Director of literary programs for Literacy Volunteers of NYC.

ORÍGENES

My father's great-great-great grandmother
Died in childbirth on another continent
They say she had named his great-great grandmother
Mamá Chana-bien pasú pasita tanta pasa-
Because her hair was so thick at birth
That a hurricane slid right off her head
They say she grew into a big black bruja africana
Who walked the earth with a plena beat

My mother's grandmother- Mamá Juana-
Was born on the island- criolla-
They say she told stories about her own grandfather
Who used to turn into birds to escape from the cops
They say he could turn clear roads impassable
With mallas and brambles and such as he passed
She lived to be 100 years old

They say when she died
She had nails on her hands and feet like a gavilán

Her daughter Luisa la Hermosa
With her coconut smile, her molasses talk and her saucy walk
Personified Campo Rico's claim to beauty
She was crowned the Queen of mulatas
Five years in a row
At the Patron Saint's feast
They say she turned into a Baptist fanática
Who ate canned green chickens for lunch

My daughter's great-grandmother— Regina- Nina-Nini
Named after some old Spanish queen
Had a face like sun-kissed gardenias and eyes like a piece of the sky
They say she crowned her sunflower hair with fancy combs of carey
And white lace mantillas from her madre patria
They say she loved to attend the misa de gallo
She was a católica, apostólica-romana every day of her life

I knew her to be a stubborn gallega
Who fought the invasion
Of the booted legions
Who charged up the mountains
With Protestant bibles
They say when she died – her death-
Broke up a legacy of family unity for life
And the women's inheritance
Se quedó en el aire

Nina's granddaughters live in a city
Where some crazed bastard offers
1000 points of light
I have to write it all down for her great granddaughters
Those men that took over
Traded a good yunta and a plot of land
With the pasofinos thrown in for good measure
For a Korean War, a 57 Chevy and a three bedroom flat

The women have history – that's all-
They chant like their tatarabuelas
They're neither africanas nor criollas
Neither católicas nor Baptists
One hundred years from now
I want them to say
Those women were Buddhists
Every day of their lives...

ON FAMILY SECRETS

it took me a long time to know secrets
but I practiced and I learned
I am not so strong that I won't break
so I'm careful

not paralized, not dead -just careful-
and I tell my daughter "tell, tell, tell"
even though I am not as strong as my mother
nor as practiced as my grandmother
I taught her to tell the world
I cannot carry the weight of my race
on my back anymore
so everybody, please, get off

I practiced... I practiced a lot and I learned
not to tell my daughter
"the thing is don't tell daddy
so and so abused you
or did this or that to you
because it can get men killed
and it's not right
for men to loose their life's blood
over meat for dogs, a slipper
that's not really yours because in a few years
dogs will come sniffing around
and another man will have her, eat the meat
wear the slipper, own her"

I practiced and I learned not to tell my daughter
"shush your mouth
don't be getting grown people into a family mess
bringing the cops into our family business

and don't you dare run to Grandpa
with your big mouth and get somebody killed
and don't even think of telling mama
because she'll just die

& don't tell grandma either
unless you find the good words
to tell about the bad thing
or else she'll die or get you killed
when she tells grandpa"

Rage

I explore grief
anger, rage
in safe settings
at home
with Lynn
surrounded by books and African relics

But I do not feel safe

I'm afraid
I'm afraid my rage
will burn out of control
and scorch the Earth
turning our forests
into mass graves
of smoldering, broken tree stumps

shattered
scattered
like charred body parts
soaking up our oxygen
and I will be like a scream
trapped inside a curtain
of purple red orange yellow white flames

I'll be like light waves
from a newly born sun

I'm afraid
I'm afraid parched lands
will stare at all of us
from all around
while I burn
uncontrollably
at the center

PAIN CLUSTER

pain is having a baby

on Saturday night
when god is off-duty
and out with the guys
 &
when the first cry
of that mother and child
filters into the cosmos
the clink of the glasses &
the klunk of the pool cues
help god to play deaf

there were rumors in el barrio
that on saturday nights
god would be at the corner
in Mike's Bar & Grill
to drink and shoot pool
but father callahan doesn't
allow people to believe
in rumors
 so
babies are born deformed
when god is not watching

DESPEDIDA A BUENOS AIRES

Esta mañana mientras leía un periódico en la salita del Hotel Presidente
Escuché una noticia: "Militares sublevados…"
Alfonsín mandó un discurso de hombre fuerte que promete
Y yo me fui a caminar por sus calles… Suipacha, Florida, Corrientes
Visitando galerías y como la que no quiere la cosa, comencé a estudiar los rostros,
Las miradas, el ritmo de las voces, la costura, el remiendo, las puntadas del hilo,
Los broches que cerraron la ruptura del hombre con lo humano, con la elasticidad
Del tiempo, con la luz del mediodía y la magia de la luna…

Mi vista ávida tragaba luces, vidrieras, ceños fruncidos, rostros cerrados,
Máscaras de carnaval… rastreaba un estado de gracia o de infierno
Que no se lee en el velo de ojos vacíos,
Ni en labios donde todavía se destila algo amargo
Ni en el cruce de peatones suicidas al mediodía…
No lo pude captar detrás de la palabra escrita
Ni en tu *Clarín* de Buenos Aires,
Ni detrás de la laguna que dejó en el pensamiento la *Revista Sur*…
Intenté ritos y mitos… en vano

Me pareció escuchar gritos, voces quebradas, gemidos
Llantos entrecortados, alaridos, golpes, golpes, quejidos...
Admiré el fingido olvido de apagones, secuestros, enfrentamientos
Al tropezar con la implacable mirada de un General ofendido
Pero el pueblo quedó absuelto entre suspiros, murmullos, exilio, exterminio
Picana, golpes, sangre, pesadillas y maldiciones masticadas
Cuando el aire susurró:
"Siempre se habla pero no se dice nada...
La verdad no puede irrumpir en el ámbito donde habita la memoria"

Mañana me iré... adiós Buenos Aires querido...

Mañana me iré a bordar el traje de tu memoria en palabras
Voy a pintarte un rostro con pinceladas largas
Voy a tejer sobre tu calva un sombrero de pieles
Trabajadas en llanto, murmullos, gemidos, secretos,
Sangre, silencio, tortura, muertes y rostros perdidos
Voy a descifrar miradas que dicen todo sin nombrarlo, pero se entiende:
"Ché, de su propia casa, del hospital, frente a la escuela, detrás de la Iglesia,
Detrás del cuartel, frente al edificio de la esquina, detrás de aquel cerro,
Detrás del silencio, sobre la playa uruguaya, detrás del silencio,
Detrás de las noches, detrás de los días: la muerte, los jueves y pañuelitos blancos"

Mañana me iré... adiós Buenos Aires querido...

Tal vez me persigan las sombras que se deslizan
Sigilosamente por tus paredes, tus galerías
Esas que invaden tus calles, la noche y el día...
Mañana me iré de esta ciudad del silencio
Pero presiento un movimiento de repliegue
Detrás de la escuela de la Marina...
Cuidado...

CARMEN D. LUCCA

Carmen D. Lucca es poeta-cantante, maestra y promotora cultural. Su libro *Rosas en el espejo* (1992) fue la primera colección bilingüe de la poesía de Julia de Burgos. Otros libros incluyen *Pinceladas y paisajes,* (poesía, 1990) *Maboiti, el Tallador de Madera* (cuento para niños, 2000) y *Al compás de una vida* (memoria-biografía de Enrique Lucca, fundador de la orquesta de baile más antigua de Puerto Rico). Su poemas se han publicado en diversas antologías de Estados Unidos e Irlanda: *Love to Mama* (2001), *Bum Rush The Page: A Def Poetry Jam* (2001), *Spirit in the Words* (2000), *In the West of Ireland* (1992 y 1994). Además de escribir y enseñar, D. Lucca colabora con músicos intercalando la poesía con la música en sus presentaciones, que se han escuchado en New York en WBAI y WNYE, y en Puerto Rico en WUPR. También se ha presentado en Notre Dame University, the Museum of the City of New York, City College, Montclair State College, Hunter College y Tibes Indian Museum (Puerto Rico). Fundó la Poets Refuge V.P. Association, es vice-presidenta de la Asociación Pro Cultura Hispánica–Puertorriqueña, productora y directora del Rafael Hernández–Sylvia Rexach Festival of Puerto Rican Composers en el Museo de la Ciudad de Nueva York y fundadora en Nueva York del Festival de Música Dominicana. Recibió la Medalla de Plata de la Sociedad de Artes, Ciencias y Letras de Francia (2000) y fue nominada para el premio Disney's American Teacher en el año 2001.

Carmen D. Lucca is a poet-singer, teacher and cultural activist. Her book *Roses in the Mirror* was the first bilingual collection of Julia de Burgos' poetry (1992). Other books include *Brushstrokes and Landscapes* (poetry, 1990), *The Wood Carver* (a children's tale, 2001) and *Al Compás de una vida* (a memoir and biography of Enrique Lucca, founder of Puerto Rico's oldest dance band, la Sonora Ponceña, 2007). Her poetry appears in anthologies published in the United States and Ireland: *Love to Mama* (2001), *Bum Rush The Page: A Def Poetry Jam* (2001), *Spirit in the Words* (2000), *In the West of Ireland* (1992 and 1994). In addition to writing and lecturing, Carmen D. Lucca works with musicians, fusing poetry and music in her performances, which have been aired in New York at WBAI and WNYE, and in Puerto Rico at WUPR. She has presented her work at Notre Dame University, The Museum of the City of New York, City College, Montclair State College, Hunter College and the Tibes Indian Museum (Puerto Rico). She is the founder of the Poets Refuge, the Vice President of the Association for Puerto Rican–Hispanic Culture Inc., the producer and director of The Rafael Hernández–Sylvia Rexach Festival of Puerto Rican Composers at The Museum of the City of New York and the founder in New York City of the Dominican Music Festival. She is the recipient of the French Silver Medal (2000) and was nominated for the Disney's American Teacher Award in 2001.

TE LLAMO POETA

> *Un clavel interpuesto entre el viento*
> *Y mi sombra, hijo mío y de la muerte,*
> *¡Me llamará poeta!*
> *—Julia de Burgos*

Tu clavel, hijo-guardián de tu sombra,
cumple tu profecía y te llama poeta.
Los que no te conocen insisten en llamarte
"lástima de mujer y bohemia borracha".
Te imaginan tambaleándote ebria
en una que otra esquina en Nueva York
y dicen que la muerte llegó en tu borrachera.
No pueden concebirte con manos jugueteando
en la fuente y ojos recreándose en la flor.
No han logrado pensarte en esa media tarde
contemplando la feria de verano en Nueva York,
alimentando una paloma o a un gorrión.
Creen que tu musa murió antes que tú
que lejos de tu río, el fango te envolvió.
Deforman tu presencia en el mundo poético
con el temido lente de su interpretación.

Perdónalos porque eso lo han aprendido
de los otros que dicen haberte conocido
aunque nunca auscultaron tu intenso corazón.
¿Por qué moriste sola si habían tantos amigos?

Julia, muchos han intentado escribir el drama
de tu historia en actos exentos de poesía.
Te han pensado pero no te han sentido.
En vez de escudriñar tus versos, han revestido
la irreverente anécdota de tu alcoholismo.

¡Ay! Julia, tu metáfora fue síntesis perfecta
para explicar a Dios, amor y patriotismo.
Pero no te conocen.
Hablan de ver la realidad de tu poesía
ignorando las altas dimensiones de tu verbo.
Ni ellos mismos entienden lo que dicen de ti.
Quieren encontrar tu poesía sin sentir tu palabra.

ELEGÍA TARDÍA

A Carmen Alicia Cadilla de Ruibal

Sordo quedó el sonido donde cantó tu voz
y el reloj no detuvo las saetas punzantes
que deshojan la flor.

Te fuiste con el tiempo que recuerda tu belleza
y tu cuerda armonizante sobre la que pulsaste
tus poemas de amor.

El hombre de tus musas sin lágrimas te llora.
Su tristeza de fuego es un desierto ardiendo
en su nido vacío.
Él recibe la noche recitando tus versos
y amoroso, adornando su lecho con tus libros,
te espera con el alba.*

Silenciaste tu dulce acento de ave…
Bajo su luto verde los árboles abrigan tu eco.

Muy pocos transeúntes notaron tu partida
y los celebrantes de pompa y circunstancia
no legaron sus rúbricas al álbum funeral.
Acto de tu despedida con butacas vacías.
En tu sala de espera imperaba el silencio.
Sólo te acompañaron unas flores y cirios
y apenas nueve rostros contemplando esa rosa
amarilla que, recostada sobre tu pecho congelado,
auscultaba los latidos de tu corazón dormido.

*Billy Ruibal, compañero por vida de Carmen Alicia Cadilla, falleció poco tiempo
después. [nota de la autora]

HOMENAJE VITAL

Al poeta Francisco Matos Paoli
(Cuando cinco poetas le llevaron una serenata)

Niño terrible ...
Sabio prisionero en el capullo
De una flor

No cesas de crear la magia,
¡Hipnotizas mis musas!
Poeta,
Niño terrible...
Sabio, hermoso
Profeta de este pueblo,
Vigía de esta tierra embrujada
Eco del coquí
Quejido del mar
Rumor de flamboyán
Rumor de palmas
Poeta
Ángel elegido
Llego a tu templo.
Ante tus alas de raíces hechas,
Mis versos ...

A LOREINA

Marinera de la ruta cósmica,
mensajera del onto, guardiana de la ría.
La pupila del ojo que te mira
Se dilata con la luz de tu sabiduría.

Mensajera viajera, guardiana,
mujer dueña de tu sentir y ley.
En el zumo embriagante de tu verso
está el sabor de fruta borincana:
níspero, mangó, guanábana y mamey.

Ese ojo que te mira
sigue la ruta de musas desveladas
que contigo, día y noche, van de ronda.
Ese ojo que te mira
vive de tu verbo que irreverente e indómito
se lanza desde el cerro hacia el océano-mar
a galopar sobre los adoquines de San Juan.

Ese ojo que te mira
vio a la luna, jineta de tu poema paso fino,
quedarse alucinada sobre la catedral
y a la nube impregnada de tu alegría de vida
unirse a tu homenaje en la vieja ciudad.
Celebrándote, honrándote Loreina Santos Silva…
porque eres y estás …

FAENAS MILITARES
(Que hay que hacer en tiempo de guerra)

No llorar
mientras sacas masas de carne
de tus botas.
Recoger
partículas de piel y huesos
de la hierba,
de la arena.

Ignorar
el RAT-A-TAT-TAT– de artillería,
los cuerpos descompuestos en las calles,
los hombres y mujeres decapitados
torturados
y cumplir
la horrorizante orden de matar
niños
y ejecutar los perros y gatos
que comen los cadáveres en Irak.
Olvidar
cómo el olor del curri se mezcla
con el de los cuerpos quemados.

Recordar
que aunque el cura te absuelva
ni cien Ave Marías sanarán
el dolor en el alma
por todas las matanzas legales
cometidas en campo de batalla.

María Mar

María Mar, nacida con el nombre María Quiñones, es escritora, performera, artista visual y chamana que reside en Nueva York desde 1978. Su labor como miembra fundadora y actriz de los grupos de teatro Anamú, Moriviví y Colectivo Nacional de Teatro la señalan como figura pionera del teatro popular en Puerto Rico, donde también fue pionera del movimiento teatral feminista de los '70. En NY funda y dirige de 1986-91 Ecuelecuá, colectivo de performance y artes integradas dedicado a crear conciencia sobre la violencia doméstica. Su obra, que a menudo combina poesía, performance e instalaciones de arte creadas por Mar, está dedicada a presentar la experiencia de la mujer. Su novela digital, *Catch the Dream Express: Alchemical Journey to Manifest Your Dream* (2008) se publicará como libro impreso por ShamansDance Publishing and Production bajo el título "Angelina and the Law of Attraction." Ha escrito y dirigido más de doce obras dramáticas y obras de danza-poesía, presentadas en Puerto Rico, Estados Unidos, Sur África y otros países. Entre sus obras de teatro se encuentran *Chúpate ésta en lo que te mondo la otra* (1971-73), *Tiempo de Beso y Macetazo* (1979), *Diagnóstico y resurrección de una suicida* (1982), *Latina* (1989), *Love That Kills I* (1992), *Love that Kills II* (1992), *Temple of Desire* (1994-96), *Amarmina's Journey* (1999) y *The Shaman's Bag* (2005). Mar describe la metodología de su "Teatro de Transformación", un teatro chamánico desarrollado con la escritora Corazón Tierra, en el ensayo "Dancing With The Voice of Truth", publicado en *Puro Teatro: A Latina Anthology* (2000). Sus performances de poesía, *Womerican, El eterno soldado, Bewomaning, Caribeña* y otros, se han presentado en The Village Gate, The Julia de Burgos Cultural Center, The Puerto Rican Traveling Theatre, Café Teatro La Tea (PR), Boricua College, Rutgers University y El Museo del Barrio. Sus poemas se han publicado en revistas literarias y su labor teatral fue documentada por PBS, Canal 13 en *The Americas* Series (1992); CBS-TV; y el *New York/Newsday* "Manhattan Profile". Ha ofrecido más de 60 talleres de escritura creativa en las escuelas de Nueva York. Recibió el "Premio de Familias Unidas" y un Appreciation Award del Alcalde Koch. Sus más recientes creaciones son el poema en medios múltiples *Dreams are Never Tiny,* presentado en dreamalchemist.com y el programa de instalaciones poéticas *thepoetrybotanica.com.*

María Mar, born María Quiñones, is a writer, performer, visual artist and shaman who lives in New York since 1978. A pioneer of the popular theater in Puerto Rico during the 1970's, Mar was a founding member and actress for the theater groups Anamú, Moriviví and Colectivo Nacional de Teatro, as well as a pioneer in the feminist theater of the 1970s. In New York, she was the founder and director of Ecuelecuá (1986-1991), an interarts performance collective to create awareness about domestic violence. Her first e-novel, *Catch the Dream Express: Alchemical Journey to Manifest Your Dream* was published in 2008 and will be published as a hard cover book by ShamansDance Publishing and Production under the title *Angelina and The Law of Attraction.* Mar has written and directed over twelve plays and poetry performances presented in the USA, Puerto Rico, and South Africa. Among her theatrical works are *Chúpate ésta en lo que te mondo la otra* (1971-73), *Tiempo de Beso y Macetazo* (1979), *Diagnóstico y resurrección de una suicida* (1982), *Latina* (1989), *Love That Kills I* (1992), *Love that Kills II* (1992), *Temple of Desire* (1994-96), *Amarmina's Journey* (1999) and *The Shaman's Bag* (2005). Mar describes her "Theatre of Transformation," a shamanic theatre methodology developed with writer Corazón Tierra, in the essay "Dancing With The Voice of Truth," anthologized in *Puro Teatro: A Latina Anthology* (2000). Mar often combines poetry, performance and art installations to depict the experience of women and to empower them. Her poetry performances *Womerican, Bewomaning/Enmujecer* and *Caribeña* have been featured at The Village Gate, The Julia de Burgos Cultural Center, The Puerto Rican Traveling Theatre, Boricua College and El Museo del Barrio. Her poems have been published in literary magazines and her theatre work was featured in the series *The Americas* in PBS, Channel 13 (1992); CBS-TV; and the *New York/Newsday* "Manhattan Profile." She has offered over 60 workshops on creative writing in the NY schools. Mar received the award "Premio de Familias Unidas" and an Appreciation Award from Mayor Koch. Her most recent creations are the multimedia poem *Dreams are Never Tiny* at dreamalchemist.com and the program of literary installations *poetrybotanica.com.*

GAJES DEL OFICIO

Echa un vistazo a tu poeta.
La que nació de noche
con una luna fresca entre las cejas.
Respiró el aire lleno de palabras
que escupió como un cigarro amargo
y reclamó:
"Yo soy las líneas de tu mano."
Un buen día
se irguió desde su vientre hasta tus ojos
para tocar la estatura del átomo—
explicó,
y cayó en una infancia tartamuda
empeñada en sobar pan de sueños
bajo el brazo.
Cuando recuperó la sangre entre las piernas
tuvo sospechas.
Tú le enseñaste la censura
y ella te sorprendió un olor a levadura
que la llevó al amor.
Y del amor vino a la protesta
por esa espuma
que se llama ausencia.
A los treinta y seis
ha prendido treinta y seis mil hogueras
y tiene cayos en el cielo de la boca.
Echa un vistazo
a este cuarto prestado
en el county de un país ajeno,
a esta desarropada densidad
donde el hambre flota como un sapo.
Echa un vistazo a tu poeta,
peleando con las nubes de sus ojos
que no la dejan ver tus versos.
Mientras
tú vas y vienes del trabajo
comes o buscas tu comida
vistes más o menos a la moda
y te enorgulleces de tus guerras.
Conoces la importancia de tus deudas
y a pesar de esto
celebras nupcias, semana santa y funerales.

CARTA A MI HERMANO

Cuando al fin me invitabas a tus juegos
era yo la india y tú el cowboy.
Tuyas eran las modernas pistolas,
la placa de Sheriff que te autorizaba
al puño y la patada.
Tuyos eran el arco y las flechas
que me prestabas
porque no te gustaba hacer de indio.
Mías eran las trenzas
y las dos o tres plumas
que le robaba al gallinero.

Era el Wild West que orillaba
la quebrada.
Era la frontera inexplorada
de los matorrales.
La expedición al otro lado de la verja:
al caserío: territorio apache.
Era una guerra de exclamaciones
en la que te rehusabas a perder
insistiendo que los vaqueros siempre ganan.
Ya desde entonces demarcábamos territorios,
esbozábamos filosofías sociales,
definíamos posiciones de clase.
Hoy sigues jugando al vaquero
con la "Wells Fargo."
Aún cargas tus pistolas.
Yo, india entre carapálidas,
vivo en el Lower East Side,
donde se ultrajan hoy nuevas fronteras
y el hombre oscuro lucha ya no por tierra,
sino por un pedazo de techo
y una calle a la que llamar patria.

Esto no es juego, hermano.
Andas con la ilusión en la vaqueta.
Tu propia muerte duerme
en la recámara de tu revólver.
Deja la TV y ven,
cruza el Valle de Mississippi,
tierra fertilizada
con miles de cadáveres de indios,
tierra donde el negro dejara sangre y sudor
cultivando un algodón
blanco, blanco, blanco.
Ven y cruza el sureste,
donde Jackson, el héroe,

tornó indio contra indio
con falsas promesas.
Donde Jackson, el presidente,
hizo campaña masacrando tribus
y rifando sus tierras
en la lotería estatal.
Visítanos al norte,
donde blancos pobres y negros libertos
se enfrentaron y se enfrentan
mientras el patrono
sueña ileso
bajo tus cocoteros.

Pasa al oeste,
donde centenares de inmigrantes
irlandeses y alemanes
murieron y mataron
para arrancarle a México
sangre y tierras.

¿Y todo para qué?
¿Para quiénes todo?
¿Haz recibido tú, hermano mío, alguna parcela,
tu parte del oro, franquicias
o ganancias?
El cowboy de estas tierras
no es el pionero en technicolor
que nos pintó la TV.
No es el hombre libre
en busca de fronteras.

Ven y cruza a esta orilla,
en donde tú eres, como yo, un indio más
destinado a perder
en este juego a muerte,
en el Wild West
del Norte de esta América.

Iniciación

Eras llorona y piponcita.
No tenías cintura
y estabas despintada.
¿Qué esperabas?
¡Hasta intenté maquillarte!
Pero el color se resbalaba
en tus cachetes redondos.
Te empezaste a parecer
a mi mamá.

Santa Claus me trajo una Barbie.
Sus pechos no tenían pezones
y no le salían pelos allá abajo.
Era tersa y esbelta.
Rubia. Perfecta.
Era una estrella de Joliud
y con ella jugaba a los boifrens.

Mi Barbie no hablaba.
Venía en un pequeño pedestal.
Allí, entre polvos y perfume,
se mantuvo intacta.
Pero tú chillabas
desde el fondo del baúl.
Me llenabas de culpa.
Mojabas mi cama por las noches.
Me hacías cosquillas durante la Misa.
Y llorabas.
Llorabas cuando mi padre le gritaba a mi madre.
Llorabas cuando mi madre me pegaba.
Llorabas cuando te buscaba en el fondo del baúl.
"Beibi lovs momi"
gritabas con tus pilas al borde
de un colapso.
Te destruí las entrañas
un Domingo de Ramos.
Esta mañana encontré un mensaje
en el espejo. Está escrito
con mi lipstick y mala ortografía:
"Ablaré por tí, como Prometeo".

LA NIÑA INVISIBLE

Tengo una muñeca
vestida de azul
zapatitos blancos
y encajes de tul.

Tiene problemas con la lectura.
Escribe poemas inconexos
donde se rompen los arcoiris
- dice - como la boca de los cielos.

El terror le dio alas,
y aunque es blanco de todos
la he visto fundirse con la pizarra,
haciéndose invisible.

Tengo una muñeca
de trenzas tisú
y ojos de azabaches
que son todo luz.

Siempre está limpia,
como una taza rota
a la que el agua
no le borra las cicatrices.

Tiene ocho años
y tres intentos de suicidio.
Es que a veces la llaman
por las ventanas—dice.

Tengo una muñeca
de rizos trú-trú
mediecitas rosas
y encajes de tul.

A veces tiene un ojo azul,
casi violeta y encendido.
A veces un extraño sarampión
de pintas rojo-oscuras
se asoma bajo los volantes de su traje.

A veces tacha a los otros
con su lengua,
lanza palabras que no le caben
en el cuerpo.
A veces amuela tijeras
con los ojos.

O cierra el puño como una mano
de piedra
sobre el pequeño mundo
del papel.
Y se fuga por las grietas
con las cucarachas.

Tengo una muñeca
vestida de tul
negros moretones
y heridas con pus.

AN OPEN AND SHUT CASE

At the corner, a stranger
plink! plink!
of such and such a color,
of such and such a height.
plink! plink!
Where does he come from?
Where does he go?
Why does he seek shelter
in the dark?
plink! plink!
Footsteps in the street
plink! plink!
Footsteps from heels, spiked and high
plink! plink!
hurried steps, step by step
plink! plink!
The blinds open and shut
Behind the blinds the woman pulls back
the wind whirls
as the woman who walks move closer
to the corner-- into the wind
the woman turns
the knife shines at her throat
plink! the blinds shut
plink! the eye-lids shut
plink! the world shuts
behind the blinds
on the woman who looks
but does not see
how she is dragged
into the abandoned building,
how she is raped, how her womb is sliced
from top to bottom, how she's left for dead.
Behind the blinds there is silence.
Behind the blinds the neighbor dials a busy number.
Behind the blinds the busybodies blend
into the design of the wallpaper.

Translated by María Mar and Ben Soto.

NEMIR MATOS-CINTRÓN

Nemir Matos-Cintrón es escritora, guionista, investigadora y educadora. Nació en Puerto Rico en el 1949. Ha publicado los poemarios *Las mujeres no hablan así* (1981), el primer libro de poesía erótica abiertamente lesbiana en Puerto Rico; *El arte de morir* (2009); y *A través del aire y del fuego pero no del cristal* (1981). Los poemas de su colección *Aliens in New York City* se pueden leer en su portal en el internet y algunos de ellos se incluyen en la antología *Conversación entre escritoras del Caribe Hispano* (1999). Un fragmento del manuscrito de su novela, *Amordio de Amanda*, se incluye en la antología *Los otros cuerpos* (2007). Emigró a la Ciudad de Nueva York en la década del 1970 y luego hizo estudios en la UNAM en la Ciudad de México. Más tarde, estudió en Syracuse, Nueva York. Desde el 1981 al 1991, Matos-Cintrón trabajó en el campo televisivo en Puerto Rico. Escribió la serie dramática de televisión *Insólito* y trabajó en la Isla como productora ejecutiva, escritora y profesora de Telecomunicaciones en la Universidad del Sagrado Corazón. Regresó a Nueva York en 1992, donde trabajó como profesora en Brooklyn College; y luego como investigadora del Centro de Estudios Puertorriqueños, donde produjo *Puerto Ricans in the USA: A Hundred Years,* un CD-ROM multimedios sobre la historia de los puertorriqueños en los Estados Unidos. En el 2002 se mudó a la Florida donde es diseñadora educativa en Valencia Community College y cursa estudios doctorales en Nova Southeastern University. Tiene un Bachillerato en Humanidades de la Universidad de Puerto Rico y una Maestría en Ciencias del S. I. Newhouse School of Public Communications de Syracuse University. Matos-Cintrón fue homenajeada en Puerto Rico en un evento titulado "Labiosas" y participó como escritora invitada en el Festival de la palabra en San Juan (2010).

Nemir Matos-Cintrón is a poet, scriptwriter, researcher and educator, born in Puerto Rico in 1949. She has published the poetry books *Las mujeres no hablan así* (1981), the first openly lesbian erotic poetry book published in Puerto Rico; *A través del aire y del fuego pero no del cristal* (1981); y *El arte de morir* (2009). Poems from her collection *Aliens in New York City* can be read at her webpage and some of them were included in the anthology *Conversación entre escritoras del Caribe Hispano* (1999). A fragment of her novel in progress, *Amordio de Amanda,* was published in the anthology *Los otros cuerpos* (2007). In the 1970's she lived in New York City, followed by studies at UNAM in México, D.F. and afterwards, in Syracuse, New York. From 1981 to 1991, Matos-Cintrón worked in the field of television in Puerto Rico. She wrote the dramatic series *Insólito* and worked as a scriptwriter, producer, and professor of Telecommunications at Universidad del Sagrado Corazón. She returned to New York in 1992 and worked as a Lecturer at Brooklyn College. She then worked in multimedia projects at The Center for Puerto Rican Studies, where she developed in 2000, *Puerto Ricans in the USA: A Hundred Years,* a two volume CD-ROM used in Latino studies. In 2002, she moved to Florida, where she has pursued doctoral studies in Educational Instructional Technology and Distance Learning from Nova Southeastern University while being an Instructional Designer at Valencia Community College. Matos-Cintrón holds a B.A. in Humanities from the University of Puerto Rico and a Masters of Science from S. I. Newhouse School of Public Communications at Syracuse University. She was recently honored in Puerto Rico at the event "Labiosas" and was a guest writer at the Festival de la palabra in San Juan (2010).

Este trópico malsano destilándose lento

Este trópico malsano destilándose lento
a través de la grieta de la pared
este dolor fermentando en cada poro
y la tierra que palpita debajo del cemento
gritando no morir
este musgo contaminado y los animales muriendo
lamidos por el polvo mientras se hinchan como Salcedo
quinientos años después en la carretera
me vinculan con la herida total de la existencia
y después de tanta palabra rota con el tiempo
todavía esperas que yo salga y sonría
la respuesta última del universo
precisamente hoy que creo haber dejado por descuido
mi alma olvidada en un salón de espera
y tengo miedo que alguien la lleve bajo el brazo
creyéndola el último diario de la tarde.

Me robaron el cuerpo

Me robaron el cuerpo
Yo Puta Sanjuanera
Yo Monja Lesbiana
Yo Mujer Estéril
 cero población
madre de veinte hijos
obrera mal pagada
Me robaron el cuerpo

Mutilaron mis senos
mi vientre
mi rostro
mis sentidos
mi belleza de tierra

Yo mujer perfecta
Mujer afeitada mujercontacones
labiosavón y peloclairol
Me robaron el cuerpo y vendieron mi alma
a cosmopolitan
a la alta costura a wall street
y me tallaron a imagen y semejanza
de la mujer femenina mujer virginal la mujermujer
reprimida mujer de la casa mujer de la calle mujer endrogada mujer
businesswoman
y me violaron porque
"en el fondo eso es lo que quieren todas las mujeres"

A KRUGGER
COCINERO

> " Esto se come ...así.
> Chop, chop, chop....rapidito
> como ataca el tiburón "
>
> Krugger

El sube y baja del cuchillo de cocina repite su ritual
de ajo molido y aceite de oliva ..
Chop, chop, chop....me entero de tu muerte
y me persigue
la quijada de tiburón,
la mandíbula batiente de ese voraz mamífero marino
que solía colgar de una pared en tu friquitín Krugger.
Chop, chop, chop.... estás muerto
desde el 13 de diciembre
un siniestro día impar en el cual no se consigue
ni ajo ni cebolla y el recao
es una enredadera que aprisiona mi cuerpo
y me susurra al oído que moriste de SIDA.
Al fondo de la barra yace tu cuerpo adobado
y coronado de hojas de laurel
Veo en tu sonrisa
el hueso de mandíbula de tiburón que aún me persigue
y me recuerda que estás descarnado
Chop, chop, chop....Despierto...
me encuentro frente al bar
tu hermano ahora dueño del Friquitín
rememora orgulloso
lo bonito que siempre te mantuvieron hasta el final
mientras colgada en la pared..
una máscara indú
Chop, chop, chop...me acecha
Es el rostro sangriento de la diosa Kali...
El espanto de tu muerte le cuelga de su lengua
mucho más larga que la esperanza de todos tus pobres
Sí, los que trajiste desde Quisqueya a vivir contigo
para que conocieran una vida mejor,
y no precisamente esa otra que ahora te reclama

REVISITING CUBAN POET NICOLAS GILLÉN'S POEM:
TODO MEZCLADO

Licking your black armpits of dreams forgotten
now remembered under the jungle beneath your navel,
I find myself swimming in turquoise waters
of the West Indies.
Sounds of yoruba drums resonate in my temples
as I taste the rhythm between your legs.
Indian smells of cinnamon and curry overflow my senses,
as I lift my head from your deep sea
to see your face in rapture.
Three hills greet me:
the first one,
erupting volcano on my tongue,
the other two sway at a distance as I,
a true conquistador reaching your shore, rename you Trinidad.
Fierce Carib armies in your hands
hold my body captive under yours
as if dancing to the music of *parangs*
brought from Venezuela as *parrandas*
Feel my fingers dancing gently for you now,
no Spanish soldiers to ignite your wrath
and propel your arrows.

It must be, love, that you can taste in me
that same Spanish blood which conquered your ancestors
It must be, love, that I'll never forget
sweet nothings you whispered in my ear
in the language of the master.
You and I, both "esclavo" and the "señor"
master and slave
in this journey of sweat,
sweet and sour chutney, pasta de guayaba
English breakfast tea, café con leche,
horseradish and ground garlic,
Todo mezclado: *mangú , mofongo, calalú*
a mixture, a melange of smell, sweat and sap from our bodies
molten under a fake tropical sun
painted on a wall
behind my bed in New York City.

SOY EL PRINCIPIO

Soy el principio
Salí del caos original
he sido siempre
Sola parí el cielo el tiempo y los dioses
soy el huevo universal partido en dos Tierra y Luna
Soy la hilandera del tiempo venerada aún en Meca
por los hijos de las ancianas

Soy la piedra negra luna nueva
soy la piedra blanca luna llena

Soy Yemayá
 la humedad vientre y madre de las aguas primigenias
Soy Ishtar estrella de la tarde soy
la santísima trinidad y los tres rostros de mi luna
 Creciente Artemisa provocadora del rocío
 Plena Estrella de la mar Selene
 Menguante Hécate la subterránea
 la terrible destructora del orden
Luna Tierra Infierno
Soy Isis y habito en la casa del fuego
Soy Omecíatl
 Sola parí la vida y la muerte.
 Sobre la meseta azteca
 parí el cuchillo de Obsidiana
 y de la herida terrestre
 brotaron todas las diosas y dioses
Soy Coaticlue
 la diosa serpentina de ojos mortales
 toda la vida de mi fluye
 y toda la muerte regresa a mis brazos en alto.
Ahora me voy a la tierra del no retorno
hasta que ustedes me llamen con sus voces más altas
Sólo entonces bajará la marea
de los siglos sin rostro de los siglos sin nombre
de los siglos sin cuerpo
de los siglos del hombre y de la guerra
Solo entonces girará la rueda del karma
la rueda de los cambios el camino

NANCY MERCADO

Nancy Mercado es poeta, dramaturga y educadora. Es autora del poemario *It Concerns the Madness* (2002). Ofreció su colaboración editorial y obra literaria a *Letras Femeninas Tomo XXXI, Número 1: The Journal of the Asociación de Literatura Femenina Hispánica* del Arizona State University y fue la editora de *if the world were mine*, una antología de niños publicada por el New Jersey Performing Arts Center. Fue una de las editoras de la revista literaria *Long Shot* del 1993 al 2004 y su editora principal por un año. Mercado fue una de las poetas invitadas al *35th Anniversary Celebration of the Nuyorican Poets Café* en Town Hall. Apareció también en el documental *Yari Yari Pamberi: Black Women Writers Dissecting Globalization*, dirigido por Jayne Cortez. Su obra se ha publicado en numerosas antologías, como: *ALOUD: Voices from the Nuyorican Poets Café* (1994), *Changer L'Amérique Anthologie De La Poésie Protestataire Des USA* (1998), *Identity Lessons: Contemporary Writing About Learning to be American* (1999), *Poetry After 911: An Anthology of New York Poets* (2002), *From Totems to Hip-Hop: A Multicultural Anthology of Poetry Across the Americas, 1900-2002* (2003), *In the Arms of Words: Poems for Tsunami Relief* (2005), *Bowery Women Poems* (2006), *Kiss the Sky: Starring Jimi Hendrix* (2007) y *Pow Wow: Short American Fiction from Then and Now* (2009). Mercado ha escrito y dirigido 7 obras de teatro, todas producidas en lugares como The New Jersey Performing Arts Center y el Teatro Pregones en el Bronx. Algunas de sus obras teatrales son: *Palm Trees in the Snow* (1989), *Planet Earth* (1993) y *Alicia In Projectland* (1994), co-autora con Pedro Pietri. Mercado tiene un Ph.D. en Literatura Inglesa de SUNY Binghamton (2004). Actualmente presenta su poesía y es conferencista en EE.UU., Europa y Canadá.

Nancy Mercado is a poet, playwright and educator. She is the author of the poetry book *It Concerns the Madness* (2000). She was a contributing editor and writer for *Letras Femeninas volume XXXI, Número 1: The Journal of the Asociación de Literatura Femenina Hispánica* of Arizona State University and editor of *if the world were mine*, a children's anthology published by the New Jersey Performing Arts Center. She served as an editor of the literary magazine *Long Shot* from 1993 to 2004 and as the publication's editor-in-chief for one of these years. Mercado was a featured poet in Town Hall's *35th Anniversary Celebration of the Nuyorican Poets Café*. She was also featured in the documentary film, *Yari Yari Pamberi: Black Women Writers Dissecting Globalization,* directed by Jayne Cortez. Her work has appeared in numerous anthologies, among them: *ALOUD: Voices from the Nuyorican Poets Café* (1994), *Changer L'Amérique Anthologie De La Poésie Protestataire Des USA* (1998), *Identity Lessons: Contemporary Writing About Learning to be American* (1999), *Poetry After 911: An Anthology of New York Poets* (2002), *From Totems to Hip-Hop: A Multicultural Anthology of Poetry Across the Americas, 1900-2002* (2003), *In the Arms of Words: Poems for Tsunami Relief* (2005), *Bowery Women Poems* (2006), *Kiss the Sky: Starring Jimi Hendrix* (2007) and *Pow Wow: Short American Fiction from Then and Now* (2009). Mercado has written and directed 7 plays, which have been produced in such venues as The New Jersey Performing Arts Center (NJPAC) and Pregones Theater in the Bronx. Among her plays are: *Palm Trees in the Snow* (1989), *Planet Earth* (1993) and *Alicia In Projectland* (1994), co-authored with Pedro Pietri. Mercado has a Ph.D. in English Literature from SUNY Binghamton (2004). She presents her work throughout the US, Europe and Canada as a poet and conference panelist.

MILLA

-Mi abuela, Puerto Rico

Milla lived eons ago
When sandals pounded dirt roads
Blazing hot under palm tree lined skies.
Milla's long dark hair flowed side to side,
Glistened in the noon light.
Mahogany skinned, she shopped
Plátanos, yucas, a bark of soap.
Milla worked,
Striking clothes against wooden boards,
Gathering wood for evening meals,
Feeding chickens, hogs, dogs,
And roosters at dawn.
Milla traveled only once
To Chicago,
A color-faded photograph serves as document.
Smiles and thousands of hugs
For the grandchildren on a park bench.
Milla's a century old
And still remembers every one of us
Even those left over in the U.S.
She still carries a stick
Certain of her authority
Over four generations.
Milla outlived two world wars,
Saw the first television,
The first electric bulb in her town,
Hitler, segregation,
The Vietnam War,
And Gorbachev.
Milla can speak of
The turn of the century land reforms,
Of the blinded enthusiasm
For a man called Marín
And the mass migration of the 1950's.
Milla can speak of her beloved husband,
Sugar cane cutter for life.
She can speak of the love of a people,
Of the pain of separation.

Milla can speak of the Caribbean Ocean,
The history of the sun and sand
And the mystery of the stars.
Milla maintains an eternal candle lit
Just for me.

Milla will live for all time.

DON PORTOLO

—Mi abuelo, Puerto Rico

Lo recuerdo en la noche oscura
su sonrisa emitía un rayo de luz
que le alumbraba el rostro,
andaba lentamente con machete en mano
por los estrechos caminos de tierra
que llegó a conocer como su propia casa,
era tan negro como la noche más negra
que jamás hayas visto
era delgado
y tan sereno
que te derretía
con una palabra al oído,
era querido
por sus hijos,
era Don Portolo
mayordomo de los trabajadores de la caña
hoy desaparecidos,
era fuerte
y bastante alto,
la voz nunca le temblaba
ni siquiera en las más graves situaciones
¡era el hombre más valiente
que jamás haya visto esta nación!
Fue olvidado
antes de poder ser recordado
por los jefes de estado
a quienes proveyó de azúcar.
Nunca fue visto cerca de la Casa Blanca,
nadie allí sabe su nombre,
nadie allí sabe que se está muriendo,
nadie allí sabe que no puede
contestar las preguntas que le hacen
hoy sus nietos,
nadie allí le está dando una pensión
por su vida de servicio a la causa
de producir azúcar para el café mañanero,
no veo banderas ondeando a media asta,
no oigo disparos en su honor,
sólo se muere silenciosamente en su sillón en el balcón
recordando como era la vida
antes de la revolución industrial,
antes de la tecnología computarizada,
antes del primer bombardeo atómico.

Don Portolo se merece una salva de 50 cañonazos.

Traducción de Urayoán Noel

THE MASTER PEDRO ALBIZU CAMPOS

Slumped over
The Master weeps
Flags fly at half mast
Anthems are whispered
A solitary wail descends
Hearts stolen
Buried beneath snow
The Master contemplates
Solitary confinement
A warm hand brushes
The anguish from his forehead
Another thorn driven deeper
Crucified bodies sway in Ponce
Tattered souls stagger
Under sub-zero temperatures
Language lost in the wind
The Master sits
Wrapped by a nation
Of tears and dashed hopes
The auction block cleared
For the next descendent
A surge of migrant bodies
To the North
Cripples cut sugar cane
In their mind
The Master, lost in his thoughts
Advocates for the little people
To the stars
A small Island in his palm
Children saved with his blood
Ancestors' enlightenment restored
Legends for generations to contemplate on
The Master's work, done
Ponders beyond the coffin
From his eye
Propels a lone star into the night sky
A beacon to guide
A spec of earth in the sea
A group of travelers
Through revolving doors.

To Repair a Broken World

Go forth on a mission
Riding high on a donkey's back
Place smooth hands on a dying child's cheek
Restore the wind of his soul
Wake him now from the dead

Pluck homeless lives up from the streets
Wash their wounds with a kiss
Fill their hearts with crushed flowers
Feed them loaves of bread and fish
Give them beds where they may dream

To preserve the spirits of the earth
Petition the universe overhead
Speak in tongues toward the East
Will an end to trees' demise
Bow before a wilderness

Rub the sea's anger away
Promise to spend time remembering
The love shared
The gentle walks taken on her back

Meditate in desserts for world peace
Burn incense encased in vessels of alabaster
In Buddha temples
Chant on for years and years

As the light of the stars in a glimpse
Freely give a spark of love to a friend

HOMEMADE HOT SAUCE

for mom

Mother goes out on the hunt
In search of prime specimens
Little red peppers
Some green
Her market of choice
A vegetable post by the side of the road
Year after year you can find
The old man there
Under a perennial baking sun
His makeshift market in the wind
Mother slowly stalks the produce
Scrutinizes the baby bananas
Pores over the vianda
Pauses to ask if I'd like her
To cook some for dinner
Then analyzes the aguacates
Turing them over
Squeezing them lightly as they rest
In the palm of her wrinkled hand
Finally she comes up on them
Chubby as plum tomatoes
Their skins shiny
Smooth as plastic
Their fiery nature screaming
From inside glad sandwich bags
Where they hang on a tree

Back home mother
Patiently washes each one
Grinds up spices with her
Wooden mortar and pestle
Pounds with such force
The hanging pictures
Over the dinner table
All dance to her cooking drum
 And when her concert has ended
She packs them into
An old vinegar bottle
Adds a fresh splash of vinegar to the mix
Then promptly places
Her concoction out doors to ferment
Under a Puerto Rican sun

MADELINE MILLÁN

Madeline Millán es escritora, traductora y promotora cultural. Ha publicado tres libros de poesía: *Para no morir por segunda vez* (Senda-Vox, Argentina, 2002) y *De toros y estrellas* (Terranova, Puerto Rico, 2004) y *Leche/Milk* (Godot, Argentina, 2008). Editó *Nights of Cornelia* (2008), una antología de poetas contemporáneos y tradujo cuatro de los poetas que se incluyen en el libro. Fue la creadora de una de las primeras revistas de cine latinoamericano en la red, titulada *Entreextremos*. Algunas de las antologías latinoamericanas donde aparecen sus poemas son: *Nueva poesía hispanoamericana* (Perú, 2004), *El estruendo de las rosas* (Perú, 2006), *La trilogía Poética de la mujeres de Hispanoamérica: pícaras, místicas y rebeldes* (México, 2004) y *(Per)versiones desde el paraíso: poesía puertorriqueña de entresiglos* (España, 2005). Se publicó en España *Poetas sin tregua, Compilación de poetas puertorriqueñas de la generación del 80,* (incluye poemas del libro inédito *Tango de la viuda*), presentado durante el Primer Congreso de Poesía en Mar del Plata (2006), y luego en el mismo año en Casa Cultural de España, Lima, Perú. Sus poemas y cuentos aparecen en revistas impresas y electrónicas de España, Latinoamérica y Estados Unidos, como *Blanco Móvil, LaOtra* y *Banda Hispánica*. Algunos de estos trabajos pueden leerse en su página electrónica. Obtuvo el Premio Nacional de Poesía del PEN Club de Puerto Rico en el 2009.

Millán coordinó por varios años lecturas bilingües de poesía en The Cornelia Street Café en Nueva York. Es profesora de lenguas en el Fashion Institute of Technology (SUNY). Imparte talleres de poesía en privado y en grupos pequeños en Manhattan.

Madeline Millán is a writer, translator and cultural activist. She has published three poetry books: *Para no morir por segunda vez* (Senda-Vox, Argentina, 2002), *De toros y estrellas* (Terranova, Puerto Rico, 2004) and *Leche/Milk* (Godot, Argentina, 2008). She edited *Nights of Cornelia* (2008), an anthology of contemporary poets in which Millán translated four of the poets included. She was the creator of one of the first internet film magazines, entitled *Entreextremos*. Her poems have been published in Hispano-American anthologies, including *Nueva poesía hispanoamericana* (Perú, 2004), *El estruendo de las rosas* (Perú, 2006), *La trilogía poética de la mujeres de Hispanoamérica: pícaras, místicas y rebeldes* (México, 2004), *(Per) versiones desde el paraíso: poesía puertorriqueña de entresiglos* (Spain, 2005) and *Poetas sin tregua: Compilación de poetas puertorriqueñas de la generación del 80* (Spain, 2006). This last anthology includes poems from her forthcoming book *Tango de la viuda*, which can be read on the internet at *Herederos del caos*. She had presented her recent books during the First Poetry Congress at Mar del Plata (2006), and at the Spanish Cultural House in Lima, Perú. Millán's poems and stories can be read at her webpage. She has published her work in printed literary magazines and virtual magazines, such as *Blanco Móvil*, *LaOtra* and *Banda Hispánica*. She received the National Poetry Award of Puerto Rico in 2009.

For several years, Millán coordinated bilingual poetry readings at The Cornelia Street Café in New York. She is a language professor at the Fashion Institute of Technology (SUNY). She offers private and group poetry workshops in Manhattan.

INFERNALES POEMAS DE PAOLA Y FRANCESCA

¿Qué almas son esas a quienes
de tal suerte castiga el aire negro?
Dante (Canto V)

Naturaleza muerta 1
la ráfaga los separó, bailan las ramas de otoño. se iban poniendo rojas así también
sus bocas. cayeron hojas al suelo. nadie las levantó. ni siquiera nosotros
luego llegó el frío. parecía la vida morir y tomar la apariencia de rascacielos
incendiados en las tardes, la ceniza caía a mitad del día. el cielo de la
patagonia, donde por azar llegó el sujeto de la trama en bicicleta, tomó
color. estaba enamorado y la luz correspondía su tarea. recogen sus huesitos
de entonces. el humo lanza su cortina de luto. corre por la ciudad su
fantasma de muchacho repartiendo víveres bajo la luna. si ella en medio
de las ruinas se llamara de otro modo, por ejemplo francesca o maría,
seguramente podrán identificarla en el cuadro de esa naturaleza muerta

Naturaleza muerta 2
basta, no me quedan (aunque quisiera) más territorios incendiados, piromaniaco
obtuso investido por aguaceros de primavera. han pasado los meses. rosas negras
en su tinta o en su pincel. debo quitarme el abrigo con cuidado. desnuda no
podré asomarme jamás a la ventana. siempre el ingenio se las arregló para salirse
del marco. será mejor así pintarme los labios como si recordara el beso. lo sé, a
veces parezco prostituta de burdel en pueblo chico cuando el rojo se corre. verme
al espejo es una manera de recordar las manzanas pudriéndose en el cuadro

3 los crepúsculos me olvidaban. estoy empezando a olvidarlo todo menos el
libreto. llegaste vencido por el cielo austral. los forasteros como johny guitar
también amaron. juzgamos con el mínimo esfuerzo. la película transmuta
piel rojiza y quemada del verano. el vaquero de las estepas vaquianas
pregunta lo mismo: –¿me has amado?, dime que no me has olvidado, que
me has esperado todos estos años. y ella, la francesca —la joan crawford
descreída—, rebobina la cinta y repite que todavía le ama. pero da igual, ya
qué más da, las palabras finales de una a otra me agradecen tal mentira)

4 tan joven y bello cuando llegó. su cabellera larga, su barba incipiente,
como si estirara los brazos para ella fijo al retrato. como quien no quiere
la cosa. ideal para filmarlo un director de películas porno, echando el
cuerpo hacia atrás su sexo se dibuja. ella conoce la forma bajo los pliegues
de la ropa, ha palpado y llevado a su boca el miembro entero y ha sido
feliz quemándose en el fuego. cuando entra al umbral siempre es paolo
el que la cruza. ¿qué destino se esperaba de tus ojos, francesca?

5 soy la bella impúdica sorprendida en el beso, la implicada de historias en canto forjado por recorridos circulares, repertorio del pecado. esa palabra no debería existir para poetas entendidos en amores, pero a veces ocurre, las caducas, irremediables zombies escapan de sus cementerios. como un insulto gritar puta y no encontrar el sexo del mismo vocablo saliendo a defenderle. en el amor y en la guerra el género hace trampas. otra de ellas, a su encuentro, es el perdón. tomarle el peso. él quiso lavarse las manos. pretendió, al revés, salir absuelto de su voluntario viaje por el cuerpo. la encontró malévola, se hizo compadrito maneobrando el cuchillo de amante ante el esposo. frente a frente, invita a matar al enemigo común. olvidado del sur, culpa afirmando no ser inocente la muchacha a la que amó.

FROM: TANGO DE LA VIUDA (THE WIDOW'S TANGO)

I listen to Louis Armstrong singing in the 20's
What the Buddha sang in India:
When you're smilin' keep on smilin'
The whole world smiles with you
The most beautiful words I heard
Were swept away by the wind
What the wind stole from me was love
I was left alone with words
Ah, this sorrow, pure pleasure today!
For without you today I begin to dance
I will dance through the deserts
The dunes where I ate from your hand
You will leave some day in October

And some 6th of November, all the deaths
Of the dead will come crashing down
Upon my head, my own included
Ah, why so much sorrow in my dance!
Let the pain be not that pain
*That little-pain, pain, pain, little-pain**
I am drenched in sadness, I know
You left taking with you the words
Words not written on the walls
Of the city of Manhattan,
A small city
A hole through which my sea escapes
My sky, infinite flight to the south
The world grew so small
From Patagonia to the seas of the Caribbean
So that, crossing the water, faces were seen again:
*Oh little-little world,***
What world do you offer me?
Leap through my eyes
For I want to fly,
Oh little-little boy
What little boy do you offer me?
You want to make me your widow
To make me dance, weeping
Do not mourn for anyone,
Beautiful girl in your forties

*In Stanza IV, the play of words ("That little-pain, pain, pain, little-pain") echoes the
popular song "Pena, penita, pena," by the Spanish singer Lola Flores (1923-1995).
**In Stanza VIII, ("Oh little-little world"), we see a re-fashioning of lines from the
poem "Hombre pequeñito," by the Argentine poet Alfonsina Storni (1892-1938), born
in Capriasca, Switzerland, of Italian-Swiss parents.

I order you to smile with the suns of your island
To counter misfortune this girl this girl
If you leave twice, you are already dead
The world smiles strangely
In return
And returns

English translation by James Cascaito

Pre y pro (posiciones)

He de llamarme como mi madre, la réplica exacta he de ser
los labios suyitos, frente, negro pelo y los ojos no, esos verdes
serán míos, porque los nunca ojos copiarse han pero la boca
He de llamarme a lo ella, ayer hubiese muerto, murióse ala
bortarme. Amanecía. Lo leí es un diario cristiano. No
supe, no parlaba de las oscuras maneras aguas devolverse a,
los maremotos levantaron ancla contra, confudiendo la sangre
desde huellas digitales que oprimen el pecho y te manó leche
del pezón (bajo y con ganas). Levántate mamá, no te amargues
entre, soy budista en esta para, en aquella no, imposible fue
pues levantar la cresta de las olas por intentarlo en la otra vida
que será sin sobre y tras del miedo, uno en esos avatares del tú
donde mí serás, hija, yo daré testa, también tetaati y no te
compliques por si la cobardía cobarde de sí, tal ya vez
cual la carne ritornare, pudiera repartir las ganancias entre nos

PEZÓN

El real me dio un arsenal:
parte prominente de un pechón
repleto algunas veces de
y en otras cercado por
también en los carros
sobresale de la rueda, molinos
de papel, extremo y remate
del árbol, punta y cabo de tierra,
parte saliente de una fruta entre ellas
el limón añadir agua fría, miel o
de cosas semejantes a, beberse
en té puede caliente la vida asidero
de la bolsa (germ), en botánica rama
pequeña que sostiene la hoja de mi punta
yo, solamente quería amamantar mi niña,
leche y boca me faltaron, orden me dio
el diccionario, solamente una palabra y
tuve que inventar definiciones

El rastro

Si alguien que habla con palabras piensa por un sólo momento
ser dueño del sentido y se pone un vestido y se pone maquillaje
sombrero de verano y queda convencido de sus actos poniendo
en el mismo diván la ropa de otro día y al lavarse la cara y ver
la desnudez total de su cuerpo piensa por un sólo momento
sea lo mismo vestirse que desvestirse, y cuando habla con palabras
la raíz des le provoca in-vestirse de poder con otra raíz para salirle
callejeando a la manera de árbol retoñando ramas y queda feliz
de su verde nacer y renacer lo mismo será en primavera y otros avatares
poniendo en el mismo canasto de basura el pellejo de una gallina
o dejando la marca del pintalabios rojo recomendado por una espiritista
escudo seguro contra los malos espíritus pero si esa pintura fuera
arrastrada por otros labios y los entes invisibles aprovechando un beso
entraran a la boca y alguien hablara y tomara los dedos de ese ser
dueño de su rojo ya perdido y su lengua con la otra hiciera un nudo
marinero de lenguas un pacto imposible de ser dicho si alguien
les dijera que no hablan con palabras ni por ellos y un momento uno
sólo les hace dueños y se van derechito a la cama nupcial plena
intemperie a esperar una luna un ojo de animal que le complace
hablar sabiéndose boca redonda blanca y si ellos sabiendo estar
en otro punto un ser de otro sexo al encuentro enhiesto interroga
con ojos las alturas sin darle importancia a las escrituras respondiendo
darle lo mismo contar los días hacia arriba o hacia abajo si alguien con
los ojos elevados en forma de punta de pirámide a pie sin bicicleta
consulta el oráculo y cosiera con la aguja de Cleopatra sus destinos
trazando jeroglifos en un azul del cielo acabado en negro y los dos
se citan según los relojes del Pacífico y del sur porque estarán juntos
para ver la desnudez total de sus cuerpos y si alguien les hablara
con palabras no se lo creerían pensarían estar ante un ente equivocado
pobre diablo pensando que la sombra pertenece por un sólo momento
ser uno como una sola luna como una sola línea con el sol persiguiendo
su cola su cabeza detrás oliéndose de la nariz el culo tal es el rastro
perseguido por los perros el destino de los mortales creyendo en
las palabras de lunática luna un eclipse por venirse si alguien lo
pensara lo escribiera lo hablara, si lo

NICHOLASA MOHR

Nicholasa Mohr es autora de cuentos, novelas, obras de teatro, ensayos y libros para niños, jóvenes y adultos. Sus obras son testigo de las alegrías, penas, sueños, derrotas y victorias de nuestras experiencias en los Estados Unidos. Entre sus libros se encuentran: *Nilda, El Bronx Remembered, In Nueva York, Felita, Going Home, Rituals of Survival; A Woman's Portfolio, Growing Up Inside the Sanctuary of My Imagination, A Matter of Pride, The Song of El Coquí and Other Tales of Puerto Rico, El regalo mágico.* The Henry St. Settlement House, Arts Abrons Arts Center, llevó al teatro una adaptación de cuentos suyos de *El Bronx Remembered* (1999, 2000). The Richmond College Theater, de Londres, presentó su drama *I Never Even Seen My Father,* basado en un cuento de su libro *In Nueva York* (1995). El Duo Theater, Henry Street Settlement e INTAR han presentado lecturas dramatizadas de *Zoraida,* la adaptación de uno de los cuentos de *Rituals of Survival; A Woman's Portfolio.* Mohr fue Writer-in-Residence del Richmond College, The American University in London (1994-1995) y Distinguished Visiting Professor de Queens College (1988-1991). Sus premios incluyen: Raul Juliá Award, del Puerto Rican Family Institute, 2007; Governor George E. Pataki NYS Hispanic Heritage Month Award, 2006; Women of El Barrio, Woman of Substance Award, 2003; Hispanic Heritage Award for Literature, 1997; Professional Achievement Award in Arts and Culture, Boricua College, 1997; Lifetime Achievement Award, National Congress of Puerto Rican Women, Philadelphia 1996; An Honorary Degree of Doctor of Letters de SUNY en Albany, 1989; The American Book Award, 1981; finalista del National Book Award, l976. Dos producciones teatrales que son adaptaciones de sus cuentos se presentaron en The Clemente Soto Vélez Cultural Center NYC (2008). La Universidad de Antioquia en Medellín, Colombia, tradujo al español, con la ayuda de una Beca Fullbright, el libro *Rituals of Survival; A Woman's Portfolio.* Nicholasa Mohr vive y escribe en El Barrio, donde nació.

Nicholasa Mohr is an author of short stories, novels, plays, essays and books for children, young adults and adults. She serves as a witness and translator of the joys, sorrows, dreams, defeats and victory of our diverse American experience. Among her books are *Nilda, El Bronx Remembered, In Nueva York, Felita, Going Home, Rituals of Survival: A Woman's Portfolio, Growing Up Inside the Sanctuary of My Imagination, A Matter of Pride, The Song of El Coquí and Other Tales of Puerto Rico, El regalo mágico.* The Henry St. Settlement House, Arts Abrons Arts Center, had stories from *El Bronx Remembered* adapted to the stage (1999, 2000). The Richmond College Theater, in London, performed her play *I Never Even Seen My Father,* based on a short story from *In Nueva York* (1995). *Zoraida,* an adaptation of a short story from *Rituals of Survival: A Woman's Portfolio,* had staged readings at Duo Theater, Henry Street Settlement and INTAR. Mohr was Writer-in-Residence at Richmond College, The American University in London (1994-1995). She was Distinguished Visiting Professor at Queens College (1988-1991). Awards include: Raul Juliá Award, by the Puerto Rican Family Institute, 2007; Governor George E. Pataki NYS Hispanic Heritage Month Award, 2006; Women of El Barrio, Woman of Substance Award, 2003; Hispanic Heritage Award for Literature, 1997; Professional Achievement Award in Arts and Culture, Boricua College, 1997; Lifetime Achievement Award, National Congress of Puerto Rican Women, Philadelphia 1996; an Honorary Degree of Doctor of Letters from SUNY at Albany, 1989; The American Book Award in 1981; National Book Award finalist 1976. Two plays adapted from her short stories were performed at The Clemente Soto Velez Cultural Center (2008). *Rituals of Survival: A Woman's Portfolio,* was translated into Spanish with a Fulbright Grant by the University of Antioquia in Medellín, Colombia. Nicholasa Mohr currently lives in El Barrio (Spanish Harlem), where she was born and continues to write books and plays for readers of all ages.

A Thanksgiving Celebration
(Amy)

Amy sat on her bed thinking. Gary napped soundly in his crib, which was placed right next to her bed. The sucking sound he made as he chewed on his thumb interrupted her thoughts from time to time. Amy glanced at Gary and smiled. He was constant companion now; he shared her bedroom and was with her during those frightening moments when, late into the night and early morning, she wondered if she could face another day just like the one she had safely survived. Amy looked at the small alarm clock on the bedside table. In another hour or so it would be time to wake Gary and give him his milk, then she had just enough time to shop and pick up the others, after school.

She heard the plopping sound of water dropping into a full pail. Amy hurried into the bathroom, emptied the pail into the toilet, then replaced it so that the floor remained dry. Las week she had forgotten, and the water had overflowed out of the pail and onto the floor, leaking down into Mrs. Wynn's bathroom. Now Mrs. Wynn was threatening to take her to small claims court, if the landlord refused to fix the damage done to her bathroom ceiling and wallpaper. All right, Amy shrugged, she would try calling the landlord once more. She was tired of the countless phones to plead with them to come and fix the leak in the roof.

"Yes, Mrs. Guzman, we got your message and we'll send somebody over. Yes, just as soon as we can . . . we got other tenants with bigger problems, you know. We are doing our best, we'll get somebody over; you gotta be patient . . ."

Time and again they had promised, but no one had ever showed up. And it was now more than four months that she had been forced to live like this. Damn. Amy walked into her kitchen, they never refused the rent for that, there's somebody ready any time! Right now, this was the best she could do. The building was still under rent control and she had enough room. Where else could she go? No one in a better neighborhood would rent to her, not the way things were.

She stood by the window, leaning her side against the molding, and looked out. It was a crisp sunny autumn day, mild for the end of November. She remembered it was the eve of Thanksgiving and felt a tightness in her chest. Amy took a deep breath, deciding not to worry about that right now.

Rows and rows of endless streets scattered with abandoned buildings and small houses stretched out for miles. Some of the blocks were almost entirely leveled, except for clumps of partial structures charred

and blackened by fire. From a distance they looked like organic masses pushing their way out of the earth. Garbage, debris, shattered glass, bricks and broken, discarded furniture covered the ground. Rusting carcasses of cars that had been stripped down to the shell shone and glistened a bright orange under the afternoon sun.

There were not people to be seen nor traffic, save for a group of children jumping on an old filthy mattress that had been ripped open. They were busy pulling the stuffing out of the mattress and tossing it about playfully. Nearby, several stray dogs searched the garbage for food. One of the boys picked up a brick, then threw it at the dogs, barely missing them. Reluctantly, the dogs moved on.

Amy sighted and swallowed, it was all getting closer and closer. It seemed as if only last month, when she had looked out of this very window, all of that was much further away; in fact, she recalled feeling somewhat removed and safe. Now the decay was creeping up to this area. The fire engine sirens screeching and screaming in the night reminded her that the devastation was constant, never stopping even for a night's rest. Amy was fearful of living on the top floor. Going down four flights to safety with the kids in case of a fire was another source of worry for her. She remembered how she had argued with Charlie when they had first moved in.

"All them steps to climb with Michele and Carlito, plus carrying the carriage for Carlito, is too much."

"Come on baby," Charlie had insisted "it's only temporary. The rent's cheaper and we can save something towards buying our own place. Come on . . ."

That was seven years ago. There were two more children now, Lisabeth and Gary; and she was still here, without Charlie.

"Soon it'll come right to this street and to my doorstep. God Almighty!" Amy whispered. It was like a plague: a disease for which there seemed to be no cure, no prevention. Gangs of youngsters occupied empty store fronts and basements; derelicts, drunk or wasted on drugs, positioned themselves on the street corners and in empty doorways. Every day she saw more abandoned and burned-out sections.

As Amy continued to look out, a feeling that she had been in this same situation before, a long time ago, startled her. The feeling of deja vu so real to her, reminded Amy quite vividly of the dream she had had last night. In that dream, she had been standing in the center of a circle of little girls. She herself was very young and they were all singing a rhyme. In a soft whisper, Amy sang the rhyme: "London Bridge is falling down, falling down, falling down, London Bridge is falling down, my fair lady" She stopped and

saw herself once again in her dream, picking up her arms and chanting, "wave your arms and fly away, fly away, fly away . . ."

She stood in the middle of the circle waving her arms, first gently, then more forcefully, until she was flapping them. The other girls stared silently at her. Slowly, Amy had felt herself elevated above the circle, higher and higher until she could barely make out the human figures below. Waving her arms like, the wings of a bird, she began to fly. A pleasant breeze pushed her gently, and she glided along, passing through soft white clouds into an intense silence. Then she saw it. Beneath her, huge areas were filled with crumbling buildings and large caverns; miles of destruction spread out in every direction. Amy had felt herself suspended in this silence for a moment and then she began to fall. She flapped her arms and legs furiously, trying to clutch at the air, hoping for a breeze, something to get her going again, but there was nothing. Quickly she fell, faster and faster, as the ground below her swirled and turned, coming closer and closer, revealing destroyed, burned buildings, rubble and a huge dark cavern. In a state of hysteria, Amy had fought against the loss of control and helplessness, as her body descended into the large black hole and had woken up with a start just before she hit bottom.

Amy stepped away from the window for a moment, almost out of breath as she recollected the fear she had felt in her dream. She walked over to the sink and poured herself a glass of water.

"That's it, Europe and the war," she said aloud. "In the movies, just like my dream."

Amy clearly remembered how she had sat as a very little girl in a local movie theatre with her mother and watched horrified at the scenes on the screen. Newsreels showed entire cities almost totally devastated. Exactly as it had been in her dream, she recalled seeing all the destruction caused by warfare. Names like "Munich, Nuremburg, Berlin" and "the German people" identified the areas. Most of the streets were empty, except for the occasional small groups of people who rummaged about, searching among the ruins and huge piles of debris, sharing the spoils with packs of rats who scavenged at the safe distance. Some people pulled wagons and baby carriages loaded with bundles and household goods. Others carried what they owned on their backs.

Amy remembered turning to her mother, asking, "What was going on? Mami, who did this? Why did they do it? Who are those people living here?"

"The enemy, that's who," her mother had whispered emphatically. "Bad people who started the war against our country and did terrible things to

other people and to us. That's where your papa was for so long, fighting in the army. Don't you remember, Amy?"

"What kinds of things, Mami? Who were the other people they did bad things to?"

"Don't worry about them things. These people got what they deserved. Besides, they are getting help from us, now that we won the war. There's a plan to help them, even though they don't deserve no help from us."

Amy had persisted, "Are there any little kids there? Do they go to school? Do they live in them holes?"

"Shh . . . let me hear the rest of the news . . ." her mother had responded, annoyed. Amy had sat during the remainder of the double feature, wondering where those people lived and all about the kids there. And she continued to wonder and worry for several days, until one day she forgot all about it.

Amy sipped from the glass she held, then emptied most of the water back into the sink. She sat and looked around at her small kitchen. The ceiling was peeling and flakes of paint had fallen on the kitchen table. The entire apartment was in urgent need of a thorough plastering and paint job. She blinked and shook her head, and now? Who are we now? What have I done? Who is the enemy? Is there a war? Are we at war? Amy suppressed a loud chuckle.

"Nobody answered my questions then, and nobody's gonna answer them now," she spoke out loud.

Amy still wondered and groped for answers about Charlie. No one could tell her what had really happened . . . how he had felt and what he was thinking before he died. Almost two years had gone by, but she was still filled with an overwhelming sense of loneliness. That day was just like so many other days; they were together, planning about the kids, living from one crisis to the next, fighting, barely finding the time to make love without being exhausted; then late that night, it was all over. Charlie's late again, Amy had thought, and didn't even call me. She was angry when she heard the doorbell. He forgot the key again. Dammit, Charlie! You would forget your head if it weren't attached to you!

They had stood there before her; both had shown her their badges, but only one had spoken.

"Come in . . . sit down, won't you."

"You better sit down, miss." The stranger told her very calmly and soberly

that Charlie was dead.

"On the Bruckner Boulevard Expressway . . . head on collision . . . dead on arrival . . . didn't suffer too long . . . nobody was with him, but we found his wallet."

Amy had protested and argued – No way! They were lying to her. But after a while she know they brought the truth to her, and Charlie wasn't coming back.

Tomorrow would be the second Thanksgiving without him and one she could not celebrate. Celebrate with what? Amy stood and walked over and opened the refrigerator door. She had enough bread, a large pitcher of powdered milk which she had flavored with Hershey's cocoa and powdered sugar. There was plenty of peanut butter and some graham crackers she had kept fresh by sealing them in a plastic bag. For tonight she had enough chopped meat and macaroni. But tomorrow? What could she buy for tomorrow?

Amy shut the refrigerator door and reached over to the money tin set way back on one of the shelves. Carefully she took out the tin and put it away.

Amy had thought of calling the lawyers once more. What good would that do? Right now . . . today!

"These cases take time before we get to trial. We don't want to take the first settlement they offer. That wouldn't do you or the children any good. You have a good case, the other driver is at fault. He didn't have his license or the registration, and we have proof he was drinking. His father is a prominent judge who doesn't want that kind of publicity. I know . . . yes, things are rough, but just hold on a little longer. We don't want to accept a poor settlement and risk you future and the future of your children, do we?" Mr. Silverman of Silverman, Knapp and Ullman was handling the case personally. "By early Spring we should be making a date for trial . . . just hang in there a bit longer . . ." And so it went every time she called: the promise that in just a few more months she could hope for relief, some money, enough to live like people.

Survivor benefits had not been sufficient, and since they had not kept up premium payments on Charlie's G.I. Insurance policy, she had not other income. Amy was given a little more assistance from the Aid to Dependent Children agency. Somehow she had managed so far.

The two food stores that extended her credit were still waiting for Amy to

settle overdue accounts. In an emergency she could count on a few friends; they would lend her something, but not for this, not for Thanksgiving dinner.

She didn't want to go to Papo and Mary's again. She knew her brother meant well, and that she always had an open invitation. They're good people, but we are five more mouths to feed, plus they've been taking care of Papa all these years, even since Mami died. Enough is enough. Amy shut her eyes. I want my own dinner this year, just for my family, for me and the kids.

If I had the money, I'd make a dinner tomorrow and invite Papa and Lou Ann from downstairs and her kids. She's been such a good friend to us. I'd get a gallon of cider and a bottle of wine . . a large cake at the bakery by Alexander's, some dried fruits and nuts . . . even a holiday centerpiece for the table. Yes, it would be my dinner for us and my friends. I might even invite Jimmy. She hadn't seen Jimmy for a long time. Must be over six months . . . almost a year? He worked with Charlie at the plant. After Charlie's death, Jimmy had come by often, but Amy was not ready to see another man, not just then, so she discouraged him. From time to time, she thought of Jimmy and hoped he would visit her again.

Amy opened her eyes and a sinking feeling flowed through her, as she looked down at the chips of paint spread out on the kitchen table. Slowly, Amy brushed them with her hand, making a neat pile.

These past few months, she had seriously thought of going out to work. Before she had Michele, she had worked as a clerk-typist for a large insurance company, but that was almost ten years ago. She would have to brush up on her typing and math. Besides, she didn't know if she could earn enough to pay for a sitter. She couldn't leave the kids alone; Gary wasn't even three and Michele had just turned nine. Amy had applied for part-time work as a teacher's aide, but when she learned that her check from Aid to Dependent Children could be discontinued, she withdrew her application. Better to go on like this until the case comes to trial.

Amy choked back the tears. I can't let myself get like this. I just can't! Lately, she had begun to find comfort at the thought of never waking up again. What about my kids, then? I must do something. I have to. Tomorrow is going to be for us, just us, our day.

He thoughts went back to her own childhood and the holiday dinners with her family. They had been poor, but there was always food. We used to have such good times. Amy remembered the many stories her grandmother used to tell them. She spoke about her own childhood on a farm in a rural area of Puerto Rico. Her grandmother's stories were about

the animals, whom she claimed to know personally and very well. Amy laughed, recalling that most of the stories he grandmother related were too impossible to be true, such as a talking goat who saved the town from a flood, and the handsome mouse and beautiful lady beetle who fell in love, got married and had the biggest and fanciest wedding her grandmother had ever attended. Her grandmother was very old and had died before Amy was ten. Amy had loved her best, more than her own parents, and she still remembered the old woman quite clearly.

"Abuelita, did them things really happen? How come them animals talked? Animals don't talk. Everybody knows that."

"Oh, but they do talk! And yes, everything I tell you is absolutely the truth. I believe it and you must believe it too." The old woman had been completely convincing. And for many years Amy had secretly believed that when her grandmother was a little girl, somewhere in a special place, animals talked, got married and were heroes.

"Abuelita," Amy whispered, "I wish you were here and could help me now." And then she thought of it. Something special for tomorrow. Quickly, Amy took out the money tin, counting out just the right amount of money she needed. She hesitated for a moment. What if it won't work and I can't convince them? Amy took a deep breath. Never mind, I have to try, I must. She counted out a few more dollars. I'll work it all out somehow. Then she warmed up Gary's milk and got ready to leave.

Amy heard the voices of her children with delight. Shouts and squeals of laughter bounced into the kitchen as they played in the living room. Today they were all happy, anticipating their mother's promise of a celebration. Recently, her frequent moods of depression and short temper had frightened them. Privately, the children had blamed themselves for their mother's unhappiness, fighting with each other in helpless confusion. The children welcomed their mother's energy and good mood with relief.

Lately Amy had begun to realize that Michele and Carlito were constantly fighting. Carlito was always angry and would pick on Lisabeth. Poor Lisabeth, she's always so sad. I never have time for her and she's not really much older than Gary. This way of life has been affecting us all . . . but not today. Amy worked quickly. The apartment was filled with an air of festivity. She had set the kitchen table with a paper tablecloth, napkins and paper cups to match. These were decorated with turkeys, pilgrims, Indian corn and all the symbols of the Thanksgiving holiday. Amy had also brought a roll of orange paper streamers and decorated the kitchen chairs. Each setting had a name-card printed with bright magic markers. She had even managed to purchase a small holiday cake for dessert.

As she worked, Amy fought moments of anxiety and fear that threatened to weaken her sense of self-confidence. What if they laugh at me? Dear God in heaven, will my children think I'm a fool? But she had already spent the money, cooked and arranged everything; she had to go ahead. If I make it through this day, Amy nodded, I'll be all right.

She set the food platter in the center of the table and stepped back. A mound of bright yellow rice, flavored with a few spices and bits of fatback, was surrounded by a dozen hardboiled eggs that had been colored a bright orange. Smiling, Amy felt it was all truly beautiful; she was ready for the party.

"All right," Amy walked into the living room. "We're ready!" The children quickly followed her into the kitchen.

"Oooh, Mommy," Lisabeth shouted, "everything looks so pretty."

"Each place has got a card with your own name, so find the right seat." Amy took Gary and sat him down on his special chair next to her.

"Mommy," Michele spoke, "is this the whole surprise?"

"Yes," Amy answered, "just a minute, we also have some cider." Amy brought a small bottle of cider to the table.

"Easter eggs for Thanksgiving?" Carlito asked.

"Is that what you think they are, Carlito?" Amy asked.

"Because they are not Easter eggs."

The children silently turned to one another, exchanging bewildered looks.

"What are they?" Lisabeth asked.

"Well," Amy said, "these are . . . turkey eggs, that's what. What's better than a turkey on Thanksgiving day? Her eggs, right?" Amy continued as all of them watched her. "You see, it's not easy to get these eggs. They're what you call a delicacy. But I found a special store that sells them, and they agreed to sell me a whole dozen for today."

"What store is that, Mommy?" Michele asked. "Is it around here?"

"No. They don't have stores like that here. It's special, way downtown."

"Did the turkey lay them eggs like that? That color?" Carlito asked.

"I want an egg," Gary said pointing to the platter.

"No, no . . . I just colored them that way for today, so everything goes together nicely, you know . . ." Amy began to serve the food. "All right, you can start eating."

"Well then, what's so special about these eggs? What's the difference between a turkey egg and an egg from a chicken?" Carlito asked.

"Ah, the taste, Carlito just wait until you have some." Amy quickly finished serving everyone. "You see, these eggs are hard to find because they taste so fantastic." She chewed a mouthful of egg. "Ummm . . . fantastic, isn't it?" She nodded at them.

"Wonderful, Mommy," said Lisabeth. "It tastes real different."

"Oh yeah," Carlito said, "you can taste it right away. Really good."

Everyone was busy eating and commenting on how special the eggs tasted. As Amy watched her children, a sense of joy filled her, and she knew it had been a very long time since they had been together like this, close and loving.

"Mommy, did you ever eat these kinds of eggs before?" asked Michele.

"Yes, when I was little," she answered. "My grandmother got them for me. You know, I talked about my abuelita before. When I first ate them, I couldn't get over how good they tasted, just like you." Amy spoke with assurance, as they listened to every word she said. "Abuelita lived on a farm when she was very little. That's how come she knew all about turkey eggs. She used to tell me the most wonderful stories about her life there."

"Tell us!"

"Yeah, please Mommy, please tell us."

"All right, I'll tell you one about a hero who saved her whole village from a big flood. He was . . . a billy goat."

"Mommy," Michele interrupted, "a billy goat?"

"That's right, and you have to believe what I'm going to tell you. All of you have to believe me. Because everything I'm going to say is absolutely the truth. Promise? All right, then, in the olden days, when my grandmother was very little, far away in a small town in Puerto Rico . . . "

Amy continued, remembering stories that she had long since forgotten. The children listened, intrigued by what their mother had to day. She felt a calmness within. Yes, Amy told herself, today's for us, for me and the kids.

CENÉN MORENO

Cenén Moreno (1945-2002) nació en Nueva York y murió en el Lower East Side, donde vivió la mayor parte de su vida. Fue escritora, artista visual, productora de radio y televisión, anfitriona de programas de diálogos, actriz, diseñadora y promotora comunal. Su trabajo se ha publicado en antologías y textos universitarios: *If I Lived Here, Homegirls, Compañeras, The Black Woman, Cuentos: Stories by Latinas*; en revistas: *And Then, Azalea* y el periódico local *Loisaida Voice*. Su obra artística se incluyó en el libro *I am from the Lower East Side*, y en los periódicos *The New York Times*, *The New York Press* y *The Village Voice*. Leyó su obra en Long Island University, Rutgers University, Hunter College, Exit Art, Tompkins Square Park y Boricua College. Cenén Moreno participó como actriz en la dramatización de cuentos de Myrna Nieves, *Dream Directory*, en el Nuyorican Poets Café en 1999 y en eventos en Barnard College, Columbia University, The Living Theater y la película corta *Mother's Hands*. Mientras estudiaba psicología e historia en City College, viajó de 1960-75 a México, Cuba, Puerto Rico, Marruecos, Argelia, Túnez, Libia, Egipto, Sudán, Uganda, Kenia, Tanzania, Burundi, Ruanda, a través de los Estados Unidos y en años recientes, a Palestina (2002). Vivió en Puerto Rico (en Sábana Grande) por tres años y en África por dos años y medio. En Africa nunca vio un turista o visitante puertorriqueño porque, señaló, "No nos educan para creer que buscar nuestras raíces africanas es aceptable". Cenén Moreno fue también la productora y anfitriona del programa de cable televisión *Universal Diaspora* (CH. 16) y administradora general de la estación que transmitía semanalmente su programa radial, *Loisaida USA (Universal Soul Awareness)*.

Cenén Moreno (1945-2002) was born in New York City and died in New York's Lower East Side, where she lived most of her life. She was a writer, visual artist, television and radio producer, talk show host, actress, designer and community activist. Her work has been published in anthologies and college texts, such as *If I Lived Here, Homegirls, Compañeras, The Black Woman, Cuentos: Stories by Latinas;* magazines, such as *And Then, Azalea* and in the local newspaper *Loisaida Voice.* Her art was included in the book *I am from the Lower East Side,* as well as in the newspapers *The New York Times, The New York Press* and *The Village Voice.* She read her work at Long Island University, Rutgers University, Hunter College and Boricua College. Cenén Moreno participated as an actress in Myrna Nieves's dramatization *Dream Directory* at the Nuyorican Poets Café in 1999 and in events at Barnard College, Columbia University, The Living Theater and in the short film *Mother's Hands.* A student of history and psychology at City College, she traveled from 1960-75 to Mexico, Cuba, Puerto Rico, Morocco, Algeria, Tunisia, Libya, Egypt, Sudan, Uganda, Kenya, Tanzania, Burundi, Rwanda, the USA and Palestine (her last trip). She lived in Puerto Rico (in Sábana Grande) for three years and in Africa for two and a half years. While living in Africa, she never saw a Puerto Rican visitor because, she stated: "We were never educated to believe that to seek our African roots was acceptable." Cenén Moreno was also the producer and host of the cable TV program *Universal Diaspora* (CH. 16) and the general manager of the station in which her radio program *Loisaida USA (Universal Soul Awareness)* was heard weekly.

ROAR

I WANT TO ROAR
I WANT TO TELL IT TO YOU
LIKE I FEEL IT
I WANT TO ROAR
UNTIL MY MIND IS MY OWN

ROAR
I WANT TO ROAR
LIKE I HAVE LIVED IT
I WANT TO BITE THE HAND THAT FEEDS ME
AND CONTROL THE SUPPLY MYSELF

ROAR
I WANT TO ROAR
TILL I AM AWAKENED
BY MY OWN CRIES
REMINDING ME WHAT IT WAS LIKE
TO BE AN UNWANTED CHILD

ROAR
I WANT TO ROAR
TO THINK I WAS TAUGHT
TO BE LAZY
ABOUT TAKING CARE OF MYSELF

ROAR
I WANT TO ROAR
BECAUSE I FEEL IT
IWANT TO LISTEN TO MY OWN FEELINGS
AND GIVE MYSELF THE LOVE I DESERVE

ROAR
I WANT TO ROAR
UNTIL THE SUN RISES UP INSIDE
OF ME

ROAR
I WANT TO ROAR
BECAUSE I AM FREE
TO ROAR

Tu amor por mí

Cuando la indiferencia
De tu mirada
Se baña
Con una incontrolable
Ola de ternura
Y tu cabeza
Cae
Escondiendo
El reflejo desnudo
De tus sentimientos
Reconozco tu amor
Por mí

IF ONLY I COULD SAY

IF ONLY
I COULD
SAY
WHAT IS IN THE
FACES
OF THE PALESTINIANS
LOOKING AT THEIR HOMELAND
THROUGH THE BARBED WIRE FENCES
OF THE REFUGEE CONCENTRATION CAMPS

IF ONLY
I COULD
SAY
WHAT IS IN THE
GENETIC HISTORY
OF GENERATIONS OF PALESTINIANS
WHOSE MEMORIES LIVE
IN THE HOUSES BULLDOZED BY
THE NEW STATE OF ISRAEL

IF ONLY I COULD
SAY
WHAT IS IN THE
HEARTS
OF THE THOUSANDS
WALKING
A BABY
WITH A BULLET HOLE

IN HER STOMACH
TO HER FINAL
REST

IF ONLY
I COULD
SAY
WHAT MADE AN ENGAGED
TEENAGE PALESTINIAN
STRAP EXPLOSIVES
AROUND HER
WAIST
AND WALK INTO
A CROWD
OF THOSE WHO
OCCUPY
HER HOMELAND

IF ONLY
I COULD
SAY
WHAT IS IN THE
MIND
OF A FATHER
REALIZING
HIS SON IS
DEAD
EVEN AFTER
PROTECTING HIM
WITH HIS OWN
BODY

IF ONLY
I COULD
SAY
WHAT DROVE A
CHILD
TO STAND
IN THE MIDDLE
OF THE
STREET
AND PICK UP A
STONE
AS A
TANK
TURNS ITS
CANNON
TOWARD
HIM

IF ONLY
I COULD
SAY
WHAT A MOTHER
FEELS
SEEING HER CHILD
BLOWN UP
AND HIS FLESH
CRUSHED
AS THE
TANKS
MOVE
ON

IF ONLY
I COULD
SAY
WHAT IS IN THE
LANGUAGE
OF THE FAMILY GRAVES
DIAMOND MINES, STONE QUARRIES, INDUSTRIES, BUSINESSES
OLIVE AND ORANGE GROVES
RENCHED
FROM THEIR
PRE-BIBLICAL
ROOTS

IF ONLY
I COULD
SAY
WHAT IS IN THE
FUTURE
OF A CHILD
AIMING A
SLING SHOT
AT AN
ISRAELI SOLDIER
AIMING A
U.S.A. TAX DOLLARS ISSUED
HIGH POWERED RIFFLE
AT HIM

IF ONLY
I COULD
SAY
WHAT ARE THE EMOTIONS
OF A MOTHER
AS SHE CLEANS
HER CHILD'S FACE

WITH HER SPIT
TO PREPARE HIM FOR
BURIAL
IN THE DARK
OF HER BACKYARD
ALONE
BECAUSE
THE WATER
ELECTRICITY
COMMUNICATIONS
TRANSPORTATION
MEDICAL SERVICES
AND FOOD
HAVE BEEN CUT
FOR WEEKS
AND ANYONE
CAUGHT OUT SIDE
IS SHOT
DEAD

WHO WILL BE LEFT TO
CLEAN
HER FACE
IF SHE HAS
ONE

2002 "IF ONLY I COULD SAY"
4:05 A.M. SÁBADO 23 DE MARZO: 390

El Pueblo grita, Presente

El Pueblo grita Libertad	The People cry out Liberty
El gobierno grita Comunistas	The Government cries out Communists
El Pueblo grita Paz	The People cry out Peace
El Gobierno grita Cobardes	The Government cries out Cowards
El Pueblo grita Pan	The People cry out Bread
El Gobierno grita Trabajen	The Government cries out Work for it

El Pueblo grita	The People cry out
Un día de descanso	One day of rest
El Gobierno grita	The Government cries out
Vagos	Lazy bums
El Pueblo grita	The People cry out
No más opresión	No more oppression
El Gobierno grita	The Government cries out
Escuadrones de la muerte	Street Crimes Unit
Apunten	Ready Aim
Fuera	Fire
El Pueblo deja de gritar	The People stop crying out
El Gobierno reparte	The Government gives out
Medallitas plásticas	Plastic medals
El Pueblo se habla	The People speak to each other
El Gobierno se asusta	The Government becomes frightened
El Pueblo se organiza	The People organize themselves
El Gobierno asume	The Government assumes
Un estado de alerta	A state of alert
El Pueblo se hace	The People become
Responsable por sí mismo	Responsible for themselves
El Gobierno ataca	The Government attacks
El Pueblo se defiende	The People defend themselves
El Gobierno sale corriendo	The Government runs away
El Pueblo crea	The People create
Cooperativas Nacionales	National Cooperatives
El Gobierno grita Pueblo	The Government cries out People
El Pueblo grita	The People cry out
Presente	Present

20 de diciembre de 1996
"El Pueblo grita, Presente"

Hands Off Our Children

Hands off
Our Children

They will
Not Fight
Your wars

Hands off
Our Children

They will
Not
Give their
Lives
To protect
Your investments
Any more

Hands off
Our Children

They will
Not
Be Blown up
As your
Children
Blow out
Their
Birthday candles

Hands off
Our Children

They will
Not
Kill
Your competition
So that your
Oil, poppy, coca
Etcetera stocks
Make you
More billions

Hands off
Our Children

Take your
Accountants
To War

Invite your
Lawyers

For a stroll
Across
The Mine Field

Call on the
Patriotism
Of your
Wall Street
Stock Brokers
To donate —
Their Commissions
To fund
Your
Terrorist Wars

Pray your
Religious leaders
Will make
The ultimate
Sacrifice

Interest
Bankers
In suicide
Missions

Petition your governments
And Judicial
Systems
To enact
Laws
Placing
Them
On the front lines

Recruit
Your children
As spies
To make

Them
The bull's eye
Of
Sharp shooters

Encourage
Your Children
To hack other
Trans National Capitalist
Imperialist Corporations' Computers
So they can, become
Trans National Technological Fugitives

Hands off
Our children

Have your son's
Arms
Blown off

Have your daughters
Raped
By their squad mates

Have your
Self medicated
Wives
Take your
Sons
To be
Fitted
For a prosthesis
After visiting
Your daughters
In Psychiatric
Prisons

Hands off
Our Children

Let your
Grand children
Be born
Deformed
Because of your
Experiments

Try finding
Your Family
Gone missing
After welcoming
The Pilgrims

Try finding
Your family
After being
Dragged
Off a continent
And across
An ocean
To enslave
Your humanity

Try finding
Your family
After being
Internally

Displaced by
Wars, Drugs, Death Squad
Plagues, Unemployment
War Games, Relocation
Physical
And psychological torture
For generations

Destroying your
Culture
History
Economic Stability
Ecology
Self Respect

In order to exploit your
National resources
Labor
Strategic Geographic
Position
The creative
Minds and Souls
Of your millions

Hands off
Our Children

Test your
Wars
With your
Sex Organs

Hands off
Our Children

Or it will be
You 2% or less of the population
And I 98-99% of the population
Facing off
With no ones
Children and tax dollar
To
Save
Your
Ass
Hands off Our Children

2001 "Hands Off Our Children"
5AM Saturday
October 27: 390
Last edition

HILDA R. MUNDO-LÓPEZ

Hilda R. Mundo-López es poeta y educadora, nacida en San Juan en 1957. Ha participado en numerosos recitales de poesía en Puerto Rico y Nueva York. Sus primeros poemas fueron publicados en *Contornos*, una revista literaria adscrita al Programa de Honor de la Universidad de Puerto Rico. Poemas selectos de Mundo-López se publicaron en las revistas literarias *Mairena, Brújula/Compass, Trasimagen* y *Tercer Milenio* y en las antologías *Antología de poesía joven en Puerto Rico* (1981) y *Antología de la poesía cósmica puertorriqueña* (2001), ambas editadas por el Dr. Manuel de la Puebla. Su poesía se ha publicado también en antologías de poesía en México, Chile y República Dominicana. Ha dictado numerosas conferencias, tanto en universidades como en centros culturales, sobre temas relacionados con la literatura latina en los Estados Unidos, en particular la literatura latina escrita en inglés. Mundo-López ha publicado ensayos sobre literatura en las siguientes revistas: V*oice, En Rojo, Caronte, Malandragem, Cupey, Caribbean Studies* y The *Caribbean Writer*, entre otras. Compiló la investigación para el recurso bibliográfico *Latinos in English: una bibliografía selecta de escritores de ficción latinos en los Estados Unidos* (1992). Obtuvo un BA en Literatura Hispánica y Literatura Comparada de la Universidad de Puerto Rico en Río Piedras (1980); una MA en Literatura Comparada del State University of New York en Stony Brook (1982); y en 1989 obtuvo el grado de Maestría en Filosofía (ABD) en New York University. Vive en la ciudad de New York desde 1982, donde enseña español, inglés y literatura Latina y Latinoamericana en varias instituciones de educación superior.

Hilda R. Mundo-López is a poet and educator born in San Juan in 1957. She has participated in literary recitals both in Puerto Rico and New York. Her first poems were published in *Contornos*, a literary journal ascribed to the Honors Program at the University of Puerto Rico. Selected poems were also published in the literary journals *Mairena, Brújula/Compass, Trasimagen, Tercer Milenio* and the anthologies *Poesía joven en Puerto Rico* (1981) and *Antología de la poesía cósmica puertorriqueña* (2001), both edited by Dr. Manuel de la Puebla. Her poetry has also been published in anthologies in México, Chile and the Dominican Republic. Mundo-López has lectured extensively in universities and literary centers on topics related to Latino literature in the United States, particularly on Puerto Rican literature written in English. Her essays on literature have been published in journals such as: *Voice, En Rojo, Caronte, Malandragem, Cupey, Caribbean Studies, The Caribbean Writer,* and others. She compiled the research for *Latinos in English: a Selected Bibliography of Latino Fiction Writers of the United States* (1992). Mundo-López holds a BA in Hispanic and Comparative Literature from the University of Puerto Rico (1980); and an MA in Comparative Literature from the State University of New York at Stony Brook (1982). She earned a Master in Philosophy (ABD) from New York University in 1989. She resides in New York City where she teaches Spanish, English and Latino and Latin American Literatures in institutions of higher education.

Pareja

No te conozco, Hombre.
Debajo de tanta noche
sólo percibo tu cara de manta.
No te conozco,
aunque te internas en los periódicos
como hacia el estómago la maldición.
Andas atado a la columna
irguiéndote los trece pecados
de tanta mala suerte
en que no tuvo ni cueros la sandalia.
Arrojado de liendres,
tienes el labio en la mordida
de lo que no sana;
la sinalefa de tu música putrefacta
que te pasea la noche al hombro
como al Goliat de tanta historia repetida.

Mujer, no te conozco,
debajo de tanto gorro y tanto pelo
sólo percibo la cara del ansia
y la cartera de tu último baile.
No te conozco, aunque te internas
cuerpo a cuerpo dentro del abrigo
fabricado a tu desmedida.
Andas palabreando
la ortiga como al broche que te falta;
descubriéndote el rascacielos
que llevas en la curvatura debajo de que te veo.
Arrojada de liendres,
tienes avenidas a ti los alacranes
de lo que no sana;
la sílaba en la cartera
guardada como token
para el banquete
de la última boca del subway.

A TRAVÉS DE LA VENTANA
y mucho más allá...
nuevos ojos que sólo miren
mis manos y nuevas manos
que sólo escriban mis ojos.

Cómo duelen los seis muertos
del Continente...
los recuento, los multiplico,
a través de la ventana
revivo cómo duele toda selva,
todo eucalipto,
todas las Dafnes, toda isla Puerto Rico,
a través de la ventana
cubierta de pelos grifos
arriba y abajo proscrita
de los cantos, de los gritos, de todo baile
con sandalias antillanas.

Tendida en su arena
cómo duele,
tendida, cómo suspira
por más agua y más ojos
y más manos,
por menos vientre a su costado,
por más sílaba...
a través de otras ventanas
que no sean mis ojos que la miran,
que no sean mis manos que la escriban.

DE QUÉ TE QUEJAS–

la fuerza de tu mano extraña está sola
mientras el otoño cae
y los enchufes prenden
y la vida se acorta...
más allá del aire
los trenes siguen la vía de su delirio
y los cañaverales del barro
anuncian una zafra de siglos.

PARA AMARTE

he puesto marco de madera a tu rostro,
he gorjeado violines a tu dolor antiguo,
he ungido bálsamo a tu piel,
he tendido tu cama con sábanas frescas,
he lavado toallas,
para cubrirte del frío
he amado nueve días a la semana.

En secreto he revisado papeles,
puesto en claro cuentas,
he salvado la palabra
que te llega hasta la puerta;
buscándote en cervezas
he roto madrugadas, he andado descalza;
entre las ventanas
he amado tu rostro, he amado tu sol ...
tus arenas cálidas he amado,
entre piernas he bebido la sal de tus mangles rojos.

MUERE DE BARRO

la enardecida aurora;
ataviada, la pluma
vuela en la sílaba
que en esta página canta
--- luz modesta ---
de nido el ala,
en su boca aposenta
a la dulce víbora
y en su garganta
cimbra de pájaros la voz.

MYRNA NIEVES

Myrna Nieves es poeta, narradora, ensayista, promotora cultural y educadora. Es miembro fundador y catedrática de Boricua College, donde dirigió por 20 años la Serie Invernal de Poesía. Publicó *Libreta de sueños (narraciones)* (1997) y *Viaje a la lluvia, poemas* (2002). Es también co-autora/ co-editora de la colección de poesía y prosa *Tripartita: Earth, Dreams, Powers* (1990), las publicaciones *Lugar sin límite* (1978), *Guaíza* (1986) y *Moradalsur* (2000). Compiló la sección de Puerto Rico en la antología de narradoras *Mujeres como islas* (2002), que también incluye su obra. Nieves produjo y actuó en *Directory of Dreams*, una dramatización de su narrativa para el Nuyorican Poets Café (1999). Su obra se ha incluído en las antologías *Mujeres/98; Enlaces: Trasnacionalidad-El Caribe y su diáspora; Conversación entre escritoras del Caribe hispano* (Tomo II), *Antología de la poesía cósmica puertorriqueña (Tomo II)* y *Cuando escritoras latinoamericanas narran en Estados Unidos (Tomo II).* Su trabajo se ha publicado en revistas literarias y por la red, como, *The Poetry Project, And Then, Brújula-Compass, Hybrido, Red y Acción, Letras salvajes, A Gathering of the Tribes, Banda Hispánica* y *Letras.* Escribió por varios años una columna mensual en el periódico *Nosotros los latinos.* Fue invitada al "Festival de Poetas Latinas" del Teatro Rodante Puertorriqueño (2007) y a numerosos festivales literarios. Es también Artista Asociada a PEPATIAN, una organización de artistas con sede en el Bronx.

Premios y reconocimientos: Premio de Cuento del PEN Club de Puerto Rico (1998), escritora invitada a la Biblioteca del Congreso por La Conferencia Nacional de Mujeres Puertorriqueñas (1997) y un reconocimiento de su capítulo en Nueva York (2007), "Latina Sobresaliente de Estados Unidos" de *El Diario La Prensa* (1998), Premio Contribución a la Literatura de la Federación Nacional de Pioneros Puertorriqueños (2001) y Premio al Logro Profesional en Literatura de Boricua College (2008). Obtuvo un BA en Literatura Mundial de la Universidad de Puerto Rico (Magna Cum Laude), un MA en Español de Columbia University y un doctorado en Literatura Latinoamericana y del Caribe de New York University.

Myrna Nieves is a writer, cultural activist and educator. A founding member and professor at Boricua College, she was director for twenty years of its Winter Poetry Series. Her published works are: *Libreta de sueños (narraciones)* (1997) and *Viaje a la lluvia, poemas* (2002). She is co-author/co-editor of the collection of poetry and prose *Tripartita: Earth, Dreams, Powers* (1990) and the literary publications *Lugar sin límite* (1978), *Guaíza* (1986) and *Moradalsur* (2000). Nieves compiled the section of Puerto Rican fiction writers for the anthology *Mujeres como islas* (2002), which also includes her literary work. She produced and performed in *Directory of Dreams*, a dramatization of her narrative for the Nuyorican Poets Café (1999). Her work has been anthologized in *Mujeres/98; Language Crossings: Negotiating the Self in a Multicultural World; Enlaces: Transnacionalidad-El Caribe y su Diáspora; Conversación entre escritoras del Caribe Hispano* (Volume II), *Antología de la poesía cósmica puertorriqueña* (Volume II) and *Cuando escritoras latinoamericanas narran en Estados Unidos* (Volume II). Her work has been included in literary journals and internet magazines, such as *The Poetry Project, And Then, Brújula-Compass, Hybrido, Red y Acción, Letras salvajes, A Gathering of the Tribes, Banda Hispánica* and *Letras*. For several years, she wrote a monthly column for the newspaper *Nosotros los latinos*. Nieves was also selected for "The Latina Poets Festival" of the Puerto Rican Traveling Theater (2007) and many literary festivals/performances. She is also an Associate Artist for PEPATIAN, a Bronx-based arts organization.

Awards and recognitions include Literary Award of the PEN Club of Puerto Rico (1998), guest writer at the Library of Congress for The National Conference of Puerto Rican Women (1997) and a recognition by its New York Chapter in 2007, "Outstanding Latina of the United States" by *El Diario La Prensa* (1998), Award for Contribution to Literature from the National Federation of Puerto Rican Pioneers (2001), Professional Achievement Award in Literature from Boricua College (2008). Nieves earned a BA in World Literature at the University of Puerto Rico (Magna Cum Laude), an MA in Spanish at Columbia University, and a Ph.D. in Latin American and Caribbean Literature at New York University.

JOYA

No hay palabras
para describir
el mentón de mi hija
cuando se levanta
levemente inclinado
contra el cristal de la ventana
mientras sus manos
suaves mentas nevadas
aguantan un pincel
acumula trazos
dispuestos a deslizarse
por la libreta abierta
de par en par...

detrás
en los edificios despintados
palomares
de niños sensitivos

arriba
telón inmenso
el cielo
es un toldo empolvado

pupilas fijas
joya en la memoria

NONCONFORMIST

You say you don't understand my discontent with reality
that I dream too much and in the mornings I'm tired,
you say I don't accept life as it is,
that I camouflage it, disguise it,
prettify it, deform it
homesick for the future
like a poor girl from a lost village
making up games for lack of toys
among dusty screens and spiderwebs
in my dead uncles' deserted houses,
reading love letters written during the war,
inventing intrigues and lovers in alleyways
that smell of urine and saltpeter...
When I realize that's what I do,
I wash, iron, cook, mop,
but then washing the windowpanes,
to be precise the one by the bath,
I recall
my grandparents' mirrors with the flamingos,
I dream
of Chinese sunshades, ancient nobles, infamous nightclubs
And break free of my mind
This star-filled womb I inherited from my mother

Translated by Chris Brandt.

EPOPEYAS SECRETAS

En el Copán maya nace un gran linaje
una larga línea de reyes
presidida por Tlaloc
dios teotihuacano
bajo el silencio de los árboles
bajo la sombra de la selva
su ciudad de geografía sagrada
-la casa del murciélago
-la casa de los cuchillos
-la montaña donde crece el maíz
se prolonga hasta las vetas de la tierra
se yergue solemne hacia las nubes
Las fases cósmicas en ella
se cumplen rigurosa
cíclicamente
Los dioses del mundo subterráneo
rinden su poder nocturno
el sol incandescente
reina absoluto en las escalinatas
en las pirámides de la acrópolis.
Los arqueólogos maravillados
desempolvan cuidadosamente
los restos de muchos reyes
con fruición descifran
estelas, frisos de piedra
Admiran las tumbas reales
con curiosidad advierten
que las más decoradas
las más ricas
las más suplidas
eran de mujeres
amadas, incógnitas
perdidos sus nombres en los siglos
Una misteriosa mujer
en la alborada de la dinastía
la rodean de las cabezas de tres hombres
¿maridos, sirvientes, aliados?
en su tumba circular
animales y amuletos
el venado, el puma
el mercurio, el quarzo
Shamán de adivinaciones
convocadora de fuerzas sobrenaturales
piedra angular de dinastías
Su tumba no tiene nombre
las estelas aluden a sus poderes
sin nombrarla

Me pregunto si su nombre se daba por sentado
si era secreto o prohibido
si era demasiado sagrado para pronunciarlo sin castigo
o si en verdad sería lo que
los expertos concluyen
sólo sabríamos lo que los hombres
de esa civilización querían que supiéramos
En la historia maya -sostienen-
las mujeres eran invisibles
La otra tumba
una mujer
a sus pies diez mil piezas de jade
el rostro lo cubren con hematitas
con sagrado cinabrio para el resplandor
La visten ricamente
la colocan hacia el este
luz, imaginación, resurrección
su tumba se mantiene abierta
generaciones la veneran.
Los arqueólogos se preguntan
quién sería
concluyen que quizá era la esposa del fundador
no piensan en su poder
no piensan en el amor que despertó
no piensan en los peregrinajes
asumen su importancia derivada
no entienden su lugar privilegiado
bajo el altar mayor
de toda una civilización
La estelas cuentan
la historia escrita por los mayas
los arqueólogos miran la historia maya
yo miro a los arqueólogos
la historia del observador observado
¿Quiénes me observan a mí?
En la historia de esta parte de América
hay muchas mujeres así
levantan familias lavando pisos
lavando ropa
no saben leer
pocos creen que deban aprender
no figuran en los libros
los dignatarios, abogados, ingenieros
nunca las visitan
sus opiniones rara vez cuentan
excepto en el amor de sus hijos
ningún epitafio las honra
Algunas pelean en las montañas
mueren con las guerrillas

los periodistas no escriben sus nombres
Y me pregunto
¿Cuál es la verdadera historia
de la Tierra?
Sin embargo
en el Copán maya
en la selva, bajo la sombra de los árboles
entre templos, plazas, pirámides
están ellas
ausentes de la memoria escrita
imborrables en la memoria histórica
eternizadas por los pueblos a los que sirvieron
Madres de los linajes de Centroamérica

La encomienda

—Escucha—me dijo abuela Juana, con la mano aún firme pero la voz fatigada y la pupila algo volcada hacia atrás—es bueno hacer algo para la suerte; los cristianos no podemos andar por estos mundos sin protección. Vas a comprar lo siguiente y me lo traes; da los viajes que tengas que dar para conseguirlo. No costará mucho, serán treinta y dos cincuenta y es lo mejor que puedo darte. Consigue lo que te pido o trázate tu propia ruta espiritual, pero no dejes de comenzar la búsqueda.

Yacía entre sábanas empapadas de sudor, sin la perenne risa en los labios, con el pelo pasa revuelto, las carnes flácidas de su enorme y querido cuerpo un poco frescas, descolorido el negro brillante de años atrás. Miré en la penumbra del cuarto por la ventana y vi las matas de plátano del patio, meciéndose suavemente en la brisa, indiferentes a la muerte en ciernes de la habitación.

"Será que estoy maldita"—pensé sin sentimiento—y recordé que mi madre había visitado la espiritista de Maracayo que luego me envió con mi padre un papelito blanco. En el centro del papelito estaban grabados unos elaborados portones de metal que abrían a un patio y debajo de los portones se encontraba lo que quería que rezara, La oración del buen camino. Me asusté. Nunca la hice; creo que la perdí. Mis padres no insistieron, para mi sorpresa. Mi madre era incrédula, mi padre era más bien resignado. Desde entonces pensé que yo no era buena, no era normal, iba a dar candela. Recordé el almanaque de la iglesia, con las mujeres y hombres quemándose entre las llamas y en el centro un trono con dios compasivo mirando a sus hijos achicharrarse eternamente. En mi adolescencia mi madre me recordaba lo del papelito. "Esta tira para el monte"—le decía a mi padre, enojada. Yo entendía que me estaba diciendo que era medio cabra porque no hacía lo que me decían y exploraba, pero en realidad no sabía por qué tanta preocupación.

Siempre me gustó mirar por las ventanas desde un interior. Acá, la penumbra, allá, la luz. Todo el mundo ocupado adentro, yo contemplando algo en la lejanía; y pensando, siempre pensando. Desde mi salón de sexto grado miraba la loma llena de plantas y árboles, naturaleza sin domar, verde, exuberante, sin plan no control, cubriéndolo todo, millares de insectos y animalitos pululaban por la tierra, entre las hojas, por encima de las plantas. Llovía a veces, o estaba húmeda. El maestro me dejaba mirar porque siempre sabía la lección y en verdad me aburría, así que miraba la vegetación y soñaba despierta con la nana de la lluvia y el rumor distante de las voces familiares. En realidad me gustaba estar allí, en un pupitre apartado, al pie de la tierra, en aquellos salones amplios de puertas-paredes que abrían completamente. No cerraban las paredes ni con la lluvia, a

menos que fuera con viento. Nunca más vi arquitectura semejante. Sabían lo que era el trópico.

—Consigue...

Abuela continuaba y me apresuré a buscar lápiz y papel en la cartera, pues siempre hablaba para la memoria. Culta y analfabeta, pensaba que yo tenía la misma capacidad para recordar. Años antes le pedí que me enseñara las plantas y sus remedios, y en el patio empezó por la corteza del túa túa, buena para el estómago, y logré captar el té de barbas de maíz para el asma; el guarapo con chapaná, curía, yerbabuena, hoja bruja, limón y mejorana para el pecho; el guarapo de la raíz de cadillo para los vómitos, la corteza de almácigo blanco para la diarrea y la del árbol de mangle en gárgaras para la garganta; el guarapo de raíz de coquí, juana la blanca o baquiña para los riñones y el cataplasma de mostaza caliente para el dolor en el cuerpo, además de recomendar casualmente el precipitado rojo para los piojos, el unguento del soldado para las llagas, la miel con cenizas para las heridas y la grasa de la tela frita del coco blanco para las canas. A la próxima planta le dije que esperara, que no la estaba escribiendo y se me iba a olvidar. Me miró con burla y ese fue el final de la lección. Con los años había mejorado la paciencia y ahora se detuvo con pesar unos segundos para que yo me sentara y escribiera.

—Consigue...

El anillo de Solomón

El gran talismán de constelación

Anverso

Reverso

Talismán exterminador

Talismán de Isis

Talismanes ordinarios

Primer talismán de Saturno

Segundo talismán de Saturno

Talismán de Júpiter

Talismán de Marte

Primer talismán del Sol

Segundo talismán del Sol

Talismán de Mercurio

Talismán de la Luna

Talismán divino

—Abuela, que nombres tan lindos. —respondí, entre sorprendida y melosa.

Para comerte mejor—una voz de Caperucita me dijo adentro. Doblé el papelito y lo metí en la cartera.

—No te apures, que yo los buscaré.

Ella sonrió bondadosa a su nieta-loba. Sin saber que años después encontraría mi propia ruta en el bosque espiritual, besé la piel fría y me di vuelta con mi capa roja.

Nunca los busqué, pero siempre conservo el papelito, a pesar de la emigración.

BREATHING
SUEÑO

Era una mujer que vivía en una pequeña casa de madera en la esquina de la calle 86 y Lexington. Alrededor los edificios crecían como hongos gigantes. La casa estaba sin pintar; de tan vieja las tablas eran oscuras, aunque podía ser de la humedad de las matas y helechos que la rodeaban. La casa era tan pequeña que ella decidió dormir afuera, porque adentro no podía respirar. Así que sacó su cama twin y la colocó en la tierra, al lado de la acera. Ahí dormía con sus sábanas y su almohada blanca. La gente pasaba por las dos aceras a sus trabajos, sin reparar mucho en la casita ni en la cama y ella entonces podía conciliar el sueño por la noche y pensar antes de levantarse por la mañana. Trataba de recordar sus sueños, que eran muy raros, de corporaciones y corbatas y maletines de cuero, y de asfalto, mucho asfalto.

Un día la mujer tomó un avión y fue a visitar a su familia a su país. Al llegar, visitó la casa de sus primas, en una urbanización elegante de ésas que tienen nombre de santo. La casa era amplia y fresca, decorada sin mucha elaboración pero sí agradablemente, aunque le hubiese gustado ver un cuadro interesante. Su prima se acercó, con su pelo claro y sus manos suaves. Le dijo con ternura que su estado en la urbe no era el apropiado para una poeta de su país. "Qué van a decir acá"—sostuvo con tono compasivo—"hay que mantener la imagen. Se puede hacer todo a la misma vez. Debes demostrar que has progresado, aunque te hayas divorciado." Se sintió inadecuada; recordó amantes lejanos. No dijo nada por educación; pensó que su prima trataba de instruirla en un difícil arte secreto.

Después pasó a un cuarto estrecho, pero bellamente decorado. Era una cama amplia con una colcha abundante que llegaba, generosa, al piso. Alrededor, aéreas cortinas blancas, casi transparentes, colgaban de todas las paredes. Habían sido colocadas junto al techo y se extendían levemente por el piso oscuro con alfombras mullidas. La dejaron sola. Se sentó en la cama y pensó que nunca hubiese sabido decorar así. "No sé hacer cortinas—se dijo—decoro una sola vez y per sécula, jamás muevo nada de sitio y coloco las cosas por razón de uso, excepto los cuadros y la cerámica, que me gustan mucho y los cuelgo o los pongo en cualquier parte para verlos mientras leo." Definitivamente, pensó cabizbaja, no era una mujer cabal, dueña y experta de su ámbito doméstico, no entendía lo apropiado, esas delicadezas exigían una atención que no era capaz de darle. "Quizá por eso no vivo con un hombre, no tengo los platos que corresponden, le doy agua en una taza, mis papeles invaden constantemente la mesa del comedor. No class. Soy una desgracia familiar, ni siquiera indico que progreso; living in a chanty house, la barbarie incorporada."

Al final del día, la mujer pensó que debió haberse quedado a dormir en la casita de la 86 aunque le faltara el aire. Tomó el avión de vuelta, con la firme resolución de vivir como la gente, en su casita pequeña. Pero a media noche se cambió a la cama de la calle, porque soñó que se hundía en un hondo pozo que se la tragaba, y de cuyo borde interior colgaban ondulantes cortinas blancas.

MARINA ORTIZ

Marina Ortiz es periodista, poeta, promotora cultural y líder comunal. Nació en East Harlem en la Ciudad de Nueva York y se crió en East Harlem/ El Barrio y en el sur del Bronx. Desde 1990 ha presentado su poesía en el Centro Cultural Agueybaná, Casa Atabex Aché, East Harlem/El Barrio Renaissance Center, The Knitting Factory, The Nuyorican Poets Café, The University of the Streets y el *Poetry Corner* de WHCR,WBAI Radio. Ha publicado su obra en *Liberator, El Pitirre* y *Norwood News,* del Bronx. Fue co-fundadora y publicista de los grupos de poetas The Bread is Rising, Como Coco y Sisters Underground. Ortiz es también periodista comunal. Sus columnas y reseñas se han publicado en *The Free Press/La Prensa Libre, El Pitirre, The New York Daily Challenge* y *The New York Planet.* Ha sido también productora asociada y co-animadora del *Latino Journal* de la Radio Pacífica-WBAI y *Friday Talkback!.* Fue también la publicista y editora de la guía bi-mensual de programas de la estación, el *WBAI Folio.* Fue miembro del International Workers Party (New Alliance Party, et.al) y escribió y dirigió programas para WBAI sobre tópicos que giran en torno a la explotación política y psicológica. Ha publicado también informes de investigación sobre esos temas. Fue co-autora en el 2007 del documental de 30 minutos para Hope Community, Inc., *East Harlem Focus: A Community Facing Transition,* sobre la rápida transformación de esa comunidad en los últimos años. En el 2008 ganó una demanda contra la privatización de áreas para parques públicos en Randall's Island. Ortiz es la creadora del portal en el internet Virtualboricua.org, que ofrece información sobre poesía, arte, política y noticias sobre la comunidad puertorriqueña de Nueva York.

Marina Ortiz is a journalist, poet and community activist. She was born and raised in East Harlem/El Barrio and the South Bronx. As an upstart poet during the 1990s, Ortiz performed at a variety of venues, including Agueybaná Cultural Center, East Harlem/El Barrio Renaissance Center, Kenkeleba Gallery, the Knitting Factory, The Nuyorican Poets Café, and The University of the Streets. She served as a co-founder and promoter for The Bread is Rising, Como Coco, and Sisters Underground poetry collectives. Excerpts of her work have been aired over WBAI Radio and *The Poetry Corner* of WHCR Radio, and published in *Liberator, El Pitirre*, and *Norwood News*. As a community journalist, her columns and reviews can be found in *The Free Press/La Prensa Libre, El Pitirre, The New York Daily Challenge* and *The New York Planet*. She served as an associate producer and occasional co-host of Pacífica-WBAI Radio's *Latino Journal* and *Friday Talkback!*. She was also the station's former publicist and editor of its program guide, the *WBAI Folio*. A former member of the International Workers Party (New Alliance Party, et. al), she has written and produced specials on topics about political and psychological exploitation for WBAI Radio and written investigative reports for various publications. In 2007, she co-authored a Hope Community, Inc. 30-minute documentary, *East Harlem Focus: A Community Facing Transition,* that documented the neighborhood's rapid and transformative change. In 2008, she won a lawsuit challenging the privatization of public parkland on Randall's Island. Ortiz is the creator of the website Virtualboricua.org, which offers information about poetry, art, politics and current events related to the New York Puerto Rican community.

IT'S THE BLOOD, STUPID!

whenever i am asked "what are you, anyway?"
i look upon the questioner with wizened but still puzzled eyes
(especially if we've been engaged in conversation for more than two minutes)
what are you? ... what the hell does that mean
like, what freaking planetoid did you happen to fall from, you mean?
like, who let you out and why don't you just crawl back in now, you mean?
and, if they are stupid enough to get even more specific
like with, "so, what's you're ethnicity, anyway?"
or "where was your family born?"
or even so brazen as to challenge the authenticity of my boriken blood
i simply answer with a question of my own:
"well, what do <u>you</u> think?"
the response which tells me all i need to know about my inquisitor
and therein begins yet another boring debate
which often includes the following:
"gee, you don't look puerto rican
i was thinking you were italian, french, maybe even jewish"
and whenever they persist in asking why i consider myself boriken
i always answer ...
because, as long as this country tries to define who i am
as "non-white, un-american, foreign other"
then i shall continue to humbly embrace and accept
that more-telling-than-you'll-ever-know label with pride ...
because, i can never forget what i have learned about
my people ... mi bello país ... and which side i am on
no matter that i may very well die
without having walked about it on bare feet
that's why ... and because, it's the blood, stupid!

"SISTER" ... AIN'T NOTHING BUT
(for brothers who can't hear me)

and when i hear you say we must respect our women
because they are majestic champions of the human spirit
because they hold the sacred key to life and eternity
because they are the standard bearers of all truth
i remember why i love you
and i remember why i stay
i remember why i fight
and i remember what i pray
for a better world ... where we don't have to
bow and scrape
and climb and rhyme
and jump and hurdle
and snatch and snuff
for our due supper
and when i hear you say come here sister
because you need to support your brother
because this is all the manhood we have left
because we have needs that must be met
and when i hear you say that i ain't really down
because you got my number
because i'm really nothing but a c*ck-teasing
wanna-be, c*nt bitch
because i won't put out
because i'm really asking for it now
because i got a smart mouth and I won't shut up
because i probably never had a real man
and because i need to be taught how to respect a brother
i remember why i love you
and i remember why i stay
i remember why i fight
and i remember why i pray
for a better world ... where we don't have to
bow and scrape
and climb and rhyme
and jump and hurdle
and snatch and snuff
for our due supper

SPECIES: SADLY SEPARATE

(for those of us who are, unfortunately, two of a kind)

"whalebone's out, but spandex is in ... the tools of fashion change
but the impulse to contort and control one's physique remains the same"
so says a mortimer zukerman tidbit, which went on to promote
various "contributions" to reshaping human form
quite an interesting take on human butchery
and their slice 'em and dice 'em
caucasoid standards of beauty
yes, indeed, our species has learned to covet
those monstrous nips and tucks
the vacuous removal of excess capital waste
and silicon implants and vaginal reductions
(which others call mastectomies and genital mutilations)
and we grind our precious yellowed ivories
down to sharp, inhuman shapes
so that they can be replaced
with shiny synthetic symbols of purity
we polish, buff and tone and flex solo
and dye and die each time
yes, we burn, baby, burn
and pump and hump
to the rhythm of nothing
so that you all may gaze and gawk
at once forms firmly encased in spf35
yes, indeed, our species has learned to covet
those wonder bras and push-up butts
but you, of course
you don't need no so-called super-shaper brief
no wonder jock for you, my testosteroned dear
for your thick, venal brain protrudes most efficiently
at the slightest glimmer of mannequin skin
and you need no extra tool to make us run to you
because we are of a different species, you and I
you want it so badly you can almost taste it cum ...ming
while we want out (of your maddening, padded cell of passion)
you just want it in ... then out ... then far and away
but we would be content if you tried to go the distance
you know, far deeper than what you're thinking about
you know, so as to meet the very core of my soul
but, alas, we are of different species, you and I
even so, it's a proven fact that your precious testosterone
would have no meaning without our estrogen
and your life power is but millions of minute infantile forms
faring war amongst themselves on a feral moment's notice
just to claim the right to pierce our sleeping madonna yolk
a sacred sagacious substance senior to your own

and not at all swayed by your primitive bone
you know, lorena bobbit hit it right on the head
when she said what she said and did what she did
because she proved to all the world
that what really make your kind tick
what sadly controls you ... owns you
is simply
what you cradle below the belt
and that what moves your kind's mind
so you can never be believed
nor be trusted to act rationally
but to resort to lies and lies and more lies
just so you can get some ... and cum ... and then go
on to snag ... and then brag ... about the next one
is that we are, sadly, of a different species, you and I
and it is your card-carrying member[ship]
and devotion to that universal primal club
that, sadly, makes us two of a kind
and it is that impenetrable venal allegiance
that forces us to grant you temporary visas

IS THERE A DOCTOR IN THE HOOD?

doctor, doctor ... i'm in awful, awful pain
all the foul toxins of life under kapitalism and its inherent social morasses
seem to have collected in my body ... and i'm in awful, awful pain
my hands are swollen and my fingers always ache
(especially after eight hours of non-stop typing and handling a mouse)
no, not that kind ... you know ... the desk publishing kind
no, i'm not kidding ... i'm a writer
yes, me ... i get paid, too ... no, i'm not kidding
and now my hands are all swollen ... and my fingers are sore
and by the end of the day ... i'm always tired and listless
so much so that i can barely carry five bags of groceries anymore
let alone the shoulder bag and tape recorder
that accompany me wherever i go
and by the time i'm through with dinner and the dishes
and the sweeping ... and the mopping and the garbage ... and the laundry
i can barely use the remote control to turn on whichever boring tv show
will take me to the dead zone long enough to face another day
no, i don't use drugs (haven't done so for quite a while)
yes, i'm sure ... why do you ask
my hands? yes, they hurt
no, i didn't open your supply closet
yes, i know that you can't be too careful these days
yes, i know that your receptionist says she didn't leave it open
but i didn't open your fucking closet, ok?
no, i don't want painkillers .. no, i don't want tranquilizers
no, i don't want sleeping pills .. no, i don't want codeine
no, i don't use drugs ... haven't done so quite a while
yes, i'm sleeping fine ... i told you
new york 1 takes care of that every night
no, i don't drink bacardi or colt 45
no, i'm not in methadone ... no, i'm not on any medication
i flushed it down the toilet years ago
and told the doctor to go fuck himself when i remembered
what that poison did to my mother who died of cancer in 1980
in lincoln fucking hospital ... where my daughter was born
(i guess they thought we owed them something, eh?)
and so, they took my mother's life
but not before attempting to send her home
with a vitamin subscription
and finally admitted her ...
only so their interns could perform exploratory surgery
(the little perverts found a tumor the size of a grapefruit)
but it was too late ... and they sent her home to die
(it was terminal capitalism, you see)
yes, my grandmother ... also died of cancer ... that same year
yes, she also had diabetes ... and high blood pressure
yes, my father has also had cancer

and high blood pressure ... and heart problems
no, he's still alive ... he's waning away
in the mountains of puerto rico
yes, i'm puerto rican
you know ... that little island next to cuba and haiti
the one with the tennis courts and casinos
and brown-skinned waiters who spit in your drinks
no, san juan's just the capitol city ...
but, what about my hands?
no, i don't use drugs
yes, by all means ... please test me
blood, urine, pap smear? it's all yours
yes, i'm insured ... no, not medicaid ... u.s. health care
yes, it's up to date
twenty dollars co-payment? ok
yes, this is my account ... see my name on the check
no, i don't have a driver's license ...
yes, i have a credit card
go right ahead ...
the telephone number is right there on the back
come back in four weeks? can't you make it sooner?
i'm in awful, awful pain
oh, and please tell your receptionist it's ok to let me in early next time
i had to stand outside for 15 minutes ...
i rang the buzzer and i could see her at the peephole
but i think she got scared
to let a puerto rican into your swank 57th street office
why'd you? well, your name was in the catalog
and because i thought that a midtown doctor
would somehow be more courteous and competent
than the heartless butchers who attend our respective
ghettos in their medicaid mercedes
and who make you wait hours in filthy and airless storefront mills
only to be handed a tylenol prescription
my former doctor? she called the cops on me and threw me out of her office
because i insisted on using her private bathroom
because the other one was out of order and smelled of feces
and urine and mucous and vomit ... and because i couldn't wait
no, i don't do drugs ... but, i'm in awful, awful pain

CONSECRATION/MOONLIGHT MIRAGE

under the moonlight, as our eyes meet
and i behold and marvel at the splendor of your true essence
that which is noble, valiant and most keen
and which i endeavor to nourish and caress
there are moments, under the moonlight
when i chance a glimmer of faith and love
and i imagine those moments wax eternal
as we soar beyond the obscure twilight of our pain and misanthropy
adjoining spirits sauntering forth in resplendence

but the dream is as elusive as the moment
for reservation soon creeps forth and we are left with nothing
but the anguish of our souls waning away
as we fashion yet another guise
with which to keep them safe, but distant
(yes, i am also loath to allow mine to be seen
for it too has been seized and ravaged)

for those fleeting moments
which i have fared to capture
we are but one
embracing and rejoicing in the ecstasies of our mortal passion
and i am then nourished and inspired to seek more
believing the dream to endure

for i trust that the glimmer always linger
never fully extinguished but merely tapered
and hidden behind a mask of dolor and doubt
and i aspire to demolish that facade
and, ascending to eros, to capture
not those ancient dreams of sorrow and chimera
but even older ones
in which we waltz within the brilliance of our passion

DYLCIA PAGÁN

Dylcia Pagán es activista social y política, maestra, ex-prisionera política puertorriqueña, escritora, artista visual y sanadora. Hija de emigrantes puertorriqueños, nació en el Bronx y se crió en El Barrio de Manhattan. Es una de las primeras productoras latinas de televisión en los Estados Unidos. Desde el 1999, ha leído su poesía en espacios culturales de Nueva York, como Carlito's Café, Cemí Underground, The Clemente Soto Vélez Cultural Center y en universidades, incluyendo New York University y Cornell University. Es autora del libro *Have You Seen La Nueva Mujer Revolucionaria Puertorriqueña? The Poetry and Lives of Revolutionary Puerto Rican Women* (1982). Su poesía se incluye en varios libros, entre ellos, *Let Freedom Ring* (2008). Trabajó para la Agencia de Desarrollo de la Comunidad (CDA) evaluando programas contra la pobreza. Fue directora de programas en el Aguilar Senior Citizen Center en East Harlem y directora del programa de verano El Grito del Barrio que enseñaba a los jóvenes fotografía y poesía. Estudió en Brooklyn College en 1969 y fue una de las fundadoras de la Unión Estudiantil Puertorriqueña de NY. Fue, también, maestra de Estudios Sociales de la ciudad de Nueva York durante los veranos de 1969-1971. A principios de 1970, trabajó con el Puerto Rican Media and Education Council en una demanda legal contra los medios de televisión que culminó con la creación del primer programa televisivo puertorriqueño de PBS, *Realidades*. Fue la primera mujer puertorriqueña en los Estados Unidos en trabajar en la televisión con NBC, ABS, CBS y PBS. Ha producido, dirigido y escritos programas investigativos, documentales y programas para niños para audiencias latinas y negras. Fue editora del primer periódico bilingüe de Nueva York, *El Tiempo*. En 1980 fue arrestada por luchar por la independencia de Puerto Rico y sentenciada a 63 años de cárcel. Su hijo se crió en México, para su protección. Pagán logró su libertad en el 1999.

Dylcia Pagán continúa su labor política y social, ofrece charlas sobre conciencia revolucionaria y espiritualidad y escribe un libro de memorias y poesía. Vive en Puerto Rico.

Dylcia Pagán is a social and political activist, teacher, former political prisoner, writer, visual artist and one of the first Latina television producers in the United States. She was born in the Bronx and raised in El Barrio-East Harlem. Since 1999, Pagán has read her poetry at cultural spaces in New York, such as Camaradas, Cemí Underground, The Clemente Soto Vélez Cultural Center, and at universities, including New York University and Cornell University. She is the author of the book *Have You Seen La Nueva Mujer Revolucionaria Puertorriqueña? The Poetry and Lives of Revolutionary Puerto Rican Women* (1982). Her poetry has been included in several books, including *Let Freedom Ring* (2008). Pagán worked for the Community Development Agency (CDA) of the City of New York, evaluating poverty programs. She was program director of Aguilar Senior Citizen Center in East Harlem and director of the youth summer program, El Grito del Barrio, which created programs for youth training in writing and photography. In the late 1960's, she studied at Brooklyn College, where she was one of the founders of the Puerto Rican Students Union, a city-wide organization. During the early 1970's, Pagán worked with the Puerto Rican Media and Education Council, filing a series of lawsuits against the major television stations which facilitated the local public affairs programming that exists today. These lawsuits enabled Pagán to become the first Puerto Rican woman television producer in New York. She worked as producer, writer, host and/or director in the production of groundbreaking Latino and African American programming at ABC, CBS, NBC and PBS. Among these programs was PBS' first Latino television series, *Realidades* (1972). She was also Editor of the first bilingual newspaper of New York, *El Tiempo*. In 1980, Pagán was arrested for her struggle for the independence of Puerto Rico and sentenced to 63 years in jail. Her son was raised in México, for his protection. She was released from jail in 1999.

Pagán continues her work as an activist. She also lectures on revolutionary consciousness and spirituality at universities and is writing a book of memoirs and poetry. She lives in Puerto Rico.

The Littlest Warrior

Many moments of my days
are spent contemplating your face
I remember your beaming eyes
and precious nose
Your strong little body, which at an early age had the semblance of strength
You had a gaiety in your soul,
that led me to believe
that warrior genes are happy ones
I remember your first step,
your first words of defiance:
"No, Mama" you proclaimed.

Early on, you had a softness about you
that I shared when you caressed me,
seeking comfort in my arms
and at times just comforting me.

Yes, you have comforted me although I never asked
We have been intertwined with each other
since the first moment of your existence.

And now you have reached the age of reason,
but I know not what you look like or where you are.

I envision you with curled locks of dark mahogany- with a halo of red sparks!
Hands, strong; capable of holding a gun
Limber, ready to move
Joyful, because you possess a spirit
of triumph and victory
(it is difficult to write of you because
when I begin to express that which I hold inside,
emotionally I am overwhelmed).

I wonder if you know our names,
those of your true parents
You have come from an act of Love-
totally conscious of your birth
You were chosen to be born-
contrary to all the obstacles in the way
You arrived, "Triumphantly"
You were embraced by our comrades,
our friends
You Are Our Little Warrior.

Before you is a challenge, my Son,
a responsibility to yourself and our people
Right now this may not be clear to you

In due time as you continue to grow,
you too, will see the necessity for change.

Even though I have not glanced in your eyes
or held you in my arms
or cared for you in times of fear or hurt,
I have done so in my mind
because I feel your spirit in me.

You are a fortunate child
Many love you
Some have crossed your path,
others extend their love for you
by their commitment to struggle.

Oh little Warrior of My heart
I embrace you from a distance
Hold you in my heart,
awaiting the time when we will meet again,
eye to eye, spirit to spirit.

I will know you at first glance,
at any given moment,
because I have seen you
in the children of the world of struggle.

Happy Birthday, Hijo Querido

February 28, 1986

PRISIONERA-PAULA SANTIAGO

Prisionera-Paula Santiago nació y se crió en Fajardo, Puerto Rico. Vive en la ciudad de Nueva York desde hace 28 años. Publicó el libro artesanal *Mi Corazón* con Ediciones Mixta (2001). Publicó un segundo poemario, *Puro Ritmo y Patriotismo,* con Lola Publishing Press (2007). Ha leído sus poemas en el Centro de Estudios Puertorriqueños, el Museo de Arte de San Juan de Puerto Rico, El Centro Cultural Clemente Soto Vélez, El Nuyorican Poets Café, El Centro Cultural y Educativo El Maestro, conmemoraciones de El Grito de Lares, El Teatro Rodante Puertorriqueño, Hope Community *Poetas con Café,* Cemi Underground, el Centro Cultural Julia de Burgos y en varios colegios, conferencias y universidades. Actualmente reside en el estado de Nueva Jersey con su compañera Carmen.

Prisionera-Paula Santiago was born and raised in Fajardo, Puerto Rico. She has resided in New York City for 28 years. She published her first book *Mi corazón* with Mixta Editions (hand-made, 2001) and her second book *Pure Rhythm and Patriotism* with Lola Publishing Press (2007). She has read her poetry at various venues: el Centro de Estudios Puertorriqueños, el Museo de Arte de San Juan de Puerto Rico, The Clemente Soto Vélez Cultural Center, at events conmmemorating El Grito de Lares, El Nuyorican Poets Café, El Centro Cultural y Educativo El Maestro, The Puerto Rican Traveling Theatre, Cemi Underground, Hope Community's *Poetas con Café*, Julia de Burgos Cultural Center, and at various colleges, conferences, and universities. She currently resides in New Jersey with her partner Carmen.

1954

Fue el primero de marzo
que una mujer y tres hombres,
de valentía se armaron
para tomar parte en la historia
que tantos han deshonrado.

Los llamaron terroristas
mentalmente perturbados.
Los que sabemos la historia
los llamamos ídolos, santos.

Ya los Estados Unidos
nos tenían pisoteados,
de tantas humillaciones
nos creían destrozados.

Ni las Naciones Unidas
discutieron nuestro caso,
"Eso es asunto interno"
dijo un gringo americano.
Y nos quedamos aislados
del universo, mi hermano.

El Dr. Albizu Campos
se encontraba encarcelado,
y desde adentro envió
a mi gente su mandato.

Lolita obedeció,
estudiando lo planteado.
Tomó serias decisiones,
todo fue premeditado.

Boletos de una ida,
a Washington se marcharon.
La patria en el corazón
revólveres bien guardados.
Pisadas muy decididas
dispuestos a dar sus vida.

El Congreso en sesión,
que de hecho el tema era inmigración,
y en sus dichosos balcones
mi gente se acomodó.
Sacó Lolita de lo más profundo
de su vientre,
un grito monumental,

"Viva Puerto Rico Libre"
comenzando a disparar.

El caso de Puerto Rico
quedó allí iluminado
y en los rincones del mundo,
al fin todos se enteraron,
que Puerto Rico es colonia
del Imperio Americano.

Lolita Lebrón se llama
y cuando allí la arrestaron,
simplemente dijo así,
"Yo no vine aquí a matar
yo vine aquí a morir".

Rafael, Irving y Andrés
tres hombres Puertorriqueños
el calibre y el espíritu,
orgullo de nuestro pueblo.

Y con toda dignidad,
con orgullo y con sentir,
más de 25 años de cárcel
sufrieron por ti y por mí.

Patriotas sin cobardía,
ejemplos de humanidad.
Luchan por la soberanía
amantes de la libertad.

TRISTEZA

Roca pesada,
tumba fría,
estás conmigo
al despertar el día.

Acostumbrada a
tu fiel compañía,
eres parte íntegra
de mi vida.

Obscura nube,
filo cortante,
toda mi vida
he de arrastrarte.

Y tu presencia
es tan constante,
que aún en mi muerte
he de abrazarte.

Nadie sospecha
tu inmensa presencia,
no se imaginan
que eres intensa,

Pues mi sonrisa
es una mueca
qué bien disfraza
mi gran tristeza.

MI RELIGIÓN

¡Espiritista hoy, santera, aché, mañana,
pero el domingo, a la iglesia sin falta!

Niñez que recuerdo, de cosas calladas,
de santos espíritus, mesa blanca adornada.
Inciensos, Allan Kardec, velas, fuentes de agua,
tantos crucifijos, collares, barajas.

Las mediunidades sus cuadros aclaman,
y las buenas noches, a Dios sean dadas
porque al atrasado su luz sea dada,
pero que se vaya, porque aquí no encaja.

De noche en la playa a despojar de espalda,
cantos a la luna, el sol y el agua,
mientras me despojan a Yemayá aclaman.

Y en las fiestas grandes donde el tambor canta,
vuela la paloma con nombre en su pata,
sangre del ternero, sacrificio a las almas.

Entra ese cacique bailando su Danza,
fumando tabaco, traga su ron palma,
Changó, la Madama, Negro Liberato hablan,
diciendo a la gente cosas … no esperadas.

¡Espiritista hoy, santera, aché, mañana,
pero el domingo, a la iglesia sin falta!
Pues Dios Poderoso, su ejército manda.

CARMEN PUIGDOLLERS

Carmen Puigdollers (1919-2008) fue poeta, educadora y líder comunal que vivió en Nueva York del 1943-1958 y del 1960-1985, regresó a Puerto Rico en 1985 y murió en Puerto Rico en el 2008. Publicó los poemarios *Dominio entre alas* (1955) y *Espacio vibrante* (1990). Sus cuentos, poemas y ensayos se han publicado en varias revistas, entre ellas *Hispanic Arts News, Cupey, La Revista del Centro de Estudios Avanzados de Puerto Rico y el Caribe* y en la *Antología de la poesía de Asomante* (1945-59). Enseñó en la Universidad de Puerto Rico, Hostos Community College, Lehman College y en escuelas de Puerto Rico y Nueva York. Se casó con el intelectual puertorriqueño Josemilio González en 1985. En Nueva York enseñó en Lehman College, Fordham University y Hunter College. Fue directora de varios programas y agencias comunales, entre ellos el Puerto Rican Congress of New Jersey y el Taller Puertorriqueño de Filadelfia. Sus esfuerzos en pro de la educación y la cultura de los niños puertorriqueños de Nueva York la llevaron a trabajar como coordinadora de currículo, ofrecer talleres y conferencias y en comités que examinaban y preparaban materiales educativos para las escuelas. Fue editora de una edición especial de la revista *Interracial Books for Children*, para quien además escribe el ensayo "A Feminist View of 100 Books About Puerto Ricans", junto a Dolores Prida y Susan Ribner (1971). Fue también subdirectora de la revista *Puerto* de la Universidad de Puerto Rico. Obtuvo un Bachillerato en Educación en 1963 y una Maestría en Artes en Estudios Hispánicos en 1964, ambos de la Universidad de Puerto Rico.

Carmen Puigdollers (1919-2008) was a poet, educator, and community activist who lived in New York from 1943-1958 and from 1960-1985, returned to Puerto Rico in 1985 and died in Puerto Rico in 2008. She published the poetry books *Dominio entre alas* (1955) and *Espacio vibrante* (1990). She taught at the University of Puerto Rico, Hostos Community College, Lehman College, and in the public schools of Puerto Rico and New York. She married the Puerto Rican intellectual Josemilio González in 1985. She was the director of several programs, among them, the Puerto Rican Congress of New Jersey and the Taller Puertorriqueño in Philadelphia. Her work in favor of the education and culture of the Puerto Rican children of New York brought her to work as a curriculum coordinator and to offer workshops, conferences, and participate in committees which prepared and examined teaching materials. She was the editor of a special issue of the magazine *Interracial Books for Children*, for which she also wrote the article "A Feminist View of 100 Books About Puerto Ricans", with Dolores Prida and Susan Ribner (1971). She was also sub-director of the magazine *Puerto* of the University of Puerto Rico. Her poems, short stories and essays have been published in various magazines, among them *Hispanic Arts News, Cupey, La Revista of the Centro de Estudios Avanzados de Puerto Rico y el Caribe;* and in the *Antología de la poesía de Asomante* (1945-59). She obtained a Bachelor in Education and a Masters of Arts in Hispanic Studies, both from the University of Puerto Rico.

POR LA RUTA DEL AIRE

(a 27 de diciembre, segundo viaje a Nueva York.)

Por la ruta del aire
se descorren los grises
aplomados de vuelo

y el laberinto muestra
al luminoso toro del engaño

Nueva York: profética invención

entre redes de acero la ingienería
puebla con otros rascacielos
la vertical escala del aire gris
que asciende en maraña de luces
y congestión de máquinas,
con mecánico agarre las escaleras
bajan y suben y se pierden

Dédalo choca y vuelca
su último modelo de construcción latina

mientras
con oropel diseñan mil ventanas insomnes
con telas estampadas del Oriente
para comprar a plazos con tarjeta
por el cristal cerrado
que en el convenio guarda
su contrato de plástico

se anuncia de la esquina un peligroso salto

y el de la piel más clara del vecino se burla
porque la luz no alumbra
el final de la calle del barrio donde habita

Con grandes titulares
se comentan los hechos

 LA SENTENCIA ESTÁ DADA
 EL VUELO ASESINADO

sobre las multitudes
 llueven plumas heladas de humo y hojalata

Cuando aterriza el vuelo

sobre el agua se advierte
que en tres puntos distintos

los puentes cuelgan brazos de adiós

*"que mueran las palomas
hoy día 27 en la ciudad".*

ASISTO AL BANQUETE PARA CELEBRAR LA PARADA

Y me digo que hay palmeras
y pájaros
cuando en el banquete del Concilio
como un martillo
 sin la hoz
batiendo cada golpe
con el ritmo de la ocasión
Hernán Padilla -alcalde
de San Juan - diagnostica
lo que somos: la inmensa
minoría marginada
de la década de los 80

y el público aplaude con delirio
todo lo que en silencio queda allá ...

y me sigo diciendo que todavía
hay monte y pájaros
con adoquines que relucen
en la noche sin sol
mientras en las murallas
toca insistentemente
su sosegada queda el mar

y me sigo diciendo
 que
aunque coronen una reina más
Lola estuvo presente con su melena
a la garcon
como una siempre-viva-flor

y aunque el filo del destierro
corte sobre la nuca

la sombra dividida
en dos banderas
sobre el mantel
descubro un solo canto:

¡que han dado la señal!

y allá en la 5 en Filadelfia
en lo que llaman Barrio

frente a la mueblería de Lamboy
la fila dibujada de palmeras
ocupan de repente una pared
y un vejigante ensaya en el Bloque de Oro
al compás de Roy Brown:

"El río de Corozal
el de la leyenda dorada
la corriente arrastra oro
la corriente está ensangrentada".

Luego, me digo
que aquí también
hilamos con las manos y la vida
nuestra nueva canción.

en Filadelfia, a 28 de septiembre de 1980

Con Nombre

A Nilita: mi meditación por su ausencia

Tomamos el atajo del pasaporte en blanco
y fuimos
a Newark
a buscar en el triduo
la imagen fotogénica
 a la orilla del gueto

Del otro lado tricolor
lo aseguró Jo Thomas
en la edición del lunes:

 "at the campus of Rutgers
 in a survival island
 with roots in broken buildings"

allí estábamos

Sin embargo
faltándonos la tierra

y por costumbre

se nos viene a la mente
la relación que existe
entre la afinidad gramatical
que estudia
propiedad en las voces y en los tiempos

y se expanden los lazos y razones

 no importa donde estemos - me digo -
 la analogía parte hacia el encuentro"

y se acerca clara a la palabra

como una imagen nueva en un antiguo texto:
 el día que en la sala de mi casa
 conociste a Rodón
 con sus sorpresas

la línea en claroscuro del retrato que falta
 y el mito del sombrero
ausente en el aceite o la acuarela
que no cobija

de tu quehacer omnicolor-trilita
tu anatomía entera.

> (La anécdota no importa
> nunca vamos en cueros
> aunque el vestido falte.)

Por buscar pan y patria venimos desde lejos
 nada extraño
es costumbre ya nuestra
 descendientes de vuelta ...

Y hacia afuera
llevarnos de la mano
lo que roe por dentro
o un par de alas secas
o una camisa sola
o una rosa al encuentro

FANTASIA OF THE FALL IN MANHATTAN

Using strange light
the solstice resolves
its last-ever blues

and the tattooing is fall's

that flings out elastic meetings
with the perennial leaves
among ochre swarms of naked branches

> An orange renewal has bloomed from Roualt
> already (a glazier's guava of violets snowed
> in the cobalt blue of this glass pane)

> And Picasso they imitate multiplying names
> that appear in immobile cement cemented
> and every free space
> > to cover

> like the spider's web
> of dark butterflies
> the purslane missing from the poor people's quarter

> In Van Gogh's olive green
> maddened wheatfields
> proclaim a choice of itineraries
> and the prize bargains surface
> to meet with the Antillean sun
> in all
> > but one

> Goya bets that in May
> the placards will bloom once more
> León Golub inking shots sets alight
> an image that bursts in the Americas
> > to echo Vietnam.

And in a brief span the day does resolve its colors
when the cold hangs from stamens of ice

> from river to sea

Translated from the Spanish by Elizabeth Macklin.

DE LAS ESPECIES VIVIENTES

> *"más parecemos dos especies en guerra empeñadas*
> *en destrucción, que dos variantes dignas de una*
> *humanidad rica y variada"*
> *Ana Lydia Vega*

Este frágil tejido de estambre vegetal
libera mis visiones
igual a flores secas
-bajo el árbol de Guernica-
guardadas entre páginas yacentes
de mi fuero interior

Hiroshima bordada como un hongo silvestre en estambres de seda
o Verdún sobreviva

donde brota la gleba
con los huesos silentes del suicida primate
"La neblina miope, al asolar los glóbulos
de su herencia genética", aducen los biólogos

y aunque

la profeta nunca disfrute la ventaja de predecir
ni escala ni tonos
y aunque en el pentagrama del ritmo impresionista
se encuentre de antemano prendida la crisálida

y Claude Monet, faltándole la vista, salvara
en un estanque a los nenúfares o a su hermano el nelumbio

Del azul ambicioso del proyecto y la idea
parten todos los lirios:
la catedral de pétalos

 (ya que, afuera es adentro)
donde la raza humana
tiene un solo color y muchos tonos
sin líneas divisorias
sin bordes ni artificios
diluídas arterias y acuáticas violetas de cristal
para que el ojo humano con iris incoloro
prismara los abruptos de galán picaflor

y así
resuelto el hiato
converjan las varices de rojo

con fibras amarillas de luz
rizomas
raíces y semillas
yemas en flor: los brotes y retoños
de la linfa que corre
a encontrarse en las venas de su última verdad.

María Riquelme Muñiz

María Riquelme Muñiz es artista visual, escritora y promotora cultural, nacida en Puerto Rico. En 1996 publica el poemario *Alas por tres tiempos*. Sus poemas se han publicado en las revistas *Revista Espuela Lírica del Bronx* (1977-1978) y *Mairena* (1988) y las antologías por el internet *Poetas.com, Antología de la Guerra* (2005) y *catchall@centropoetico.com* (2006). Recibió una Mención de Honor (en cuento) del Certamen Federación de Maestros de Puerto Rico (1994). Riquelme vino a Nueva York en 1967, después de estudiar por un año en la Universidad de Puerto Rico (1965-66). Sus contactos en Nueva York con las escritoras María T. Babín y Loreina Santos Silva la estimularon a integrarse al mundo de las letras. Estudió poesía en Nueva York con Clemente Soto Vélez (1977). Organizó en el Bronx el Comité Pro Defensa de la Cultura Puertorriqueña en 1979 y participó en las luchas políticas junto al que era entonces su esposo, el líder comunal y concejal Gerena Valentín. Fue delegada en 1979 al Parlamento de la Paz en México y Sofía, Bulgaria. Hizo estudios libres en el Art Students League (1972) y The New School for Social Research (1973). Completó en 1985 un Bachillerato en Artes Plásticas (Pintura) en Lehman College.

Regresó a Puerto Rico en el 1985 y fue Presidenta del Centro Cultural de Lares de 1985-1987. Fundó y dirigió la Galería Nacional 23IX (1986-88) y diseñó y dirigió la *Revista Grito Cultural* (1992). Fundó en el 2003 la organización ALMAVE (Alternativas Literarias, Musicales, Artes Visuales y Escénicas), de la cual es directora

María Riquelme Muñiz is a visual artist, writer and cultural activist, born in Puerto Rico. Her poetry book *Alas por tres tiempos* was published in 1996. Her poems have also been published in the literary magazines *Revista Espuela Lírica del Bronx* (1977-1978), *Mairena* (1988) and the internet anthologies *Poetas.com, Antología de la Guerra* (2005) and *catchall@centropoetico.com* (2006). She received an Honorary Mention in the short story contest, Certamen Federación de Maestros de Puerto Rico (1994). Riquelme Muñiz came to New York in 1967, after studying for one year at the University of Puerto Rico (1965-66). Her contacts in New York with the writers and scholars María T. Babín and Loreina Santos Silva motivated her to continue writing literature. She also studied poetry with Clemente Soto Vélez (1977). She organized the Comité Pro Defensa de la Cultura Puertorriqueña in the Bronx in 1979 and participated in the socio-political movements of the 1970's and the early 1980's with her former husband, the Bronx Councilmember Gilberto Gerena Valentín. Riquelme Muñiz was a delegate in 1979 to the Parlamento de la Paz in México and Sofía, Bulgaria. In 1983 she founded the Coalición de Artistas Puertorriqueñas, which she directed until 1985. She studied at the Art Student League and The New School for Social Research and graduated in 1985 with a B.F.A. in Painting from Lehman College.

Riquelme Muñiz returned to Puerto Rico in 1985 and was President of the Lares Cultural Center from 1985-1987. She was also the founder and director of the Galería Nacional 23IX (1986-1988) and the director and designer of the magazine *Revista Grito Cultural* (1992). Presently, Riquelme Muñiz is the founder (2003) and director of the arts organization ALMAVE (Alternativas Literarias, Musicales, Artes Visuales y Escénicas).

Para compartirte

Insisto en que me ames
para preñar la solidez de este vacío
que seas un motivo más para otro encuentro.

Si me amas
dejaré de pensar en tantas soledades
que se cruzan entre palabras y sonidos.

Amándome,
esta copa que me espera
para brindar solo
dejará de sorber
mi mirada
para compartir
con tu labio
y el mío.

Amor,
¡cuánto pesas
si no te comparto!

Por si te encuentro

Te busqué como gota temblorosa
arrastrada en la vertiente de un mar enloquecido,
como un perro rabioso cuando ya nada le queda
agarrando los temblores de la tierra,
por si eran tus pisadas extraviadas
carcomiendo los minutos de las noches en desvelo
para que no quedara un silencio adelantando
tu abandono,
por si algún transeúnte preguntara
decirle,
esta allí en el reposo de los ríos
cuando buscan mar abierto
al infinito.

HORAS DE SALITRE

I

El perro aúlla,
no sabe si ellos,
los que van y vienen
con sus ropas de camuflaje,
juegan a la guerra
o les patearán
con la culata
las horas contadas
de salitre.

II.

Entraron
en un plazo
determinado
para que le entregáramos el alma
y ellos, continuar su empeño
de fabricar guerras nuevas
…en nuestro suelo.

VII

Esta quietud de pájaros
amedrenta
los cansancios.
Aquellos no duermen
vigilan,
planifican,
Cómo matar
al niño
sin que les duela
la consciencia.

Las bayahondas
tiemblan
petrificadas
como guerrilleros
vencidos
en los campos
desérticos
de viequenses.

CLANDESTINOS

Hemos cabalgado
en tardes de espera
y noches largas
por ahí
entre ramas verdes
y sueños postergados
aumentando la fe
pero has llegado
acariciando mi nostalgia
de hombre-patria.

Beatriz de los silencios
de las calles sepultadas.

Estamos aquí
en esta ola de vigilias clausuradas
aprisionados entre las consciencias carpeteadas.
Toma mi mano enternecida de dolor
aunque mañana eterna
en una lucha nos rediman
aunque estemos sepultados
en una leyenda
de mentiras
de soldaditos de guano.

EN MI VÍSPERA

Después de ser mujer
dos veces
seré hombre
entonces
iré a tu planeta
azul
a rebuscar
esas gaviotas
que hacen nidos
en tu mundo
mientras, llevo vacías
las alforjas
para cuando se crucen
los caminos
y se llenen los pedregales
de ideas.

RAQUEL Z. RIVERA

Raquel Z. Rivera es narradora, ensayista, poeta. Nacida y criada en Puerto Rico, ha vivido en Nueva York desde 1994 y reside en El Barrio. Publicó el libro *New York Ricans from the Hip Hop Zone* en 2003. Es co-editora de la antología *Reggaeton* (2009). Sus artículos académicos sobre cultura popular se han publicado en libros y revistas. Sus cuentos, ensayos y poemas se han publicado en periódicos y portales literarios, como *El Nuevo Día, Claridad, Siempre, El Fémur de Tu Padre* y la página del internet Latino Artists Round Table. Un fragmento de *Beba,* su novela en ciernes, se publicó en *Hostos Review/Revista Hostosiana: Open Mic/Micrófono Abierto. Nuevas literaturas Puerto/Neorriqueñas. New Puerto Rican/Nuyorican Literatures* (2005). Ha leído fragmentos de su novela en los eventos: "Así Cuentan las Mujeres" (2007), en el Centro de Estudios Puertorriqueños; "Lit! Putting the Fire in LITerature" (2005), co-auspiciado por el Bronx Council on the Arts' Bronx Writer's Center; "The 7th International Conference of Spanish Caribbean/Latina Writers" (2005) en Hostos Community College; y "Rivera Strikes Again" (2003) en el Bowery Poetry Club. Ha escrito artículos en periódicos y revistas como *Vibe, One World, Urban Latino, El Diario/La Prensa, Hoy, The San Juan Star, El Nuevo Día, Claridad* y *Diálogo.* Es cantautora, miembro fundador y ex-integrante del grupo de música de raíz boricua Yerbabuena, miembro del grupo de bomba Alma Moyó y miembro fundador de Yaya, un colectivo musical de mujeres dedicadas a las salves dominicanas y la bomba. Produjo con Tanya Torres la grabación (CD) *Las 7 salves de La Magdalena/ 7 Songs of Praise for Mary Magdalene* (2010). Obtuvo un Ph.D. en Sociología del CUNY Graduate Center (2000). Actualmente es Investigadora Afiliada al Centro de Estudios Puertorriqueños de Hunter College en Nueva York.

Raquel Z. Rivera is a fiction writer, essayist and poet. Born and raised in Puerto Rico, she has lived in New York City since 1994 and is a resident of El Barrio (East Harlem). Rivera published the book *New York Ricans from the Hip Hop Zone* in 2003. She co-edited the anthology *Reggaeton* (2009). Her academic articles on popular culture have been published in books and journals. Her short stories, essays and poetry have been published in newspapers and literary websites, including *El Nuevo Día, Claridad, Siempre, El Fémur de Tu Padre* and the Latino Artists Round Table webpage. An excerpt from *Beba*, her novel-in-progress, was published in 2005 in the *Hostos Review/Revista Hostosiana: Open Mic/Micrófono Abierto. Nuevas Literaturas Puerto/ Neorriqueñas. New Puerto Rican/Nuyorican Literatures.* She has also read excerpts of the novel at the events: "Así Cuentan las Mujeres" (2007) at the Center for Puerto Rican Studies; "Lit! Putting the Fire in LITerature" (2005), co-sponsored by the Bronx Council on the Arts' Bronx Writer's Center; the "7th International Conference of Spanish Caribbean/Latina Writers" (2005) at Hostos Community College; and "Rivera Strikes Again" (2003) at the Bowery Poetry Club. As a freelance journalist, her articles have been published in newspapers and magazines, among these: *Vibe, One World, Urban Latino, El Diario/La Prensa, Hoy, The San Juan Star, El Nuevo Día, Claridad* and *Diálogo.* A singer-songwriter, she is a founding and former member of Boricua roots music group Yerbabuena, and currently works with bomba group Alma Moyo. She is also a founding member of Yaya, an all-women's musical collective dedicated to Dominican salves and Puerto Rican bomba. She released the recording (CD) *Las 7 salves de La Magdalena/ 7 Songs of Praise for Mary Magdalene* (2010). Rivera received a Ph.D. in Sociology from the CUNY Graduate Center in 2000. She is currently an Affiliated Scholar at the Center for Puerto Rican Studies at Hunter College, New York

WHILE IN STIRRUPS
(a chapter from the novel-in-progress *Beba*)

"Sweetie, that's amazing," the nurse practitioner gushed. "Here I am assuming you're a teenager and you're a doctor. Wow."

Yeah, a doctor with no health insurance and absolutely no knowledge how to heal anyone or herself. P.—h.—D. A great deal of good those three grand letters did in my case. Intelligence is overrated when common sense is not part of the package deal. Maybe Josue was right: I was one of the many educated beyond our intelligence.

Lie down with dogs, get up with fleas. Have sex with your ex, get up with a urinary tract infection. I should have known I would have to pay for that sweet sweet Saturday afternoon of breakup sex.

Right after our Sunday Tarot card session, Carmen had suggested I take my infection right over to Taino Health Clinic. She said I only had to take proof of my meager freelancing income and they would only bill me around $30.

So bright and early on Monday, I bundled myself up in five layers of clothing and rode my bike the ten frosty blocks separating my East Harlem studio from the clinic. Barely an hour of paperwork and waiting later, I was called in to Laurie Miles' office.

She was a white nurse who grew up in Long Island, she told me, and had been working for more than a decade in the neighborhood.

"It's incredible, the kind of stories I hear," she lamented. "It's such a pleasure to have such an educated young woman as a patient."

Is this lady for real? Does she actually think this is a compliment? How to respond to such elitist nonsense?, I wondered. But surprise, surprise, I decided to let it slide. I told myself it made no sense to create static with the lady about to wrench my slit open and explore its tender insides. But who was I kidding? It was once again my chronic avoidance of confrontation.

She went through the standard questions regarding my reproductive health history. Abortions? No. Had been tested for HIV? Yes, a few years back. Sexually transmitted diseases? None that I knew of. Intravenous drug use? No.

"I apologize," she said with a sheepish smile. "I have to ask."

Of course she did. Why apologize? Did she think she had to give me special treatment because I had a doctoral degree? Did she think Ph.D.'s are above hard-core drug use and assorted recklessness?

"Do you typically use condoms?"

"Always, except for my last lover who I was with for five years," I responded. "We got tested and we were both o.k."

"Good," she said, sounding pleased and encouraging. "Have you had more than five sexual partners, total, throughout your life?"

"Yes."

"More than 10?"

"Yes."

"More than twenty?" she inquired with an edgy squeak in her voice, unable to hide her astonishment.

"Yes." I looked at her defiantly, resentful.

"More than fifty?" she asked, bug-eyed.

"Probably," I responded dryly. "At some point, I stopped counting," I added in all honesty, but choosing my words carefully for maximum effect.

I had been going for gynecological exams regularly for over a decade. And never had a nurse or doctor betrayed any kind of emotion over my answers. Should I report this fool?, I wondered.

"Have you ever exchanged sex for money?" she asked, attempting a business-like tone.

"No," I responded, majorly taken aback.

Was that a new question for GYN exams, recently introduced by the board of something or other? Was it a standard question I had just never been asked? Or was it a question reserved for promiscuous East Harlem women with no health insurance? I honestly could not picture the same query being posed to slutty young heiresses at a gynecologist's office a mere thirty blocks south, in the heart of Manhattan's Upper East Side.

"Sex for drugs?"

"No," I responded, struggling to keep my voice level.

Is my sexual mileage that uncommon? Does my experience really only make sense within the logic of prostitution and drug addiction?

Maybe those last few questions were not on that form she was filling out. Maybe she asked just to satisfy her curiosity. Maybe she only scribbled on the margins of the page, to hide the fact that the queries came from her.

She had assumed I was more like her, less like those other women that came into her office. It turned out I was worse: I laid my life on the line for pleasure, for non-drug related vice, with full awareness. My sluttiness could not be explained by a struggle to make ends meet or to sustain an addiction.

Or maybe both the nurse and her questions were objectively neutral, only driven by numerical facts. Maybe I was just overly defensive.

Nurse Miles and I then both switched on the coldness. She said she would step out of the room and asked me to take off my clothes, put on the paper robe and climb on top of the examining table that was covered by waxy paper. I did.

My favorite black and white striped socks were my only defense against the frigid air seeping into the room from the big icy window set high on the wall. As I waited for Nurse Miles to come back, I hoisted my legs unto the table, crossing them so each foot would be tucked in the crevice between calf and thigh. That warmed me up a little and I lost myself in thought.

Up until I became Josue's lover, I had cultivated a defiantly slutty identity. Throughout high school, college and most of graduate school, I loudly railed against monogamy and declared myself bisexual. Back then I though my promiscuity was rooted in clarity and courage. Why shield ourselves behind the hypocrisy of monogamy? Why deny our lusty physical reality? Why bow down to the double standard that views male sluts with permissiveness but female sluts with contempt? Yes, I knew from experience that jealousy and insecurity were horrible sentiments to be dealt with and high prices to pay for sexual freedom. Yes, I knew I was the object of negative judgments—even by some of the very same men who enthusiastically pursued me. But what was the alternative? To promise fidelity and then lie?

There had been some truth to my self-righteous rantings and ravings. They certainly were based on earnestness. But I didn't realize then everything that was at stake. I had not yet realized that being loverless was not the most horrid condition in the world. It had not yet dawned on me that being picky about who one sleeps with could actually be a good idea; that better things come to those who take their time; that I could have avoided myself some heartache if I had just observed the individuals in question for a few moments longer before sinking my greedy teeth in. Back then, I was still optimistic about the chances of a pretty face and appealing body containing a beautiful soul.

I wished I could have said all those things to my 16-year-old self, the one who left home to go to Brown University, the adolescent who swore she was so mature, the one in a heart-wrenching picture an ex-lover took. In it, I am naked, save for my round gold wire-rimmed glasses and the

renegade dark fuzz I had refused to shave since I had met a few beautiful, hairy young women at Brown. I lay curled up in my dorm bed, with my ex's kitten wrapped in my arms—the poster girl for nerdy, licentious innocence.

Then again, maybe I needed to live through everything I lived through. Maybe I had only been faithful to my process. Maybe it was not a mistake to amass an army of ex-lovers.

I was surely thankful that so many things that could have gone wrong did not. I never caught any horrible disease, or got pregnant, or was raped. With a track record like mine, it was indeed a wonder I had managed to remain relatively intact.

But though I had been faithful to my body's desires, I had turned a blind eye to my unfulfilled emotional yearning. In a way, I whored myself for brief moments of pleasure, for momentary illusions of connections, for protection against my solitude. Meanwhile, my truths started to ring steadily at my ears. My body even started giving me desperate signs of its sensory overload. I remember quite a few times waking up in a panic, laying in bed next to a new lover. As I would utter the right name, the wrong names struggled to spill out of my throat. Later, the lover whose touch I had enjoyed as I had woken up, would make me bristle in repulsion over breakfast.

I felt trapped in a waking nightmare, as strangers repaid with superficial caresses my ambivalent passion. Until I could ignore it no more. I had been whoring myself for emotional crumbs.

There was a soft knock at the examining room door that snapped me back to the present. Without waiting for a reply, Nurse Miles came back in and asked me to place my feet on the stirrups. I did, bracing against cold metal drilling into my soles, even through my striped socks. I lodged each heel firmly unto the stirrups and, before she had to say it, dragged my naked butt over crackling paper to the far end of the examining table.

I had a brief flashback to the Tarot session with my girls the previous day. Since The Priestess card is the embodiment of wisdom and since a card that appears upside down represents the opposite, then The Priestess Inverted must have been my patroness that morning. The Priestess, inverted, and in stirrups.

Tersely, Nurse Miles asked all the requisite questions throughout the pelvic exam. Sullen, I studied the lines in her pasty face, framed by my naked open legs.

ESMERALDA SANTIAGO

Esmeralda Santiago nació en San Juan y vive en Westchester County, Nueva York. Vino a los Estados Unidos a los trece años. Su primer libro de memorias fue *When I was Puerto Rican* (1993). Su novela, *América's Dream* (1996), se publicó en seis idiomas y fue Alternate Selection of the Literary Guild. Su segundo libro de memorias, *Almost a Woman* (1998), recibió numerosas menciones de honor como "Best of Year" y el Alex Award from the American Library Association. La adaptación que hizo de *Almost a Woman* para PBS Masterpiece Theatre recibió el George Foster Peabody Award por excelencia en radiodifusión. Su tercer libro de memorias, *The Turkish Lover* (2004), fue recomendado por BookSense (2004) y apareció en listas de "Best of 2004." Fue co-editora con Joie Davidow de las antologías *Las Christmas: Favorite Latino Authors Share Their Holiday Memories* (1998) y *Las Mamis: Favorite Latino Authors Remember their Mothers* (2000). Es autora del libro ilustrado para niños *A Doll for Navidades* (2005). En 1977, ella y su esposo, Frank Cantor, fundaron CANTOMEDIA, una compañía de cine y medios de comunicación que ha ganado premios por su excelencia en la producción de películas documentales. Santiago es productora y directora de películas documentales y educativas. Sus ensayos se han publicado en periódicos como *The New York Times* y *The Boston Globe*, en revistas, y en los programas televisivos de comentarios NPR's *All Things Considered* y *Morning Edition*.

Santiago es promotora cultural y social, portavoz de las bibliotecas públicas, co-fundadora de un hogar que acoge mujeres abusadas con sus niños y miembro de las juntas de varias organizaciones artísticas y literarias. Ha diseñado y desarrollado programas comunales para adolescentes. Recibió el Girl Scouts of America National Woman of Distinction Award en el 2002. Luego de estudiar en colegios comunales de Nueva York, recibió una beca para estudiar en la Universidad de Harvard, de donde se graduó Magna Cum Laude en 1976. Santiago obtuvo un MFA en Fiction Writing del Sarah Lawrence College y doctorados honorarios de Trinity University, Pace University y la Universidad de Puerto Rico, recinto de Mayagüez.

Esmeralda Santiago is a writer, born in San Juan. She came to the United States at the age of thirteen and now lives in Westchester County, New York. She published the memoir *When I was Puerto Rican* in 1993. Her novel, *América's Dream* (1996), was published in six languages, and was an Alternate Selection of the Literary Guild. Her second memoir, *Almost a Woman* (1998), received numerous "Best of Year" mentions and an Alex Award from the American Library Association. Her adaptation of the first memoir into a film for PBS Masterpiece Theatre received a George Foster Peabody Award for excellence in broadcasting. Her third memoir, *The Turkish Lover* (2004), was selected a BookSense recommendation in 2004 and appeared on several "Best of 2004" lists. With Joie Davidow, she is co-editor of the anthologies, *Las Christmas: Favorite Latino Authors Share Their Holiday Memories* (1998) and *Las Mamis: Favorite Latino Authors Remember their Mothers* (2000). She is the author of the illustrated children's book, *A Doll for Navidades* (2005). She is co-founder with her husband, Frank Cantor, of CANTOMEDIA (1977), a film and media production company, which has won awards for excellence in documentary filmmaking. Santiago is also a producer/writer of documentary and educational films. Her essays have run in newspapers like the *New York Times* and *The Boston Globe*, in various magazines, and as guest commentary on NPR's *All Things Considered* and *Morning Edition.*

She was one of the founders of a shelter for battered women and their children and is a social and cultural activist on behalf of public libraries, community-based programs for adolescents and organizations devoted to the arts and to literature. She received a Girl Scouts of America National Woman of Distinction Award in 2002. Santiago studied at various community colleges, and then transferred to Harvard University, where she graduated Magna Cum Laude in 1976. She has earned an MFA in Fiction Writing from Sarah Lawrence College and Honorary Doctor of Letters from Trinity University, Pace University and the University of Puerto Rico, Mayagüez Campus.

A FUERZA DE PUÑOS
(excerpts)

Room 9 has a sleeping porch walled with shutters, so that it's really two rooms. Usually, it's rented to couples with children, because there's enough space in the porch for a bed and a crib. This time there are toys scattered around, and a couple of mangy- looking stuffed animals on the small bed and in the crib. In the bathroom there are three baby bottles with nipples. The garbage can is stuffed with dirty diapers.

From the clothes, she can tell they're boys, one of them under three perhaps. Overalls and sneakers with cartoon characters are neatly folded on top of the dresser. So many clothes! A stack of Huggies for toddlers, a few clean diapers on the bedside table. A box of wipes.

She dusts, noting how much this couple has brought. They must have needed a separate suitcase for all the toys, books, puzzles, and plastic figures of muscular manlike creatures with loincloths and green skin. On the bedside table closest to the sleeping porch, the mother has left a pair of earrings in the shape of bananas, and a purple headband with the rounded tips worn to the plastic. On the husband's side, a pair of glasses with severe black frames, a thick paperback book with a gavel picture on the cover.

They read a lot, the tourists who come to La Casa del Francés. They always bring fat books with them, the women's with laces and flowers or beautiful girls entwined with brawny men, the titles with cursive writing. The men's books are austere, usually no more than the title and the author in block letters, with few colors, no gilded edges or ornate designs. Sometimes they bring magazines, and she's noticed that they too seem designated male or female. On one of them, the cover was nothing but a white background with a large dollar sign in red. The women's magazine has pictures of movie stars, or teenage girls with pouty lips and smooth skin where there should be a cleavage. When the guests throw them out, América saves them and brings them home to study the fashions, the picture-perfect dinners, the tips for making rooms over. In one, they changed the look of a room by draping sheets on the walls, the windows, the furniture. To America, it looked like a house abandoned, protected from dust, ghostly and unwelcoming.

"Buzzzz ... You're an airplane.... Buzzzz.... rat tat tat tah ..." the door flies open and a man carrying a toddler comes in. "Oh, I'm sorry!"

"Is okéi," she says. "I finish later--"

"No, no, that's all right. You can keep working. We just came to change a stinky." He drops the child on the bed, tickles him with one hand, while on

the other he reaches for a clean diaper in the box next to the bed. "You're a stinker, yes, you are, a stinker ..." the little boy delighted with his father's silliness, and giggles.

"I'm a stinker ... stinker ..."

America watches as the father deftly slips a clean diaper under the dirty one, wipes his son's bottom with a wet tissue from a plastic box, blows air in the child's belly before fastening the tapes.

"There you go!" He pulls the child up, slings him over his shoulder. "All done!" he says and pats his padded bottom. "See you later," he says to América, and they leave the room.

All the while he was changing the baby, América had to restrain herself from offering to do it for him. His movements were confident, as if he had done it many times, but she couldn't help herself. She wanted to change the baby's diaper.

If Rosalinda is pregnant, there will be a baby in the house. América has no doubt that her daughter will be home before a baby is born. Yamila and Roy are not about to sacrifice their son for Rosalinda's sake. What mother would do that to a sixteen-year-old boy? If Rosalinda is stupid enough to get pregnant, she'll have to take responsibility for what happens next. As Ester said, "You've made your bed, now lie in it."

A dull ache forms in América's chest. She didn't learn from Ester's mistake, why should she expect Rosalinda to have learned from hers? Maybe it's a family curse. Just as Ester left her mother with a man who promised her God knows what, América left, at the same age, with Correa, whose promises she doesn't remember. Perhaps there were none. Maybe, when you're fourteen, no promises are necessary, just the insistent need to be with a man in a way you can't be with your mother or your friends. Maybe, when you're fourteen, you're not running toward something, you're running away from it. Maybe all girls go through this phase, but only some act on it. América doesn't know. América has no idea what she's done to make Rosalinda do what she's done. Or what Ester did that made her run off with Correa, come back to the island, and remain his woman all these years, in spite of the fact that he has betrayed her again and again.

Is it my fault? She asks herself, but she can't answer. She's tried to be a good mother to Rosalinda. She's told her straight out that she hopes Rosalinda will not repeat her mistakes, that she should get an education and make something of herself. Rosalinda always seemed to understand, to share América's dreams for her, to have dreams of her own. América shakes her head, as if trying to unfasten a clue to her daughter's escape. I've brought her up the best I could, she assures herself. I did everything to

make sure she'd have a better life than mine. What happened?

⸎

"Boys are easier to bring up than girls," Nilda declares in between mouthfuls of yellow rice with ham. "They're not as moody, and they're up front about what's bothering them. Girls are deceptive that way."

América eats her lunch under a mango tree behind the kitchen sitting at a picnic table set up for the help's meals and coffee breaks.

"I don't know about that," says Feto, father of six daughters. "It's all a gamble. Some kids are easy, others aren't. It has nothing to do with their sex."

They chew thoughtfully, considering Feto's statement. Since they sat down to lunch, the conversation has circled around sons and daughters, their merits and drawbacks, but no one has come straight out and asked América what's happening with Rosalinda.

"One good thing about daughters," says Tomás, who lives with his in a small house surrounded by lush gardens, "they never leave you."

Everyone looks at América.

"Or if they do," amends Nilda, "they always come back." Everyone nods.

"Buen provecho," América says, getting up to carry her half-finished lunch to the kitchen. As she's scraping the leftovers into the compost bowl, Nilda comes up the back steps.

"We didn't mean to offend you when we were talking," Nilda apologizes.

"No offense taken," she responds crisply.

"There are only so many things we can talk about when we know each other so long."

"Don't worry about it." She knows that they all think she's conceited and uppity. That when she comes to work with bruises in her face and arms, she deserves it. That Correa has to control her with his fists because otherwise she would be too proud.

She's heard the men talk about how a man has to show his woman, from the very first, who wears the pants in the house. Especially nowadays, when women think they can run the world. Even Feto, the father of six

daughters, says a man has to teach women the way he likes things and if the only way she can learn is "a fuerza de puños," well, then, his fists should be the teacher. Tomás says he doesn't believe in hitting women with his fists. An open hand, he says, is as effective. "A man who hits a woman with his fists," he says, "is taking advantage."

América doesn't talk much at lunchtime. Anything she says can get back to Correa, who plays dominoes with these men. And often Correa is part of their conversation. He eats lunch at La Casa three or four times a week and sits with the men on their end of the table while she and Nilda huddle at their end pretending not to hear them.

HOW CORREA KNOWS

Are you all right?" Karen asks the next morning. "You look like you didn't sleep well."

"Is okéi, she responds. "Time of month."

"There's Motrin in the medicine chest if you need it."

"Is okéi, thank you."

She manages to make breakfast for everyone, to get them off to school and work, to clear the dishes and clean the kitchen and pick up in the den and family room, to make the beds and bring the soiled clothes to the basement. She does her job automatically, with less efficiency, perhaps, than when she's paying attention. But everything gets done, and after a morning, the house is sparkling and she's still in a fog.

He knows where I am. It's like a verse of a song, repeating in her brain over and over again. He knows where I am doesn't leave room for any other thought, for reason to enter and begin gnawing at fear. He knows where I am punctuates her breathing, her walking, makes her jump when the gardener drives up with his lawn mower and rakes. He knows where I am follows her to school, where she picks up Meghan, to Liana's house, where the children watch Power Rangers. He knows where I am plays in her brain as the women talk, complain, joke, and tell stories.

She returns home, makes dinner, feed the children, although she barely touches her own food. It's Friday, and both Karen and Charlie come home early because they're taking the children to a party at a friend's house. She'll be alone tonight, and she talks herself into not being afraid. He knows where I am, but he's in Vieques. He's not here.

꧁꧂

She draws the shades, locks her door. Because she's home, the Leveretts did not set the alarm when they left, as they would if the house were unattended. But I shouldn't be afraid. He's in Vieques, and I'm here. Every time she passes the phone, she expects it to ring. But it's silent.

Rosalinda picks up as if she too has been waiting for the phone to ring.

"Oh, Mami, hi." Wary, mistrustful.

"How are you?" She will remain composed, will think before she speaks. Will not let on that she's nervous, afraid, or worried.

"It's fine. I got your letter. I'm sorry I hung up on you." An insincere apology, meant to appease her.

"Is everything all right?"

"Yeah." Uncertain.

"Have you seen your father lately?"

A gasp, short but perceptible. "He was here this week."

"Where is he now?"

"I don't know." Defensive.

América takes a deep breath. "Does he know where I am?"

"I ... don't think so." Doubtful, lying. "I mean, I think he knows you're not in Puerto Rico."

"Where does he think I am?"

"I guess he thinks you're in New York." She's a poor liar. Her voice shakes, and she speaks too fast.

"Did you tell him that's where I am?"

"No." Her voice quivers, on the verge of tears.

"Did you?"

She breaks. "He saw the envelope ... when you sent a money order and that letter."

América breathes, long even breaths. She will remain calm.

"I didn't put the address on the envelope."

Rosalinda's voice rises. "It was in the postmark."

A cry escapes her. América bites her lips so that she will not be taken by surprise again.

"The name of the town was printed right in the postmark."

"Did you ..." América falters in her efforts to remain calm, stops herself, tries again. "Did he find it, or did you show it to him?"

Silence. For a moment it seems to América that Rosalinda has again hung up on her. But she hears her breathing on the other end, quick, sharp

breaths.

"I'm sorry, Mami." Rosalinda whimpers. "I was so mad at you, at your letter. And then he came over and found me crying." América lets her cry. This time Rosalinda's tears don't affect her the same way. She listens to her, doesn't question her, doesn't interrupt the sobs. Rosalinda continues, as if her mother's silence were an inducement. "He wrote down the name of the town, and then he checked the sheets from the guardhouse. He looked for names from the same place."

"So he has my address, too."

The resignation in her mother's voice startles Rosalinda.

"I was so mad at you." As if that excuses everything. "You shouldn't have written that letter." She's so self-righteous, so unwilling to take responsibility. "You always yell at me and criticize everything I do." Am I really that bad? Have I been such a terrible mother that she owes me no loyalty? "I tried to call and warn you, but I don't have the number. You should have given me your number."

América bites her lips, doesn't say anything.

"He just ... ju-ju-just w-w-w-wants ... he jjjjust ... he just wants to talk to you." Now she's angry, frustrated.

"All right, nena, take it easy. If you see him, tell him I'll talk to him." She will remain calm at all costs, will not let on that she's afraid.

"You will?" Rosalinda sounds unnerved, as if she has been found in a game of hide-and-seek.

"Tell him I'll talk to him."

"I will, Mami."

"Is he there now?"

"No, he went out."

"Okéi, mi'ja."

"You're not mad, Mami?"

"Don't worry."

"I'm sorry, Mami."

"I'll call you next week."

She sets the phone gently, delicately. She's exhausted. Her arms feel tense and tight, as if she's been lifting weights. She sits propped up by pillows, her white stuffed cat on her lap. There's nothing to do but wait. Correa will call, she will talk to him. She doesn't want him to think about what will happen after that.

Corazón Tierra

Corazón Tierra, nacida con el nombre Ivelyse Padilla Laboy, es escritora, performera, bailaora, editora de revistas y experta en crecimiento personal mediante las artes. Nació en la ciudad de Nueva York, se crió en Puerto Rico y reside en Nueva York desde el 1988. Transforma sus cuentos y poemas en presentaciones interdisciplinarias sanativas, una nueva modalidad de teatro co-creada con María Mar, llamada Teatro de Transformación. Ha presentado su obra en Estados Unidos (en el Julia de Burgos Cultural Arts Center, the Nuyorican Poets Café, Hunter College y otros lugares), África del Sur y España. Escribe sobre su experiencia al sanar de la anorexia. Su prosa poética se publicó en Puerto Rico en la antología *Ana y su anorexia* (2005) y artículos sobre el tema se han publicado en revistas como *Latina* y *Siempre Mujer*. Leyó fragmentos del manuscrito de su novela *Casi desaparecida: Retorno al territorio de mi cuerpo* en el Instituto de Cultura Puertorriqueña, Boricua College y la Universidad de Granada en España, donde recibe una beca para pasar una temporada en la Fundación Valparaíso escribiendo ese manuscrito (2006). En España, ha leído su obra literaria en la Feria de Asociaciones de Mujeres (Sevilla), la Fundación Valparaíso (Almería) y en Granada leyó de otro manuscrito suyo, *CuerpoAdentro: Rescate poético del cuerpo de la mujer,* en el programa de radio *El zaguán de la poesía.* Su obra de danza-teatro *CuerpOdiosa* fue documentada en la televisión de Sevilla (2002). Es cofundadora de ShamansDance, una compañía que se dedica a ayudar a las mujeres y a las familias mediante las artes. Fue editora de salud y cocina de la revista *Siempre Mujer.* Tiene un B.A. de Hofstra University y estudió flamenco en la Fundación Cristina Hereen de Arte Flamenco y en la Academia de Flamenco de Manolo Marín.

Corazón Tierra, born Ivelyse Padilla Laboy, is a Puerto Rican performer, dancer (bailaora), writer, magazine editor and expert in personal growth who integrates theater, dance, poetry, singing and live music. She was born in New York City, raised in Puerto Rico and has lived in New York City since 1988. Tierra presents interdisciplinary, healing performances (a new modality of theatre co-created with María Mar, called "Theatre of Transformation") and has presented her work in the USA (at the Julia de Burgos Cultural Arts Center, the Nuyorican Poets Café, Hunter College and other venues), the Karoo desert in South Africa and Spain. She has written articles about eating disorders in magazines such as *Latina* and *Siempre Mujer.* Her poetic prose was published in Puerto Rico in the anthology *Ana y su anorexia* (2005). She has read excerpts of a novel in progress, *Casi desaparecida: Retorno al territorio de mi cuerpo* at the Instituto de Cultura Puertorriqueña, Boricua College and the Universidad de Granada in Spain. In 2006, she received a writing residency award at the Fundación Valparaíso in Almería, Spain to work on that manuscript. She has read and performed her work in Spain at the Feria de Asociaciones de Mujeres (Seville), the Fundación Valparaíso (Almería); and she has read from another manuscript, *Reina de tu cuerpo,* at the poetry radio program *El Zaguán de la Poesía* (Granada). Her performance piece *Goddess/dam Body (CuerpOdiosa)* was featured on television on Seville in 2002. A co-founder of ShamansDance, a company dedicated to helping women and families through the arts, Tierra was Health and Food Editor of *Siempre Mujer Magazine* (USA). She holds a B.A. from Hofstra University and studied Flamenco in Spain at the Cristina Hereen Flamenco Foundation and the Academia de Flamenco de Manolo Marín.

CASI DESAPARECIDA: RETORNO AL TERRITORIO DE MI CUERPO (fragmento)

La despedida

No los miré a los ojos ni me entregué a su abrazo. Mamá estaba a punto de llorar aguantando las lágrimas en el fondo de sus pupilas. Me miraba con una mezcla de orgullo, pena y miedo. Se ahogaba en un tumultuoso mar de emociones, en la angustia de una madre que se siente huérfana cuando deja ir a su cría, en el desaliento de una niña cuando pierde a su madre.

Papá había adoptado una postura cabizbaja. La tristeza que llevaba grabada permanentemente en su rostro se hizo más distante, como si el sentimiento del momento se estuviese volcando hacia adentro, desapareciendo en un rincón de su alma. Estaba tan acostumbrada a esa expresión en papá que no me di cuenta cuánto le dolía la separación. Años después, mamá me comentó que el día de mi partida al despegar mi vuelo, papá le dijo: "La hemos perdido para siempre".

No soportaba el sentimentalismo de mis padres. Todavía no había llegado a la ciudad de los rascacielos, pero ya andaba de prisa, huyendo del presente. En mi estómago palpitaba un reloj. Me marcaba el tiempo sin piedad. Sentía que estaba a punto de perder el único tren que me sacaría de un país inhóspito. Me estaba obligando a la formalidad de la despedida para no parecer una hija malagradecida, o peor aún, malcriada.

Había esperado este momento durante años. Planifiqué mi partida con lujo de detalles. Al principio, cuando empecé a imaginarme como estudiante universitaria, creía que iba a estudiar en la Universidad de Puerto Rico. Papá siempre decía que las mejores mentes del país salían de esa institución. Lo decía casi con pesar, como si le doliera el diploma en economía que había obtenido de una universidad neoyorquina.

Mamá, en cambio, siempre me decía que Nueva York era la ciudad de las oportunidades. Cuando lo decía la rabia se le escapaba en lo que estuviese haciendo en ese momento. Si estaba machacando ajo en el pilón, empezaba a dar golpes severos con la maceta. Si estaba fregando, empezaba a tirar las tapas de las ollas contra la encimera. Y entonces empezaba a repetir una letanía que me penetraba por mis poros como una sentencia. "Si yo hubiese regresado con un diploma universitario, no tendría que aguantar tanto".

Al final, la letanía de mamá surtió más efecto que los argumentos inteligentes de papá. Decidí ir a estudiar a Nueva York y desde el momento en que lo decidí, empecé a contar los días, y a planificar el más mínimo

detalle de mi partida.

Para mí, estudiar en la universidad significaba mucho más que mi independencia. Representaba mi libertad, y mi libertad, lo tenía claro, se encontraba fuera de la nube gris que arropaba mi casa, lejos de mis padres. Me fui, sin saber cuánto peso arrastraba en mi equipaje.

En una maleta gris que casi no podía arrastrar había puesto mi ropa. En una caja los residuos de la biblioteca de mis padres, algunos de los libros que habían sobrevivido la debacle de más de una década. Una antología de poesía puertorriqueña que había pertenecido a mamá en sus años de estudios literarios. Las biografías de Pedro Albizu Campos, el Maestro, y un libro de portada anaranjada titulado Los que murieron en la horca, con las historias de los que fueron sentenciados a muerte en Puerto Rico en el siglo XIX. No sé porqué arrastraba con ese libro. Me habían impactado las historias de aquéllos que murieron en la horca por el simple delito de robo o de adulterio. Este último era un delito que parecían cometer solamente las mujeres.

Todos eran libros viejos con portadas desgastadas por el tiempo, manchadas por el agua de las numerosas tormentas que inundaron mi casa. Eran libros con un aspecto muy triste causado por la falta de atención. No había visto ni a papá ni a mamá leer sus páginas desde hacía más de una década.

En mi equipaje también llevaba mis primeros escritos. Cuentos y dos obras teatrales que había mecanografiado en la maquinilla de papá, un aparato de los años sesenta que rescaté del abandono.

Agazapado en mi corazón llevaba otros equipajes. Mis sueños se escondían dentro de los sueños que mamá y papá secretamente me habían pasado de herencia. No sabía que en ese momento la herencia tenía mucho más peso que los sueños.

La despedida ya me estaba sofocando. Sentí un gran alivio cuando anunciaron que ya podía abordar el avión. A mamá se le desbordó el llanto. A papá se le enrojecieron los ojos. A mí no me salió ni una lágrima. Sólo sentí un nudo en la garganta. La última imagen que tengo de aquella primera despedida se quedó grabada en la puerta de vidrio del aeropuerto. Al otro lado, dejé las miradas de mamá y papá siguiendo mis pasos mientras me dirigía a entregar mi pasaje.

Caminé hacia al avión sin mirar hacia atrás, segura de mí misma, con mis 18 años de experiencia pueblerina y mis 85 libras, las mismas que pesaba cuando tenía 12 años de edad. Estaba segura de que lograría todas mis metas. Sería una estudiante universitaria de honor, sería la número uno y no aumentaría ni una onza.

TANYA TORRES

Tanya Torres es poeta, artista visual y activista cultural. Nació en Nueva York de padres boricuas y vivió sus primeros años en Puerto Rico. Crea libros artesanales de poesía con reproducciones electrónicas, imágenes, papel decorativo y palabras, entre ellos *Bestiario mío* (2001), *I Can Certainly Survive* (2002), *Cuerpo de batalla* (2004) y *Sagrario* (2007). *Cuerpo de batalla* relata su experiencia con el cáncer y se ha presentado en las Naciones Unidas, la Biblioteca del Centro de Estudios Puertorriqueños, el Museo de la Familia Dominicana del Siglo 19 en Santo Domingo (RD) y el Museo Porta Coeli del Instituto de Cultura Puertorriqueña. En 1999 creó la Galería Mixta, un espacio artístico en el primer piso de su casa en El Barrio, donde organizó exhibiciones de arte, lecturas de poesía y talleres de arte. Documentó su contacto con artistas, músicos y poetas en el periódico *Siempre*. Organizó además el "Encuentro Intergeneracional de Escritoras Puertorriqueñas" en Hunter College (2005). Su trabajo se ha reconocido en revistas y periódicos y en el año 2002 fue seleccionada como una de las 50 Mujeres Destacadas del Año por *El Diario/ La Prensa*. Ha exhibido su obra en el Centro de Estudios Puertorriqueños, la Biblioteca Pública de Nueva York, el Taller Boricua, Boricua College y Hostos Community College. Combina arte y cuentos de niños como parte del programa "El Primer Contacto con el Arte" del Museo Metropolitano de las Artes. Enseña gratuitamente talleres de arte y de poesía en hospitales y organizaciones comunales. Estudió en la Universidad de Puerto Rico, la Universidad de Alcalá de Henares en España y The City College de Nueva York, donde obtuvo una Licenciatura en Educación del Arte y una Maestría en Bellas Artes (Grabado).

Tanya Torres is a poet, visual artist and cultural activist, born in New York City of Puerto Rican parents. She spent her infancy and childhood in Puerto Rico, moving back to New York City at age 15. Torres has written and produced limited editions of art books that integrate electronic reproduction with images, decorative paper and poetry, including *Bestiario mío* (2001), *I Can Certainly Survive* (2002), *Cuerpo de batalla* (2004) and *Sagrario* (2007). *Cuerpo de batalla*, which relates her own experience with cancer, has been presented at the United Nations Organization, the Center for Puerto Rican Studies Library, the Museum of the 19th Century Dominican Family in Santo Domingo (Dominican Republic) and the Porta Coeli Museum of the Institute of Puerto Rican Culture. Her artwork has been exhibited at The New York Public Library, Taller Boricua, the Consulate of Honduras in New York City, Boricua College and the Casa de la Cultura Dominicana. In 1999, Torres created Mixta Gallery, an artistic space at her house in El Barrio, where she organized art exhibitions, poetry readings, art workshops and classes. She has documented her contact with artists, musicians, and poets through the pages of the newspaper, *Siempre*. She has also organized literary events, such as the "Intergenerational Encounter of Puerto Rican Women Writers" at Hunter College (2005). Her work has been recognized in magazines and newspapers. In 2002, she was selected as one of the 50 Women of the Year by *El Diario/La Prensa*. Torres teaches voluntary art/poetry workshops at hospitals, community organizations and other institutions. She studied at the University of Puerto Rico, the University of Alcalá de Henares in Spain, and The City College of New York, where she obtained a B.A. in Art Education, and an M.F.A. in Printmaking.

ADIVINANZAS

I
te encontré tras presagios,
te di un altar
y en una batalla hasta la muerte
me entregué a ti,
invencible

II
con tu pelo
de migas
surgió calor
en el hojaldre
de mis pensamientos

III
hijo de ave,
tus ojos bizantinos
aún respiran los sueños
por tu índice
y mi ombligo

VII
somos
el aviso
en carne
y muerte
a los contaminados

IX
la calidez de
sus manos
siempre
ha sido
más intensa
que el miedo

Luz María Umpierre-Herrera (Luzma)

Luz María Umpierre-Herrera (Luzma) es poeta, educadora y defensora de los derechos humanos. Nació en Santurce, Puerto Rico, donde se graduó con honores de la Academia del Sagrado Corazón y la Universidad del Sagrado Corazón. Vive en los EE.UU. desde 1974. Ha publicado siete libros, entre ellos, *Una puertorriqueña en Penna, En el país de las maravillas, The Margarita Poems, For Christine. Poems & One Letter; Pour Toi/For Moira;* la colección de ensayos *Nuevas aproximaciones críticas; Ideología y novela en Puerto Rico* y más de cien artículos, entre ellos, "La ansiedad de la influencia en Sandra María Esteves y Marjorie Agosín", publicado en la antología *Woman of Her Word: Hispanic Women Write.*

Umpierre-Herrera ha librado muchas luchas contra la discriminación y por la inclusión de asuntos relacionados con raza, clase, género y etnicidad en los currículos de varias universidades. Ayudó a fundar y trabajó con PABE (The Pennsylvania Association for Bilingual Education) y el International Classroom of the University of Pensylvania para lograr que los niños recibieran una educación apropiada en el sistema escolar de ese estado. Recibió en 1995 una nominación para el Women's Hall of Fame de Seneca Falls, Nueva York. Fue nominada, además, para el Jefferson Outstanding Citizen Award en 1996. En el 2004, el MLA le rindió un homenaje en su convención anual, honrando su poesía y labor humanitaria. Recibió en 1990 el Life Time Achievement Award de las organizaciones Gay y Lesbianas de Nueva Jersey. Ha recibido también premios por su defensa de los pacientes de SIDA, incluyendo el Bayard Rustin Award del AIDS Massachusetts y Mujer del Año de Western Kentucky University. Ha trabajado también con la Cruz Roja, la Ford Foundation y Amnesty International. El Congreso de EE.UU. la nominó "Mujer Distinguida del Estado de Maine" en el 2002. Umpierre-Herrera recibió su Ph.D. de Bryn Mawr College. Umpierre hizo estudios de posgrado en el Woodrow Wilson International Center de la Universidad de Kansas (auspiciados por la Fundación Ford) y en The Milano School for Social Work and Social Research. Vive en la Florida.

Luz María Umpierre-Herrera (Luzma) is a poet, educator, and human rights advocate; born in Santurce, Puerto Rico, where she graduated with honors from both the Sacred Heart Academy and the Sacred Heart University. In 1974, Umpierre-Herrera came to reside in the United States. She has published seven books, including *Una puertorriqueña en Penna; En el país de las maravillas; The Margarita Poems; For Christine. Poems & One Letter; Pour Toi/For Moira*; a collection of essays, *Nuevas aproximaciones críticas;* the book *Ideología y novela en Puerto Rico;* and over 100 articles, among them, "La ansiedad de la influencia en Sandra María Esteves y Marjorie Agosín," published in the anthology *Woman of Her Word: Hispanic Women Write.*

Umpierre-Herrera has undertaken legal battles and pioneering work for the inclusion of issues of sexual orientation, gender, race, class, and ethnicity in the curriculum of universities. She also helped found and worked for PABE (The Pennsylvania Association for Bilingual Education) and the International Classroom at the University of Pennsylvania to help Latina/o children be given proper educational rights in the state's school system. In 1995, she received a nomination to the Women's Hall of Fame in Seneca Falls, NY. She was also nominated for the Jefferson Outstanding Citizen Award in 1996. In 2004, the MLA honored Umpierre-Herrera's poetry and humanitarian work at their yearly convention. She received a Lifetime Achievement Award in 1990 from the Gay and Lesbian organizations of New Jersey. She has also received awards for her advocacy of AIDS patients, including the Bayard Rustin Award from AIDS Massachusetts and Woman of the Year at Western Kentucky University. She has also worked with the Red Cross, the Ford Foundation, and Amnesty International on human rights projects. She was named "Outstanding Woman of Maine" by the USA Congress in 2000. Umpierre-Herrera received her Ph.D. from Bryn Mawr College, PA. She also has done post doctoral work at the Woodrow Wilson International Center, The University of Kansas (sponsored by the Ford Foundation) and The New School for Social Research. She now resides in Florida.

6/30/93 en Long Island
Unos cuantos picotazos y nada más

connaître Paris et mourir...
{for Frida Kahlo}

Tu cuadro, Frida, me perturba.
Cientos de heridas en un sublime cuerpo
orificios de
una cuchillada
como la que me dio la vida al entregarme un dolor
 ajeno
en una ciudad distante.

Orly, aeropuerto internacional, y una soga
que separa dos vidas.
Yo queriendo contener mi corazón
sabiendo que una tragedia yace cercana
y ella perdida buscando a un fantasma de
su mente. Aeropuerto de Orly al final de
una vida

Aeropuerto de Orly y alguien se acerca
como una herida de la infancia lejana;
trato de contenerme,
de no pensar
en los ultrajes a mi corazón, a mi cuerpo,
a mi espíritu, a mi inteligencia perpetrados
por tantas manos en mi infancia.
Frida y sus picotazos
como la camiseta que agujereo
hoy, con esta pluma,
determinada a sacar de mi vida
la opresión de esas manos.
Nadie me entiende.

¿Dónde, me pregunto, se marcha una mujer cuando
desea no ser vista o penetrada ya por más manos,
miradas, intrusiones de dedos y sonidos?

¿Dónde, me pregunto, termina la vida cuando los
otros quieren determinarla por nosotros, dejarnos sin
vida propia, sin ilusiones, sin alegrías eternas?

¿Dónde, me pregunto, se termina la vida?

Una mañana y unos ojos húmedos que se juntan a
los míos para llorar por las múltiples heridas por las

que sangro.

Unos ojos, simplemente una mano que acepta
unirse a la mía en una ceremonia prevista.

1987 y soñé que un día me uniría a otro ser y
5 años más tarde surgen unos ojos, una mujer, una
voz, un grupo secreto en su dolor que viene a llenar
mi vida; una mujer comprende mi dolor, al fin.

Me preguntan ¿de qué ceremonia secreta hablo y qué
auguro? Me preguntan ¿a quién me refiero? Una
ceremonia secreta ya tuvo lugar una mañana en
octubre, entre lágrimas, un círculo surgió y hoy, sólo
te pido que regreses conmigo, ya para siempre, a
aquel día.

To a beautiful illusion / Bella Ilusión (danza)

{for Sylvia Plath}
{to T.S.}

I look at a picture of your grave full of weeds
and I want to dig in and press myself against your
 skeleton
and kiss each emptiness
and pretend that the grass growing is your sex.

I want to take you out walking the streets of
 L.A.,
Sylvia,
I want you to smell the odor of gasoline in the air,
a premonition of yours nobody understood: the
 pollution of our minds, of our bodies.
I want you to see people lined up for the psychiatrist,
the young suicides,
mothers who leave milk
for their children while they sleep;
mothers who had no choice,
mothers abandoned,
mothers empty
who weave another kind of stove gas
every day without knowing
that you had shown them a way.

I want you to walk arm in arm with me
and raise your voice from

your skeleton
and whisper in my ear softly, arousingly,
that you want to make love on the beach at Cape
 Cod, under the sun,
and in Provincetown
city of ultraviolet power
where once they tried
 to lock you up
where you return today
 laughing, at my side,
 to watch barges and
 whales.

It's February again, Sylvia.
For the time being, it's not freezing;
stamps have gone up
in price and they have a different image
but they can still be bought in the middle of the night
by nocturnal poets
to send their poems home
to the mother.
Come take my arm, walk with me.
I too am returning this February
from far away.
Let's make love on the shore
while the leaves break and penetrate,
waves sent to us
from far away by an island.

I see your abandoned grave
and I want to press myself
 and I kiss
 and pretend
 and the salt
 and the calcic
 fill my mouth
 and I know, Sylvia,
 that on this night
 of this February warmer than usual
 I love you.

Translated by Patsy Boyer and Luz María Umpierre

[When will we bring the remains of Sylvia Plath home?].

No Hatchet Job*

for Marge Piercy

They would like
to put the tick and flea collar
around her neck and
take her for walks on sunny afternoons
in order to say to the neighbors:
"We have domesticated this unruly woman."

They would like
to see her curled up on the corner,
fetal position, hungry, un-nursed
so that they can enter the scene,
rock-a-bye her to health
to advertised in the Woman News or Psychology Today:
"We have cured, we have saved this vulnerable woman."

They would like
to see her unclean,
10 days without showers,
in filth and foul urine,
frizzle hair and all,
her business in ruins,
her reputation in shambles,
her body reputedly raped on a billiard board
so that they can say in their minds:
"We have finally reduced this superior woman."

They would like
to have her OD on the carpet,
anorexic, bulimic and stiff on her bed
so that they can collect a percentage for burial
from the deadly mortician:
"We have found you this cadaverous woman."

They would like
to spread her ashes at the sea,
arrange pompas fúnebres,
dedicate a wing or a statue in her name
so that their consciences
can finally rest in saying:
"We have glorified this poet woman."

But headstrong she is unleashed,
intractable she nourished her mind,
defiantly she lives on in unity,

obstinately she refused the limelight, the pomp and the glory.
Eternally she breathes
on line after next,
unrestrained, unshielded
 willfully
 WRITER
 WOMAN

IMMANENCE

for Gail

I am crossing
the MAD river in Ohio,
looking for Julia
who is carrying me away
in this desire.

I am crossing
the river, MAD
afflicted by the rabies
for those who'll call me
sinful, insane and senseless,
a prostitute, a whore,
a lesbian, a dyke
because I'll fall,
I'll drop
I'll catapult
 my Self
into this frantic
excitement for your
 SEX
my Margarita,
my yellow margarita,
my glorious daisy.

I am traversing
this river MAD,
crossing myself
against the evil eye,
hectic, in movement,
my narrow body
covered with pictures

of women I adore or I desire,
armies of Amazons
that I invoke
in this transubstantiation
or arousal
that will bring my Julia forth.
Julia
who'll lose her mind
over your glorious vulva,
my Margarita,
my yellow margarita,
my luminous daisy.

I am traversing
this body full of water,
 MAD,
cursing all Hopkinses,
incestuous writers,
who fucked your head and mine
in spring and summer
with images of death and sin
when all we wanted
was to touch the yellow leaves,
the fall under our skirts.

I am transferring my Self,
changing my clothes,
spitting three times,
clicking my heels,
repeating all enchantments:
Come, Julia, come,
come unrestrained,
wild woman,
hilarious Julia,
come Julia come forth
to march the streets
at winter time,
to walk my body,
to proclaim
over the radio waves
the coming of the lustful
kingdom,
in sexual lubrication
and arousal
over my Margarita,
my yellow margarita,
my brilliant daisy.

I am crossing

the MAD river in Ohio,
leaving possessions and positions,
shedding my clothes,
forgetting, oh, my name,
putting life on the line,
to bring my Julia forth,
lesbian woman,
who'll masturbate and rule
over my body, Earth,
parting the waters
of my clitoral Queendom,
woman in lust,
who'll lose her mind
and gain her Self
in want,
in wish,
in pure desire and lust
for the rosie colored lips
covered with hair
of Margarita,
my yellow margarita.

 (pause)

I am Julia,
I have crossed the river
 MAD,
I have come forth,
new lady lazarus
to unfold my margarita,
my carnal daisy
that buds between
my spread out legs.

I touch my petals:
"I love me,
I love me not,
I love me,
I love me not,
I love me!"

TRANSCENDENCE

for Ethel Sager

He regresado a la ciudad
a soltar a Julia
en mis adentros,
a dormir en la acera este diciembre,
a congelarme los glóbulos de sangre
que salen de mi sexo,
a golpear mis pies
en las parrilas del subway,
a despeinarme, a desgreñarme
el pelo de acá arriba y
el de allá abajo.

He vuelto a la ciudad,
a llenarme los zapatos de espuma,
a rozar mis tetas contra
contra los cuerpos de las gentes en las calles,
a que me toquen las nalgas, a rezar con aquel hombre
perturbado que me compra una taza de té,
a ver el pueblo hablar de mí en las calles,
a observar, a imaginar, que el mundo se viste
de azul eléctrico o rosa chocante.

He entrado en la ciudad
a abandonar la ropa,
a vestirme de primavera en el invierno,
a declararme prisionera política, a no bañarme,
a olvidar dónde he dejado mi coche,
a ser conducida por la policía.

Algunos querrían ponerme
al cuello una cadena y pasearme
como a una perra callejera.
Otros querrían llamarme
una mujer loca.

Todo por Margarita,
siempre por Margarita, para poder besar,
uno a uno,
los labios de su amarillo sexo.

RHINA VALENTÍN

Rhina Valentín es productora, directora, performera, comediante, bailarina, escritora y educadora. El periódico *Village Voice* la llamó "Diva" y el periódico *Siempre*, "La Diva del Barrio". Junto a su compañero, Efraín Nazario, ha producido los performances: *Diva Attack!* (2001), *Mirrors* (2002; co-escrita con Sandra Rodríguez) y *Metrogroove* (2003). Creó y produjo *OHMen* (co-coreografiada con Awilda Sterling-Duprey y acompañada por la banda Palo Monte), en el Baad! Ass Women Festival (2004); el Hostos Center for the Arts and Culture (2005); y el programa local de cable Bronxlive (2005). Valentín creó *La Reina's Barriolesque,* que se convirtió en una residencia de artista en el Nuyorican Poet's Café con presentaciones mensuales por un año. Es una de las fundadoras, productoras y directoras de The Nuyorican Universal Theatre Society (NUTS). Dirigió y actuó en la obra *Our Times,* que se presentó en The Hostos Repertory Theatre (2007). Sus obras escritas se han presentado en *Latina's Don't PMS* en el Café Remy's (2005), The Apollo Theater (2006) y en el Festival de Poetas Latinas del Teatro Rodante Puertorriqueño (2007). Desempeñó el rol de "La Reina" en el programa de cable *Betty La Flaca* y desde el 2006 ha sido la anfitriona del programa de diálogos *Open* del canal 67 del Bronxnet. Es anfitriona de galas y fue co-anfitriona con Bob Lee del 10th Annual Beta Awards. Desde el 2005 es directora, productora y maestra de teatro de niños de quinto grado en la Escuela Intermedia Clemente 166, a través de The Childrens Aid Society. Obtuvo el Premio BRIO por "Mejor Actriz" (2007), el Premio UAI en Performance Arts (2006) y el Premio HOLA por el "Outstanding Female Performer in a Featured Role" (2005).

Rhina Valentín is a jack-of-all-trades in the arts and entertainment industry. She is a producer, director, performance artist, comedic actress, dancer, writer, and arts educator. *The Village Voice* newspaper called her "Diva" in 2000 and *Siempre* newspaper granted her the title "La Diva del Barrio." Together with her creative partner Efraín Nazario, she has created and produced the performances: *Diva Attack!* (2001), *Mirrors* (2002; co-written with Sandra Rodríguez) and *Metrogroove* (2003). She also created and produced *OHMen*, co-choreographed with Awilda Sterling-Duprey and accompanied by the band Palo Monte, at the Baad! Ass Women Festival (2004); at The Hostos Center for the Arts and Culture (2005); and in the local cable show *Bronxlive* (2005). Valentín also created *La Reina's Barriolesque* in 2004, which developed into a residency at the Nuyorican Poet's Café with monthly performances for a year. She is one of the founders, producers and directors of The Nuyorican Universal Theatre Society (NUTS) and directed and acted in the play *Our Times* (2007), featured at The Hostos Repertory Theatre. She also performed as "La Reina" in HBO's *Betty La Flaca*. Her written works have been featured in *Latina's Don't PMS* at the Café Remy's (2005) and the world famous Apollo Theater (2006); and at The Latina Poets Festival of the The Puerto Rican Traveling Theatre (2007). Since 2006, she is the host of the talkshow *Open* every Friday on Bronxnet Channel 67. She has hosted gala benefits and co-hosted with Bob Lee the 10th Annual Beta Awards. Since 2005, Valentín has been a Theatre Arts Director/Producer/Instructor for fifth graders at the Clemente Intermediate School 166 for the Childrens Aid Society. She received a BRIO Award for "Best Actress" (2007), a UAI in Performance Arts (2006) and a HOLA Award for "Outstanding Female Performer in a Featured Role" (2005).

ANALYTICAL BEHAVIOR

Analytical Behavior
Perhaps Anger or Fantasy
Adventuring into the extremities
Of all the senses in our bodies

Analytical Behavior
Creating singing sentences
Pronouncing every syllable
With pride of annunciation
A-E-I-O-U

Analytical Behavior
Bleachers in front of the stoop
Colorful people
Who speak with their hands
Every motion so Dramática

Analytical Behavior
El ataque de diva
De la gigigi
Came from long songs
Ayy…
So soulful
You can cut It with a stare
Verses that smash doors open
With Bombastic Blues
Eccentricness grows
Forever more in one's veins
Ayy…Allinamá

Analytical Behavior
Con mi culito parado
Nested on a bed
Of sexuality
Accented with
An exhibitionist smile

The love of the mind
The love of the thought
Behind the creation of hiding
To take up different faces
In a stage called Life
Different situations, different masks
To be aware of the change
Adapt
To love the emotion
And pain

To release
To tap
But more than anything
To have the power
To feel like a God-dess
Because of the energy
And the force
From the magic
Of the stage
As you have
A Diva Attack… tack…tack

In The Presence Of

In the presence of;
Women

Determined by circumstances,
Relations in which I'm dealing;

Around my mother,
I am a child.
A new Branch
Of her tree.
Thinking of playgrounds,
Double Dutch,
Jacks, Jumping Rope,
Barbie Dolls!!!

meow

With time,
I became, the woman
She had in mind.
Still feeling like
A little Girl
Waiting to play with Ken!

RRrrrr!

In The Presence of;
Other Women,
I, feel like a Cat
Lurking, around different corners.
Trying To find what I,
May think is family.

Meow!..., Meow!....

I Exude Love, Confidence, Compassion,
But, I also have the tendency
To express male energy
Spiritually.
He came with me; Yin and Yan.
Like a woman in the presence of a Man.

So in exercising.
I give strength to,
The ladies
Under my wing
To them,
I am a woman of power.

When instructing class,
I am a leader.
When Entertaining on stage
I am a public servant.
When negotiating,
I represent, what I see versus what they see.

I am a Bitch!
If they're throwing daggers at me,

Meow!

I am a loser to some;
Not having a husband or children.
But, I am a warrior!
Because I fight for my right to be a woman!

MEOOOWW!

In the Presence of;
Men, in my family,
I'm this 21st century model
Of what not to marry!
A Woman who wears pants?
Oh No......
What happened to the mold?

In the presence of
Men, in the street.

I'm a Hottie!

I'm so pretty!
They're all so educated,
The only way for them to greet me is,
By saying Mira Mami,
COÑO!

In the Presence of;
Men at Work,

Todos son Putos!
They think rehearsal means other things.
Oh! Its Ok… I'm a professional
Me dicen.

Professional what?
Mindless piece of meat, thinks,
My sole purpose as a woman,
Is to
Satisfy his every need

An affair?
An affair of the Body?
Or an affair of the Mind?
You did say you were a professional?
A professional what?

MAMAU!!!

In the presence of;
Men I lust for,

RRRRRR…..

Boy Oh Boy,
Why don't you notice me?
How could you not see?
You're the one for me?
Tonight at least!
I wanna,
Feel your big hands,
Ravishing my body,
Gently!

First run your hands through my hair.
Caress my face.
Embrace my body,
In such a way,
I become immersed,

inside of thee.

Sit me on top of your,
Hard rock
Let me stroke,
My Genie,
As I make a wish.
For Love!

Purr..Purr..Purr

In the presence of;
Men I disgust,

How dare you practice superiority! (Claws)
Don't you know,
You came from me! (Other Claw)
My type that is? (Both)

If they're uneducated,
That's one thing.
If they are educated,
They think they can handle
Me?
In a way for ME,
To conform to Them?

(Double Claws)

OH NO!
You are highly mistaken.
You got the Wrong Lady!

Hiss! (Clawing)

In the presence of
Myself,

I am the Goddess!
La Reina
The Leading Lady!
Anacoana!!!
That tends to wander
A bit

A Free Spirit,
Floats on Earth,
Influencing History
A Shining Star,

Overlooking this Planet,
Contributing Energy,
To the Universe.

A River that
Has no end.
Sweet Water cleanses
The Soul!

Perfect in my imperfection,
In the presence of Me
I am Pure Poetry.
Meow! Meow!

CONFORMITY

Who said
It's OK
To change
For someone

Domestication
Of the mind
Set in a way
That does not
Allow things to
manifest positively
drowning in poison
as one is constantly
being reminded
of what's wrong

Nowhere to run
Or hide
So you think?
In all actuality
Denying your own
Individuality

Words taken so lightly.
Domestication

Epistle to Charm Vida

Nam myoho renge kyo
Nam myoho renge kyo
Nam myoho renge kyo

Charm Vida
Named before conceived
The feeling of weight
In me, on me, around me
I live to say your name

As I rush to the place of healing;
You took over my life
As I watch you,
Floating, flipping, dancing, in nothing
I want to protect you.

Through the monitor;
A scene of happiness
In your universe of creation,
I want to teach you

Without a care to decipher
Only the possibility of
Being born, into this cipher
I want to watch you grow

Elements of emotions;
Fear versus excitement
Scared of the unknown
Excited about who I've become
Extraordinary transformation and love in being.
I want to be your Mommy.

Fortune child;
A seed moving
When the moon dances with the sun
And stars are born,
I love you, My Universe
It is a Charmed Life

Nam myoho renge kyo
Nam myoho renge kyo
Nam myoho renge kyo

UNTITLED

The World is a big place
Don't hate
Embrace
The Unity of Diversity
Different cultures
Different languages
Endless information
To learn
Go through books
To educate
But it is your state
Of mind
Determining
How far or how low
You go
Life has a lot of fork roads
Three is the magic number
Keeper of the door
Opens or shuts
Fill the well with knowledge
People, Places and Things
Influence who you become
From young to old
We are all one
With the same purpose
Contributing
Making a better place
Of Existence
Flowing with Love!

Carmen Valle

Carmen Valle es poeta, novelista y educadora, nacida en Puerto Rico. Su obra poética comprende: *Un poco de lo no dicho* (1980), *Glenn Miller y varias vidas después* (1983), *De todo da la noche al que la tienta* (1987), *Preguntas* (1989), *Desde Marruecos te escribo* (ed. bilingüe, 1993) y *Entre la vigilia y el sueño de las fieras* (ed. bilingüe, 1996), *Esta casa flotante y abierta* (2004), *Haiku de Nueva York* (2008). Como narradora, ha publicado *Diarios robados* (1982) y *Tu versión de las cosas* (2007). Sus poemas se han incluído en las antologías *Herejes y mitificadores, Poetas en Nueva York, Al fin del siglo, Miradas de Nueva York, Anthology of Contemporary Latin American Literature, Inventing a Word: An Anthology of Twentieth-Century Puerto Rican Poetry, Reclaiming Medusa: Short Stories by Contemporary Puerto Rican Women Writers, Fe de Errantes* y *Cauteloso engaño del sentido.* Ha publicado poemas en las revistas *El signo del gorrión, Mairena, Tercer Milenio, Scriptura, Realidad Aparte, Balcón, Tinta Seca, Galerna, Alhucema, The World, The Portable Lower East Side, Third Woman, Review: Latin American Literature and Arts* y *The Literary Review* y en las revistas digitales *alex-loot, Letras salvajes, Respiro, Baquiana, Islanegra.zoomblog* y *sandrapayne.com* Ha sido coeditora de las revistas *Ventana,* de *Bilingual Review* (número especial *Hispanic Women Writers in the USA*) y de *Poesía/Venezuela* (número especial *Poesía puertorriqueña en Nueva York y en Puerto Rico*). Ha dirigido talleres de poesía en el St. Mark's Poetry Project de Nueva York. Obtuvo el Premio de Poesía/2007 del Instituto de Puerto Rico en Nueva York y el Tercer Premio de Narrativa del PEN Club de Puerto Rico en el 2009. Es doctora en Literatura Latinoamericana por la Universidad de la Ciudad de Nueva York (CUNY).

Carmen Valle is a poet, novelist and educator, born in Puerto Rico. Her books of poetry include: *Un poco de lo no dicho* (1980), *Glenn Miller y varias vidas después* (1983), *De todo da la noche al que la tienta* (1987), *Preguntas* (1989), *Desde Marruecos te escribo* (bilingual edition, 1993) y *Entre la vigilia y el sueño de las fieras* (bilingual edition, 1996), *Esta casa flotante y abierta* (2004), *Haiku de Nueva York* (2008). She has published the novels *Diarios robados* (Buenos Aires, 1982) and *Tu versión de las cosas* (Buenos Aires, 2007). Her poetry has been anthologized in: *Herejes y mitificadores, Poetas en Nueva York, Al fin del siglo, Miradas de Nueva York, Anthology of Contemporary Latin American Literature, Inventing a Word: An Anthology of Twentieth-Century Puerto Rican Poetry, Reclaiming Medusa: Short Stories by Contemporary Puerto Rican Women Writers, Fe de Errantes* y *Cauteloso engaño del sentido*. Her poems has also been published in the literary magazines *El signo del gorrión, Mairena, Tercer Milenio, Scriptura, Realidad Aparte, Tinta Seca, Galerna, Alhucema, The World, The Portable Lower East Side, Third Woman, Review: Latin American Literature and Arts, The Literary Review* and the digital journals: *alex-loot, Letras salvajes, Respiro, Baquiana, Islanegra.zoomblog* and *sandrapayne.com* She has been coeditor of the literary magazines *Ventana, Bilingual Review* (special issue *Hispanic Women Writers in the USA*) and *Poesía/Venezuela* (special issue *Poesía puertorriqueña en Nueva York y en Puerto Rico*). She received the Poetry Award of the Institute of Puerto Rico in New York in 2007 and the Third Award in Fiction of the PEN Club of Puerto Rico in 2009. She has a Ph.D. in Literature and presently teaches at the City University of New York (CUNY).

CAMINO

Camino, como quien dice volar,
como quien mira al azul y está en medio de él,
como quien sale de una jaula
que siempre estuvo abierta.
Atrás queda prendido en velas blancas
y adelante contesta todas las preguntas.
Una flecha multiplicada es la marcha con la senda,
una rosa de los vientos en plural decidida.

A dónde voy conmigo y qué busco:
lo que se encuentre andando
y lo que a mí me encuentre.
Cómo decidir con qué quedarme
lo que no se me pierda es lo que es mío.

(De "Trashumante", inédito).

UNOBSTRUCTED

Without eyes.
Without the eye's mirage.
Without the eye's torture.
Without pleasure, without that gluttony.

To lower the eyelids,
curtain fantasies grow behind,
mask that conceals confession,
blindfold that hides the look of defeat.

To close them. Not to see.
Not to see. To see with the body.

The body. Organ of sight. Blind oracle.
Censor of light, beginning at a remove,
minister of the unrecognized,
prompter of instinct.
Vigilant one.

Translated by Chris Brandt.

Allá o lo posible

Nómada sitiada,
nómada presa,
nómada contenida en ciudad nómada.
Nómada del paisaje humano
nómada de cuerpos
y de un corazón detrás de otro.
Nómada dentro del camino
cuando el retorno no cabe
porque no sólo el cuerpo es el que ya se ha mudado.
Nómada como el que busca horizonte
como el que no se detiene
pero algo espera
como el que no puede
pero quiere y se atreve y falla.
Nómada como la costumbre de nunca tocar el cielo
ni el fin del camino
pero quiere siempre
y se atreve siempre
y fallar no se contempla,
no se puede contemplar.

(De "Trashumante", inédito).

A MAP OF LILA

Lila took her leave
left behind not even a button,
nor a ribbon, no note,
no garden, no planted fields.
Her day grew short;
she left her hair to a beloved woman
and she took out her eyes for a man.
To her children she gave life:
to her dead, many of her thoughts.
For herself she kept her wildest memories.

If you are going Lila, take me with you;
give me your necklace so I can tell its beads;
give me the peacefulness of your body so I can put it on;
give me your heart so many have held, whole.

True to you
I give you nothing
you have not already taken.

MAPA DE LOS ADIOSES 2

Qué puedo querer de ti
que si te di algo te lo quité.
Me diste una sombra y un deseo
más que la inabordable angustia.
Te tomaste el tiempo;
te lo bebiste,
ni masticaste, ni saboreaste.
Tu congénita maquinaria aritmética.

Das vueltas y vueltas con baterías
agotadas en el hueco de tu pecho,
obscuro, necesitado túnel
por donde pasan trenes abarrotados de gente
que no dejaste bajar en la estación que escogían.
Tu congénita maquinaria aritmética.

Arrancas precauciones del futuro,
clavas una banderilla de amor
con mucho amor pero banderilla
vítores, salvas, estocadas,
se te quedó rendida la frente
en un coágulo de dicha.
Tu congénita maquinaria aritmética.

GLORIA VANDO

Gloria Vando es poeta, editora y promotora cultural, nacida en Nueva York. Su poemario, *Shadows and Supposes* (2002), ganó el Poetry Society of America's Alice Fay Di Castagnola Award, del Latino Literary Hall of Fame. Su primer poemario, *Promesas: Geography of the Impossible* (1993), ganó el Thorpe Menn Book Award. Otros premios incluyen el River Styx International Poetry Prize, dos premios Billee Murray Denny Poetry Prizes, el Barbara Deming Memorial Fund Grant y el Kansas Arts Commission Poetry Fellowship. Su obra se ha publicado en revistas, antologías, libros de texto, grabaciones (incluyendo el disco compacto *Poetry on Record: 98 Poets Read Their Work 1888-2006*, nominado para el premio Grammy en el 2006) y ha sido adaptada para teatro y presentada off-Broadway y en el Lincoln Center. Es co-editora de *Chance of a Ghost: An Anthology of Contemporary Ghost Poems* (con Philip Miller) y *Spud Songs: An Anthology of Potato Poems to Benefit Hunger Relief* (con Robert Stewart). Es además, la editora de Helicon Nine Editions, una editorial independiente y sin fines de lucro que fundó en 1977 y que publicó por diez años la revista literaria *Helicon Nine: The Journal of Women's Arts & Letters*. Esta revista, que auspició premios de poesía y narrativa por quince años, recibió el Kansas Governors Arts Award. Vando recibió el Coordinating Council of Literary Magazines Editors Grant por su labor en *Helicon Nine*. Es además, editora de *The North American Review* y miembro de la Junta de Recomendaciones del *BkMk Press* (University of Missouri-Kansas City). Vando y su esposo fundaron en 1992 The Writers Place, un centro literario en Kansas City. Actualmente viven en Los Angeles.

Gloria Vando is a poet, editor and cultural activist, born in New York City. Her poetry collection, *Shadows and Supposes* (2002), won the Poetry Society of America's Alice Fay Di Castagnola Award and the 2003 Latino Poetry Book Award from the Latino Literary Hall of Fame. Her first book of poems, *Promesas: Geography of the Impossible* (1993) won the Thorpe Menn Book Award. Other awards include a River Styx International Poetry Prize, two Billee Murray Denny Poetry Prizes, a Barbara Deming Memorial Fund grant and a Kansas Arts Commission Poetry Fellowship. Her work has appeared in many magazines, anthologies, CDs (including the 2006 Grammy-nominated *Poetry on Record: 98 Poets Read Their Work* 1888-2006), and textbooks, and has been adapted for the stage and presented in productions off-Broadway and at Lincoln Center. She is coeditor of *Chance of a Ghost: An Anthology of Contemporary Ghost Poems* (with Philip Miller) and *Spud Songs: An Anthology of Potato Poems to Benefit Hunger Relief* (with Robert Stewart); and is the editor/publisher of Helicon Nine Editions, an independent non-profit literary press she founded in 1977. For ten years H9 published a national literary magazine, *Helicon Nine: The Journal of Women's Arts & Letters*, which received the Kansas Governors Arts Award and sponsored poetry and fiction prizes for fifteen years. She received the Coordinating Council of Literary Magazines Editors Grant for her work on *Helicon Nine*. Vando is a contributing editor of *The North American Review*, and is on the advisory board of *BkMk Press* (University of Missouri-Kansas City). In 1992 she and her husband, Bill Hickok, co-founded The Writers Place, a literary center in Kansas City. Vando and her husband now live in Los Angeles.

AT MY FATHER'S FUNERAL

My father, a free-thinker, who
insisted I be reared like him,
lies in his open casket,
the blood of Jesus dripping
on his clean white shirt,
El Grito de Lares pinned
to one lapel, La Bandera
to the other, and instead of
boleros or plenas permeating
the heavy incense of the chapel
a rosario of Padre Nuestros
and Ave Marías churns the air.

I study his hands, try to stroke away
the spots that will bury themselves
into my skin like spiders, brown
recluses, that will never let go.
Be careful, his doctor warns me,
your father died of skin cancer—
but at 93, I'd say he's entitled to go
as he pleases, and this ceremony
that accompanies his departure is
not my doing. I have no rights here.

My half sister removes the pins
from my father's lapels and presses
them into my hand like an omen.
You're the firstborn, she says.
We decided you should have them.
I pin them on my blouse.

At the cemetery, an older woman with
white hair stands on the sidelines
flanked by men in gray suits.
Lolita Lebrón, my sister whispers—

and it is 1954. I am in Holland
studying literature and art
when the news comes over the wires
and students at school start
asking me whether I'm ashamed of being
Puerto Rican and I in turn ask them
whether they feel shame for Hiroshima
or Dresden or Dachau—because I do—
and they can't understand that
it all has to do with me, with them—

and here's Lolita Lebrón, patriot
or terrorist, take your pick—
though she never fired a shot
(I didn't come to kill, I came to die!
she proclaimed, ready to give
her life for *el gran ideal*),
her sole aim to publicize the plight
of a besieged island. They stormed
the Spectator's Gallery—she and
three men—waving German Lugers
and their outlawed flag and
shouting Freedom for Puerto Rico!—
when one of the men went berserk
and began shooting into the crowded
floor of the House—congressmen
diving for cover, under desks,
behind chairs, five hit, bleeding,
visitors screaming for help.

It was a suicide mission: born
in Lares, she felt it was her destiny—
but how could she have known
the sacrifice would be her children—
her son murdered during the trial,
her daughter killed in an accident,
or so they said, and she in and
out of solitary confinement
for thirty-five years, unable to eat
or sleep, unable to breathe,
her hair turning white overnight,
like her heart, a dead weight.

The roster at the grave site reads
like a who's who of better days.
The leaders old and infirm come
on crutches and canes—but they come.
My other sister tapes their tributes.

They recite my father's poems,
sing songs I didn't know he wrote.
When they sing *La Borinqueña,*
the one song I do know, my words
are all wrong—this is a new version
and my anthem, my sweet anthem,
is no longer a danza, but a marching song.

Your father was a great man,
they all tell me, a great man.

I look cautiously around me
and spot them—one, two, maybe three
dark-suited men in the distance,
blending into the trees, documenting
our sorrow with hidden cameras
and tape recorders. No one
pays attention to them—the F.B.I.
is as much a part of their lives
as the shadows their bodies cast
across my father's grave. I want to cry
out that I am innocent, that I
have nothing to do with violence—
I'm there because we share a name,
a face—but when I look at my sisters

I see my fate. The next morning
my half brother waits at the airport.
He sees Papi's slogans like
stigmata bleeding on my lapels.
Ten cuidado, he warns me, they might
not let you out. We embrace
and I see our shadows on the sidewalk
merge—when I kiss him it is as if
I were kissing myself goodbye.

MY UNCLE, AGE 93, IS ARRESTED AND DETAINED SIX HOURS FOR BLOCKING THE ENTRANCE TO THE U.S. NAVAL BASE IN VIEQUES, PUERTO RICO, AFTER A LIVE BOMB KILLS AND INJURES CIVILIANS

— for Carlos Vélez-Rieckehoff

"Born that way," his mother, my grandmother, would say,
in the same tone she would use to explain genius
or Siamese twins. At sixteen Carlos took off
with the Stars and Stripes from the Capitol and hid
in the hills, where the guardia civil never found him—
who would betray him, their hero, doing what they
lacked the courage to do? In the fifties he flew
the outlawed flag of his country on the roof of
his farmhouse where all the villagers could see it
and revel in the illusion that they were free.
The judge offered him leniency if he'd recant.
¡Soy nacionalista hasta los cojones!—
they claim he cried (he claims they lied). He spent the next
three years in "La Princesa," a euphemism
for the San Juan federal penitentiary,
much of the time in solitary confinement.
Yesterday Don Carlos, tall and elegant in
his white suit, the sea breezes ruffling his white hair,
trekked the miles across Vieques on his walker, up
the Sisyphean hill, for his final act of
defiance. "Good," I tell my mother, "he'll assume
he's still a threat to colonialism. Now he
can die with pride." It's comforting to think one has
power in one's old age. Four years ago, during
a hurricane that devastated Borinquen,
my husband asked his friend, a retired admiral,
to check on Carlos, see if he had survived.
When the Navy knocked at his door, Carlos was sure
they had come to arrest him, though he'd done nothing.
"Can't blame him," my mother says. "Why should he trust them?"
Today he stands with Robert Kennedy, Jr.,
and other dignitaries from the States, and waits
for the gavel to sentence him this one last time.

guardia civil: Civil Guard
La Princesa: The Princess
Soy nacionalista hasta los cojones: I'm a Nationalist down to my balls
Borinquen: Indian name for Puerto Rico, the oldest colony in the world

GUERNICA

—for Michael Montel, October, 1973

Could he have imagined
when he wept on canvas
showing the open wounds
of his native soil and flesh
that someday someone
in a country out of range
would transcribe his horror
into stitchery? Yet there it is,

highlighted in the window
of this fancy East Side store:
a massacre in miniature,
stencilled for dowagers
to stitch in shades of gray
while viewing newer wars
in living color.

Further down Fifth Avenue
Father Berrigan and a few
of his disciples bear witness
on the steps of St. Pat's Cathedral,
leaning wearily across
dead centuries as they
spread the blood-stained word
 thou shalt not kill
in (this time) Cambodia.

Uptown, in the *barrio,*
a rat-gnawed baby screams.

And somewhere in between
as though to round off
this American joke,
a tacit people, unseeing, unseen,
transform Guernica
into needlepoint.

KNIFE

She was old. She lived alone in a small house
two blocks away. When they found her, days after,
she had been stabbed seventeen times—as if
a host of assassins had struck an empress down.
She might have even looked up briefly
before the final cut, spurting blood and
an imperious last line or two. Perhaps not.
Perhaps the first wound had done the trick—
the rest sport for the mad or wicked. A handyman
lived nearby. He worked odd jobs while leading
a secret life with his neighbor's Anglo wife,
who would sneak him in when her husband
and her son were out. No one questioned
Sánchez about the old lady. He traveled alone.
This was a gang job. One day while walking past
a vacant lot close by the boy spots a shiny
object winking at him through a layer of rust
like a cheap sequin--summoning him to stoop
down, swoop it up, later to brandish it
with pride before his mother's sucked
astonishment. *Give it here*, she says.
The name on the crudely carved handle is clear,
letters printed in black Magic Marker—but
are they clearly the handyman's? Sánchez
is a common name. She knows he doesn't stand
a chance if he stands trial. Knows they'll find
guilt hidden like stacks of money unexplained
beneath the floorboards of his mind. She knows
Texas. Knows how stuff gets planted when you're
a Mexican without an alibi and they need
a solution. And most of all she knows, knows
as she digs the tiny grave for the homemade knife,
knows as she pats the soil over it and sows
the seeds of justice, knows as she pours
a 50-50 mixture of water and fish emulsion
over it to make the seeds grow, knows, damn it,
she just knows that he is guilty as hell.

HE 2-104: A TRUE PLANETARY NEBULA IN THE MAKING*

On the universal clock, Sagan tells us,
we are only moments old. And this
new crab-like discovery in Centaurus,
though older by far, is but
an adolescent going through a vital
if brief stage in the evolution
of interacting stars. I see it
starting its sidereal trek
through midlife, glowing complex—
"a pulsating red giant" with a "small
hot companion" in tow—and think
of you and me that night in August
speeding across Texas in your red
Mustang convertible, enveloped in dust
and fumes, aiming for a motel bed,
settling instead for the backseat of the car,
arms and legs flailing an all directions,
but mostly towards heaven—and now
this cool red dude winking at me
through the centuries as if to say
I know, I know, sidling in closer
to his sidekick, shedding his garments,
shaking off dust, encircling
her small girth with a high-density
lasso of himself, high velocity
sparks shooting from her ringed
body like crazy legs and arms until
at last, he's got his hot companion
in a classic hold and slowly,
in ecstasy, they take wing and
blaze as one across the Southern skies—

no longer crab but butterfly.

*Won the Billie Murray Denny Poetry Prize

LOURDES VÁZQUEZ

Lourdes Vázquez es poeta, cuentista y ensayista. Entre sus libros se encuentran *Samandar: libro de viajes/ Book of Travels* (2007), *Salmos del cuerpo ardiente: Libro de artista con Consuelo Gotay* (2007), *Sin ti no soy yo* (2005), *Bestiary: Selected Poems 1986-1997* (2004; finalista del premio para Mejor Libro del Año/ revista de crítica literaria *Foreword*), *La estatuilla* (2004), *Salmos del cuerpo ardiente* (México, 2004), *May the Transvestites of my island who tap their heels...* (2004), *Obituario* (2004), *Desnudo con Huesos/Nude with Bones* (2003), *Park Slope* (2003), *Hablar sobre Julia* (2002), *Historias del Pulgarcito* (1999), *De identidades: bibliografía y filmografía de María Luisa Bemberg* (1999), *La rosa mecánica* (1991), *Las Hembras* (1987) y *Poemas* (1988). Fue ganadora del Premio Internacional de Literatura Juan Rulfo del año 2002 en Francia. Su obra ha sido traducida al inglés, sueco, italiano, portugués, rumano, gallego y mixteca. Ha publicado en revistas como *Tsé, Tsé* (Argentina); *Revista Actual* (Venezuela); *Kaledoiscope* (Canadá); *Site* (Suecia); *El Universal* (Colombia); *Lumina Lina* (NY-Rumania); *Xinesquema* (República Dominicana); *Jornal do Poesía* (Brasil); *Revista Casa Las Américas* (Cuba); *Periplo* y *FEM* (México); y *Barcarola, Babab, Salinas* (España); en Estados Unidos en *Indiana Review, The Gathering of the Tribes, the Poetry Project, Letras femeninas*; en Puerto Rico *Autana, Claridad, Cupey*. Su obra se incluye en varias antologías, entre ellas: *Writing Toward Hope: The Literature of Human Rights in Latin America* (2007); *Memoria del VII Encuentro Internacional de Poetas en Ciudad Juárez* (2004). Ha colaborado con artistas y co-producido los videos: *Meche en doble luna llena* (NY, 2006) y *Gato/Cat* (NY y Dinamarca, 2006). Vivió en Nueva York y vive ahora en Florida.

Lourdes Vázquez is a writer of poetry, essays and short stories. She has published the books *Samandar: libro de viajes/Book of Travels* (2007), *Salmos del cuerpo ardiente: Libro de artista* with Consuelo Gotay (2007), *Sin ti no soy yo* (2005), *Bestiary: Selected Poems 1986-1997* (2004; finalist, The Best Book of the Year Award/ literary criticism magazine *Foreword*), *La estatuilla* (2004), *Salmos del cuerpo ardiente* (México, 2004), *May the Transvestites of my island who tap their heels...* (2004), *Obituario* (2004), *Desnudo con Huesos/Nude with Bones* (2003), *Park Slope* (2003), *Hablar sobre Julia* (2002), *Historias del Pulgarcito* (1999), *De identidades: bibliografía y filmografía de María Luisa Bemberg* (1999), *La rosa mecánica* (1991), *Las Hembras* (1987) and *Poemas* (1988). Vázquez was the winner of the Juan Rulfo Internacional Prize of Literature of 2002 in France. Her work has been translated into English, Swedish, Italian, Portuguese, Romanian, Galician and Mixteca. She has published in magazines such as: *Tsé, Tsé* (Argentina), *Revista Actual* (Venezuela); *Kaledoiscope* (Canadá); *Site* (Suecia); *El Universal* (Colombia); *Lumina Lina* (NY-Romania); *Xinesquema* (República Dominicana); *Jornal do Poesía* (Brasil); *Revista Casa Las Américas* (Cuba); *Periplo* and *FEM* (México); *Barcarola, Babab* and *Salinas* (España); in the USA in *Indiana Review, The Gathering of the Tribes, the Poetry Project, Bilingual Review, Letras femeninas*; in Puerto Rico *Autana, Claridad, Cupey*. Her work has been anthologized in *Writing Toward Hope: The Literature of Human Rights in Latin America* (2007); *Memoria del VII Encuentro Internacional de Poetas en Ciudad Juárez* (2004). Vázquez has also done collaborative work with various artists and produced the artistic videos *Meche en doble luna llena* (NY, 2006) and *Gato/ Cat* (NY and Denmark, 2006). She lived in New York and now lives in Florida.

THALYS

Captivity.
I have taken your
white horse...
—Jack Agüeros

I must say I have dreamed
of a poet with a clear mind and firm hands.
I saw myself caressed in the way
a Chinese mandarin touches the body of his concubine.
I felt I was a cathedral full of demons,
a heart beating on pure stone.

I have met him as a passenger
in the early-morning train.
He has interrupted my reading of the daily paper.
I have lifted my eyes at the instant when
a whisper of an Excuse me
surprised me like a tourist guide bereft of direction.
But I had already invented him in a clear wardrobe.
I was secretly waiting for him so that he could decipher my signs,
without my feeling shot between the legs
and wishing his presence would germinate
in any womb,
so that in some airport, train station or small hotel

I'd bump into his magnificent presence.

Translation by Enriqueta Carrington.

MEDITERRANEAN

*It's summer in Athens, in a small hotel
without air conditioning.*

This morning at day-break a whale appeared on the coast. He arrived with good intentions and roosted in front of the cupolas and the small caged birds. He chose the amphitheater, the mosques, and the Greek and Ottoman sculptures. He selected the palaces of the crusaders, the white edifices, the spectacle of the cliffs, and the complexity of imperial ruins.

He took my red hair and the pentagram that formulates our affection, that intensity which moves up and down the sea dividing continents, with Bach as background music.

I've climbed onto my friend's back. I've hugged one of his eyes. I've kissed his face so that not the slightest doubt remains of my simple and solid devotion.

It's that when I have a mammal near me, I feel you coming close, rhythmic, noiseless, untrammeled. In that epistle of disproportionate love, you absolutely plunge into my head, amidst the animal's jets of water and the beat of that great Mediterranean.

Translation by Enriqueta Carrington.

ESCENAS CON GEISHA EN SALÓN DE BAILE

Her beauty and accomplishments only invited jealousy,
Her death was hastened by baseless slander.
—Tao Sueh-Chin, siglo 18

—¿Geishas?

—Es una manera elegante de describir la situación.

Jim B. se enamoró locamente de una de ellas. Un amor no correspondido. Cuenta que por unos cuantos meses se metió en una depresión de manicomio. Se dedicó a beber y a sentirse como una víctima. Pasó días tirado en su cama escuchando la radio, porque no tenía ánimos de ver ni la tv, dejándose envolver en la voz melodiosa del locutor y en el silencio pesado de la noche.

—Esto es chisme, puro cotilleo.

Matineé de sábados y domingos en aquel o cualquier espacio que sirva de espacio para el baile es siempre una experiencia deslumbrante. La amalgama de razas que se mueven de dos en dos, al ritmo sincopado de cuatros, sietes o dieciseis o en tiempos suaves o acelerados, es algo para ver y contar:

—Jim B. conoció a Kikuto en un nightclub. Ella, como tantas otras, llegó a la ciudad con el propósito de estudiar inglés.

—Me parece normal llegarse hasta acá…

—No te das cuenta que los estudios de idioma es la excusa clásica para entrar al país. En realidad se trata de una red de confort women. Imágenes del Japón moderno.

—¡No te lo puedo creer! ¿Qué sucede con las mujeres de aquí?

—Nada que ver. La agenda nuestra es más directa, más agresiva. Esas mujeres llegan adiestradas por maestras sabias en la insinuación, el camuflaje, la reserva y el secreto. No hay que olvidar que están educadas en el arte de hacer sentir bien a la pareja. Son seductoras y sensuales y capaces de celebrar una noche erótica con un nice caballero que tenga mucho, mucho cash. Comienzan sirviéndoles los tragos y los aperitivos, les encienden los cigarros, ellos se relajan y se sienten sexualmente estimulados porque una mujer joven y atractiva está atendiendo sus caprichos. Es un Nirvana.

Se escucha una conversación en una de las mesas de un nightclub privado:

—Why so many men want to dance with you?

—I think I am an excellent dancer...

—...is something else...the way you throw your body into your partner.

—Can we ask for another bottle of Dom Perignon Gold?

—Let me make you an offer. Let's go to my apartment. I assure you we will have a good time.

And in vain her faithful Prince mourns.
—Tao Sueh-Chin, siglo 18

Una vez por semana tomaban el ascensor juntas o separadas, cinco minutos antes o cinco minutos después, pero más o menos a la misma hora, coincidiendo en el café de la esquina. El primer tema por comentar era siempre el intenso ejercicio del baile o la complejidad o sencillez de los pasos aprendidos. De ahí se pasaba al estudio de los parejos, cúantos se habían hecho la cirugía plástica, cuántos casados, cuántos divorciados, cuántos matrimonios rotos, para finalizar con el comentario en torno a los músicos más guapos y los bailarines más ágiles.

—Lo que me cuentas pertenece a un guión de cine.

—Estás equivocada. La película se está filmando, efectivamente, pero con nosotras adentro. Somos parte del repertorio.

Entre sorbos de café y bocanadas de sandwiches, quedaron suspendidas en el horizonte de las paredes blancas de aquel café, cubiertas de anaqueles y neveras con Aguas Perrier, Aguas Fiji, Aguas Saratoga Springs, Aguas Pellegrino y green teas, antioxidants teas, well-being teas, sleeping teas junto a cajitas de galletitas Olde English. Hoy hacía un intenso frío. Los pocos transeúntes se movían con paso rápido y por los vidrios del café se podía ver a unos trabajadores picoteando la piedra de la acera de enfrente. Con un gran martillo de acero o con un picador eléctrico desmoronaban el concreto. Un hombre blanco, corto de estatura, con un jacket marrón acaba de cruzar el café.

—Es Jim B.

—¡Qué coincidencia!

La conversación se intensificó ahora y nuevamente en torno a los parejos. Comentaban sobre los que tenían miradas de drogado, los de dedos velludos, los pavoneados, los tipos cirróticos, los de mal aliento, los dandys y bon vivants, los de caras de falsarios y los que poseían una sonrisa clínica como cortados con una navaja. Todos buscando Lolitas en medio de la pista. El conversatorio giraba ahora en torno al cuerpo y el ritmo, el tacto y el olor, cómo balancearse sin dar un paso en falso y cómo dejar caer la cabeza y el cuello junto a la del parejo en un eje triangular sin que éste se sienta perturbado. Todo en un movimiento circular hacia el fondo y hacia adelante para transformarse en puente de lo desconocido y dibujar la figura de un círculo o una espiral. No es un espacio cuadradado como insisten estos maestritos de acá. Hay que enfrentarse, como un felino poderoso, con la punta de sus dedos, al movimiento redondo, consonante y acentuado de este baile. Tu cuerpo, aunque cubierto de telas y accesorios, ahora se presenta desnudo. Bailar, dijo Sábato, es un rito casi religioso y cada paso responde a un propósito. A través de este ritmo inesperado, accidentado, imprevisto, impetuoso y sorpresivo se le sacuden los fantasmas a la gente produciendo nuevos encuentros y desencuentros. Es la incipiente y vertiginosa pasión humana que no cesa. Es el preludio a la seducción, pero es la seducción, el allure y la atracción con luz taimada de fondo. La Dickinson escribió: I reckon – when I count at all/ First – Poets. No, no la poesía, pero es como si lo fuera. Los bailarines construyen metáforas en el aire, alusiones que los compositores capturan en el oxígeno. Los bailaores, tangueros, swingers, balboas, salseros, afro-cubans, merengueros, hiphop, rappers, raggaes, soka, reggatones y jazz dancers componen una gran espiral y esa espiral es lo que instiga, convierte, calma y latiga la ciudad. Se bailan historias, mi historia principalmente, porque todos pensamos que la historia personal es la más definitoria. El desajuste, el rencor, la angustia, la soledad, la tristeza, la frustración, el descontento, la rabia: todo se baila, porque el baile conlleva un gran compromiso de tan sólo dos o tres minutos, un compromiso que de forma invariable altera la rotación de la tierra de una manera profana.

—y...¿por qué no? Me parece el lugar perfecto para encontrar ese tipo de hombres.

Oh, please, forgive me all these tears...
—*Junichiro Tanizaki*

En un apartamento cualquiera, ya casi anochece y se puede notar la brillante luz de las velas perfumadas, el ramo de flores en la mesa y el incienso quemado flotando en el aire, además se pueden escuchar algunos ruidos en la cocina. El dueño prepara la cena. Han tocado la puerta. Es Kikuto que llega abrigada de un coat hasta los tobillos en piel blanca y

unos stilettos del mismo color. Ahora, sin apuro o empujones se despoja del abrigo y aparece su cuerpo desnudo. El olor del romero y el deseo, las flores y la pasión, el incienso y el apetito ya se han instalado majestuosos y prominentes en aquel lugar.

—Lo único que se me ocurre preguntar es por qué Kikuto le entra a la carne vieja.

—Cuando yo tenía esa edad, disfruté muchísimo con unos cuantos viejos.

—Y, ¿ahora, no te sientes hambrienta?

—Ahora también, pero de carne joven.

Kikuto con su rica cabellera larga y su pequeña figura romántica, prepara un baño de sales. El pelo reluciente, saludable y brillante es lo que más fascina al dueño de casa, mucho más que su cuerpecito incipiente. Su pelo ahora cae en los pezones de éste provocándole cosquillitas. Kikuto ha prometido llamar a una compañera para que en la próxima cita se efectúe una reunión más amplia. A decir verdad…:

—It's me. I need another girl for next week: same day, same time and place.

Kikuto con su piel blanquísima y luminosa y ya sin decir palabra fue abrazada, como se abraza a una diosa en algún ritual antiguo. Nada se daba precipitamente aquella noche, todo movimiento era medido y armonizado y él se sentía absolutamente domesticado y a disposición de aquel ser divino. Su cuerpo se sentía particularmente ligero y ágil a pesar del tiempo y Kikuto alzaba los brazos ofreciendo su pecho tibio, liso, como un rozagante niño a punto de acurrucarse ante su padre. Un pensamiento fugaz lo trajo a la realidad.

—When did you arrive to this city?

—Six months ago.

—What do you do there?

—I worked in clubs as a waitress.

—Does a waitress earn much?

—Yes. In one night I could do one or two thousands…

—What kind of clubs?

—The usuals.

—Where are they located?

—You are asking too many questions, but I will respond, because you are sweet. I worked in a trendy club in Kabukicho, a city district. A lot of men and women of all ages come to have drinks, and casual sex.

—How did you end in that sort of business?

— I had a little debt with them.

—What kind of debt?

—Some invoices...

—You were a consumer!!!

—You can call it that way.

El hombre interrumpió la conversación y de un impulso agarró uno de los pequeños senos de aquella mujer para soltarlo en el acto. Un montón de recortes del Village Voice anunciando escorts services se encuentran apilados en una mesita de noche junto a una botella abierta de whisky. Tomó un vaso chato y ancho, lo llenó de licor y se lo tragó de un buche. Cariñosa y servil, con aires de yo no fui, Kikuto pasó sus manos suavemente por el cuello y los hombros, las orejas y la boca de aquel señor. Daba masajes al cuello, bajando a la espalda en movimientos mínimos y lentos, casi imperceptibles, para de ahí arrastrar sus dos montañas a las nalgas todavía musculosas y aún redondas de éste. El hombre tuerce su cuerpo bruscamente y Kikuto queda de frente al miembro ya engordado. El hombre se lo mete en la boca y Kikuto lo va mordiendo suavemente, sin hacerle daño, mas bien como si estuviera saboreando y tragando un puré de albaricoques. De esta manera el hombre se adormece a la misma vez que arde de entusiasmo, lo que le produce unos intensos escalofríos en la espalda. El hombre pide más y más y Kikuto le complace tomándole las bolas con ambas manitas mientras desciende una de las manos hasta llegar al culo para introducirle dos dedos suavemente y después de unos segundos largos sacarlos y empujarle un largo collar de cuentas. Una-a-una. El hombre ya no puede con tanto éxtasis quedando amarrado a Kikuto con la misma fórmula que una hechicera amarra a su víctima. El miembro se le expande aún más y en un arrebato este hombre de un tirón eleva a Kikuto por los aires hasta ponerla de frente a él. Ahora abre la vulvita pequeñita y discreta. Kikuto con la boca hinchada y salivosa y ya muy excitada insiste en seguir amándole el miembro, pero el hombre no se lo permite, abriéndola en dos mitades y metiendo su centro. El hombre ya apacible descansa al lado de Kikuto mientras le ofrece todo tipo de recompensas:

—I want you to live with me.

—Thank you, but no.

—Fine. Do you want a separate apartment? I can provide for that. Do you want me to bail you out of your debt?

—You are very kind.

—Do you understand that I love you.

Kikuto sonríe y ahora se pasea desnuda por la casa, el hombre busca con la vista aquel cuerpo, mientras extiende una mano hacia sus pantalones tirados en algún punto. Sale finalmente de la cama y saca un monte de dinero de uno de los bolsillos para depositarlos en las manos, ya lavadas y perfumadas de Kikuto. La siempre atenta, cariñosa y amable Kikuto le prepara y sirve frutas en una bandeja. De inmediato le sirve más whisky, yéndose de la mano a la cama como dos tortolitos. ¿Y la cena? Se han olvidado de aquellas ollas tapadas y olorosas a romero y del horno fustigando el gas que transforma la masa en pan. Kikuto acurrucándose a su lado como una gatiña maltratada ha quedado dormida. Han pasado más de dos horas y Kikuto despierta ya, comienza a impacientarse. A pesar del momento de descanso estaba exhausta, pero ante todo aburrida. Es hora de marcharse. El hombre se irrita, se impacienta, intenta seducirla pero ella: cabeza, neurona y memoria ya están fuera de aquel lugar. Él insiste, pero Kikuto ya se va acomodando en el abrigo blanco que la cubre de la gélida temperatura en la calle y los stilettos decorados con rhinestones de colores traslúcidos. Controlables agujas fálicas abiertas a otros juegos, a otras seducciones. Abre la puerta de salida y ya no se le vio más.

—¿Qué me dices?, ¿Desapareció?

—Pudo haber regresado a Tokío.

El hombre llama una y otra vez al club. Tiene que que ser ella, insistía. Pagaré lo que sea. Puede venir acompañada, informó en muchas ocasiones, pero a quien quiero es a Kikuto, terminaba enfatizando.

—Jim B., igual a ese hombre se desesperó, sentía que la perdía, que no tenía control alguno sobre ella. Para colmo también había desaparecido de los salones de baile. En una ocasión le pareció haberla visto de espalda, montándose en un tren. Era una chica asiática con rasgos similares a Kikuto, en unos jeans con cintura baja, casi rozando la partitura del fondillo y un pañuelo de seda amarrado al cuello y a la espalda y ambos senitos al aire. No iba sola.

Una noche se produjo la ansiada llamada:

—It's me, Kikuto. I have a problem.

—What kind of problem?

—I have something in there.

—Where?

—Downthere.

—Did you go to the doctor?

—Yes. The guy that I was with took me to a public clinic. Everyone treats you very nice in that place.

—A public clinic? Is he insane? I will pay for you to go to a private doctor.

—Thank you, thank you, thank you.

—I always will be here for you.

La dificultad que tienen ciertos hombres maduros es que asumen el papel de papás y el incesto provoca un extraordinaria pasión. Una niña a quien cuidar y proteger de otras manos varoniles, una niña a la que puede templar, moldear y dejarla madurar al ritmo que a él le dé la gana. A esta niña se le lleva a las tiendas y se le deja escoger ropa y joyas al gusto, para luego llevársela a la cama y quitarle todo ese ropaje. Se le enseña a la niña ahora los secretos típicos del amor y los más profundos, se le deja retozar entonces con el cuerpo ya maduro, escamoso y arrugado y con el látigo puntiagudo el cual procede a abrir todos los túneles delicados que ésta posee.

—Ciertamente tiene su encanto, digo yo, ese tipo de vida. Sólo hay que preocuparse por mantenerse bonita, en buena forma y estar indudablemente disponible.

—No olvidemos que se trata de una transacción comercial.

—Es fácil olvidarse.

Son las tres de la mañana y Kikuto camina sola a través de las calles húmedas y diminutas y las sombras que la poca luz de los faroles eléctricos

reflejan. En un segundo piso, un hombre sentado en la ventana de su cuarto, miraba nada en específico y todo en absoluto. Las pisadas de Kikuto son lo suficientemente poderosas como para que éste se interese en esa figura de huesos pequeños, delgada, con un abrigo Alberta Ferreti de piel de zorra blanca y unos stilettos de cinco pulgadas de largo, decorados con cristales de la India que pasó frente a él y se fue alejando en el horizonte. El pelo reluciente, lacio y fino parecía que podía derretirse entre sus manos.

ANITA VÉLEZ-MITCHELL

Anita Vélez-Mitchell es escritora de poesía, cuento y drama; es bailarina, actriz, directora de teatro, traductora y maestra de drama y poesía en las escuelas públicas de la ciudad de Nueva York. Nació en el 1916 en alta mar entre San Juan y la isla de Vieques, donde se crió con sus tíos antes de vivir con su madre en Nueva York a los trece años. Es autora del poemario bilingüe *Primavida: Calendario de amor* (1984, Premio Julia de Burgos), el libro *Loco de amor: Cuentos que me contó mi madre* (2006) y las obras de teatro *Salsa American Connection, Ripples of the Mind, La cueva llamada Ego,* y *Dust Off,* que se presentaron en los teatros Latino Playwrights, La Mama y Repertorio Español. Escribió el libreto de ópera con música de Joseph Lliso (director del Pan American Symphony), *Temple of the Souls,* que se ha presentado en tres conciertos. Sus obras se han publicado en revistas y antologías en los Estados Unidos y se han leído en lugares como Columbia University, Boricua College, el Recinto Universitario de Mayagüez y el Instituto de Cultura Puertorriqueña.

A Vélez-Mitchell la distinguió el rol de "Anita" en las presentaciones teatrales de *West Side Story* y las actuaciones con su grupo, The Anita Vélez Dancers, en el Ed Sullivan Show en la televisión, el Teatro Palace de Broadway y la cadena Hilton de los Estados Unidos, Canadá, y el Caribe. Estudió con José Ferrer, Boris Marsholov y Marcel Marceau. Bailó con Fred Kelly y Peter Gennaro y realizó giras artísticas con Marina Svetlova para Columbia Concert Artists. Ha recibido los siguientes premios: Premio Julia de Burgos en 1984 (por *Primavida*), Isaac Pérez Award en 1994; La Mama Theatre Award en 1993; Premio Centro Iberoamericano de Poetas y Escritores 1990, 1991, 1992, 1994 por poesía, cuento y ensayo; y el Premio de Dirección Teatral de Aplausos en 1992. Vélez-Mitchell fue presidenta de la Asociación Puertorriqueña de Escritores (APE). En 2005, para celebrar sus 90 años, recibió la proclama del alcalde de la Ciudad de Nueva York, "Anita Vélez Day in New York City". Es una de las fundadoras de La Casa de la Herencia Cultural Puertorriqueña. En el 2010, el periódico *El Diario La Prensa* la honró entre las "Mujeres más destacadas del año".

Anita Vélez-Mitchell is an actor, dancer, singer, circus performer, poet, short story writer, playwright, translator and an opera librettist. Born in 1916 on the high seas between Vieques and San Juan, she was brought up in Vieques by her aunt before coming to New York City at the age of thirteen. She authored the bilingual poetry book, *Primavida: Calendar of Love*, (1984), the book *Loco de amor: Cuentos que me contó mi madre* (2006) and the plays *Salsamerican Connection, Ripples of the Mind, La cueva llamada Ego*, and *Dust Off*, which were produced by Latino Playwrights, La Mama, and The Spanish Repertory Theatre. She has directed many plays and has translated into English the work of Puerto Rican writers. She wrote an opera libretto with music by Joseph Lliso (music director of the Pan American Symphony), *Temple of the Souls*, featured in three concerts. She has also read her poetry in cultural centers and colleges such as Columbia University, Boricua College and in Puerto Rico at the Recinto Universitario of Mayagüez and the Institute of Puerto Rican Culture. Her work has been published in magazines and anthologies. She taught drama and poetry in the public schools of NYC.

As a performer, Vélez-Mitchell played "Anita" in the revival of *West Side Story*. In 1954 she founded The Anita Vélez Dancers, which was featured on the Ed Sullivan Show on TV, the Palace Theater on Broadway, and the Hilton Hotels throughout the United States, Canada and the Caribbean. She studied drama with José Ferrer, Boris Marshalov, Marcel Marceau; danced with Peter Gennaro and Fred Kelly; and toured with Marina Svetlova for Columbia Concert Artists. She has received The Julia de Burgos Award in 1984 (for *Primavida*), the Isaac Pérez Award in 1994; Best Director Award from Applause News in 1992; La Mama Theatre Award in l993; Centro Iberoamericano de Escritores Award in 1990, 1991, 1992, 1993, 1994 in poetry, essay, and short story, and an award from the National Conference of Puerto Rican Women. Vélez-Mitchell was president of the Association of Puerto Rican Writers (APE). In 2005, to honor her 90th birthday, the Mayor of New York City issued the Proclamation "Anita Vélez Day." She is a founding member of La Casa de la Herencia Cultural Puertorriqueña. In 2010, she was honored as one of the "Most Oustanding Women of the Year" by *El Diario La Prensa*.

NOW

I am ninety-two
at this very moment
it is me, myself and I
poeticizing here with you

Physical reality ... vital
psychic reality ... consciousness ... forgiveness ... love
material reality ... All I own!
Not to be confused
with the potential reality
of the unknown...

Will I live to ninety-three?
Or will I suddenly expire...
Will I come back as a rose...
or a thorn?
Poor Anita undone! Still...
life goes on, and on, and on
in this miraculous body I own
at the mercy of the elements...
Earth, water, air, fire
And...Oh... men!
balancing precariously
on the horizon's high wire...
'til God knows when.......

March, 2008

Hermanas

Medía yo cinco pies
cinco pulgadas
mi hermana cinco-ocho

Ella me llamaba enana

Yo era más como mi padre
una trigueña
ella era rubia

Ella me llamaba prieta

Yo nací en Puerto Rico
ella en el Norte
yo hablaba con acento

ella me llamaba gaga

Ella era quieta
y yo viva de palabras
traté, traté, y tanto traté

que un día confesó
que era un honor
ser mi hermana

AUNTIE LILA'S PASSION

Auntie Lila was the richest of my aunts. She was perhaps twenty in the 1930s, and she was already a divorcee. She was haughty but sensual, what we still call *buena moza*, meaning that she was not precisely beautiful, but desirable; and she presented a challenge for the pretender who would dare cross the line of "look and don't touch," which Auntie Lila had adopted when she resumed her social life.

Some of the available men in town didn't dare come near her, others tried and gave up, and some felt rejected and disappeared, but one of them so charmed her, that Auntie Lila, who already had sustained three years of abstinence, weakened and consented to be his bride.

But it happened that in the day of the wedding, the groom was publicly accused of being a married man with a family. Open-mouthed before the accusing finger of Auntie Lila's ex-husband, "The Hunk", as her husband-to-be was called, turned on his heels and fled through the amazed spectators, leaving Auntie Lila flat on the stairs leading to the High Altar. This altar had been brought by Auntie Lila from Spain and she had donated it to the church, so that the Bishop would allow her to marry, even though she was a divorcée.

Poor rich Auntie Lila suffered such ridicule, became a recluse, by not allowing a soul in her room. "Not a soul; NOT A SOUL, to hush the wagging tongues of the scandal-tainted town!" Her hand-maid, Crucita, as if she had no soul, was the only one who would come in and out.

"The duplicity of that scoundrel has broken my heart! In a thousand pieces; IN A THOUSAND PIECES!" I, who was at the age of ten, heard her, knowing her to be so withdrawn and sad, imagined her heart as a jig-saw puzzle and honestly wanted to fit the pieces together in order to patch her broken heart.

Her melancholy confined Auntie Lila to bed a great part of the day. Through the mosquito-netting one could see her languid body under the percale sheet, "writhing with unfulfilled desires!" as Crucita would whisper in my ear, during the breakfast we shared at the kitchen table. "Could she be dreaming?" I would venture. Through the half-open door I could see Crucita standing by my aunt's bed, waiting for Auntie Lila to let go of her anguish and taste what was being offered to her in the tray. But Auntie would only delicately bite the very tip of the banana and taste a sip of coffee. Then she would "gar-gl-gl-gle" with water and spit it back into the glass, nauseating me to the point of my having to say "acht, fui." "I can't eat, Cruz, I'm hungry for kisses...KISSES! YOU HEAR?" and Crucita, who could not

dish out a plate of kisses, would return meekly to complain to me.

"Auntie Lila is finally getting up, Crucita, come and see!" I took Crucita to the stairs where, on tip-toes and leaning over the handrail, we could peek through the window, into Auntie Lila's room.

Holding on to the mosquito-netting, Auntie Lila pushed herself convulsively to the wall and, sliding along her stiletto heels, made her way to the vanity, where she sank before the mirror and gently began to wipe off her swollen, tear-stained under-eyes streaked with mascara. She reached for the brush and with a vapid gesture began to stroke her silky flowing taffy-colored hair; then she squeezed her atomizer under each arm letting her favorite Ylán-Ylán waft to our nostrils. She took out a Chesterfield, sucked on the tip, introduced it into the opening of the long ivory cigarette holder, and, with the élan of a movie star, inhaled deeply. Suddenly, she disappeared behind a misty veil of smoke; but no! she was still there, becalmed, her head surrounded by a halo and her half-closed eyes seething with such gall and spite, she have well been planning a sly revenge. Sensously, she vaselined her lips, and with marked ease, she began preparing herself for something special. It was music. On the victrola she had placed the record of her favorite song, the one she and her love had sung as a duet, the two of them locked inside the room. With his photo close to her heart she began to swoon to the voice of the singer who expressed so well the torment of absence and deceit:

> *I swear I can hardly go on living*
> *the world has lost its meaning*
> *without you. . .*
> *I hold your photo close , my eyes in tears*
> *and night and day I pray*
> *you love me too-oo-oo-ooh!*

More than once Auntie Lila stopped singing to dry her tears with her lace-bordered handkerchief, and now and then she would bite on it with a vengeance murmuring, "Ungrateful wretch; oh, you don't know how I suffer!" Then she would continue to sing sadly holding the photo against her heart.

Next to Auntie Lila one could see the dainty flowers Crucita placed in a petite-vase by the mirror. Auntie Lila reached for a daisy and began to tear its petal chanting with each one, "He loves me yes, he loves me not, he loves..." Crucita and I held our breath until the last petal, when Auntie Lila with a loud scream, her fist to her forehead and her head tragically thrust back, cried aloud: "No, you don't love me, you devil...two-timer...LIA-A-R." Opening her hand she threw the petals up in the air. Then glowering, posed as if ready to charge, she began to curse him with abandon: "Gigolo...

cheat... you horny-bastard, you only wanted my money...who would have guessed it? I thought you were a gentleman!"

"Will how long this torment last?" Crucita would ask, tired of being Auntie Lila's slave, while Auntie worsen day by day. But not me: I was fascinated with life's new phase of pain and pleasure.

One day I peeked through the key hole of the bathroom door, which aimed directly at the bidet, and saw Auntie Lila sitting plump on that prophylactic artifact, her soft long hair covering her naked breasts, and her eyes turned upward towards the ceiling. The waters of the bidet bubbled, refreshing her "nook of desire," as Crucita secretly called it—it was a strange and curious thing for me, for I was not allowed to sit on this sitting wash-bowl "until you grow hair under your arm pits!" But of course I had sneaked in and tried it. It was pleasant, but no big deal. Suddenly, Auntie Lila raised her voice in a vibrato, calling out her lover's name as in a rising chant: "Ricardo-o-o-oh, my God!" To me it seem as if she had thrown a fit, but then I realized it was a supreme act of adoration. So I went directly to tell Crucita. I mimicked my aunt so well, "Ricardo-o-o-oh, my God!" that Crucita scolded me with her own folk-wisdom.

"Your Auntie suffers from the pasión of true love."

"But isn't passion and love the same thing?"

"Well, it has to do with what you feel down there and what you feel up here. Love becomes *pasión* and *pasión* becomes *amol*. It's a vicious *cílculo*".

"And what comes first? I wanted to know it all.

"Two people--a man and a woman--latch on. You know what a latch is: It's like this..." Crucita showed me, making obscene gestures with her hands. "It goes in and out. In and out...in and out...well, that's it."

I knew that was a no-no, so I tried to change the subject. "Could it be they are like my two little metal dogs with a magnet that makes them stick together?"

"That's it. When it happens it can not be helped. This is why you should have *compasión* with your auntie and not make fun of her. And if they find out that you are Tom peeping they will restrict you to the out-house with us. You are only ten years old but someday *Niña, tú también* will burn with that *pasión* and you will remember Doña Lila, and what makes you giggle so today will make you cry tomorrow."

"Poor Auntie Lila! Will she be suffering the rest of her life?"

"Noooh!" Crucita pouted. "Don't you know the heart is like a big pouch?

It can accommodate many loves. *Pol supuesto* each one is different. *El corazón* has a life of its own. *Poco a poco* the heart gets even and it flushes out that godforsaken love, *así como dal del cuelpo*". She sighed as if she remembered something sad. "True, it leaves a deep, deep pot-hole!" Then she blurted, "No evil lasts a hundred years; the body cannot withstand it!" Suddenly, she beamed, "But, there's that other saying, 'If you have an empty heart fill it with *amol*, better love than hate.' " She then began to sing, *"amol, amol, amol..."*

Crucita's face brightened with a glint of satisfaction as I stood there listening to her. I smiled, and she took my hands in her hands gratefully. "Your auntie knows *to'ito eso*. She teaches me, while I adjust her corset. *Oh, Caramba, Niña*, I almost forgot this other wise saying: TIME IS THE BEST DOCTOL." We both had a good laugh.

Sometimes Crucita would start her 'LA LEI LO LA-LA LEI LO LEI' and Auntie would call out, "Crucy, hush up, that song doesn't go with the rythmn of my me-lan-cho-ly!"

Crucita, was only fifteen, but one would think she had already burnt in that fire of the senses called *'pasión, PASIÓN!'* such a beautiful word! But... was it like a living purgatory?

I finally decided to forget about it, for I would be having nothing to do with it until the hairs would grow under my arm pits. That is why with great curiosity I would examine myself in the mirror every night before going to bed—and in the morning too, just in case.

Poor and rich-no-longer, Auntie Lila, having gone through more than one "cold shower of *amol*," as Crucita would say, had now adopted a holier-than-thou attitude. I left my poor Auntie looking like a frazzled calla lilly, but still imbued with an aura of romantic memories.

I have already tasted all the ups and downs of life, and every time I shave my underarms I feel like that mischievous little girl who marveled at the mystery of life back on Isla Nena, that unspoiled land off the coast of Puerto Rico, rocked by the waters of the Atlantic and the Caribbean, where the streets were lit by dim gaslight and the women, though domineering housewives, were sweet and fragile as a *merengue*, and where that sanitary contrivance to wash the intimate parts of our bodies--today relegated to oblivion--was a dire necessity.

A few days ago I went to the Museum of Modern Art in New York City to see a film starring Theda Bara, who is currently featured in the postal-stamps series of 1995 commemorating the Silent Screen Stars. She plays Auntie Lila to a "T". I would bet my aunt also had seen the extravagant acting of that marvelous star. I might have thought my aunt had imitated

her, had I not already learn that life and art go hand in hand. The movie reminded me of the drama so thoroughly lived by my dear auntie. There was only one thing missing: the scene of the bidet.

In these years when sex themes are spewing forth like the waters of a singing fountain; Auntie Lila and her bidet would have reached the peak of erotic ecstasy. Now I know that our dear Crucita, may her soul rest in peace, was right: what had been so amusing to me back then, suddenly makes me cry.

Translated by the author.

THE SAND AND ME

The sand
 belongs
 to the sea
 meekly
 she waits
 to huddle
 in the crevice
 of her watery
 wings ... and
 to her daring
 swells
 she surrenders
 until she reaches
the shore
 her luminous
 eyes
 radiant
 with footprints
 my sand
 self
 slides down
 your briny
 body
 and in the depths
 of your abyss
 she cuddles
 pearled
 with salt
 and moonglow
until she lands
at her bed
 and lies
 flickering
 in her orbit
 of anguish...

Translated by the author.

FREEDOM IN CENTRAL PARK

(Written in the 1930s)

I'm free... alone with myself
in this green span of leisure
I speak to the pigeons
and they teach me how
to look for food

The wind urges me on
wants to help me
escape from self
from my inaccessible dreams
my desires, my longings...
To be back with those
left back home on the island
of Vieques, my abused
green homeland I love

Gone... gone forever...

I lie on the grass
the colors change to blue
and those dreams, those desires
squeeze tears from my eyes.

It's late... I guess... legs pass me by...
A shadow... It's a colorful skirt
going home... I must get up
from the chitty-chat of green.
The wind helps me up
I must return to the fold
Somehow, like my beloved island
it's been torn apart...
the arguments, the neediness, the fears
the nasty words, the secrets,
stories not told to me...
Sh.... loud as bombs... but
'she's only a child' they say...

With an effort I push
the wind from my face
as I sit to look far away
my deep breath says 'good-bye'
to the earth, to the sky... I get up
the sun cuddles my shadow
the day is about to be done...

the space overwhelms me.

Central Park is immense
like my aunt's arms extended
in a tearful good-by...

Is it South, East, West, North?
the wind insists 'go on... go home'
with a frown of concern to my feet
I say 'go on'... but where? (where?..)

Time only knows
where is home

CRÉDITOS DE LAS FOTOS / PHOTO CREDITS

Stephanie Agosto	*No photo credit*
Alba Ambert	Yanira de Posson
Maritza Arrastía	Zorin Glickman
María Arrillaga	Joe Gutiérrez
Sandra Barreras del Río	Rafael Orejuela
Evangeline Blanco	Richard L. DeJesús
Giannina Braschi	John Clifford
Susana Cabañas	Mariposa
Sheila Candelario	Catalina Santamaría
Yarisa Colón Torres	Josué Guarionex Colón
Lydia Cortés	Arthur J. Newman
Marithelma Costa	Julio Manzanares
Elizabeth Cruz	Elizabeth Cruz
Caridad De La Luz (La Bruja)	Rosalía Rivera de Craane
Sandra María Esteves	George Malavé
María T. Fernández (a.k.a. Mariposa)	Elena "Mamarrazzi" Marrero
Sandra A. García-Betancourt	*No photo credit*
Sandra García Rivera	*No photo credit*
Magdalena Gómez	George Malavé
Diana Hernández	Willie Correa
Ana López-Betancourt	Michael L. Wagner
Dahlma Llanos-Figueroa	Richard Stokes
Carmen D. Lucca	Prisionera
María Mar	Sheila Candelario
Nemir Matos-Cintrón	David Rentería
Nancy Mercado	Shivaji Sengupta
Madeline Millán	Mario Garcés
Nicholasa Mohr	Christopher Bell
Cenén Moreno	*No photo credit*
Hilda R. Mundo-López	*No photo credit*
Myrna Nieves	Louis Servedio Morales
Marina Ortiz	Elena "Mamarrazzi" Marrero
Dylcia Pagán	Sam
Prisionera--Paula Santiago	Carmen B. Gómez
Carmen Puigdollers	*No photo credit*
María Riquelme Muñiz	María Riquelme Muñiz
Raquel Z. Rivera	Jorge Vázquez
Esmeralda Santiago	Cantomedia
Corazón Tierra	Tanya Torres
Tanya Torres	Juan V. Núñez
Luz María Umpierre-Herrera (Luzma)	Nemir Matos Cintrón
Rhina Valentín	Pepper Photography
Carmen Valle	Hjalmar Flax
Gloria Vando	Anika Paris
Lourdes Vázquez	Omar Acosta
Anita Vélez-Mitchell	*No photo credit*

Portales y correos electrónicos / Websites and E-mails

Stephanie Agosto	www.theiaas.org
	StephanieAgosto13@gmail.com
Alba Ambert	paramitapath@mac.com
Maritza Arrastía	http://thewritingroom.org
	mahi@people-link.net
María Arrillaga	mariarrillaga@yahoo.com
Sandra Barreras del Río	scbarreras@hotmail.com
Evangeline Blanco	AngBlanco@aol.com
Giannina Braschi	Gbraschi@verizon.net
Susana Cabañas	Sucabanas@aol.com
Sheila Candelario	candelariosheila@hotmail.com
Yarisa Colón Torres	Espacioasiray.blogspot.com
	espacioasiray@gmail.com
Lydia Cortés	elcortes01@aol.com
Marithelma Costa	www.editorialplazamayor.com/files/expediente.htm
	marithelma@earthlink.net
Elizabeth Cruz)	edaffy@aol.com
Caridad De La Luz (La Bruja)	www.labrujamusic.com
	www.myspace.com/labruja
	boybruja@gmail.com
Sandra María Esteves	www.sandraesteves.com
	www.myspace.com/culturediva.
	estevessan@aol.com
María T. Fernández (a.k.a. Mariposa)	
	www.myspace.com/poetatremenda
	poetatremenda@gmail.com
Sandra A. García-Betancourt	SGBetancourt@nomaanyc.com
Sandra García Rivera	www.myspace.com/sandragarciarivera
	sgrpresents@gmail.com
Magdalena Gómez	www.latinapoet.net
	www.teatrovida.com
	Amaxonica@mac.com
Diana Hernández	www.thenumusegallery.com
	gitesha@yahoo.com
Ana López-Betancourt	abetancourt004@nyc.rr.com
Dahlma Llanos-Figueroa	www.llanosfigueroa.com
Carmen D. Lucca	aprhculture@verizon.net
María Mar	www.dreamalchemist.com
	www.poetrybotanica.com

Nemir Matos-Cintrón	www.facebook.com/pages/Nemir-Matos-Cintrón/124982717523324
	www.editorialatabex.com
	Nemir49@gmail.com
Nancy Mercado	www.pen.org/MemberProfile.php/prmProfileID/39084
	mercado.n@gmail.com
Madeline Millán	www.mmillan.com
	mmillanvega@yahoo.com
Hilda R. Mundo-López	hilda_mundolopez@fitnyc.edu
Myrna Nieves	mnieves2@aol.com
Marina Ortiz	www.virtualboricua.org
	www.eastharlempreservation.org
	marina@virtualboricua.org
Dylcia Pagán	www.dylciapagan.com
	dpatrialibre@gmail.com
Prisionera-Paula Santiago	www.prisionerasoy.com
	www.myspace.com/prisionerasoy
	prisionerasoy@aol.com
Carmen Puigdollers	abu2205@earthlink.net
(daughter / hija: Rita Rodríguez Puigdollers)	
María Riquelme Muñiz	mariapoeta2003@yahoo.es
Raquel Z. Rivera	www.raquelzrivera.com
	raquelzrivera@gmail.com
Esmeralda Santiago	www.EsmeraldaSantiago.com
	List@EsmeraldaSantiago.com
Corazón Tierra	www.notehagaspequena.com
	www.belovedbodysoul.com
	corazon@shamansdance.com
Tanya Torres	www.tanyatorres.com
	http://hoy-artista.blogspot.com/
	tanyaetorres@yahoo.com
Luz María Umpierre-Herrera	
(Luzma)	www.luzmaumpierre.com
	Lumpierre@aol.com
Rhina Valentín	www.rhinavalentin.com
	www.myspace.com/rhinavalentin
	rhina@rhinavalentin.com
Carmen Valle	cvalle7@verizon.net
Gloria Vando	www.heliconnine.com
	vandog@heliconnine.com
Anita Vélez-Mitchell	avelezmitchell@yahoo.com

Permisos / Permission Credits

Quotes on page 5.